Lonely planet

THE
Tree Atlas

The WORLD'S MOST AMAZING TREES
and WHERE TO FIND THEM

Matthew Collins WITH THOMAS RUTTER

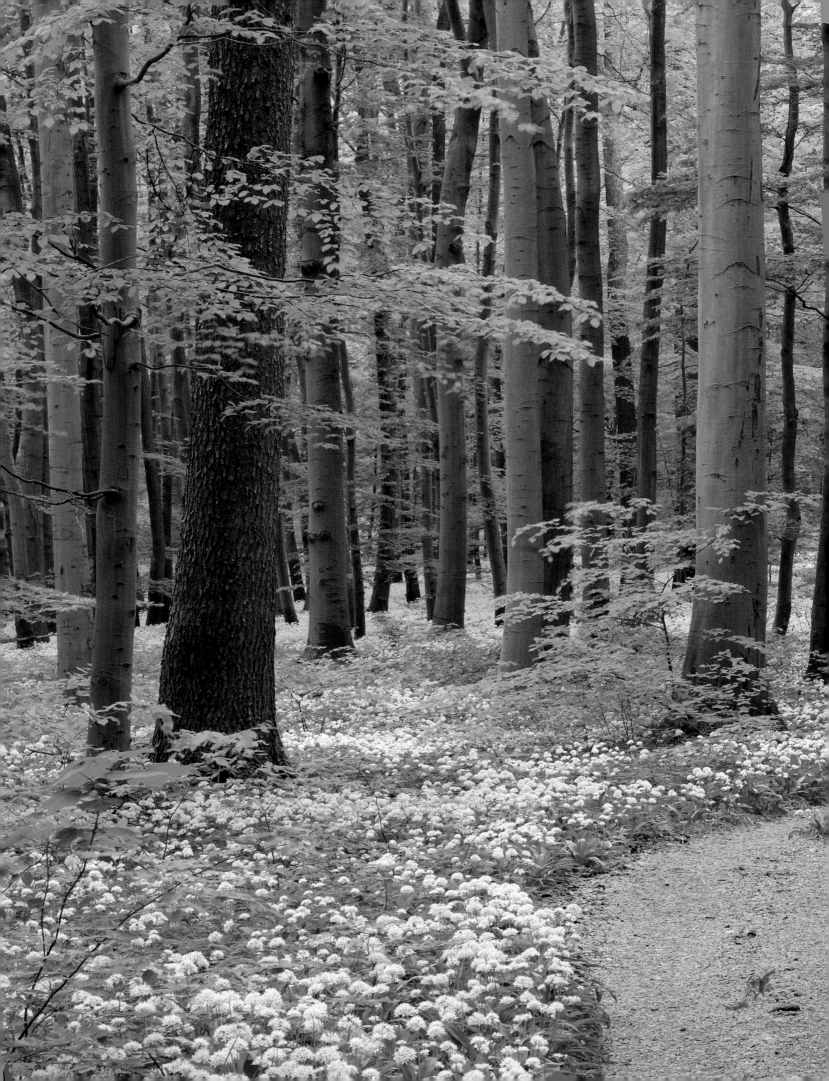

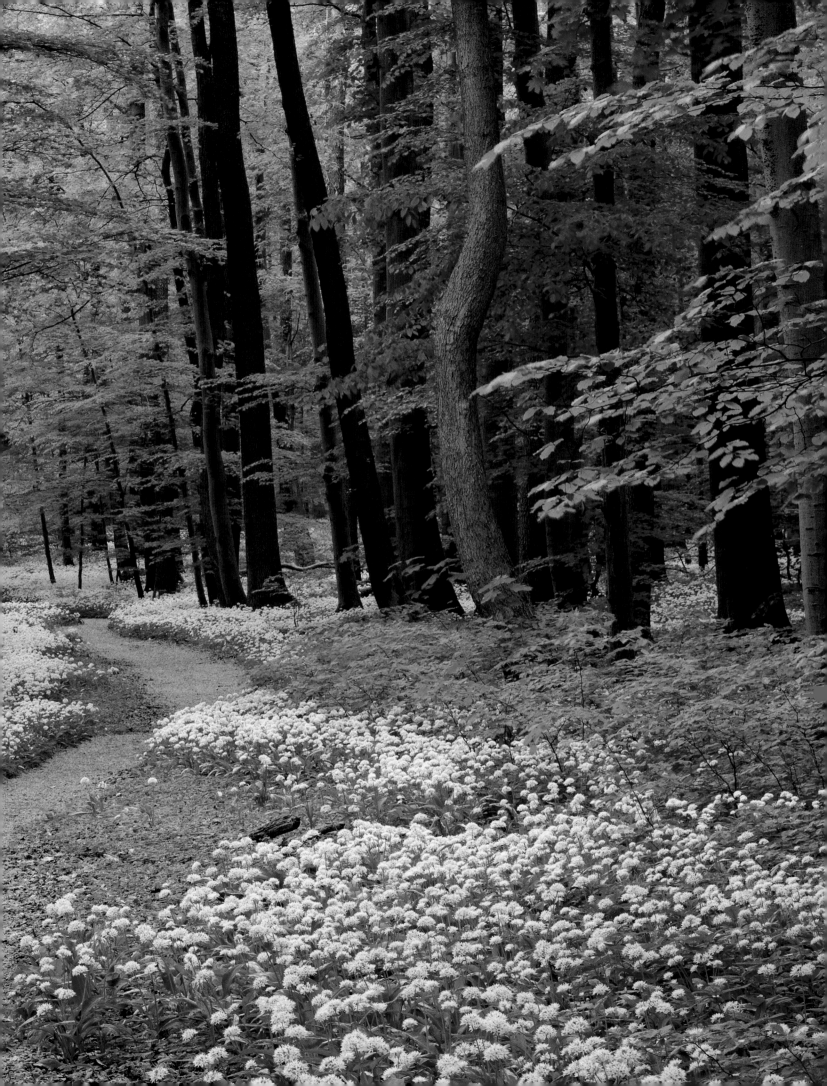

Contents

6 INTRODUCTION

8 FOREWORD

12 DISCOVERING TREES

17 AFRICA & THE MIDDLE EAST

18 Carob Tree

22 Quiver Tree

27 Red Mangrove

30 Date Palm

34 Umbrella Thorn Acacia

41 Atlas Cedar

44 Dragon's Blood Tree

49 Grandidier's Baobab

53 THE AMERICAS

54 Great Basin Bristlecone Pine

59 Sugar Maple

62 Southern Live Oak

67 Monkey Puzzle

70 Quaking Aspen

75 Pacific Madrone

78 Giant Sequoia

85 Jacaranda

88 Ponderosa Pine

93 Boojum

96 Western Redcedar

101 Alerce

104 Joshua Tree

109 ASIA

110 Black Mulberry

115 Tree Rhododendron

118 Ginkgo

123 Cherry

128 Indian Banyan

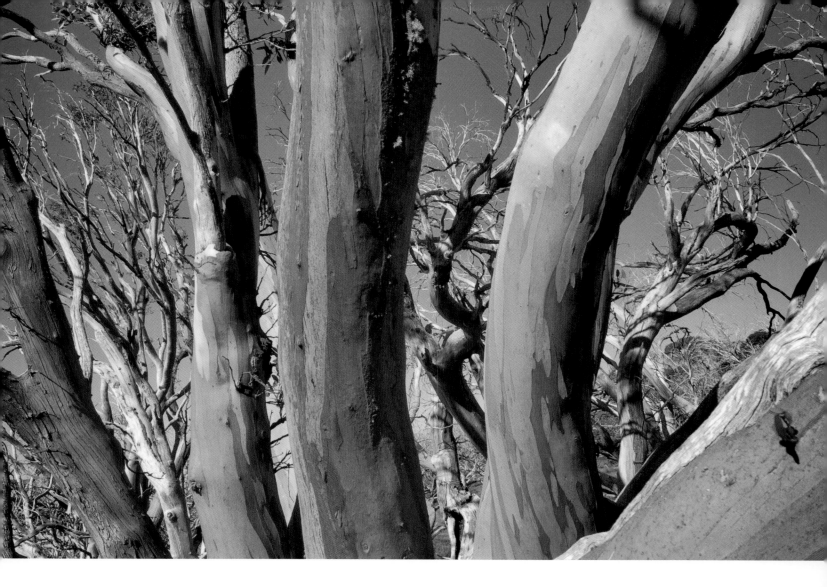

133	Coconut Palm		197	OCEANIA
136	Yulan Magnolia		198	Mountain Ash
141	Flame of the Forest		203	Wollemi Pine
			206	Karri
145	EUROPE		211	Kauri
146	Silver Birch		214	Norfolk Island Pine
151	Cork Oak		219	Snow Gum
154	Maritime Pine		224	Pōhutukawa
159	Holly		229	Rainbow Eucalyptus
162	European Larch		232	Moreton Bay Fig
167	Yew			
170	Common Beech		236	INDEX
177	Olive			
180	Oak			
184	Norway Spruce			
188	Horse Chestnut			
193	Almond			

Introduction

IN THE FOOTHILLS OF AUSTRALIA'S YARRA RANGES NATIONAL PARK, JUST BEHIND THE TOWN OF WARBURTON, THE O'SHANNASSY AQUEDUCT TRAIL WINDS THROUGH A FOREST OF SOME OF THE TALLEST TREES ON EARTH.

Mountain ash, native to just corners of Australia's southeast state of Victoria and the island of Tasmania, grow up to 300ft (90m) in height, allowing giant ferns to flourish beneath their canopy. The trail is, for the most part, level and easy-going, which is great because you'll spend most of your time looking up in awe, absorbed by these amazing trees surrounding you, only a short train trip outside Australia's largest city. A similar experience can be enjoyed across the Tasman Sea by visiting the huge kauri trees of New Zealand's Northland.

Over in California, the giant sequoias of the Sierra Nevada also inspire wonder. 'My first impression of these trees was amazement at their size and scale,' says Sintia Kawasaki-Yee, spokesperson at Sequoia and Kings Canyon National Parks. 'I love to encourage people to touch the trees, which is allowed unless it's behind a fence or protected area.'

The Tree Atlas isn't just about the world's largest trees. It's about discovering and appreciating many of the world's most amazing species of tree. We'll travel to the cities of Asia to see how cherry blossom and golden ginkgo leaves create moments of beauty in hyper-urban environments. In the most arid areas of Africa and the Middle East we'll meet quirky quiver trees, thorny acacias and bulbous baobabs. Olive and almond trees of southern Europe have sustained communities for centuries, while beech and oak forests are the sources of myths and legends. In the Americas, we'll find some of the world's oldest living organisms in the gnarled form of bristlecone pines and also some of the most vibrant hues in the autumn foliage of maples and aspens.

As beautiful as these trees look in a book, we hope that you'll be able to visit some of them too. There are significant benefits to people. Think about how you feel after spending time among trees. Calm? Inspired even? Scientists call this state 'soft fascination' or the 'attention restoration theory' proposed by Rachel and Stephen Kaplan in their 1989 book *The Experience of Nature: A Psychological Perspective*. This is why many of our best and most creative ideas come to us during a walk in green spaces. And feeling awe, research by the University of California suggests, leads people 'to be more altruistic, less entitled, more humble ... and less stressed by the challenges of daily living.'

Going to see the trees is also beneficial for the environment (with important caveats: overtourism and carelessness can harm trees, for example by bringing disease to the kauris of New Zealand). As Richard Louv, the author of *Last Child in the Woods*, puts it: without reconnecting with nature, the destruction of nature is assured. One half of the world's trees live in forests and forests are gradually disappearing. Around 17% of the Amazon rainforest has been cut down in the last 50 years. Tourism offers an alternative income to logging and raises awareness of local issues. Several organisations are dedicated to protecting forests, such as Tompkins Conservation, founded by entrepreneurs Kris and Doug Tompkins. It has created national parks in Chilean Patagonia, including Pumalín Park, home of some of the last stands of the rare alerce tree.

So, how best to spend your time with trees? Don't rush. Walk, don't run. Go alone or with a friend. Being along allows you to focus on yourself – or at least ensure your companion is on your wavelength. Engage your senses. Listen to the forest's sounds. Touch the bark. Smell the forest fragrance. Note how birds and leaves move. And breathe deeply. Feel air fill your lungs and exhale slowly. After a few minutes you may notice your mind wandering.

As Sintia says of Sequoia National Park: 'I hope everyone that visits is able to live in the moment and appreciate these special places being set aside for the enjoyment of not just us, but future generations to come.'

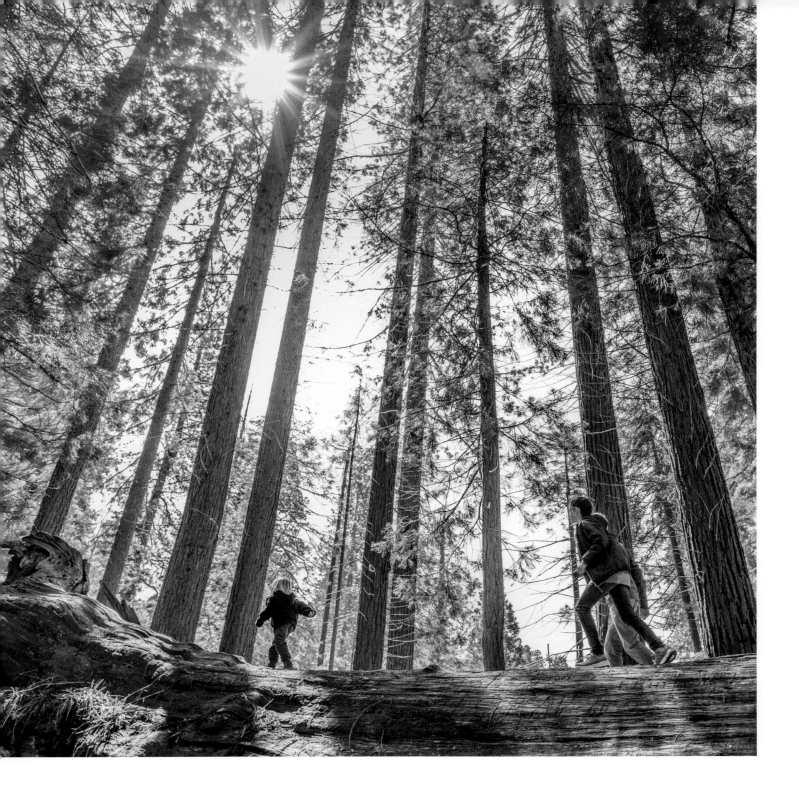

About this book

We asked Matthew Collins, with the assistance of Thomas Rutter and Joe Bindloss, to compile and write *The Tree Atlas* because, as head gardener at London's Garden Museum, his knowledge of trees is unrivalled. With more than an estimated 60,000 species of tree in the world, including 8000 in Brazil alone, the criteria for inclusion in the book was painfully strict. Difficult decisions had to be made: could we have both California's redwoods and their sibling sequoias? No, we were obliged to select only one. But, after lengthy discussions, we arrived at a list of 50 types of tree that spanned the globe and featured both familiar and rare trees, all of which had a story to tell. Then we paired those profiles with our own travel expertise to suggest the best places to be around each type of tree and how (and when) to get there to see the trees at their best. Holly Exley's hand-painted illustrations help us identify each tree by its unique characteristics. The result is a book that will inspire you to seek out these living marvels, better understand their role in the ecosystems that keep the planet functioning and appreciate how vulnerable the trees are in our changing world.

Foreword

by Matthew Collins

ONE OF THE GREAT COMPENSATIONS FOR THE RIGOURS OF LIVING IN A MAJOR CITY, IN MANY CASES AT LEAST, IS COHABITATING WITH SOME OF THE WORLD'S MOST SPECTACULAR TREES.

Certainly, copse and creek and bee-humming wildflower meadow might be sought in the countryside, but trees are the great leveller between the rural and urban experience. Humanity's age-old obsession with not only the utility but the beauty of the earth's weird and wonderful tree species has brought as much variety to the city as can be found in any rugged county of almost any single country. I write here from the perspective of a Londoner, whose reimbursement for the eye-watering cost of living has long been the freedom of the capital's esteemed parks. Some 170,000 trees occupy the city's eight 'Royal' parks alone, which include former historic hunting grounds like Regent's and Richmond parks, and Kensington Gardens at the west end of London's all-important 'green lung'. A great many of these trees are of indigenous British origin, such as English oak, beech, yew and silver birch, but among them also are specimens hailing from every corner of the globe, from the Mediterranean to the Himalayas, Australia to North America.

Even in the depths of December, on a gloomy afternoon, one might wander through the comparatively small St. James's Park in the heart of the city and behold a breathtaking diversity in the boughs of its lakeside canopy: eastern cherries in late pink blossom and alders flushed with caterpillar catkin; broad mulberries golden-yellow in autumn leaf and the bracken-brown, feathered foliage of dawn redwoods decorated with sticky cones. Great evergreen mounds of Italian holm oak and Virginian magnolia stand aloof, while smaller magnolias from Asia, thick with velvet bud, gear up for spring bloom. Papery lanterns dangle from the branches of Turkish hop hornbeams and India's golden rain tree alike; bark sheds like orange peel from the 'blood-bark' maples of central China, and sheds, too, from an avenue

of London plane trees, a hybrid giant whose parent trees – the oriental plane and the American sycamore – unite the east and west hemispheres. Together, these gathered species demonstrate just an ounce of our planet's vast and astonishing sylvan spectrum, all within a walk of twenty minutes or less. To wander among these trees is to be reminded of the world beyond, and of the remarkable and diverse landscapes from which these trees once came.

You might experience just the same in New York as in London. Central Park's 18,000 trees, for example, comprise more than 170 different species. Out in the city streets are yet more diverse varieties: broad lime trees, Norwegian maples, East Asian Callery pears. It is a similar story in Chicago, Los Angeles, Austin or Seattle; in Tokyo, Shanghai, Paris and Buenos Aires. Indeed, if going by tree species alone, 'urban forests' could be considered among the most diverse of the planet's forest systems. Much of this, of course, is the result of historic plant collecting; of botanists raking the world's enthralling plant life for commercial and cultural gain, and the subsequent intercontinental movement of plants. During the Age of Exploration in the 16th and 17th centuries, ships returning to Europe from distant and newly mapped continents carried not only the precious materials and artefacts of global trade and colonial plunder but plants hitherto unknown to such soils, brought in for their potential agricultural, medicinal and industrial value. Continuing through the 18th and 19th centuries, the thirst for new and 'exotic' species escalated to a horticultural concern, with beauty becoming the chief virtue and the garden its principal arena. Seeds arriving from abroad were cultivated by specialist plant nurseries and the resulting saplings were dispatched to eager patrons and subscribers. As trees like the Douglas fir and lodgepole pine were employed in commercial forestry, so the likes of the monkey puzzle, magnolia and rhododendron made their way to the grand estates of the age as elegant and rarified curiosities, newly stationed in temperate Europe. Thus, for many long years, the great maxim of the public botanic garden and estate-owning gentry alike

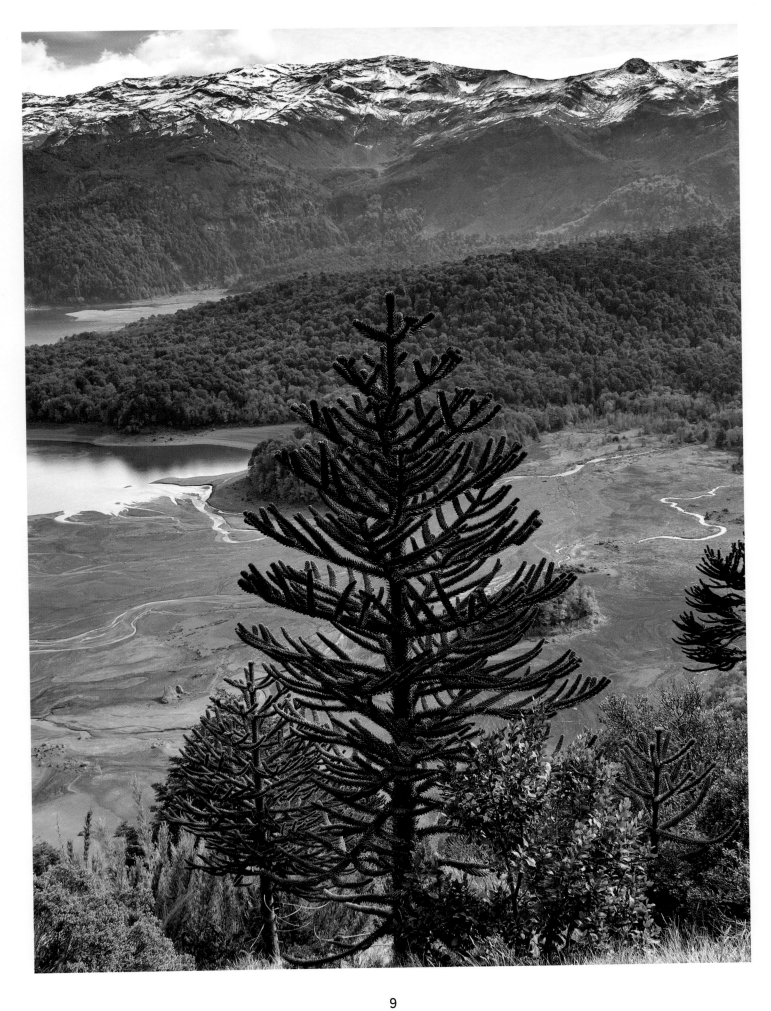

OPENING SPREAD VENTURE DEEPER INTO THE BEECH FORESTS OF HAINICH NATIONAL PARK IN GERMANY; CONTENTS SPREAD THE TWISTED TRUNKS OF SNOW GUMS IN AUSTRALIA'S KOSCIUSZKO NATIONAL PARK; INTRODUCTION SPREAD A NEW GENERATION EXPLORES SEQUOIA NATIONAL PARK IN CALIFORNIA; PREVIOUS SPREAD MONKEY PUZZLE TREES THRIVE IN CHILE'S PARQUE NACIONAL CONGUILLIO; RIGHT A BURST OF SUMMER BLOSSOM FROM NEW ZEALAND'S PŌHUTUKAWA TREE

was, 'look at what we can show you of the world', their expanding arboreal collections – their avenues of blossoming cherry, ginkgo and laburnum – a source of national pride and personal prestige.

But things have changed. Though apathy towards trees might remain dishearteningly common, the fragility of the world's tree species is far better understood. We live in an age where the impacts of climate change, disease-spread, illegal and unregulated deforestation and both urban and agricultural expansion are more widely known, and more vehemently underscored, and our precious woodlands, forests, savannahs and mangroves are now being championed like never before. We have learned to see trees less as single specimens of curiosity than as members of unique and all-too-often endangered ecosystems, inseparable from their landscapes of origin. The redwood and the kauri pine alike might be revered as giant individuals, but their supreme height and longevity remains fully intertwined – and dependent upon – the niche environments of California's Sierra Nevada and New Zealand's Northland, respectively. Trees, as we now appreciate more, are but one important strand of a network of shrubby, perennial and annual plant material, not to mention the enormous spectrum of interconnected fauna and fungi.

Sadly, since 1990 more than 1.6m sq miles (420 million hectares) of forest have been lost globally. In the year 2022 alone, 25,500 sq miles (6.6 million hectares) were deforested, and a staggering 30% of global tree species are now threatened with extinction. These are alarming statistics. Indeed, in preparing the profiles of the trees featured within this book, a common and inescapable theme in many cases was that of the increasing scarcity of their indigenous populations. The Atlas cedar, much like Yemen's dragon's blood tree, now struggles to regenerate due to the effects of overgrazing and the droughts brought about by a warming climate; historic timber logging has drastically reduced populations of Canada's western redcedar and Australia's karri tree, while Chile's enormous alerce remains a target of illegal felling, despite

only recently being discovered to be among the world's most ancient living trees. This informed the inclusion of 'conservation status' within the fact box that accompanies each of the book's fifty trees, as currently listed by the International Union for Conservation of Nature's 'Red List' of Threatened Species. And yet, trees are inestimably indispensable, each and every species. They are an essential component in the mitigation of escalating global warming, drawing down and locking up huge quantities of atmospheric carbon dioxide. And in the reduction of a rapidly mounting biodiversity crisis (in which species populations have seen an average decline of 69% since 1970), forests are equally vital, providing crucial habitat for 80% of the world's terrestrial wildlife. If ever there was a time to commend and to celebrate our global tree species, it must be now.

In a less frightful and more elementary capacity, forests count among our most magnificent landscapes. Few of nature's spectacles are as enthralling as a European beech wood in dawning springtime, the fresh green leaves in shafts of sunlight made lucid against the pillared, ash-grey trunks. Or as captivating as the mangroves of the tropics, their stilt-like roots reflected in water, their canopy reverberating with birdsong. Or North America's eastern woods in glowing autumn leaf, or the cloud forests of Central and South America in which a spectral veil of humid condensation gives life to ferns, mosses and lichens. Where once these remarkable arboreal settings might have

been disassociated with the specimen tree we see before us in domestic cultivation, now there is a greater desire than ever to experience the two in harmony, to see a tree in its natural environment, among its natural pollinators and habitat companions, whatever may remain. Ecotourism – nature-based tourism with an emphasis on sustainable or responsible travel – is a rapidly growing sector of the travel industry. Recently valued at $172 billion globally, it is expected to rise to $374 billion by 2028, keeping pace with the growing appeal of exploring the great outdoors. The intention of this book is not only to extol the allure and diversity of trees, but to inspire a curiosity in their home environment. There are many good books written about trees, yet few will encourage you to visit them. Our mantra is that people are keenest to protect the nature they have encountered firsthand. Among the fifty trees featured are those whose forests of origin have long been perceived a destination – the cedar woods of Morocco's Middle Atlas, for example, and the eccentric yuccas of Joshua Tree National Park. But for many readers there will be new introductions – the land of the quiver tree, alerce or snow gum, perhaps – and new excursions added to the bucket list.

There are thought to be more than 60,000 tree species worldwide. The pages of this book feature a small selection of the most beautiful, bizarre, beloved and unusual among them; a collection from across the continents ranging in all shapes and sizes. Some will no doubt be familiar; record-breakers holding the titles of the tallest, largest, oldest and strangest of global species – the giant sequoia, the ginkgo and baobab; Australia's monumental mountain ash, for example. Others, perhaps less so: the flame of the forest dressed in unparalleled scarlet; the Christmastime-blooming Pōhutukawa tree; the spectacular autumn gilding of European larch and North American aspen alike. There are trees, too, that have been chosen for their ancient cultural significance, from the long-valued fruits of the date and coconut palms, Armenia's black mulberry and Spain's cherished almond, to the revered bark of Portugal's cork oak and Canada's western redcedar and strawberry trees. And while the cherry blossom festivals of Japan are a staple highlight in the national calendar, the jacaranda's indigo-blue equivalent is a source of celebrations across continents, showering their vibrant spring joy over the streets of Buenos Aires, Funchal and Johannesburg.

As with all of nature's bounty, we bond with certain trees – the specimen that stood beside our childhood home, or the seeds that showered down over our schoolyard; the park behemoth we loved to climb or the wilder veterans that tower over favourite woodland walks. There are remarkable qualities to all tree species that mark them out as unique, but very often it is the personal encounter that connects us so deeply to them. This is a book that revels in it all: the startling statistic and the sense of awe when standing before one of these wonders.

Discovering Trees

Five Trees to Make You Feel Small

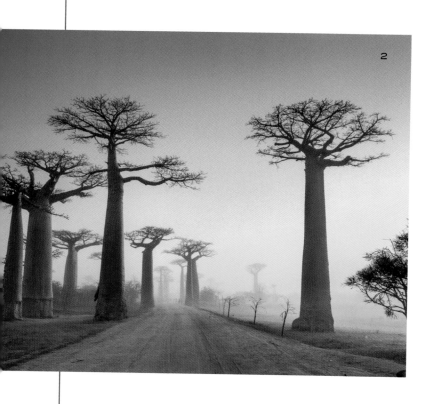

1. **Alerce,** PAGE 101

Seek out these long-lived giants in Patagonia

2. **Grandidier's Baobab,** PAGE 49

Africa's bulbous, water-storing wonders

3. **Mountain Ash,** PAGE 198

A tall and gracefully dishevelled eucalytpus

4. **English Oak,** PAGE 180

England's sturdy oak is built to last

5. **Giant Sequoia,** PAGE 78

Walk among California's beautiful leviathans

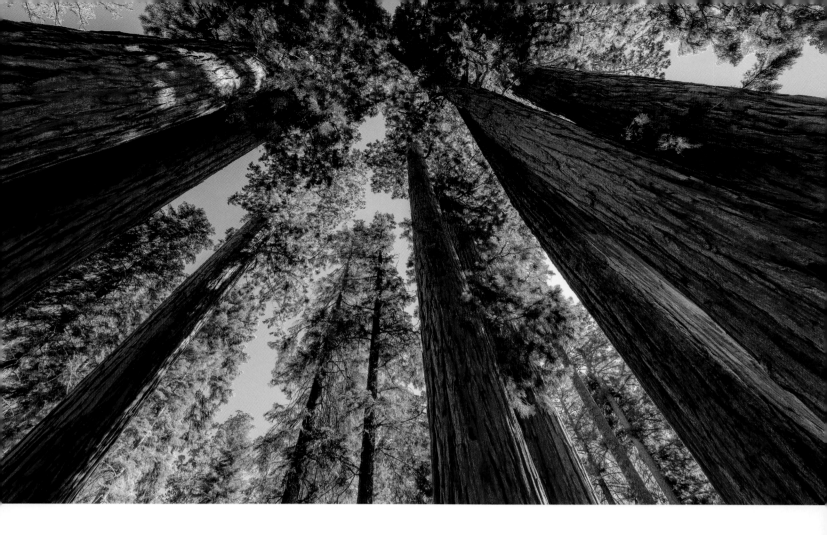

Five Trees with Blossoms to Wow You

1. **Almond,** PAGE 193

Almond trees flower below Mallorca's mountains

2. **Cherry,** PAGE 123

Clouds of pink blossom float across Japan

3. **Tree Rhododendron,** PAGE 115

The vivid flowers are a Himalayan highlight

4. **Jacaranda,** PAGE 85

Lilac blossoms line city streets around the globe

5. **Pōhutukawa,** PAGE 224

New Zealand beaches pop with bright red blooms

Five of the World's Quirkiest Trees

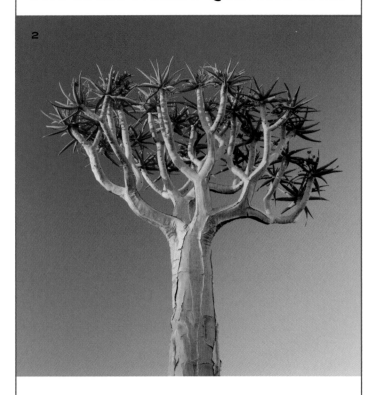

2

1. **Monkey Puzzle,** PAGE 67

Impossible to climb for most monkeys

2. **Quiver Tree,** PAGE 22

An alien aloe arrived on Earth

3. **Boojum,** PAGE 93

A tentacle of a tree in Baja California

4. **Rainbow Eucalytpus,** PAGE 229

Wears bark of many colours

5. **Indian Banyan,** PAGE 128

A nightmarish web of dangling roots

Five of the World's Longest-Living Trees

1. **Umbrella Thorn Acacia,** PAGE 34

An ancient icon of Africa's savannah

2. **Ginkgo,** PAGE 118

These beautiful trees live for millennia

3. **Olive,** PAGE 54

Growing more gnarled as they age

4. **Great Basin Bristlecone Pine,**
PAGE 177

Some sprouted more than 5000 years ago

5. **Wollemi Pine,** PAGE 203

Australia's ultra-rare 'living fossil'

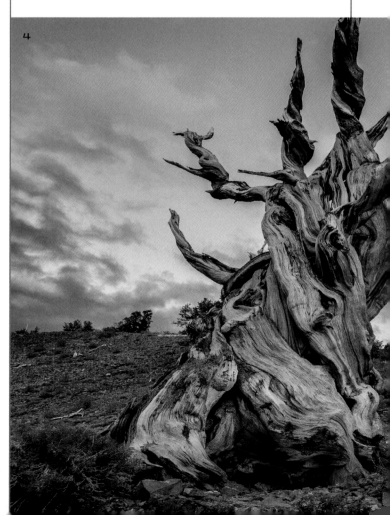

4

Five of the World's Most Vulnerable Trees

1. **Atlas Cedar,** PAGE 41

This cedar suffers from climate change

2. **Alerce,** PAGE 101

Now protected by national parks

3. **Grandidier's Baobab,** PAGE 49

Vulnerable to a changing climate

4. **Ginkgo,** PAGE 118

Rescued from extinction in the wild

5. **Wollemi Pine,** PAGE 203

Barely 100 exist in secret in the wild

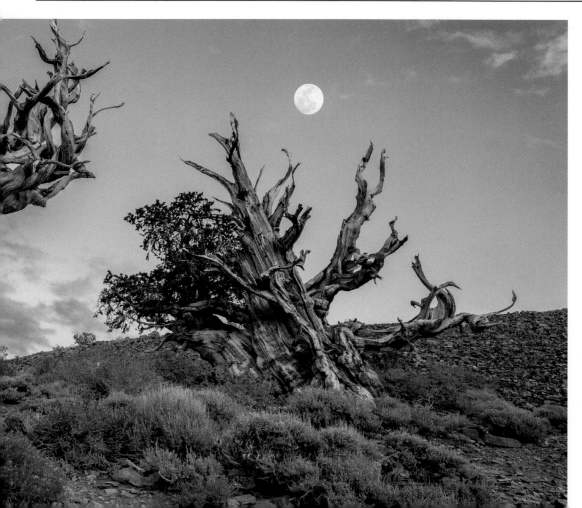

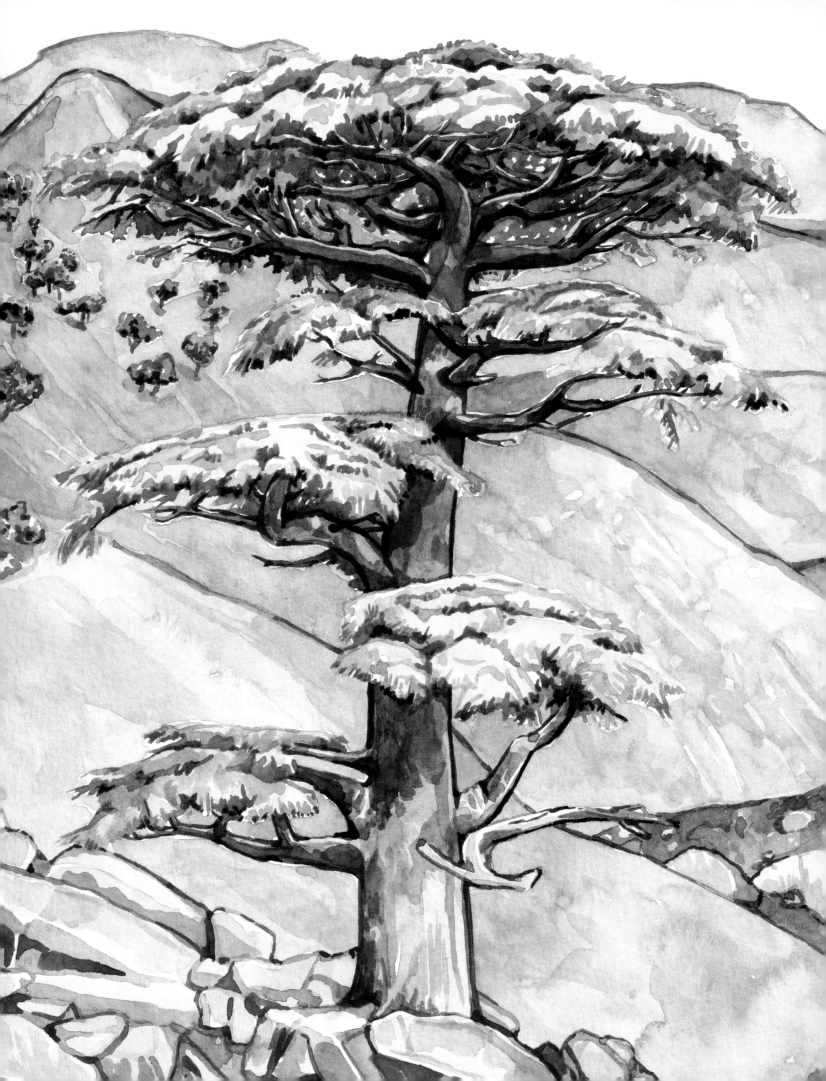

Africa & THE Middle East

Carob Tree

Ceratonia siliqua

Vitals

RANGE
Middle East and North Africa

STATUS
Least Concern

LIFESPAN
<100 years

AVERAGE HEIGHT
40ft-50ft (12m-15m)

A TREE LONG BELOVED IN THE MIDDLE EAST, THE CAROB'S DARK SEED-PODS ARE DECEIVINGLY DELECTABLE

Were the carob just a little better fortified against cold weather it would be a temperate-climate staple – you'd see it everywhere. Indeed, its tolerance of drought, fire, salt, wind and infertile soil places it among the tree species better able to contend with the effects of climate change. Perhaps in time it will spread north; for now, this magnificent tree, known also as 'locust bean', is enjoyed only where temperatures have long supported its smooth, muscular boughs and ripened its leguminous fruit, especially in the Levant, where the tree is grown by rural smallholders as a dry-farmed (non-irrigated) crop.

Undoubtedly, it is for the fruit that the carob is commended; high in fibre and protein, its hanging pods have been cultivated in the arid climes of the Middle East and Eastern Mediterranean Basin for thousands of years. Some suggest that the 'locusts' consumed by John the Baptist in the Jordanian wilderness were in fact locust beans – arguably a more likely fit than the insects for the southern Levant's dry terrain. In more recent times, carob fruit experienced flourishes of Western interest with the boom of wholefoods movements. Naturally sugary yet low in fat, the sucrose-rich pods provide a healthier alternative to cocoa when ground into powder. The carob's uses extend beyond the culinary, however. If you've ever wondered where the word 'carat' comes from – the unit for weighing gemstones – look no further than the carob tree. Bearing an uncommon uniformity of mass, its seeds were used as an ancient measurement for quantities of precious stones.

RIGHT A CAROB TREE GROWING IN ARID CONDITIONS NEAR MT ARBEL IN ISRAEL

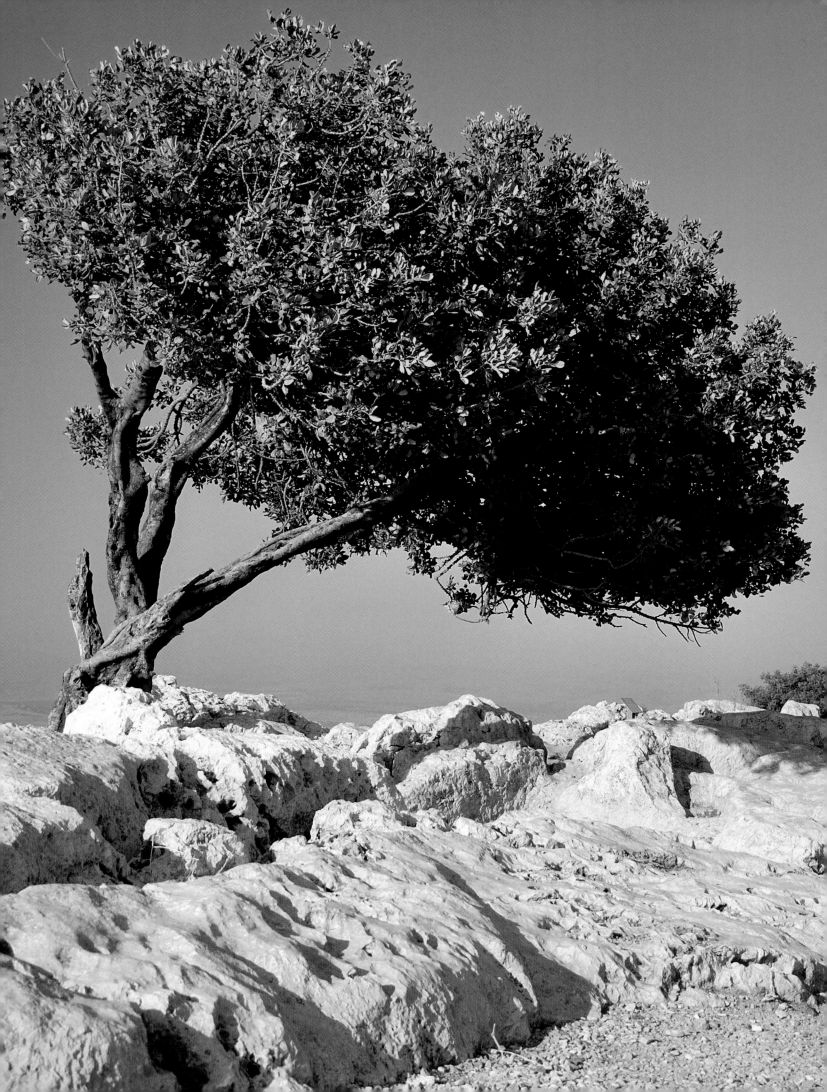

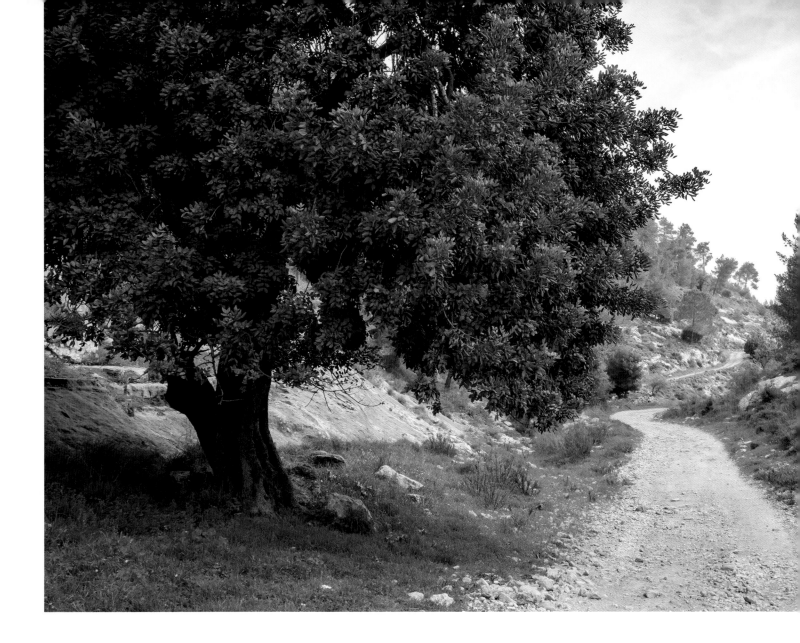

How to See

The dried beans of the carob tree are marketed as a healthy alternative to chocolate, but it's better to appreciate the sweet, slightly nutty taste of carob as its own entity. Once you've learned to identify the tree (ask local people for guidance), seed pods can be plucked straight from the branches and chewed – just make sure to spit out the small, hard seeds and tougher bits of pod.

Carob trees grow profusely around the eastern end of the Mediterranean, particularly in the Levant, with Israel being a strong candidate for the birthplace of this hardy,

drought-adapted tree species. Wild carobs and farmed groves of carobs dot the countryside, and production is expanding thanks to the efforts of sustainable agri-tech company CarobWay.

To see carob trees in an unspoiled natural setting, head to the Hamalachim-Shahariya Forest, south of Tel Aviv near the city of Kiryat Gat. The forest is best reached by hire car from Tel Aviv; from the main parking area, a 3-mile (5km) walking and cycling trail winds through a green vale studded with carob trees and pines, and carpeted with anemones and cyclamen in spring.

The Hamalachim-Shahariya Forest is at its prettiest in spring, when wildflowers dot the forest floor and the green meadows between the trees. If you have your heart set on munching carob beans, come during the harvest season from August to September.

How to Identify

The carob is a large tree with a stout, typically fluted trunk, and a spreading crown often as broad as it is tall. The compound evergreen leaves are coarse yet sheened, bearing oval leaflets in opposite pairs. As with many leguminous plants (those in the pea family, Fabaceae) the carob's fruit is a hanging pod – like a large runner bean – beginning a light green colour before maturing to purple-black. The hardened seeds within are reddish brown, numbering between five and 15 per pod.

LEFT CAROB TREES GROWING WILD IN ISRAEL'S JUDEAN MOUNTAINS; BELOW LEFT AFTER HARVESTING, CAROB PODS ARE FURTHER DRIED IN THE SUN; BELOW EVERGREEN CAROB TREES FLOWER IN SPRING

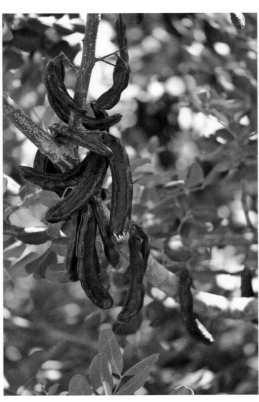

Quiver Tree

Aloidendron dichotomum

Vitals

RANGE
Southern Namibia and Northern South Africa

STATUS
Vulnerable

LIFESPAN
80-120 years

AVERAGE HEIGHT
10ft-25ft (3m-8m)

A CURIOUS FIGURE BASKING IN SUNSHINE, THE QUIVER TREE STANDS AS A NATIONAL SYMBOL OF NAMIBIA

Aloes are the botanical pride of southern Africa, a tribe of indigenous plants typified by armoured, fleshy leaves, vibrant blooms and phenomenal drought tolerance. And though many species do not exceed knee height, there are arborescent – tree-like – exceptions that are every bit as spectacular. Just as the American yucca reaches its zenith in the Joshua tree (see page 104), so the aloe finds its forest form in the quiver, a mushroom-dome of long succulent leaves borne handsomely upon a peeling clay-white trunk, like coral rising from the seabed. The word 'forest' might be applied lightly here, as the few Namibian and South African sites where quiver trees gather are less a forest ecology in the conventional sense than a rare grouping of the species. Nonetheless, quiver forests are a remarkable occurrence, stark and dramatic in their coupling of otherworldly flora and dark, magmatic dolerite rock formations.

Southern Namibia's Quiver Tree Forest is Africa's prime quiver location, made a National Monument in the mid 1990s to preserve a significant site of more than 200 specimens. Here, in one of the world's sunniest regions, the trees sustain a range of wildlife, providing shelter for birds and mammals and vital nectar for visiting insects. Interestingly, both the common name 'quiver' and botanical designation *A dichotomum* relate to the tree's curious limbs. The former tells of the historic Indigenous practice of hollowing out the spongy branches for use as quivers for arrows; the latter etymologically derived from the 'dichotomous' nature by which they separate into two at each junction. In a somewhat macabre process of self-amputation, quiver trees are known to shed their branches to reduce water loss during extended periods of drought – an increasing concern under the effects of climate change.

RIGHT NAMIBIA'S QUIVER TREE FOREST IS JUST NORTHEAST OF KEETMANSHOOP

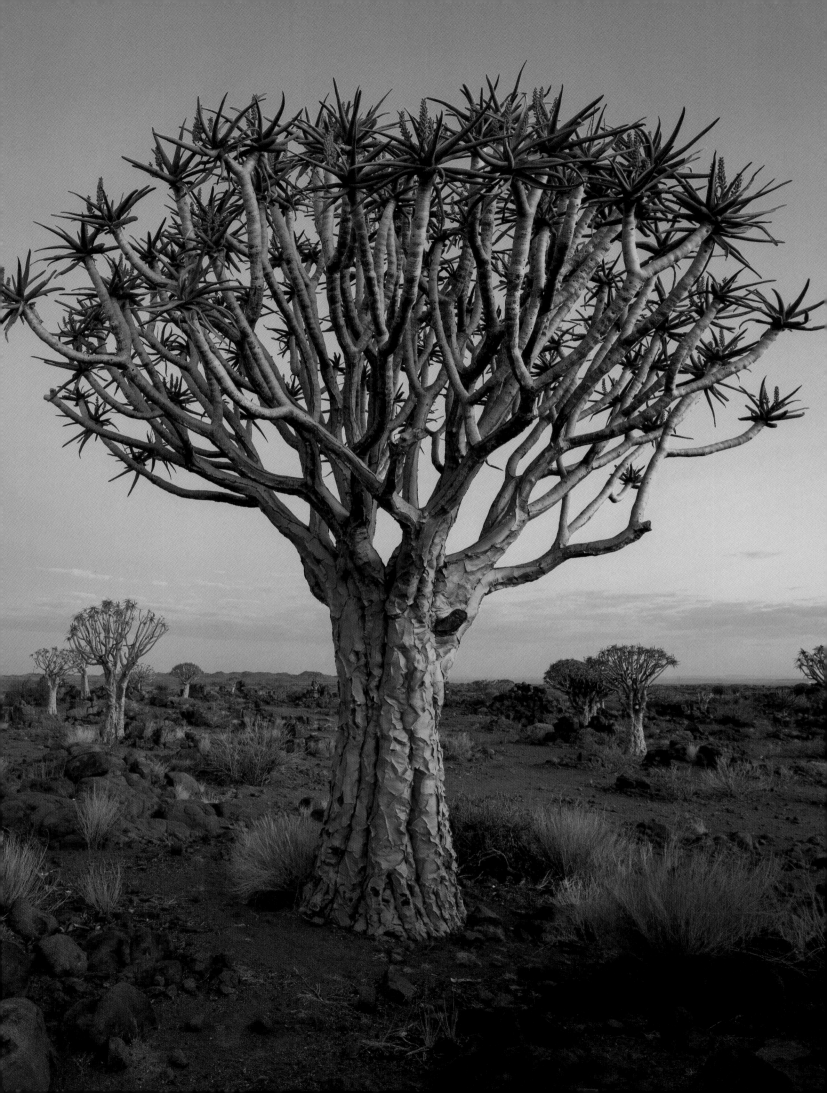

How to See

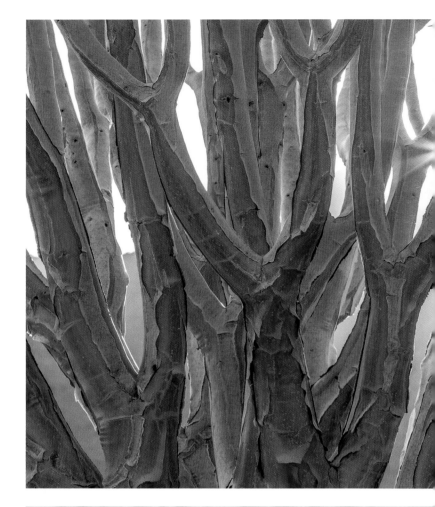

WHERE

A desert succulent elevated to tree stature, *A dichotomum* is highly adapted to the arid environment of the Northern Cape. Indeed, the parched hills spanning Namibia and South Africa are the only place the quiver tree grows naturally, and this threatened species in decline across its range due to overgrazing, human encroachment and climate-change-related droughts.

In Quiver Tree Forest in Namibia, you can view hundreds of these unusual trees scattered across a barren, rocky landscape that looks majestic at sunset – and tack on a detour to the stacked dolerite boulders known as the Giants Playground. The quiver tree grove is about 9 miles (14km) northeast of Keetmanshoop in the direction of Koës, on the grounds of the Gariganus Farm.

Quiver Tree Forest is best reached with a hired vehicle, though Namibia tours often stop here on their way across the country. From the centre of Keetmanshoop, take the B1 north, then turn east onto the C16 and north onto the M29 towards Koës. Look for signs to 'Kokerboomwoud' and park up at the Quivertree Forest Rest Camp, a handy base for exploring the forest, with guest rooms and bungalows around a pool.

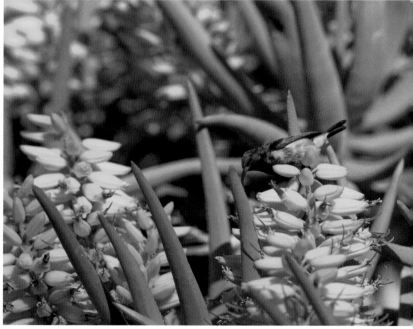

WHEN

The May to September dry season is the best time to visit Namibia, as dirt roads are navigable, skies are clear, and daytime temperatures are mild – a marked contrast to the humid heat of summer.

TOP RIGHT ADMIRE THE SCULPTURAL QUALITY OF THE QUIVER TREE'S BRANCHES;

OPPOSITE A DUSKY SUNBIRD SEARCHES FOR NECTAR IN A QUIVER TREE'S BLOOMS;

OPPOSITE RIGHT QUIVER TREES ARE THREATENED BY THE INCREASING HEAT OF CLIMATE CHANGE

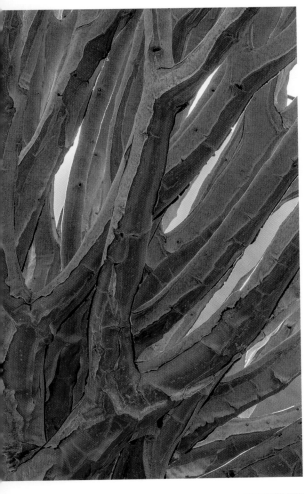

How to Identify

Quiver tree crowns are neatly dome-shaped, rising from a grey and tapering trunk that can reach 3ft (1m) in diameter at the base. They are comprised of thick white branches that separate off into pairs, and pointed, succulent green-grey foliage. The leaves are often 10in (25cm) or so in length and thorny along the margins. Flowers emerge at the branch tips between June and August, clustered in banana-yellow racemes that are lupin-like in appearance.

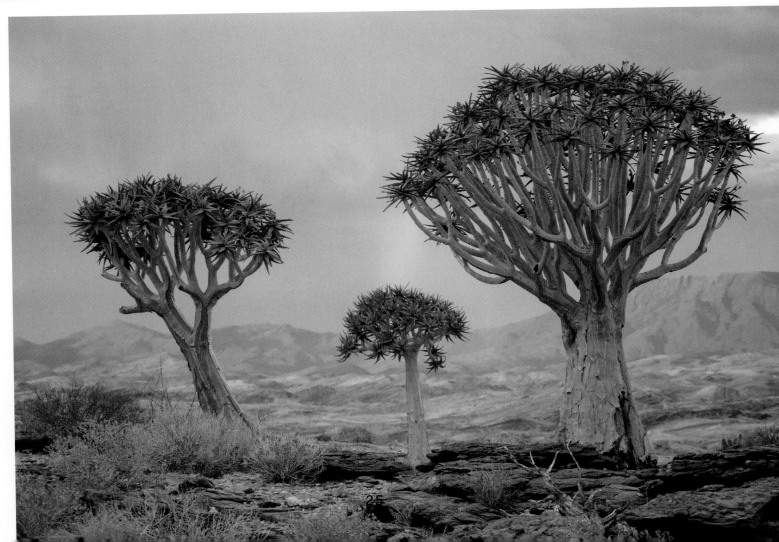

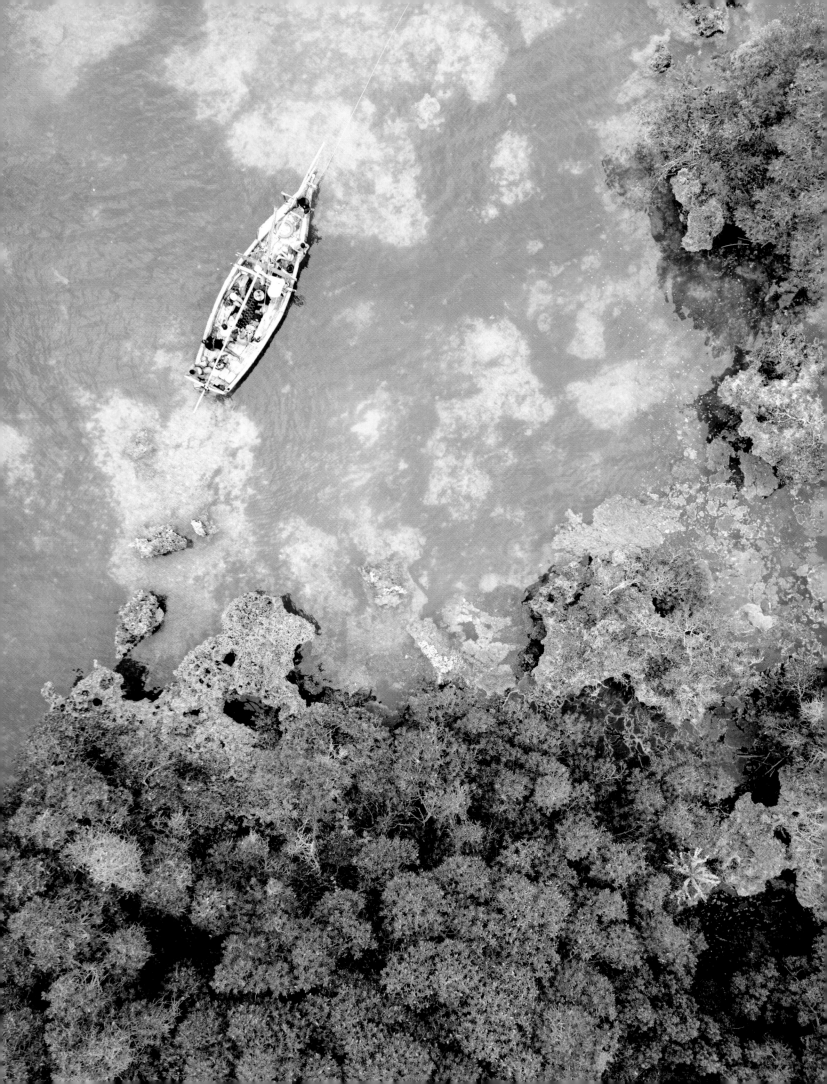

Red Mangrove

Rhizophora mangle

Vitals

RANGE
Equatorial zones across the world

STATUS
Least Concern

LIFESPAN
<60 years

AVERAGE HEIGHT
20ft-30ft (6m-9m)

THIS PROTECTOR OF THE EQUATORIAL COASTLINE IS A VITAL TIDAL BUFFER FOR THE TROPICS

Few trees embody an entire ecosystem like the mangrove, a name representative not only of numerous genera of tree, but of the whole coastal community of trees, shrubs, climbers and ferns that comprise this most valued of coastal environments. Circumnavigating the globe, straddling the equator in dense labyrinthine thickets, mangroves occupy more than a hundred countries worldwide, from Southern Asia to Central America and the Caribbean, across northern Australia and much of subtropical Africa; a humid and swampy forest biome adapted to conditions few plants can endure.

With their roots anchored into intertidal salt- and freshwater zones, mangroves are unusual in withstanding the low oxygen levels and high salinity that comes with daily flooding – this is what makes them unique. What makes them vital, however, is threefold. In the provision of habitat, mangroves excel, sheltering a great diversity of creatures including reptiles, fish, birds and rare marine mammals. They are also a key defender on the front lines of climate change. Sequestering carbon below the surface in their vast network of roots, mangroves draw down more CO_2 from the atmosphere than other forest types. Lastly, along vulnerable coastlines and their associated communities, they form a natural flood defence against storms, tsunamis and rising tides. This puts into context the desperate need to protect the world's remaining mangrove forests, currently estimated at only 3% of the planet's total forest cover.

Of the 50-plus species of mangrove tree, the red (*R mangle*) is the most widely distributed, a glossy evergreen propped up on continuously spreading, multi-layered roots capable of filtering harmful salt.

LEFT MOOR A BOAT AMONG MANGROVES IN ONE OF ZANZIBAR'S LAGOONS

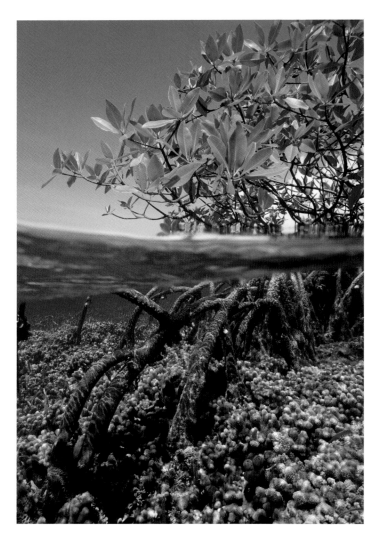

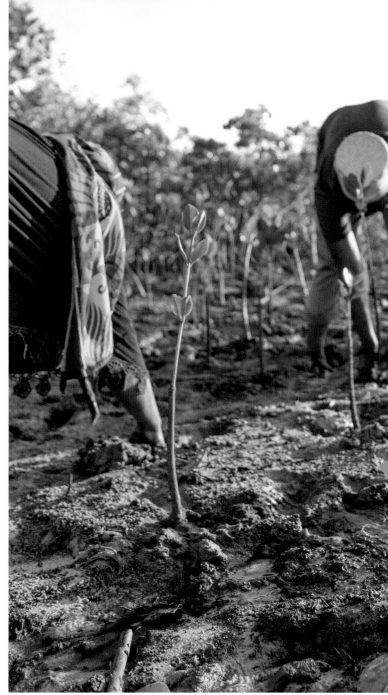

How to See

Mangroves hem tropical shores around the world and Africa has 20% of the world's mangrove forest cover, including the enormous Niger Delta in Nigeria, the third-largest mangrove on the planet, covering more than 3243 sq miles (8400 sq km). Sadly, the Niger Delta region is unstable due to disputes over Nigeria's vast oil and gas fields, but there are plenty more mangroves in Africa calling out to be explored.

For easy mangrove access, head to the Tanzanian islands of Zanzibar and Pemba, where tangled stands of half-immersed mangrove trees divide the white-sand beaches, providing a haven for myriad species of fish, birds, reptiles, amphibians and mammals, from mangrove kingfishers to sea turtles. Many local operators run guided mangrove tours, on foot or by kayak or stand-up paddleboard.

In Zanzibar, Kayak Zanzibar (www.kayakzanzibar.com), Eco Kayak Zanzibar (www.ecokayakzanzibar.com) can get you paddling around the inundated forests, or you can glide gently along the channels on paddeboard tours with 2 Winds Paddle Sports (www.paddlesportszanzibar.com) or Surf Zanzibar (www.surfzanzibar.com). Alternatively, stay dry on the mangrove boardwalk at Jozani Chwaka-Bay National

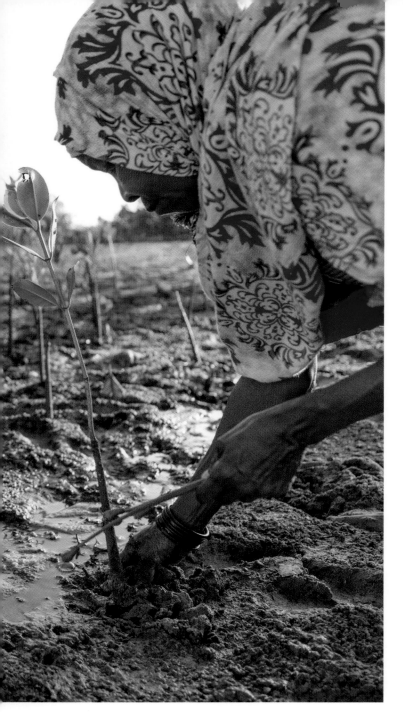

How to Identify

The red mangrove is conspicuous in its entanglement of stilt-like grey-red roots, which lift the trunk and canopy above water. Leaves are oval in shape, glossy and yellow-green; the flowers are small, scented and arranged with four yellow petals. From the resulting fruit, new plants develop from seeds still attached to the tree – a process known as vivipary. Once formed, these pencil-like propagules will drop and float, before embedding in the silt and sprouting fresh leaves at their tip.

LEFT RED MANGROVE SEEDLINGS CAN FLOAT IN THE OCEAN FOR A LONG TIME BEFORE ANCHORING; OPPOSITE THIS ZANZIBAR NON-GOVERNMENTAL ORGANISATION HELPS COMMUNITIES REPLANT MANGROVES AND PRESERVE COASTAL ECOSYSTEMS; BELOW THEY CAN TOLERATE SALT WATER

Park, southeast of Stone Town; reach the reserve on an organised tour, or take the No 309 or 310 dalla dalla (shared minivan) from Zanzibar town.

WHEN

The best time to visit Zanzibar is during the June–October dry season, when the humidity falls, temperatures dip to a comfortable 25°C (77°F) and the mosquitoes – bane of mangrove forests everywhere – are less of a menace (though wearing repellent is still a smart precaution).

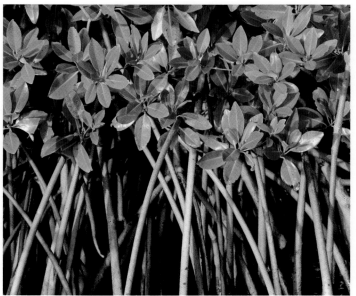

Date Palm

Phoenix dactylifera

Vitals

RANGE

North Africa and the Arabian Peninsula

STATUS

Least Concern

LIFESPAN

<150 years

AVERAGE HEIGHT

50ft-100ft (15m-30m)

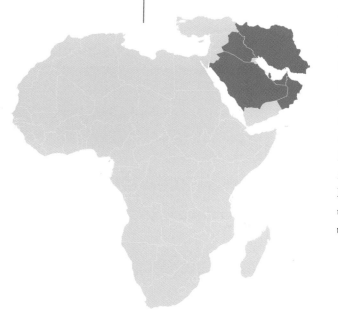

EMBLEMATIC OF THE DESERT OASIS, THE DATE PALM HAS BEEN CULTIVATED IN THE MIDDLE EAST FOR MILLENNIA

Few fruits match both the ubiquity and versatility of the date. Beyond its lauded flavour – molasses-sweet from a naturally high sugar content – all manner of nutrition, antioxidant and digestive benefits have elevated this humble fruit to a global commodity, enjoyed in cakes, stews, tagines, cereals and desserts – or simply in its purer form – the world over. And that a fruit of such value should spring forth from an environment so climatically challenging is testament to the unending wonder of nature's provision: a miracle tree of the desert oasis, flourishing in extreme, bone-dry heat.

The wild date palm is thought to have originated on the Arabian Peninsula, likely in Oman or Iraq, where its deep, thirsty roots tap subterranean and lakeside water reserves and its enormous, coarsely feathered leaves soak up the arid sunshine. Dependable in its offerings of shade and sustenance, the tree has been in cultivation here for over 6000 years, with more than 200 different varieties spreading out through the warmest reaches of the Middle East and North Africa. As such, the date palm is one of the world's oldest agricultural crops, produced in huge volumes in countries including Egypt and Saudi Arabia. But seen on the banks of the Nile, the dunes of the Red Sea, or fringing cool-spring desert oases such as Saudi Arabia's Al-Ahsa (the world's largest oasis, and a Unesco World Heritage Site), you gain a sense of the date's life-giving vitality, and why it features so prominently within the ancient religious texts of Judaism, Christianity and Islam alike.

RIGHT DATE PALMS CLUSTER AROUND THE AL-AIN OASIS OF ABU DHABI ON THE ARABIAN PENINSULA

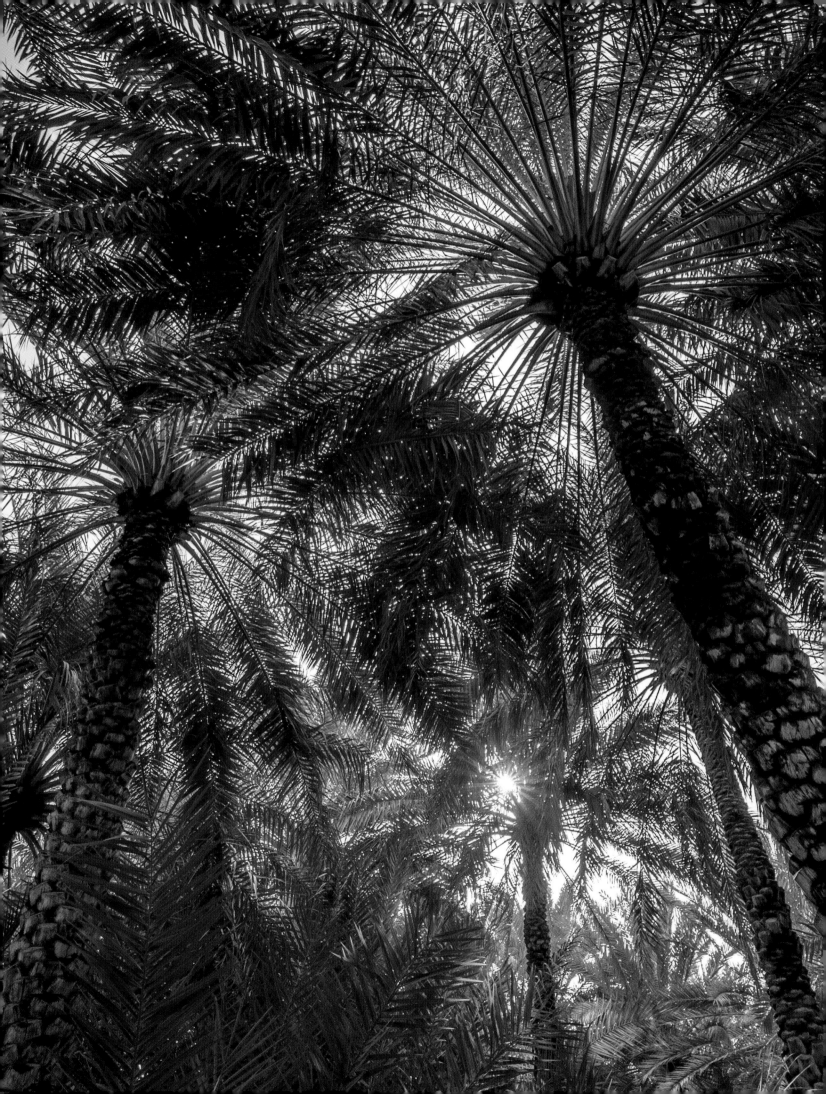

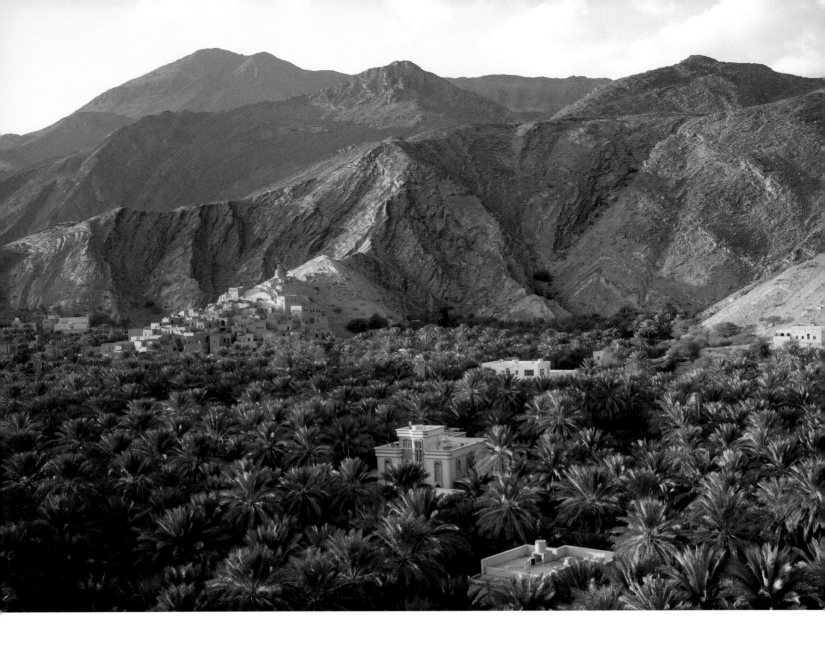

How to See

WHERE

Thanks to its enthusiastic planting, livening up seafront promenades and hotel gardens from the Med and Middle East, the date palm is one of the most easily spotted trees in the world. Head deeper into the countryside, though, and you'll find vast groves of cultivated date palms, keeping local souks, cafes and kitchens stocked with tasty dried dates.

The cultivation of dates has spilled beyond its original Arabian Peninsula home, with palm plantations cropping up as far afield as India, Egypt and the Persian Gulf. One of the most atmospheric places to see them is in Oman, where date palm plantations account for 35% of all farmed land, and the trees are irrigated using the traditional *falaj* system, with water diverted along complex systems of channels from springs and wells.

Two rewardingly remote places to wander beneath *falaj*-watered palms include Falaj Al Jeela, in the hills above the coastal town of Tiwi; and Falaj Muyasser between Muscat and Jebel Shams. To reach either area, rent a 4WD in Muscat (check you're insured for off-roading) then go *wadi* (dry stream-bed) 'bashing' en route to the villages.

WHEN

The date harvesting season runs from May to September, but it's better to come a month or so earlier or later to explore Oman's *falaj* villages – you'll avoid the face-melting heat of high summer and the slightly chilly nights of winter.

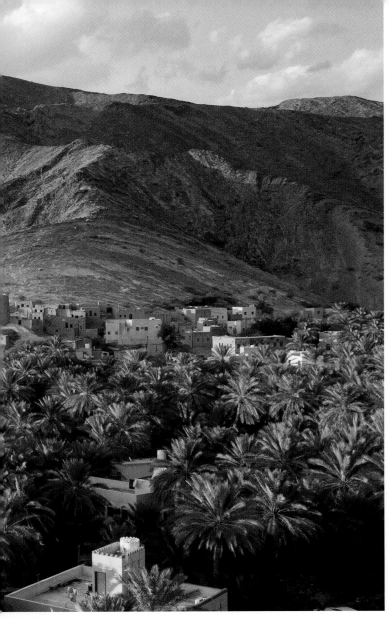

How to Identify

Date palms grow as both single and multiple-stemmed trees, with numerous 'suckers' emerging from the base. They begin life as a mound of feather-like leaves emerging from a central bud (with leaflets notably curled where they meet the leaf spine); and shed their leaves – up to 20ft (6m) long – as they grow toward maturity. The trunk is fibrous and patterned with the stubby remnants of former leaf stalks. Barley-coloured flowers give way to clusters of the famous orange fruit.

LEFT DATE PALMS IN OMAN WITH THE RUINED VILLAGE OF BIRKAT AL-MAWZ IN THE DISTANCE; BELOW LEFT TRADITIONAL ARABIAN IRRIGATION KEEPS DATE PALMS FLOURISHING NEAR MISFAT IN THE HAJAR MOUNTAINS; BELOW A DATE PALM TREE LADEN WITH SWEET FRUIT

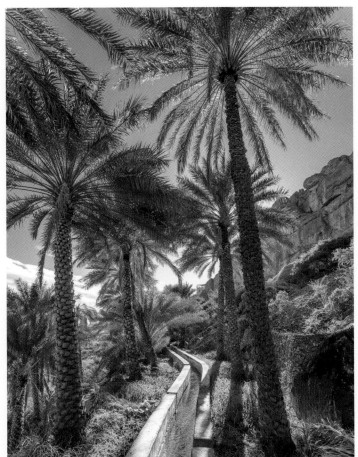

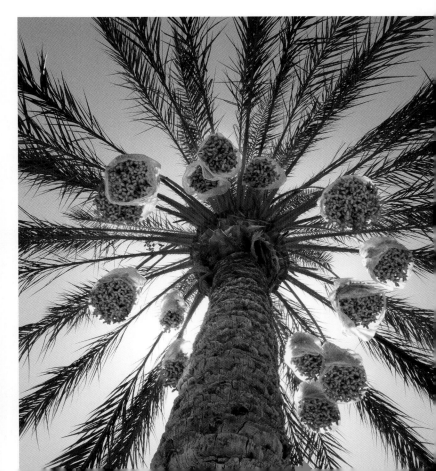

Umbrella Thorn Acacia

Vachellia tortilis

Vitals

RANGE

Africa, Arabian Peninsula

STATUS

Least Concern

LIFESPAN

<650 years

AVERAGE HEIGHT

20ft-30ft (6m-9m)

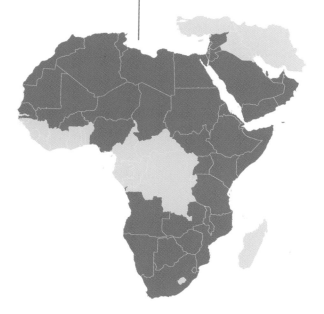

THE LONE SILHOUETTE OF THE ACACIA IS ONE OF AFRICA'S BEST-LOVED LANDMARKS, A STAPLE OF THE OPEN SAVANNAH

If the savannah is iconic of Africa, the acacia would be its flagship emblem, the tree perhaps most symbolic of the continent as a whole. In the sweeping grass of its celebrated reserves and national parks – from the Serengeti and Masai Mara in the east to the Kalahari and Kruger in the south – the acacia's distinctive, easily recognised canopy stands alone, a refuge for diverse wildlife (from elephants down to ants), tap-rooted into the sunbaked soil.

There are many species of acacia native to Africa, but one of the more widespread is the umbrella thorn acacia; indeed, there are few African countries in which it does not naturally occur, namely those of the Congo River Basin in tropical Central Africa. As the name suggests, the umbrella thorn is characterised by a lightly domed and sometimes flat-topped crown, and the sharp, needle-like thorns that run in pairs along its stems. Besides casting an attractive figure in the landscape, the umbrella thorn is of unparalleled environmental importance. Its root networks help stabilise the loose and often sandy ground in which the tree thrives, alleviating erosion, while nitrogen-fixing nodules at the root tips add valuable nutrients into the soil, as is common among the plants of the *Fabaceae* (pea) family. Above ground, its foliage and fruit-pods provide forage for visiting mammals – famously, the giraffe's elongated neck can reach the acacia's raised canopy, but its lengthened tongue and thickened lips also allow the animal to strip leaves away from the thorns. Remarkably, acacias have developed to combat this, releasing unpalatable tannins into the leaves when munched by hungry herbivores.

RIGHT AN ACACIA TREE IN KENYA'S AMBOSELI NATIONAL PARK AND MT KILIMANJARO IN THE DISTANCE

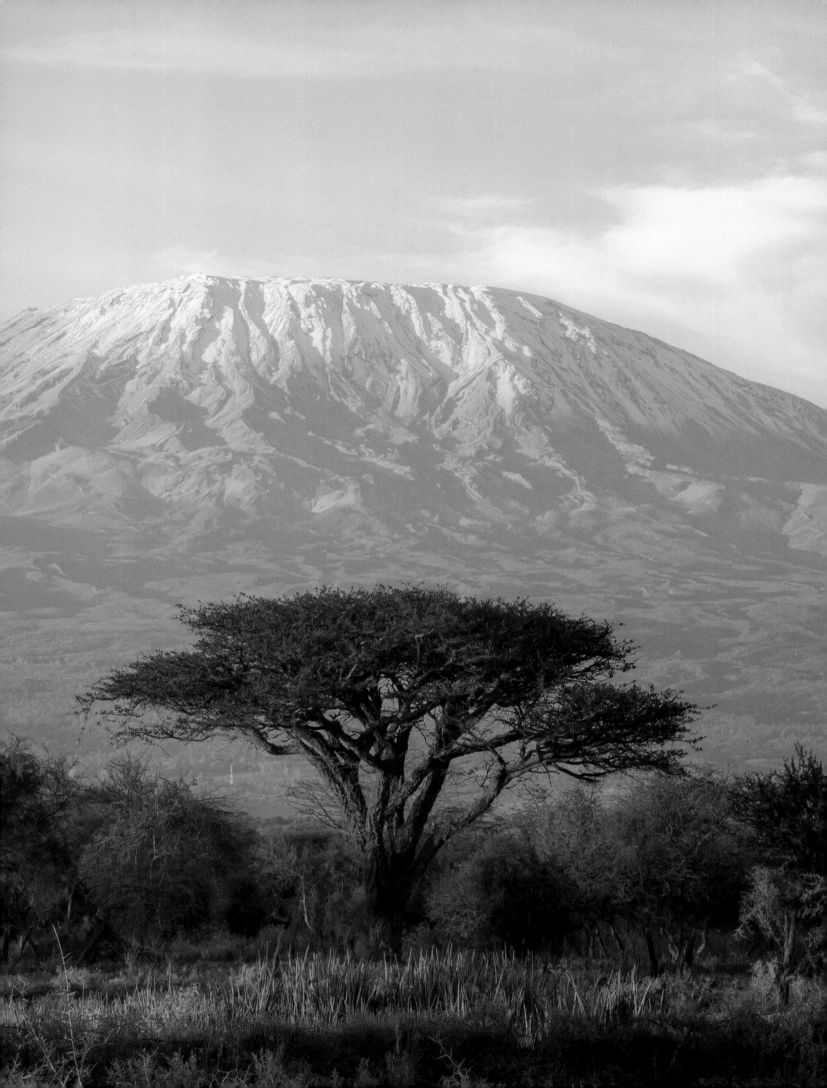

How to See

WHERE

The signature tree of the African plains, the acacia conjures up images of sheltering elephants, zebras and giraffes, or of watching the sun set against its silhouetted crown as the bush comes alive with night-time sounds. These drought-adapted trees grow prodigiously in almost every African country, and in tropical zones worldwide – including Australia, where two-thirds of the world's acacia species are found.

But if we had to pick one location to marvel at majestic silhouettes of mature acacias spread out across the grasslands, it would be the interlinked national park of the Serengeti in Tanzania and Kenya's Masai Mara. During the annual wildlife migration from the Serengeti to the Masai Mara, you're pretty much guaranteed photos of rush-hour herds and umbrella-shaped acacias framed against the dust-red African sun.

Safaris to the Masai Mara are easy to arrange in Nairobi, and to the Serengeti in Dar e Salaam. In either case, it will take most of a day to reach the reserves and most of a day to get back, so factor in the travel time when choosing a safari. Budget trips typically involve atmospheric stays under canvas; pricier safaris come with comfier accommodation in semi-permanent tented camps or game lodges.

WHEN

The great migration across the Serengeti begins in April. By July and August, the herds reach the Masai Mara.

TOP RIGHT AN ACACIA TREE MAKES AN IDEAL RESTING PLACE FOR A LEOPARD;

OPPOSITE A DEAD ACACIA TREE IN NAMIBIA'S NAMIB-NAUKLUFT NATIONAL PARK;

OPPOSITE RIGHT ACACIA ARE COMMON AROUND AFRICA'S WATERING HOLES;

OVERLEAF GIRAFFES GRAZE ON ACACIA TREES IN THE NGORONGORO CONSERVATION AREA

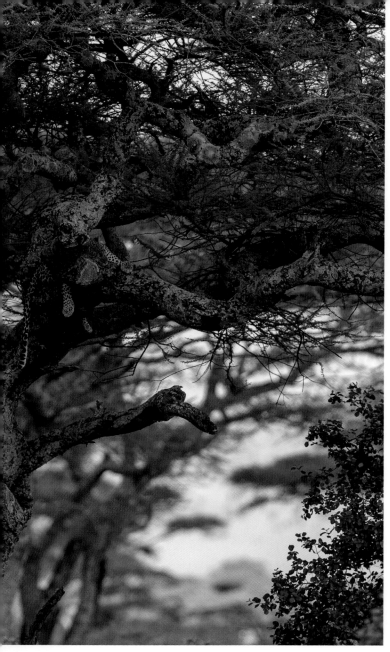

How to Identify

The umbrella thorn acacia ranges greatly in size, but can reach over 60ft (18m) when mature. Its trunk is grey-black in colour with fissures running in long vertical strips. Along the stems, thorns are arranged in pairs, regularly alternating between a shorter hooked thorn and a long straight thorn. Leaves are compound with opposite leaflets and can be somewhat blue-tinted. The aromatic yet modest flowers are yellow-white and clustered like balls of cotton.

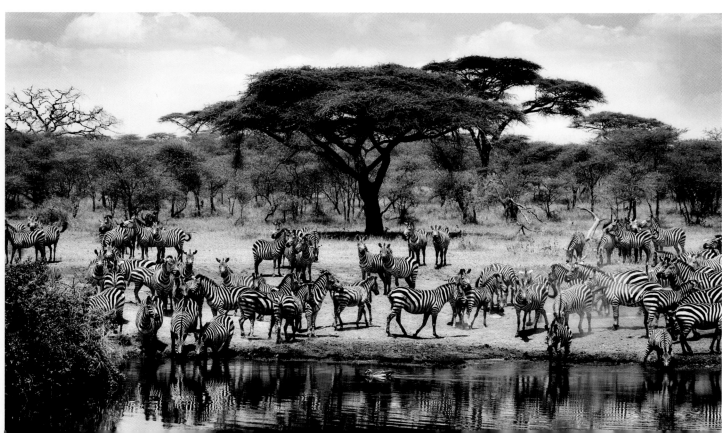

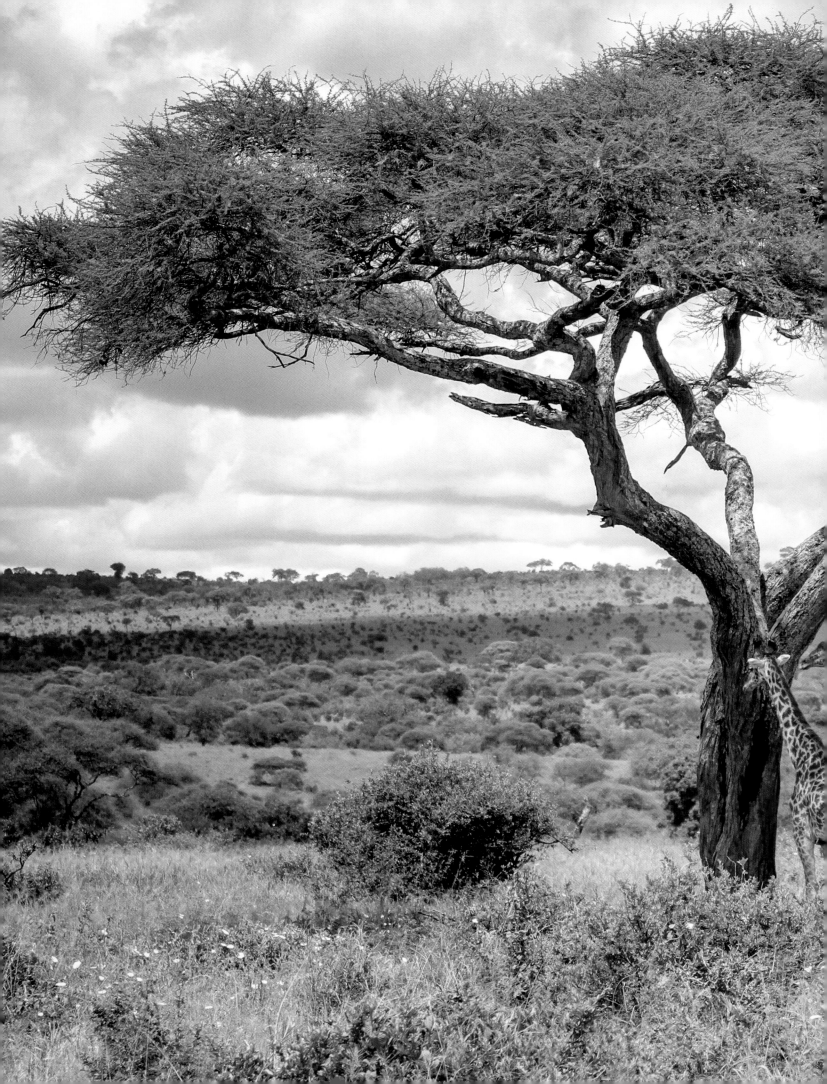

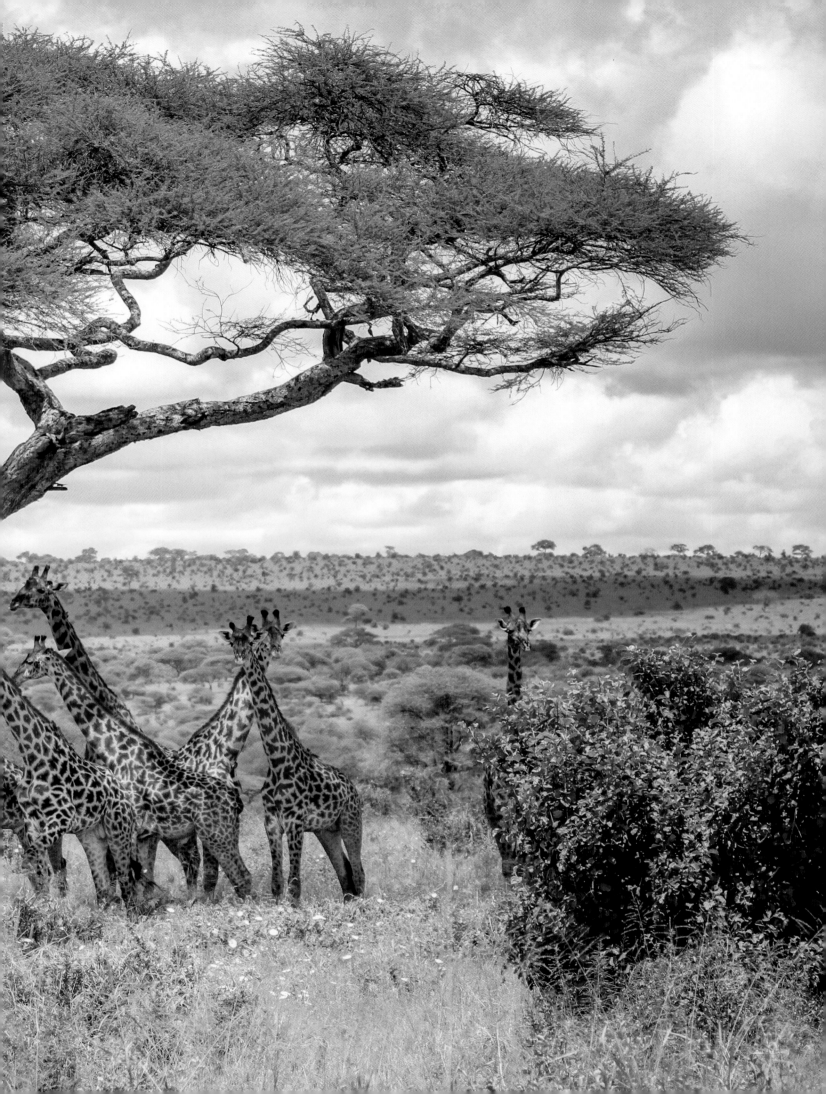

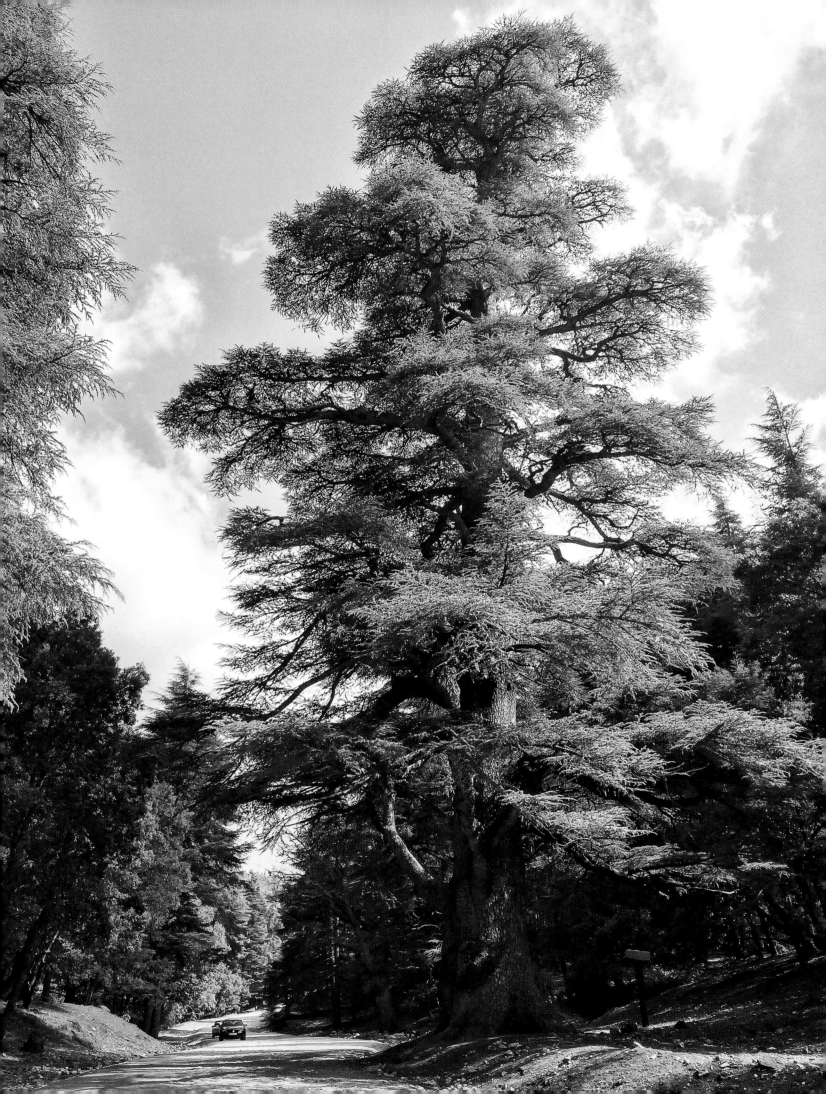

Atlas Cedar

Cedrus atlantica

Vitals

RANGE

Atlas Mountains, Morocco and Algeria

STATUS

Endangered

LIFESPAN

<150 years

AVERAGE HEIGHT

100ft-115ft (30m-35m)

IN THE HIGH MOUNTAINS OF MOROCCO AND ALGERIA, THE GRAND ATLAS CEDAR OCCUPIES THE GATEWAY BETWEEN MEDITERRANEAN AND DESERT AFRICA

Just as Morocco's vibrant culture, cuisine and diverse geography are enduring visitor draws, so forays into the cedar forests of the central Atlas Mountains have long been on the travellers' itinerary. This biodiverse forest of magnificent, imposing trees, known for its resident populations of Barbary macaques, is also home to the stately Atlas cedar, one of the world's four 'true' cedars and arguably its most attractive. Though it may lack the religious and literary status of the Lebanon cedar, or the neatly conical figure of the Himalayan deodar, the Atlas (and its blue-leaved variant *C atlantica glauca*) is undoubtedly one of – if not *the* most – beloved conifers in the northern hemisphere, favoured in temperate parks and gardens for its elegant torso and frame. In the natural setting of the Atlas Mountains, however, perched at elevations of between 4000ft and 7000ft (1220m to 2134m), these nationally treasured trees are a gateway landmark, straddling the environmental divide between the Mediterranean and Saharan Africa.

Sadly, the Atlas is also perched on another precipice: in recent years Morocco's iconic cedar forests have been on the front lines of deforestation. *C atlantica* is prized internationally for its durable and highly aromatic wood, but illegal logging has taken its toll, while livestock grazing is preventing natural regeneration. Yet the Atlas cedar's root networks are integral in stabilizing the country's river systems, many of which are fed by mountain precipitation and snowmelt from the Atlas range. As climate change affects rising temperatures, so the tree's position becomes ever more critical, and efforts are underway to conserve Atlas forests through sustainable management practices.

LEFT THE DISTINCTIVE OUTLINE OF AN ATLAS CEDAR IN THE CÈDRE GOURAUD FOREST NEAR AZROU IN MOROCCO'S MIDDLE ATLAS

41

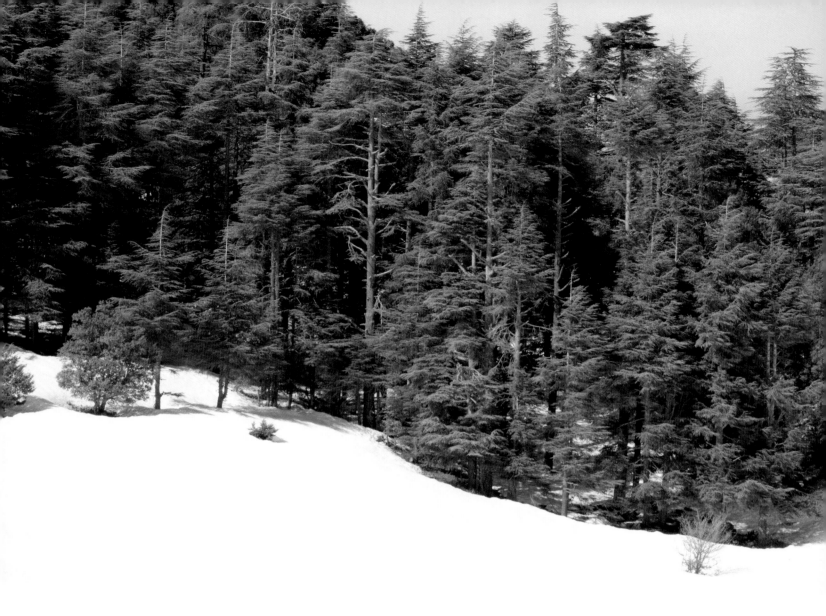

How to See

WHERE

The clue is in the name with the Atlas cedar. Morocco's mighty Atlas Mountains are the native habitat of this substantial conifer, though the trees also appear in the Rif Mountains and the Tell Atlas range in Algeria. A 444-sq-mile (1150-sq-km) swathe of Morocco's Middle Atlas range is covered by forests of *C atlantica*, and these woodlands are growing thanks to reforestation projects in Ifrane Province, replacing trees lost through agricultural encroachment.

Atlas cedars aren't a tree to see from afar; you need to walk amongst them to appreciate their size, colours and eccentric shapes. In practice, the easiest place to do this is Ifrane National Park in the western Middle Atlas, with grand taxis available for charter to reach hiking trailheads around Ifrane, Azrou and Ain Leuh.

Another solid option is Morocco's Tazekka National Park, east of Fez. Grand taxis can be hired for day trips from Fez, or more cheaply from Taza. Contact the tourist office in Bab Bou-Idir for suggested hiking routes across Jebel Tazekka's slopes. Potable water can be hard to find in the mountains, so carry plenty of your own.

WHEN

The best time to hike in the Middle Atlas is in spring or autumn, avoiding the hot months of summer – the region's forests are definitely at their most dramatic when freshened up by rain in spring. However, mountain temperatures are lower than in the baking desert lowlands even in summer.

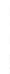

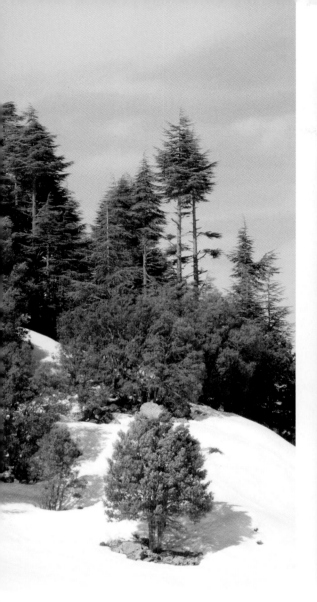

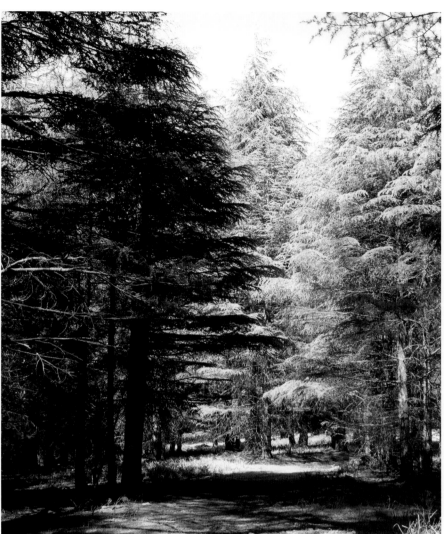

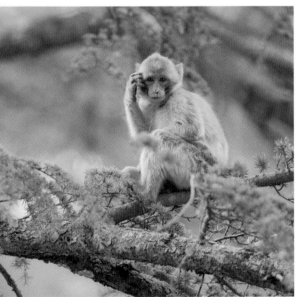

How to Identify

The Atlas is a large evergreen with grey-black bark. Leaf needles are dark green, short (up to 1in/2.5cm long) and bunched thickly in distinct clusters. The crown naturally domes with age. Barrel-shaped cones are large (around 3in/8cm) and sit upright on the branch. The easiest way to differentiate between the three most commonly found cedars – the deodar, Lebanon and Atlas – is to observe the branches. Those of the Atlas cedar point upwards, while the other two species are drooping and level respectively.

TOP WINTER IN THE CÈDRE GOURAUD FOREST IN MOROCCO'S MIDDLE ATLAS;

ABOVE THE BARBARY MACAQUE FAVOURS THE ATLAS CEDAR;

RIGHT DISCOVER MORE ATLAS CEDARS IN MOROCCO'S TAZEKKA NATIONAL PARK

Dragon's Blood Tree

Dracaena cinnabari

Vitals

RANGE

Socotra Archipelago, Republic of Yemen

STATUS

Vulnerable

LIFESPAN

<600 years

AVERAGE HEIGHT

20ft-30ft (6m-9m)

THE NATIONAL TREE OF YEMEN IS THE LIFEBLOOD OF ITS ENVIRONMENT, SHROUDED IN MYTH AND LEGEND

Archipelagos and their associated islands are a constant fascination for naturalists, owing to the unique development of their resident flora and fauna in isolation from the continental mainland. Finches endemic to the Galápagos Islands propelled Darwin towards his theories of evolution; on the rocky Socotra Archipelago – a Unesco World Heritage Site – it is a rare tree species that enchants the world. Like a grassy hillock raised on an ivory podium, the strange figure of the dragon's blood tree – *Dracaena cinnabari* – is found only here, on a sunny archipelago in the Arabian Sea, between the Arabian Peninsula and the Horn of Africa.

As is common in botanical nomenclature, the species name of the dragon's blood highlights a key physical attribute. 'Cinnabari' references the deep-red resin within the tree's living wood and berries, a colour likened to that of cinnabar, the scarlet mineral from which vermillion pigment is derived. When cut, the bark appears to bleed, which has led to centuries of both local and widespread legend and folkloric myth: a tree thought to have sprouted from the blood of a feuding dragon and elephant; in Greek mythology, a tree sprung from a hundred-headed dragon slain by Heracles. Bestowed with supernatural and healing qualities, the 'dragon's blood' resin has long been valued as a cure-all for many bodily ailments.

In the provision of habitat, however, the tree is a vital component of the Socotra landscape: its dense canopy provides shade and even channels moisture down to the soil beneath, irrigating other plant life at its base. As such, the declining numbers and poor regeneration of Socotra's dragon's blood trees is a significant conservation concern.

RIGHT AN UNDULATING FOREST OF DRAGON BLOOD TREES ON YEMEN'S ISLAND OF SOCOTRA

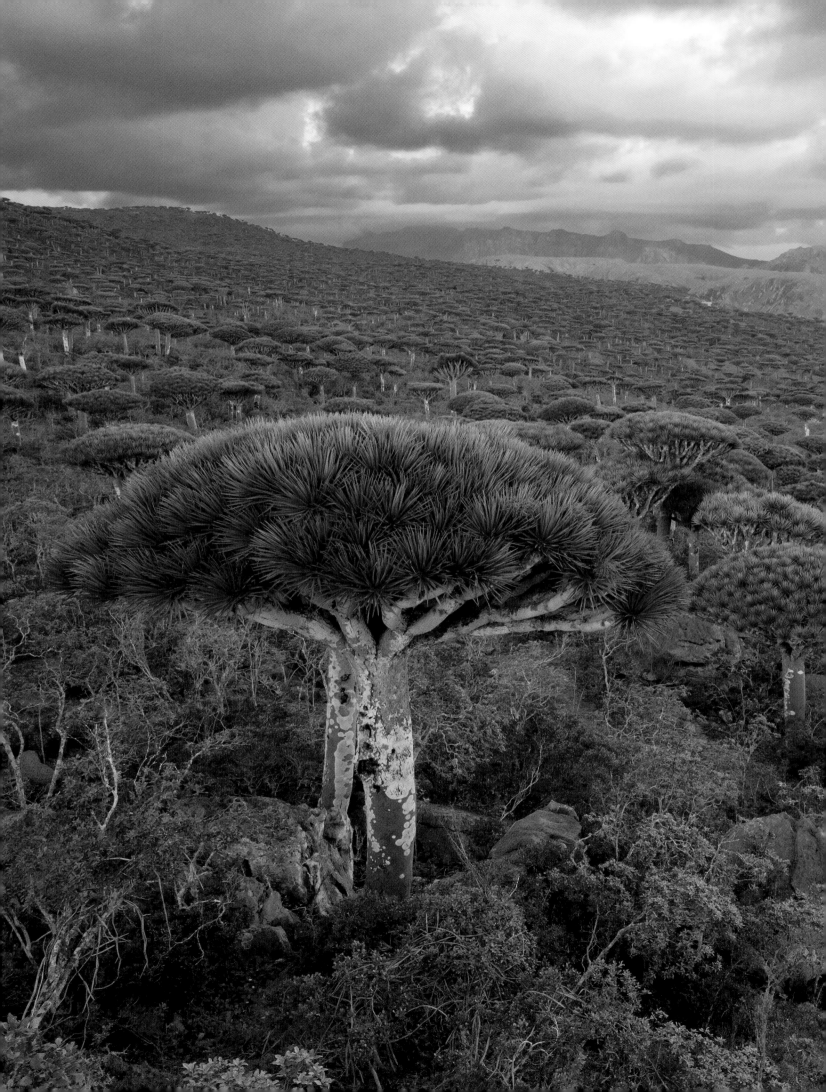

How to See

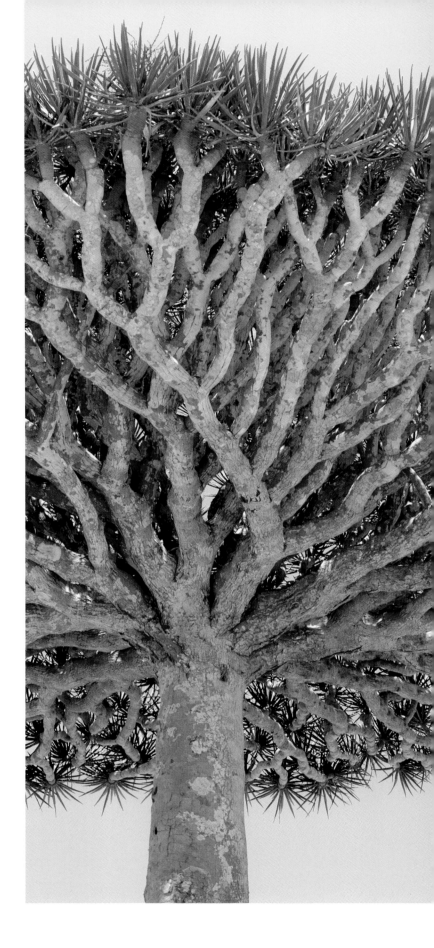

WHERE

The dragon's blood tree looks like something you'd find etched onto the margins of a medieval manuscript, straddling the boundary between what sailors really saw and the ramblings of their salt-soaked imaginations. Its range fits that idea perfectly, given the Yemeni island of Socotra was the real-life inspiration for tales of *Sinbad the Sailor*.

Despite turbulent times in Yemen, trips to Socotra are still possible – usually flying directly to the island on the once- or twice-weekly Air Arabia flight from Abu Dhabi. However, infrastructure is limited, with few hotels and little in the way of public transport, so almost everyone joins a camping tour arranged from overseas.

Hiking through the silence of the desert to see dragon's blood trees is a key part of a Socotra tour. The Diksam Plateau is the best spot on the island for close-up encounters; depending on the tour, you might stop for lunch under the umbrella-like canopy of a dragon's blood tree, or camp amidst a whole forest of them at Firmihin in the centre of the island.

WHEN

Socotra is a place to visit from February to May, when the monsoon winds die down. From June to October, the southwest monsoon brings flying clouds of grit and dust; from November to January, the northeast monsoon brings grey skies and occasional rain.

RIGHT IT IS THOUGHT THAT THE SHAPE OF THE TREE HELPS IT COLLECT MOISTURE;

OPPOSITE TOP DRAGON BLOOD TREES IN SOCOTRA'S HOMHIL PROTECTED AREA;

OPPOSITE BOTTOM RELATIVES OF THE DRAGON BLOOD TREE LIVE IN THE AZORES

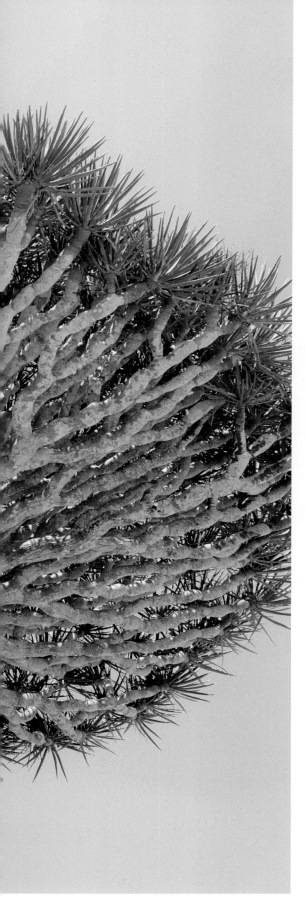

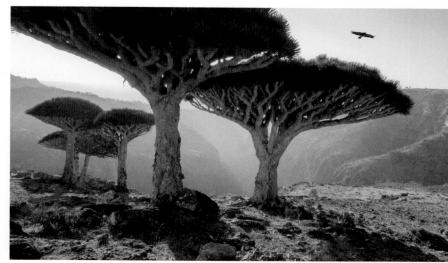

How to Identify

Neatly umbrella-shaped in form, the dragon's blood tree's mushroom-like crown is strikingly distinctive. This is formed by a thicket of repeatedly branching stems, exposed on their underside and raised on a grey-white trunk. The tough, tapering and somewhat glaucous-green leaves are similarly densely packed, arranged in rosettes at the end of the young stems. Creamy white flowers are borne in clusters at the stem terminals, producing dark berries that mature an orange-red colour.

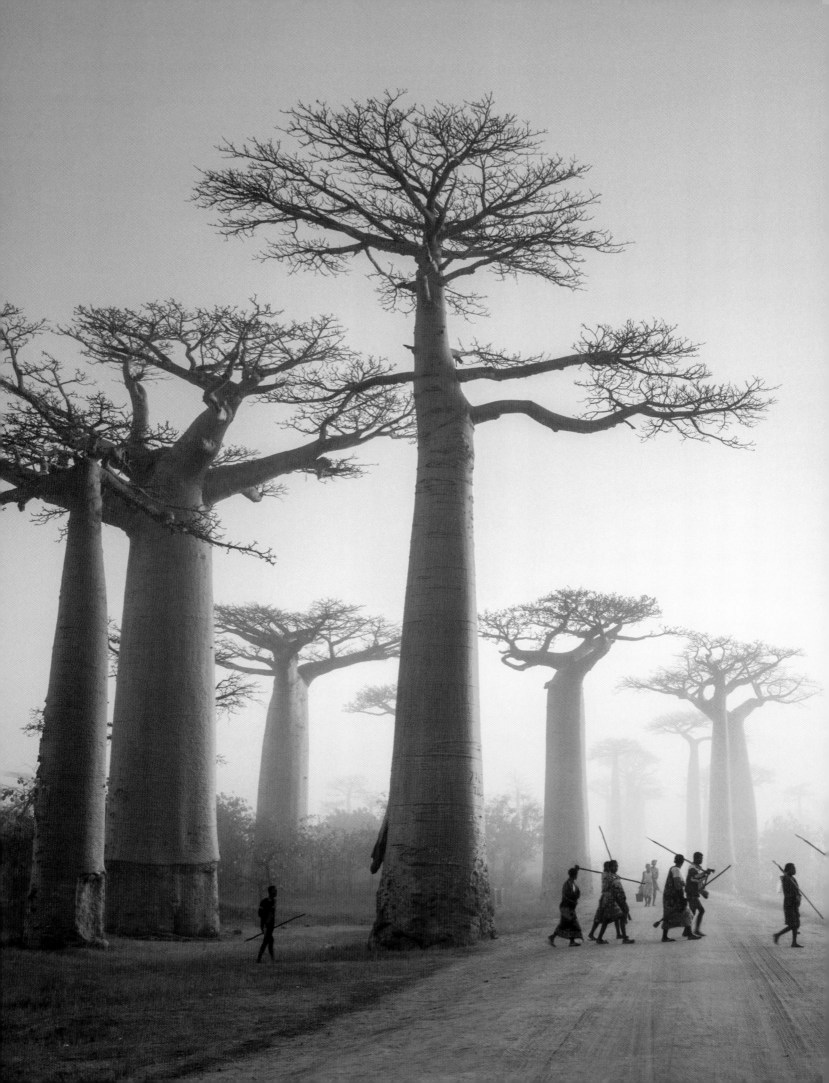

Grandidier's Baobab

Adansonia grandidieri

Vitals

RANGE

Southwest Madagascar

STATUS

Endangered

LIFESPAN

<2000 years

AVERAGE HEIGHT

70ft-90ft (21m-27m)

ENDEMIC TO AN ISLAND OF STAGGERING
BIODIVERSITY, THE BAOBABS ARE AMONG
MADAGASCAR'S MOST ESTEEMED TREASURES

Among the eight species of baobab, a singular representative stands proud: a curious, isolated figure with an enormous bloated torso, and stubby branches more akin to the roots of an upturned sugar beet than a tree. Though neither the most common nor the most ancient baobab species, *A grandidieri*, the Grandidier's or giant baobab (named after French botanist Alfred Grandidier), joins the lemur as a pillar of Madagascar's uniquely enchanting wildlife – a tree like no other, in the case of its trunk. And this is indeed something to shout about, for in a world that values its trees in measures of height, age and floral spectacle, it is rare that a trunk should find itself the centre of attention – it is the baobab's secret to success.

Native to southwestern Madagascar, the giant baobab is found grouped in sparse stands, savannah remnants of a formerly rich ecosystem that has fallen to agricultural clearance over the years. The extreme fluctuation of rainfall in this low-lying region – where a short wet season is followed by months of arid conditions – accounts for the tree's strange morphology. Like the boojum of Mexico (see page 93), it is drought-deciduous, shedding its attractively palmate leaves in the dry months to reduce transpiration. But the trunk is its ultimate safety net, a vast water tank of swollen and spongy wood, capable of storing upwards of 16,660 gallons (75,738L). This distinction is not singular to the giant baobab, rather a uniting factor among all baobab species. Nonetheless, the giants of southwestern Madagascar are an unrivalled landmark, their elephant-skin torsos rising like the columns of an imperial ruin.

LEFT MADAGASCAN FARMERS MAKE THEIR WAY TO THEIR FIELDS ACROSS
THE AVENUE DES BAOBABS IN MORONDAVA

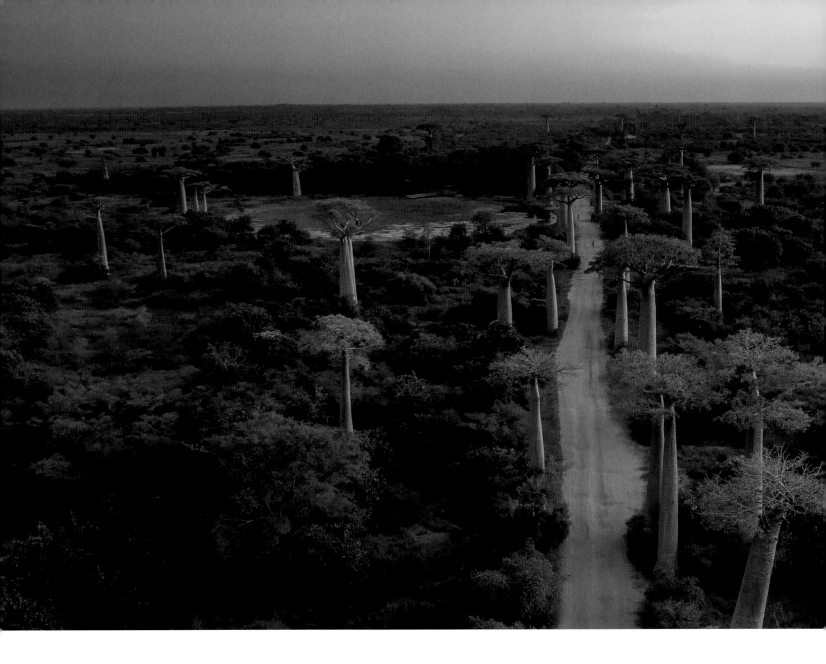

How to See

Various species of baobab thrive in sub-Saharan Africa, but the big daddy of the baobab world – the giant baobab – is native to southwestern Madagascar, particularly in the area between Lac Ihotry and Beroboka. In fact, we should probably say 'big mummy' considering the tree's Malagasy name, reny ala, meaning 'mother of the forest'.

Giant baobabs were once found in dense forests, but because of woodland loss – and the limited usefulness of baobab wood for construction or firewood – these mighty trees are now more commonly seen in denuded, open areas, such as the section of Route Nationale 8 between Morondava and Belon'i Tsiribihina – celebrated by tourist guides as the 'Avenue of the Baobabs'.

The easiest way to reach this iconic arcade of bulging baobabs is as part of a cross-country 4WD tour around southern Madagascar, but it's also possible to arrange day trips by taxi from Morondava, accessible by air from Antananarivo or by bus or *taxis brousse* (shared van) from Antananarivo, Tuléar (Toliara) and other local hubs.

WHEN
Try to reach the Avenue of the Baobabs earlier in the afternoon, before groups arrive to watch the sunset. Given the patchy state of Madagascar's roads, spotting giant baobabs is a dry-season activity; during the January to March wet season, dirt roads turn to quagmires.

How to Identify

You'll have no difficulty recognizing a baobab, but the Grandidier's is notable for its comparatively elongated trunk, which is smooth and rust-grey in colour, and can reach almost 10ft (3m) in diameter. The crown is compact and often flat-topped, the leaves palmate with defined leaflets. Summer flowers (May to July) are large, off-white and ephemeral, each blooming for a single day before the formation of its edible hanging fruits, velvety-green and oval-shaped.

LEFT AN AERIAL VIEW OF THE AVENUE DES BAOBABS NEAR MORONDAVA IN MADAGASCAR;

BELOW LEFT A 4WD VEHICLE IS NECESSARY TO REACH MANY OF MADAGASCAR'S BAOBABS;

BELOW BAOBABS CAN BE COMPOSED OF ABOUT THREE-QUARTERS WATER

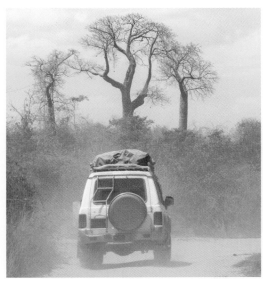

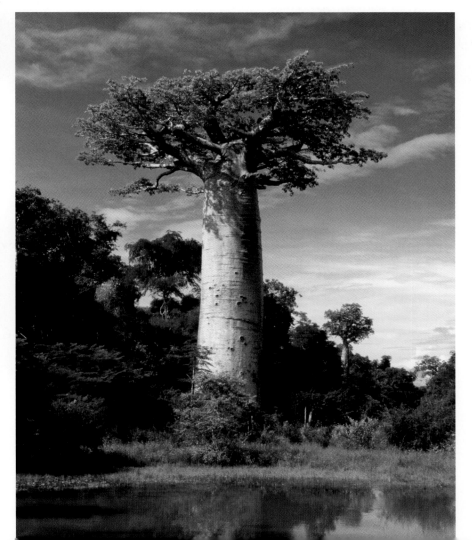

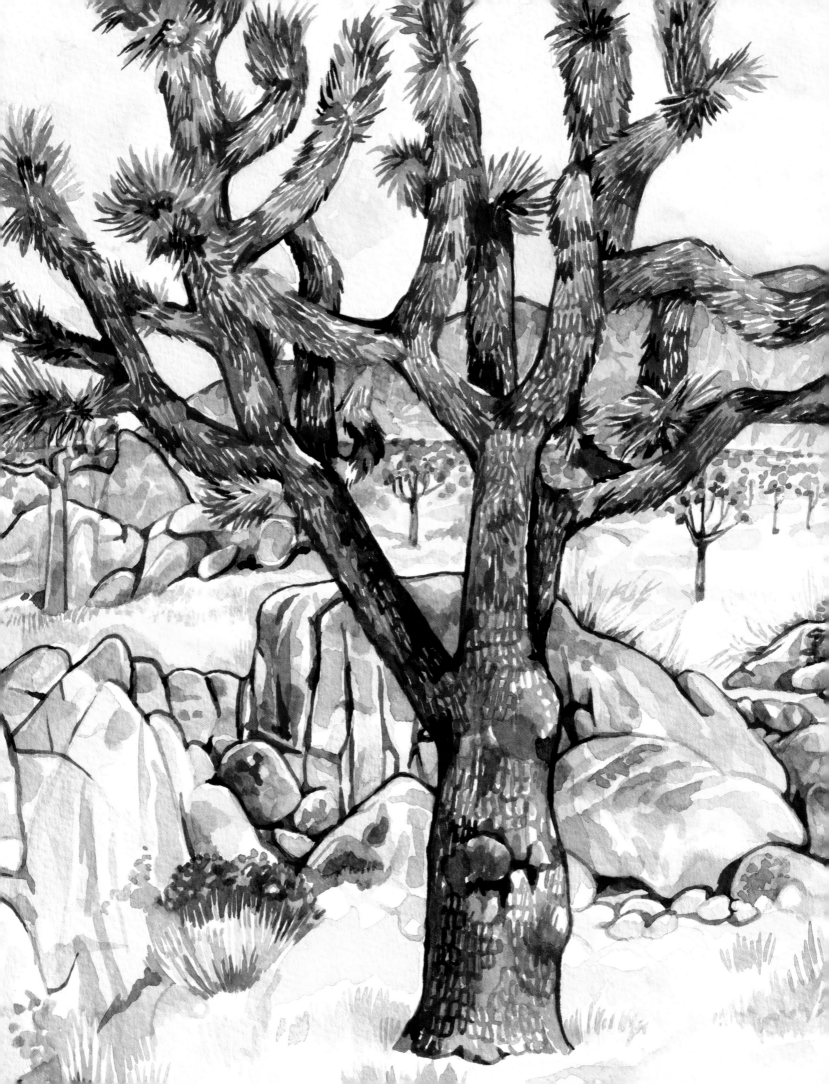

THE Americas

Great Basin Bristlecone Pine

Pinus longaeva

Vitals

RANGE
Western USA

STATUS
Least Concern

LIFESPAN
<5000 years

AVERAGE HEIGHT
40ft-60ft (15m-18m)

WITH ROOTS ANCHORING BACK TO PREHISTORY, THE GREAT BASIN BRISTLECONE IS NOT ONLY ANCIENT, BUT A RARE ENVIRONMENTAL ARCHIVE

It's a curious fact that the world's oldest living tree species should occupy one of its most inhospitable landscapes: an exposed, poor-soiled subalpine section of the USA's west, spanning remote mountainous pockets of California, Nevada and Utah. In this windswept, sun- and snow-beaten environment, the Great Basin bristlecone pine regularly grows in isolation, free of competition from other plants – and from the pests and diseases resident at lower altitudes – for multiple millennia. In California's White Mountains, for example, there are bristlecone pines whose seeds germinated between 4000 and 5000 years ago, around the time Egypt's Giza pyramids were constructed: an unfathomable longevity, as denoted in the pine's botanical etymology, *longaeva*. The many trunks of Utah's clonal aspen, Pando (see page 70), might claim the title of Earth's oldest living organism, but eastern California's Methuselah bristlecone is the single-stemmed victor.

This prehistoric provenance comes with a somewhat dishevelled appearance: as trees go, the bristlecone is no beauty. Its wood is twisted and often bare of bark, worn smooth by the wind where lightning strikes or other stimulus have caused branches to die back (the dry climate inhibits rot). But there is a charm to this ungainly figure, and great ecological value. Not only do its needles green an otherwise barren landscape, and its seeds sustain populations of resident Clark's nutcracker birds, but its ageing wood is an archival vault of natural history. The annual growth rings within the trunks of many trees can convey their age, but also environmental changes during their lifespan, such as drought and fire, and fluctuations in temperature and precipitation over the years. In cross-referencing the rings of both living and dead bristlecone pines, scientists have been able to map the changing climate going back well over 8000 years.

RIGHT CALIFORNIA'S ANCIENT BRISTLECONE PINE FOREST LIES WITHIN INYO NATIONAL FOREST

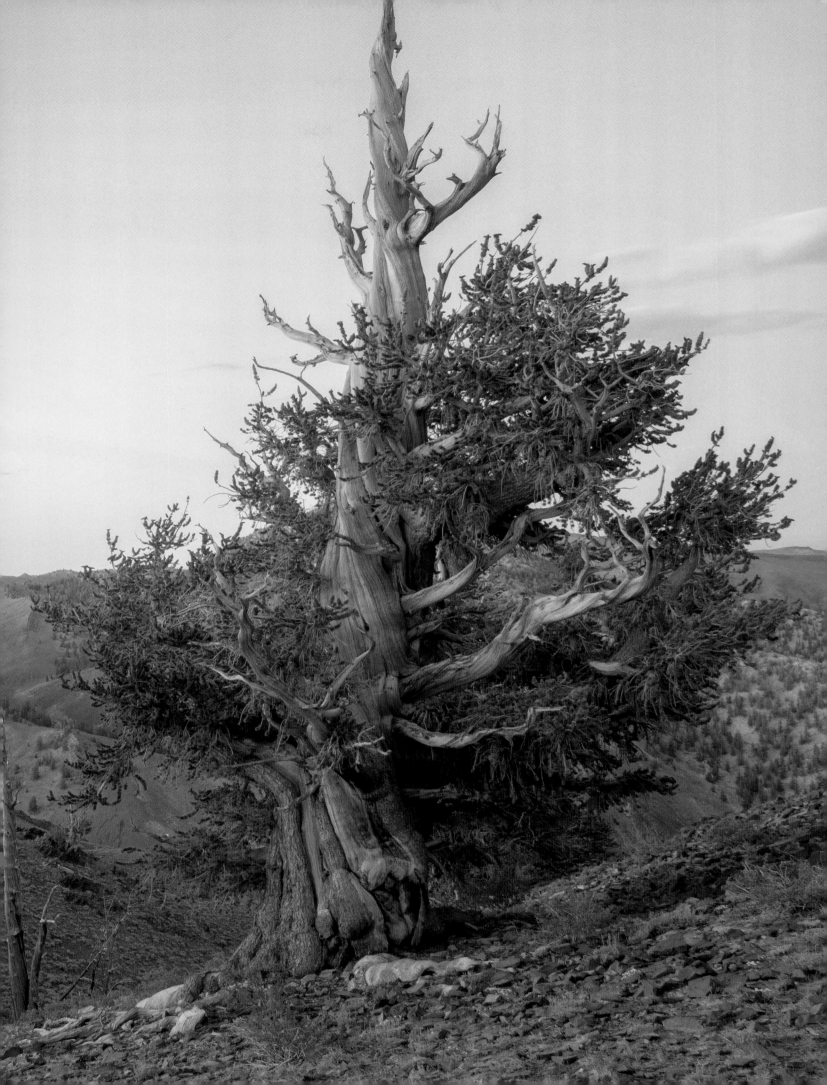

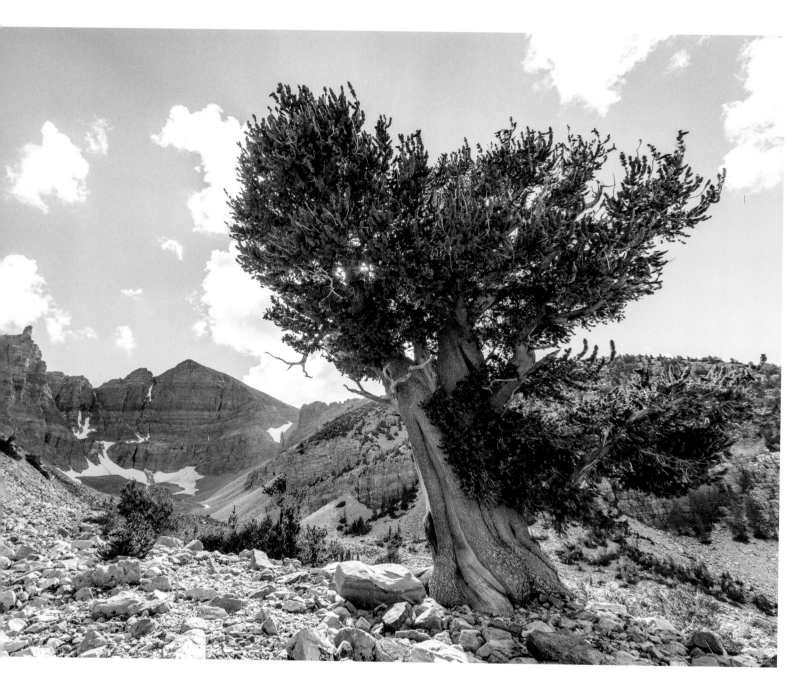

How to See

There are old trees, there are ancient trees, and there's the Great Basin bristlecone pine. Some of the venerable bristlecones found in the high mountains of California, Nevada and Utah have been around for four millennia, and the specimen known as Methuselah in Inyo County in California's White Mountains is thought to be the oldest non-clonal tree in the world, clocking in at a staggering 4855 years.

To keep this treasured old-timer safe from harm, the exact location is kept secret, but there are plenty of multi-millennial bristlecones that are easier to find within the sprawling Great Basin National Park, filling a natural scoop between the Sierra Nevada and the Wasatch Mountains. With a hire car, getting here is easy; follow US Rte 93 from Las Vegas, or Interstate 15 and US Rte 50 from Salt Lake City.

To see bristlecones without the need to go full-on old prospector, aim your hiking boots towards Great Basin National Park's Wheeler Peak Grove. The 2.7-mile (4.5km) Bristlecone Trail begins at the end of the Wheeler Peak Scenic Drive, which branches north from Hwy 488 between Baker and the Lehman Caves.

How to Identify

The Great Basin bristlecone pine is uneven in shape, often squat, with a broad and spiralling rust-coloured trunk. Dead branches tend to be retained on living trees. Needles are short and tightly packed in bunches of five, coating much of the branch length and giving the appearance of bristles. Identification is easiest by the cones, which have a purple colouration when young (maturing to brown), and are barb-tipped at the end of each scale.

LEFT WHEELER PEAK AND A BRISTLECONE PINE IN NEVADA'S GREAT BASIN NATIONAL PARK;
ABOVE THE WEATHERED WOOD OF A GREAT BASIN BRISTLECONE PINE IN INYO FOREST;
RIGHT HIKING THROUGH THE ANCIENT BRISTLECONE PINE FOREST IN THE WHITE MOUNTAINS

WHEN

Summer and fall are the best times to visit Great Basin National Park. All areas of the park at accessible to walkers and drivers, and you'll escape the chill of winter and the meltwater mud of spring.

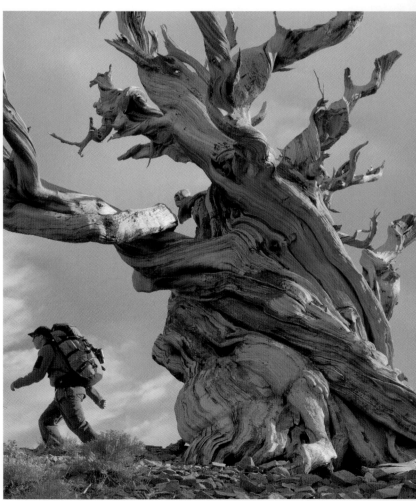

Sugar Maple

Acer saccharum

Vitals

RANGE

Eastern Canada and Central/ Northeastern USA

STATUS

Least Concern

LIFESPAN

<400 years

AVERAGE HEIGHT

80ft-120ft (24m-37m)

CANADA'S VERSATILE, HARD-WEARING NATIONAL TREE IS THE UNRIVALLED GLOBAL CHAMPION WHEN IT COMES TO VIBRANT AUTUMNAL COLOUR

Many might agree that were there an eighth Natural Wonder of the World, the autumn colours exploding through the deciduous forests of eastern North America might rank with the Grand Canyon, Victoria Falls or even the Northern Lights. When the right location, timing and weather all align, few sights are as movingly spectacular: a swathe of orange, vermillion and honey-hued leaves illuminated in October's golden light. This seasonal spectacle – in which reduced sunlight hours triggers the breakdown of green chlorophyl, exposing the heady spectrum of colours present in many leaves – draws something of a crowd. In recent years, New England states such as New Hampshire and Vermont have seen some three million leaf-peepers visiting for the fall foliage displays. Canada, however, has gone the extra mile in pinning the ambassador of all autumn leaves upon its flag: the sugar maple, key constituent of the country's southern woods, from Ontario right across to Nova Scotia. Here at the higher, cooler latitude of its range, the leaves of Canada's national tree blaze brightest, but they also do so in multiple hues upon the same tree: a technicolour effect.

The uses of the sugar maple are well known. It is the chief species tapped in the late winter months for the sweet sap from which maple sugar is derived; its tough wood lends to upmarket woodwork and cabinetry; its ornamental cultivars are widely valued park and garden trees. But to encounter sugar maples at their best, witness their fall flourish in the company of Canada's oak, hickory, dogwood and tulip trees, in all their complementary colours.

LEFT A FOREST OF SUGAR MAPLES IN THE FAIRBANK PROVINCIAL PARK OF ONTARIO, CANADA

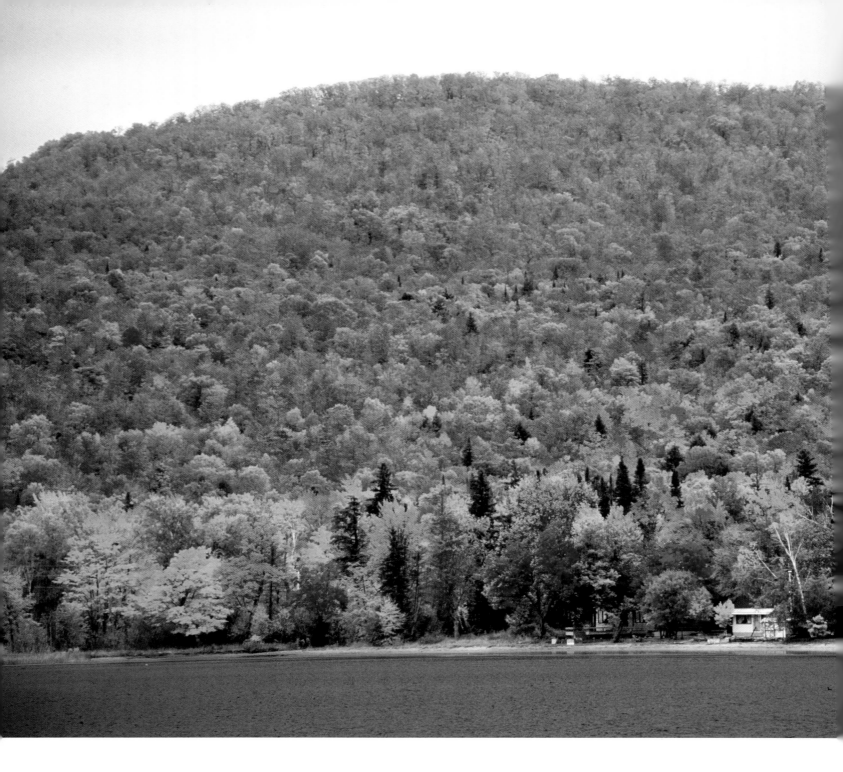

How to See

WHERE

Canadians love the sugar maple so much they put its sweet, sticky sap in their candy, on their pancakes, and pretty much everywhere else they can think of (including on savoury dishes). It should come as no surprise that the hardwood forests of eastern Canada are some of the best places to see sugar maples in their native setting.

About 155 miles (250km) north of Toronto, Algonquin Provincial Park is a peaceful patchwork of pine forests and stands of both sugar maples and the slightly larger and more widely distributed red maple (identifiable by the serrated edges on its leaves). Inside the park are trails to hike, lakes and rivers to splash in and canoe on, and peaceful campsites to set up your tent.

Algonquin's sugar maples put on a firework-red leaf show every fall, particularly along Hwy 60. Tack on a hike along the 6.7-mile (10.8km) Mizzy Lake Trail and you may also run into moose and beavers. Get here by hire car, working your way northeast from Toronto on Hwy 400, Hwy 111 and Hwy 60.

How to Identify

Although maple leaves are instantly recognizable, there is significant variation of shape and size among species. Broad and deep green, sugar maple leaves have five distinct lobes, smooth-edged and U-shaped between the points. Autumnal leaf colour can range from yellow to orange-red, unlike the common – and notably scarlet – red maple (*A rubrum*). The 'helicopter' seeds have relatively downward pointing, near-parallel wings. Bark is grey; furrowed like an oak when mature, smoother in younger trees. Both branches and buds are paired in opposite formation.

LEFT SPECTACULAR AUTUMN FOLIAGE IN ONTARIO'S ALGONQUIN PROVINCIAL PARK;
BELOW A QUEBEC SUGAR SHACK IN WHICH MAPLE SYRUP IS MADE EACH SPRING AFTER BEING
TAPPED FROM THE TREES; BOTTOM CHLOROPHYLL BREAKS DOWN TO REVEAL OTHER PIGMENTS

WHEN

From September to October, the sugar maples and red maples of eastern Canada glow like burning coals – a spectacle that lures leaf-peepers from across Canada and the world. Summer is also a great time to explore the maple forests, with warm nights for camping and days that get hot enough for lake swimming.

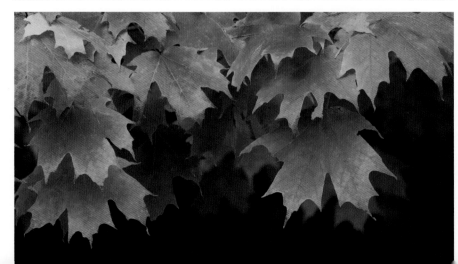

Southern Live Oak

Quercus virginiana

Vitals

RANGE
Coastal Southeastern USA

STATUS
Least Concern

LIFESPAN
<500 years

AVERAGE HEIGHT
50ft-80ft (15m-24m)

A TOUGH AND ANCIENT SOUTHERNER OF BROAD BRANCHES, THIS LEGENDARY OAK PLAYS HOST TO A BEWITCHING COMPANION

Firmly rooted in the coastal states of South Carolina, Georgia, Florida, Alabama and Louisiana, no tree could be more emblematic of the USA's Deep South than the Southern live oak. With muscular, near-horizontal limbs that can extend to twice its height, an enormous domed crown and boughs festooned with torn rags of Spanish moss, the state tree of Georgia is iconic of this entire humid subtropical region. By way of Southern grit, its tolerances are ample, resisting floodwater, shade, salt, both clay and sandy soils and, to an extent, even wildfire; and its wood has been historically employed as robust, durable material for flooring, shipbuilding and tool handles. The pin-up among all southern live oaks is a well-known – and much pho-tographed – character found on Johns Island, within the city limits of Charleston, South Carolina. Dubbed the Angel Oak, it is in every way the accentuated exemplar of its species, with dense branches spread wide like tentacles, basking in the sticky Atlantic air.

It is the coupling with Spanish moss, however, that gives to this long-lived oak its particular – and remarkable – haunting quality; a look quintessential of Southern Gothic, the stuff of a Harper Lee or William Faulkner novel. Hanging in ragged strands, as if caught in the wind, the moss appears ghostly in the shade but, as described by the poet Walt Whitman, almost 'glistens' in sunlight. Thankfully, the two species merrily coexist, the epiphytic moss taking advantage of the live oak's enormous frame without hampering its growth.

RIGHT THIS 400-YEAR-OLD SOUTHERN LIVE OAK IN ANGEL OAK PARK IN THE CITY

OF CHARLESTON, SOUTH CAROLINA, RECEIVES 400,000 VISITORS ANNUALLY

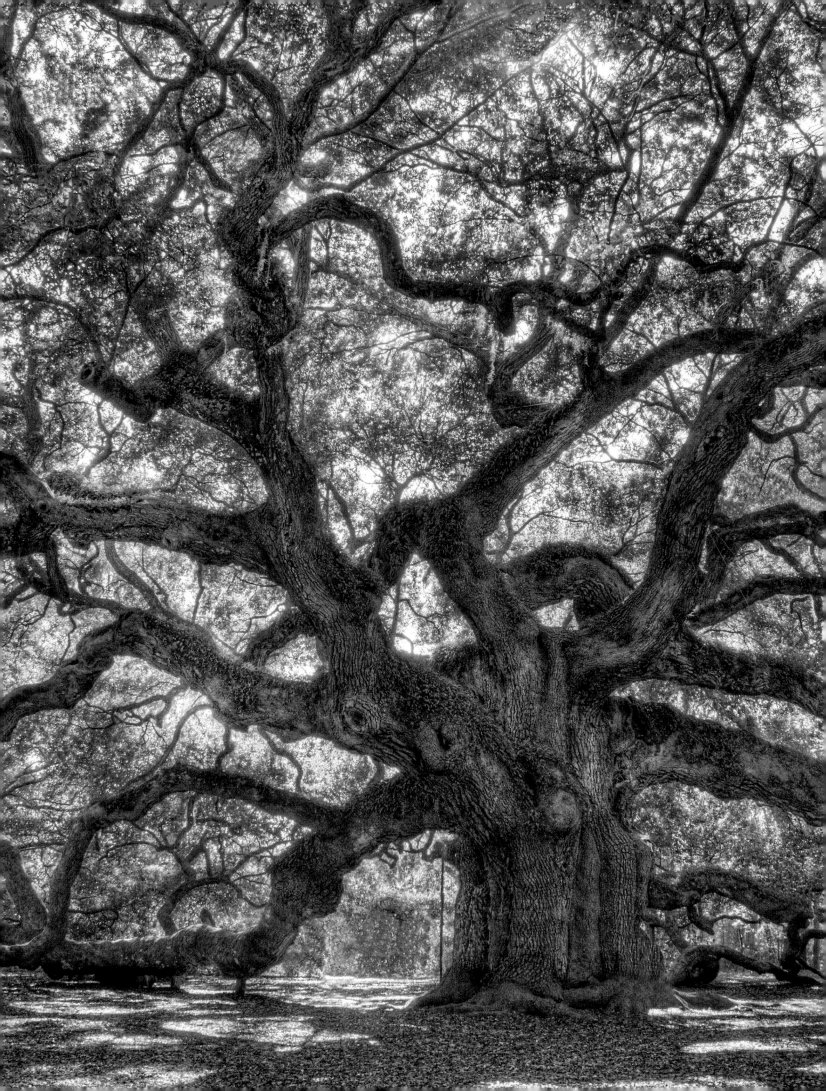

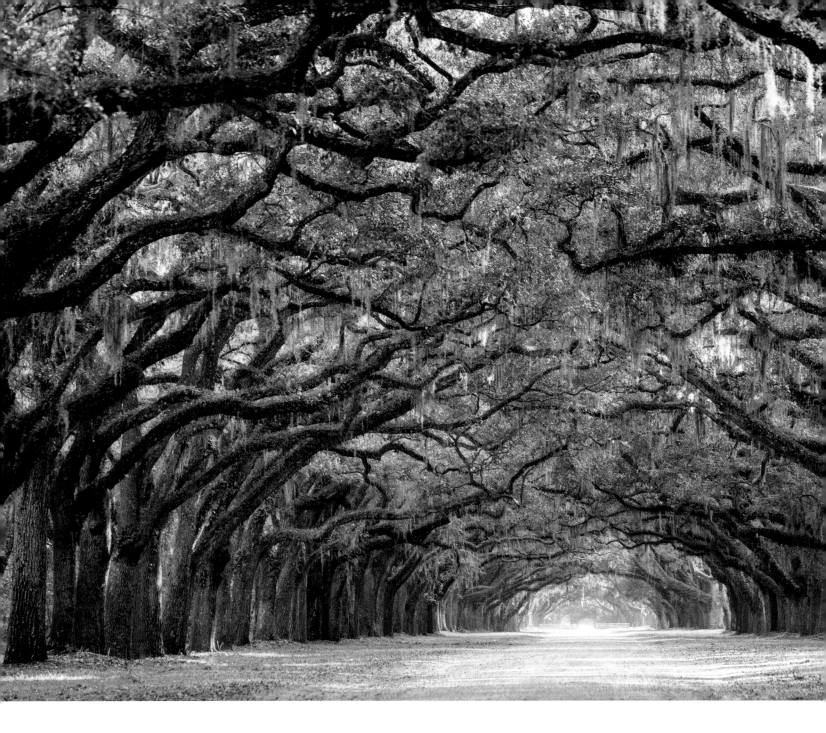

How to See

There's a difference between a live oak, and a 'live' oak of any other kind – telling them apart is easy in winter, when other oaks lose their lobed leaves, while live oaks keep their spearhead-shaped foliage. Range is another giveaway; deciduous oaks dominate in the north, while live oaks are common from Virginia down to Florida and across to the southwest and California.

Georgia takes pride in its live oak credentials, but neighbouring South Carolina is one of the best spots to get out into moss-draped live oak forests. Close to the city of Charleston, Johns, Wadmalaw and Edisto Islands are well-known for their stands of gnarled live oaks (as well as for dark days during the trade of enslaved people and the Civil War).

To get to Johns and Wadmalaw, follow State Rte 700 southwest from Charleston; to reach Edisto, follow the US Rte 17 west and branch south onto State Rte 174. The road to Edisto's Botany Bay Heritage Preserve passes through an avenue of live oaks whose twisting branches almost meet over the road (and afford excellent opportunities for tree climbing), before dropping visitors at a pristine beach.

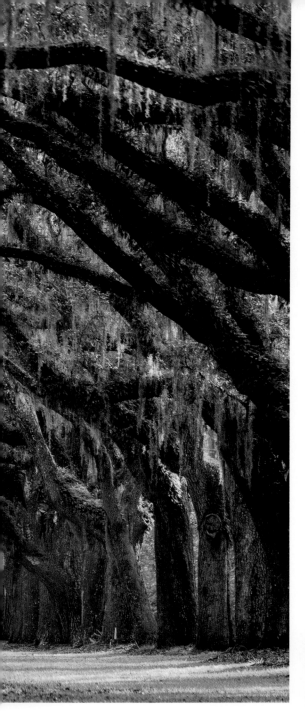

How to Identify

Southern live oaks are notable for their stout trunk and broad crown, bearing long, wide, arching and often low-spreading branches. Their narrow, unlobed leaves appear evergreen – thick, waxy and deep green on top, paler below; however, these fall in advance of fresh new leaves by springtime, making it a deciduous tree. It bears green, pollen-laden 2in to 3in-long (5cm to 8cm) catkins in spring; and tiny, dark acorns in autumn.

LEFT AN AVENUE OF SOUTHERN LIVE OAK TREES IN SAVANNAH, GEORGIA, WHICH IS NICKNAMED 'THE FOREST CITY'; BELOW THE ACORNS OF THE SOUTHERN LIVE OAK SUSTAIN BIRDS AND MAMMALS, INCLUDING BLACK BEARS

WHEN

South Carolina can be uncomfortably hot and humid in summer. April to early June and September to October are the sweet spots on the calendar, with warm, not-too-sticky weather and lots of acorns about in the fall.

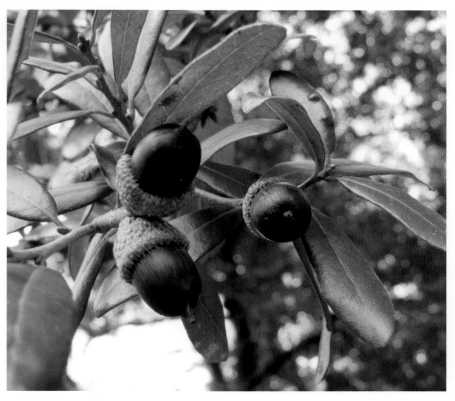

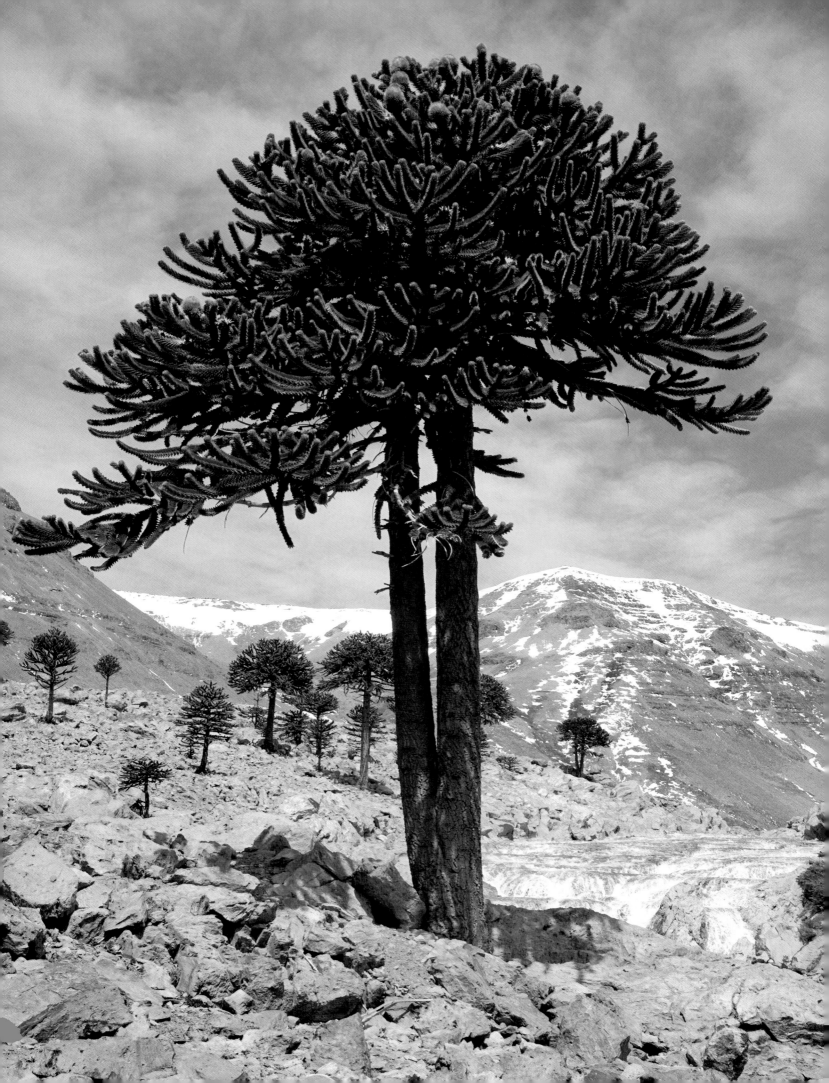

Monkey Puzzle

Araucaria araucana

Vitals

RANGE
Chile and Southern Argentina

STATUS
Endangered

LIFESPAN
<1000 years

AVERAGE HEIGHT
60ft-90ft (18m-27m)

A BELOVED ORNAMENTAL THE WORLD OVER, SOUTH AMERICA'S MOST ICONIC TREE HAILS FROM RARE AND REMARKABLE FORESTS

Beneath the strikingly unique figure cast by the monkey puzzle tree lie two great surprises. The first is its unusually long lineage: fossils suggest its prickly ancestors shared the Earth with dinosaurs 200 million years ago, placing the tree among the world's most ancient species. The second is the ease with which these eccentric, exotic-looking and once highly coveted trees adapted to sites and soils far more domestic than its Patagonian homeland forests. Native to stretches of Chile's coastal and Andean mountain ranges (and known to some as the Chile pine), *A araucana* grows naturally in picturesque stands often comprised of no other tree species, its large, nutritious seeds long valued by South America's Indigenous Pehuenche peoples. However, since its introduction to Victorian society by European botanists in the mid-19th century, the monkey puzzle has become a temperate-region staple, and you're now as likely to spy its bristled limbs adorning the front garden of a suburban home as a botanical arboretum. Initially treated as a mollycoddled greenhouse specimen for fear of fatal frost damage, a better understanding of the monkey puzzle's impressive hardiness saw trees being planted as far north as Scotland. Meanwhile, historic logging of its rare and spectacular native forests has sadly endangered natural populations.

The curious naming of the monkey puzzle is of less surprising provenance, arising – so the story goes – from a remark made by a visitor about a tree planted at Pencarrow House in Cornwall, England. Recoiling from the sharp leaves, they declared that it 'would be a puzzle for a monkey!'

LEFT A MONKEY PUZZLE TREE IN ARGENTINA'S COPAHUE PROVINCIAL PARK, ON THE EDGE OF THE ANDES MOUNTAINS

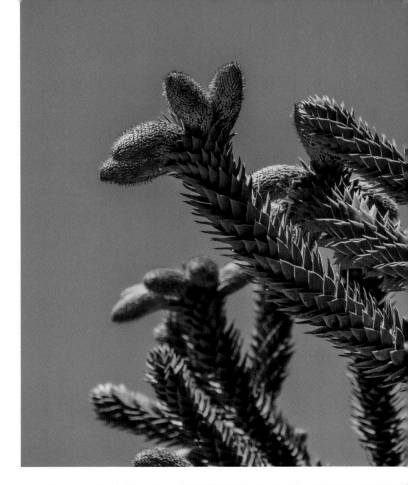

How to See

WHERE

Chile's national tree may come with naturally evolved anti-burglar protection, but this was aimed at grazing herbivorous dinosaurs – you won't see too many monkeys or dinosaurs in the areas where the trees grow today. The monkey puzzle's core zone is on the slopes of the Chilean Coast Range, typically in areas above 3280ft (1000m) with well-drained, volcanic soils.

That's the wild monkey puzzle, of course. Cultivated trees became a firm favourite of European gardeners in the 19th century, and you'll see them in private and public plantings across the world – particularly in the UK (though many didn't survive the country's 1989 storms). But to witness monkey puzzles in their full wild majesty, head to Parque Nacional Nahuelbuta between the Chilean cities of Los Ángeles and Temuco.

Access roads run to the park from Angol on Chilean Rte 180 and Cañete on Rte P-60-R; it's best to join a tour or come with a hired or chartered vehicle as there's no public transport. This is stunning hiking country; kick off with the 2.8-mile (4.5km) tramp to the Piedra del Águila – a rocky outcrop crossed by boardwalks and ringed by Dr Seuss–like monkey puzzles.

WHEN

Parque Nacional Nahuelbuta can be visited year-round, but the southern hemisphere autumn (March to May) and spring (September to November) have clement weather for hiking and smaller crowds. In winter, you may be able to see monkey puzzles topped by a canopy of snow.

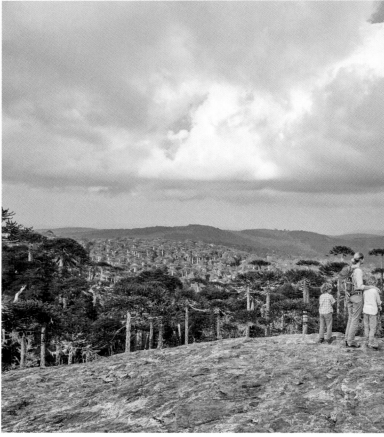

TOP THE MALE CATKINS OF A MONKEY PUZZLE TREE, THE FEMALE CATKINS ARE A SPINY CONE; ABOVE LOOKING OUT OVER A MONKEY PUZZLE FOREST IN THE COASTAL MOUNTAINS OF CHILE'S NAHUELBUTA NATIONAL PARK; RIGHT A CLOSE-UP OF A MONKEY PUZZLE TREE'S TESSELLATED TRUNK

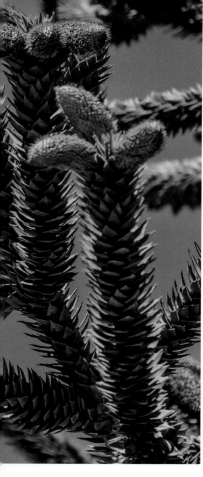

How to Identify

Unique in form, and lacking any arboreal doppelganger, the monkey puzzle is easily recognizable. A perfectly straight, thick, greyish trunk leads to a dense crown of sunward branches (lower branches are shed with age), each comprehensively clad in tough, devilishly sharp triangular leaves in a perpetual shade of forest green. Cylindrical male cones are brown and roughly 3in (8cm) long; the green, similarly spiny female cones are distinctly spherical in shape.

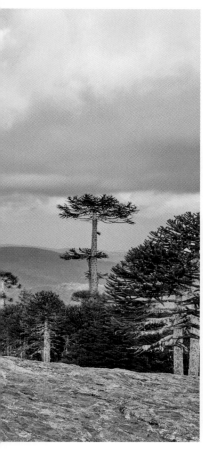

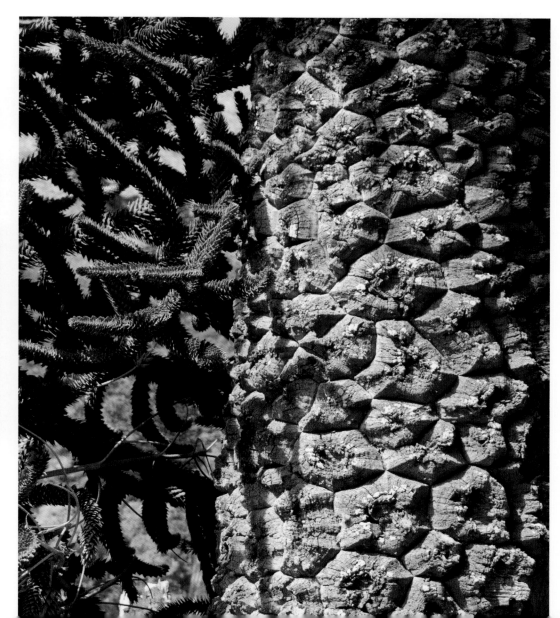

Quaking Aspen

Populus tremuloides

Vitals

RANGE
USA and Canada

STATUS
Least Concern

LIFESPAN
<150 years

AVERAGE HEIGHT
30ft-60ft (9m-18m)

THOUGH A COMMON SIGHT IN THE COOLER REGIONS OF NORTH AMERICA, THE QUAKING ASPEN BOASTS A SURPRISING, UNIQUE CLAIM

Few US states west of the Mississippi might declare autumn their season of peak natural beauty, but owing almost singularly to the glowing, candle-flame foliage of the quaking aspen, Colorado shines brightest in the fall. Somewhat blended throughout spring and summer into a landscape of evergreen pine and spruce, the aspen's turning leaf lights up through September and October, 'shivering in gold' – as noted by 19th-century Colorado explorer Isabella Bird – and gilding great streaks through the Rocky Mountain state. This is surely the time to see it.

According to the US Department of Agriculture, *P tremuloides* brags the widest distribution of any tree species across the entire United States, with a scattered range stretching from Alaska to Texas and from California right across to Maine. But the tree stands proudest when set against the spectacular panoramas of Colorado. Such is its distinctive presence in the state's subalpine meadows, lush grasslands and roaring riverbeds, they even named a city in its honour. However, a far-reaching distribution, along with other noteworthy idiosyncrasies such as the 'trembling' effect of its freely-fluttering leaves – the result of a flat leaf-stalk that spins in the wind – are but forerunners to the quaking aspen's greatest claim of all: among its exemplars is a tree considered, remarkably, the world's largest living organism. Utah's Pando, as it has been named, is a forest-colony of genetically identical trees stemming from a single connecting root system: one mass of unrivalled arboreal beauty stretched over a whopping 100 acres (40 hectares).

RIGHT A GROVE OF ASPENS IN COLORADO IN AUTUMN. BECAUSE THE TREES ARE GENETICALLY RELATED, THEY TEND TO CHANGE COLOUR AT THE SAME TIME

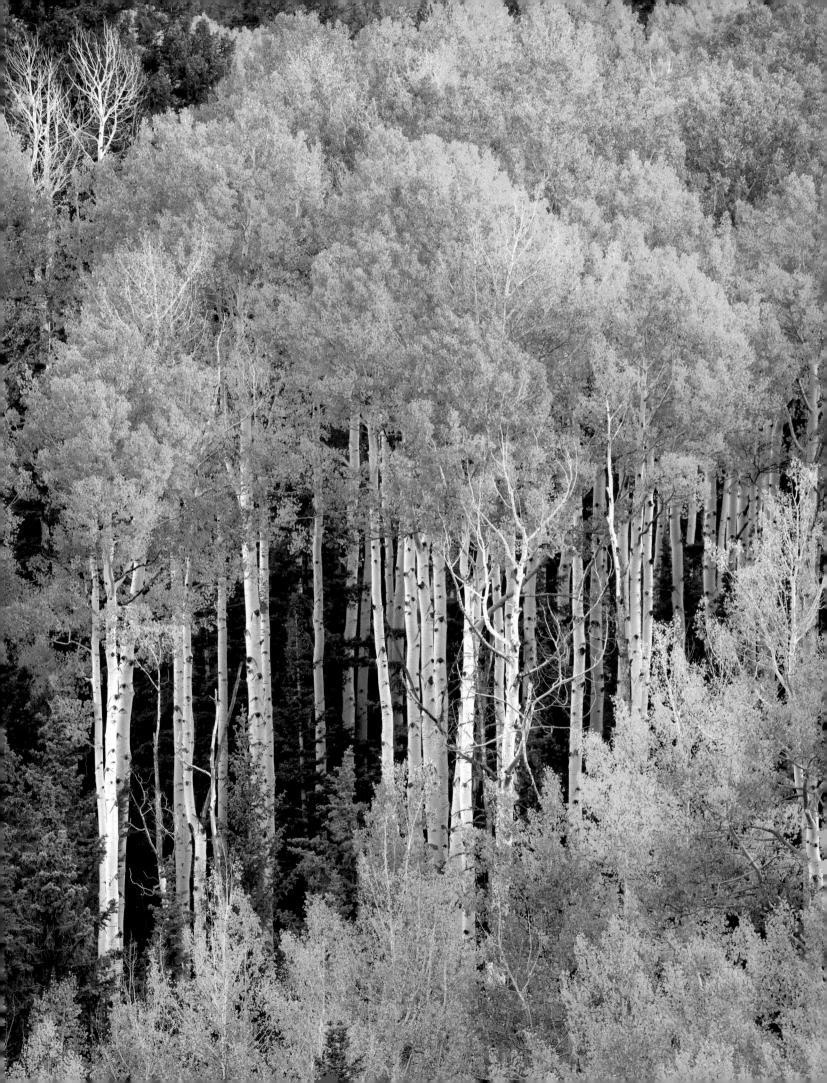

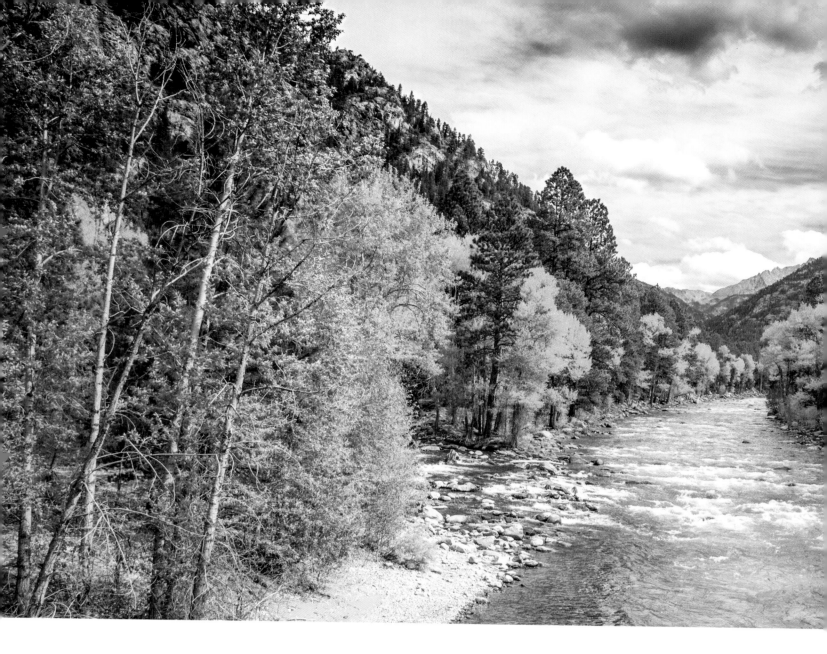

How to See

Although aspens are widely distributed across America, one of the best places to enjoy them is Colorado, not least because no fewer than 26 Scenic and Historic Byways lead visitors through the state's magnificent landscapes. To get up close to aspens, Colorado has countless hiking trails, many accessed from its mountain towns. Near Vail, west of Denver, Booth Falls Trail passes through aspen groves on its way to a waterfall. South of Denver, around Colorado Springs, you can take the Barr Trail to the top of Pikes Peak (a two-day effort for most), with

forest views all around. To the northwest of Denver, outside Steamboat Springs, the Flash of Gold trail passes through glorious aspen groves.

Denver is Colorado's main international gateway for flights. It sits almost in the centre of the state. From Denver, towns and cities such as Boulder, Steamboat Springs and Aspen are best reached by rental car. But the California Zephyr Amtrak train route between Chicago and San Francisco stops at both Denver and Grand Junction, allowing for a visit to the trees.

WHEN
Peak leaf-peeping starts from mid-September in the north of Colorado and from late September in the south. Aspen groves change spectacularly from fresh green to shimmering gold, before the leaves drop, leaving just the aspens' silvery trunks in the snow. In spring, wildflowers appear in May but high-level snow may not melt until mid-June.

How to Identify

While its small, softly serrated mature leaves are conspicuously illuminated in autumn, the quaking aspen's shimmering white trunk is a year-round giveaway, all the more so when winter-bare. Generally, it is encountered in groves – often a single clone – of multiple trees, and like silver birch its smooth bark is notched with black scars running up into the canopy. Slender, 1in- to 3in-long (2.5cm-8cm) catkins dangle in spring in advance of the new leaves.

LEFT THE ANIMAS RIVER FLOWS THROUGH THE WEMINUCHE WILDERNESS AND ITS ASPEN TREES; BELOW LEFT LEAVES OF THE QUAKING ASPEN IN SPRING; BELOW HIKING THE BOOTHS FALL TRAIL IN COLORADO'S WHITE RIVER NATIONAL FOREST

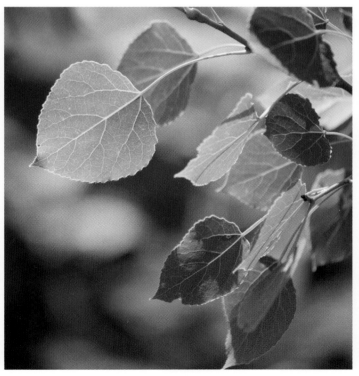

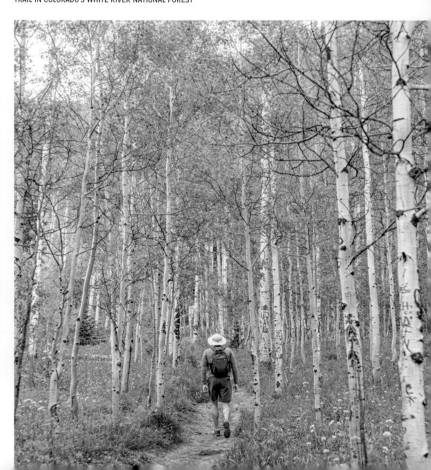

Pacific Madrone

Arbutus menziesii

Vitals

RANGE
Pacific Northwest, USA and Canada

STATUS
Least Concern

LIFESPAN
<250 years

AVERAGE HEIGHT
30ft-80ft (9m-24m)

ITS CURIOUS FRUIT AND FIGURE MAKE THE PACIFIC MADRONE ARGUABLY ONE OF NORTH AMERICA'S MOST UNIQUE AND ECCENTRIC TREES

The devilish twist in the fiery madrone's tale is that its fruit – so appealingly strawberry-soft, hanging clustered like Christmas berries – proves so unpalatable: bland, grainy, somewhat tart and far better left for the robins and band-tailed pigeons that populate the Pacific Coast's forests. Indeed, the Coast Salish peoples of Vancouver Island, where the trees are common, made more productive use of the tree's bark, as a food dye, a curative tea and a medicinal treatment for numerous sores. And it is the madrone's striking bark for which the tree is widely celebrated. Peeling away in thin strips during the summer months – much like a eucalyptus or ageing cherry – the rust-red mature bark is discarded to reveal a smooth and muscular skin, coloured mustard yellow or green-sheened, and brightened in rain or sea-spray. Bearing glossy leaves of deep green, the madrone's overall appearance is one of rich colouration; a tree whose modest proportions (averaging some 50ft/15m in height) are offset by a uniquely vibrant and attractive appearance. Little wonder, then, that it has found favour as an ornamental species for stylish gardens.

The question of why the madrone drops its bark continues to puzzle. While the speed at which eucalyptuses expand might account for their shedding, *A menziesii* are slow-growing. The answer might instead be attributed to the deterrence of competition: a peeling bark will repel pathogen and parasite alike, and prove tricky for the climbing or epiphytic plants that might seek to envelop its canopy – madrones are not lovers of shade. Yet this intolerance yields another charming attribute, as the quest for light drives the tree to form eccentric, sculptural limb shapes.

LEFT A MADRONE TREE ON VANCOUVER ISLAND, WHERE THE TREES WERE AN IMPORTANT RESOURCE FOR THE INDIGENOUS COAST SALISH PEOPLE

How to See

The Pacific madrone shares its North American range with tall straight pines, but it's a very different organism, part of the Ericaceae family, which includes the wild huckleberries that grow abundantly in the Pacific Northwest.

Stands of Pacific madrone track the west coast from California to western Canada, but they are most strongly associated with the dripping coastal forests of British Columbia, particularly the southeast tip of Vancouver Island. Indeed, it was here that the tree was first noticed and officially recorded by Archibald Menzies of the Vancouver Expedition in 1792.

Vancouver Island is still a great place to see Pacific madrones up close and feel the strange, cool-to-the-touch bark that earned the tree its nickname, the 'refrigerator tree'. Get to Victoria by flight or ferry and drive south along the coast to reach the Witty's Lagoon, East Sooke and Roche Cove Regional Parks, and shorefronts painted by peeling trunks.

WHEN
March to May is the best window for exploring Vancouver Island; you'll avoid the summertime crowds, it's not *that* rainy by Pacific Northwest standards, and you can view Pacific madrones on land and whales and orcas offshore.

RIGHT VANCOUVER ISLAND'S MADRONES ARE ABLE TO GROW IN A VERY ROCKY HABITAT;

OPPOSITE TOP THE EXPOSED ROOTS OF A MADRONE IN UPLANDS PARK, VICTORIA;

OPPOSITE BELOW THEIR RED-BROWN BARK PEELS EACH SUMMER

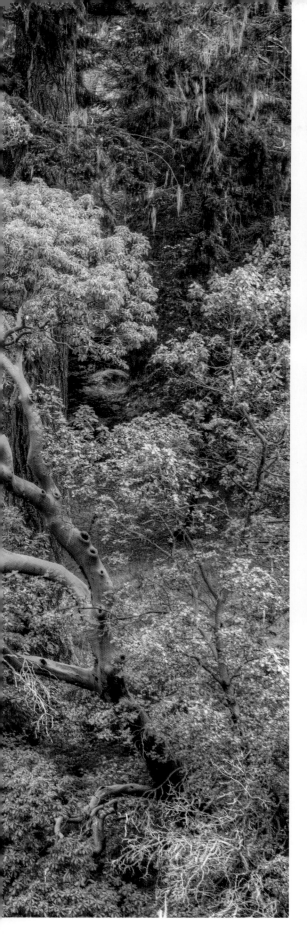

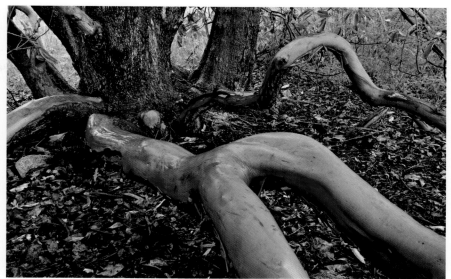

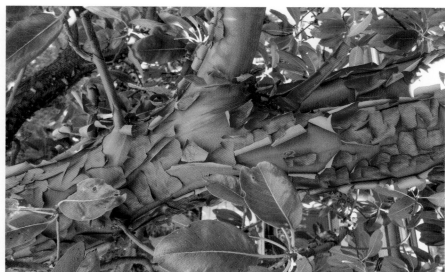

How to Identify

Much like their widespread Mediterranean cousin *A unedo*, Pacific madrones favour the kind of dry, rocky sites inhospitable to many other tree species: they're equally at home on the Sierra Nevada's exposed scree as the sea-sprayed stones of Washington's Puget Sound. Cream-white, honey-scented flower bunches akin to lily-of-the-valley appear in spring, conspicuous against the oval, leathery evergreen leaves; by mid- to late autumn the resulting strawberry-like fruit matures to a bright, unmistakable scarlet.

Giant Sequoia

Sequoiadendron giganteum

Vitals

RANGE
California, USA

STATUS
Endangered

LIFESPAN
<3000 years

AVERAGE HEIGHT
250ft-280ft (76m-85m)

WITHOUT QUESTION, THE WORLD'S LARGEST AND PERHAPS MOST ADMIRED OF ALL TREE SPECIES IS ONE OF NATURE'S GREATEST MARVELS

Though it may be a colossus, room must be made in a book of astounding trees for the giant sequoia, *S giganteum*. Its moment of contemporary fanfare came in the mid-19th century, with the discovery of the Calaveras Grove in California's Sierra Nevada mountains. Comprised of a species greater in size than the previously known coast redwood, *S sempervirens* (which is often confused with giant sequoia), the grove quickly became a popular tourist attraction, with trees cut down for exhibition and a dancefloor famously made of one enormous stump. To the English botanist William Lobb, plant-hunting in Gold Rush–era California, these vast trees presented a commercial windfall, with Victorian Britain soon rhapsodising over his collected seeds and attributing the trees with the still-used name of Wellingtonia. To naturalist John Muir, the great champion of America's unique forests, they were a national treasure to be protected from human destruction (he was no advocate of the Calaveras dancefloor). As Muir wrote: 'Seeing them for the first time you are more impressed with their beauty than their size.' Today, and in no small way thanks to John Muir, many sequoia groves are safeguarded within the boundaries of California's national parks, from Yosemite to Kings Canyon and Sequoia National Park, the latter home to huge specimens such as General Sherman.

Muir recognised the giant sequoia's beneficial relationship with wildfire. As for many western conifers, its seedling regeneration is most successful where low-severity wildfire has cleared forest debris and opened the canopy. But due to historic human wildfire suppression and the effects of climate change, wildfire severity has risen, burning through giant sequoia groves with a higher intensity. Tragically, some 10% of mature giant sequoias in California are thought to have been killed since 2020.

RIGHT HALF THE SIERRA NEVADA'S PRECIPITATION FALLS AS SNOW, WHICH SUITS THE SEQUOIAS

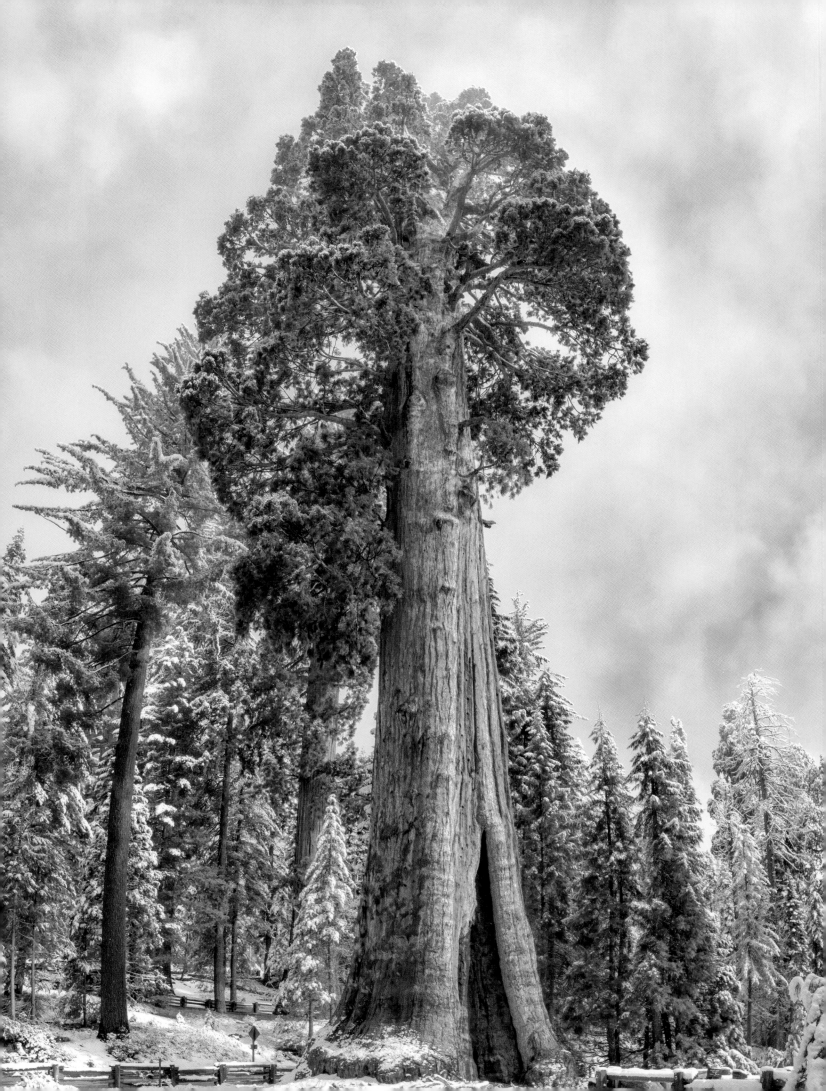

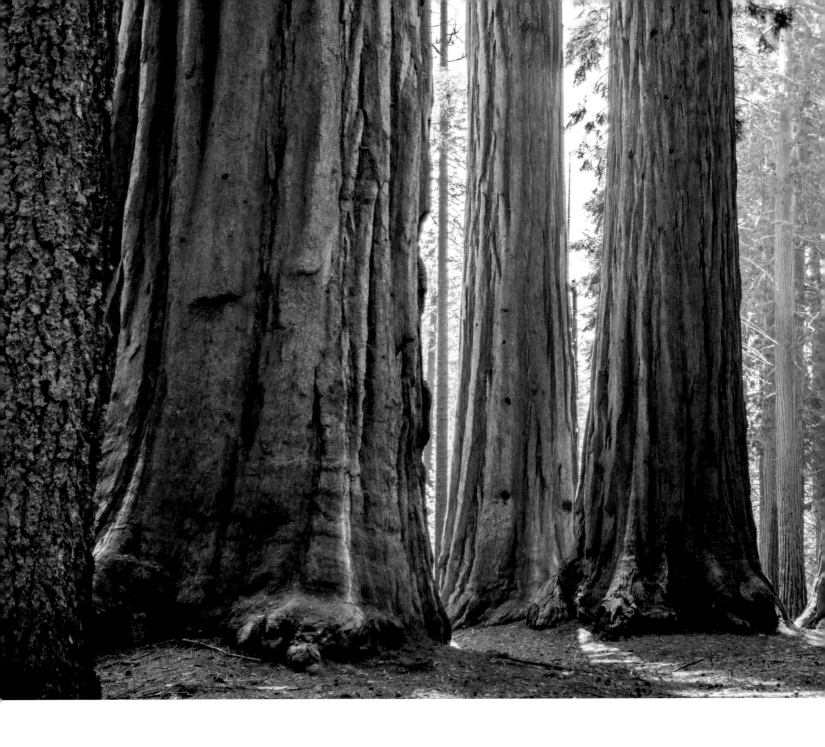

How to See

The range of the supersized giant sequoia is restricted to a small strip of the Sierra Nevada mountains in central California, accessible from either Bakersfield or Fresno (with Fresno having the best flight connections). You'll find millennia-old giant sequoias standing incredibly tall in Sequoia and Kings Canyon National Parks, and Giant Sequoia National Monument.

The scattered groves that make up Giant Sequoia National Monument can be accessed via various roads branching east from State Rte 99 between Bakersfield and Fresno. To reach Sequoia National Park, turn off State Rte 99 and follow State Rte 198 to Three Rivers; for Kings Canyon National Park, follow State Rte 180 east from Fresno to Grant Grove Village.

Linking the two parks, the Generals Highway scenic drive is lined with viewing points and short trails that take you within hugging distance of star sequoias such as General Sherman. For the best hiking in Sequoia National Park, try the Big Trees Trail in the evening or Crescent Meadow early in the morning (Crescent Meadow Rd cuts straight through the side of a fallen sequoia).

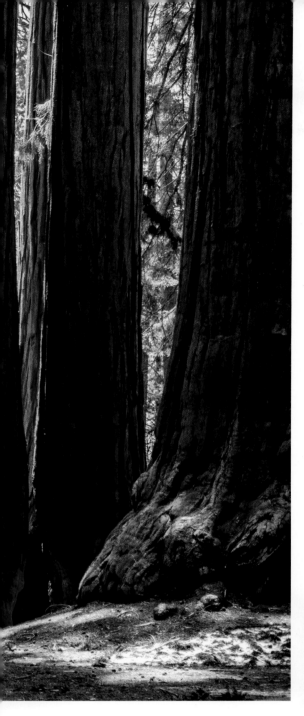

How to Identify

In comparison to the coast redwood, the leaves of the giant sequoia are slender and scalelike, with larger cones of 2in to 3in (5cm to 8cm) long. The bark is soft, fibrous and lightly reddish. In mature specimens the trunk is deeply fissured and remains broad a long way up, the lower branches shedding over time; its buttressed base can reach over 20ft (6m) in diameter. Young trees are conical in shape, with the crown maturing to more of an oval with age.

LEFT EXPERIENCE THE SCALE OF THE TREES IN SEQUOIA NATIONAL PARK;

BELOW YOU CAN ALSO DRIVE THROUGH NATIONAL PARKS OF THESE GIANT TREES;

OVERLEAF HWY 180 WINDS THROUGH KINGS CANYON NATIONAL PARK

WHEN

The Generals Highway is often closed in winter, and spring and fall can be damp or chilly in the mountains, so visit in summer, between June and August, monitoring the national park websites for wildfire warnings.

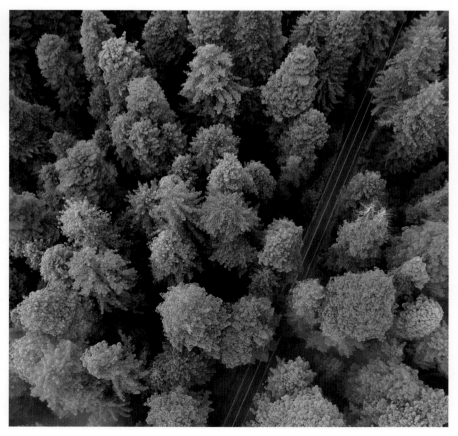

Jacaranda

Jacaranda mimosifolia

Vitals

RANGE
South-Central South America

STATUS
Vulnerable

LIFESPAN
<200 years

AVERAGE HEIGHT
25ft-50ft (7m-15m)

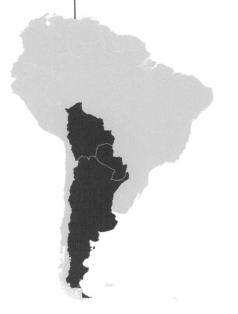

A TREE OF VIVID SPRING COLOUR, SOUTH AMERICA'S JACARANDA IS A SOURCE OF GLOBAL DELIGHT

Among the great many species enthusiastically employed as ornamental street trees, the blue jacaranda must be one of the most beloved of all. In warm and subtropical climates the world over, it enlivens monotone civic infrastructure with an unmatched vibrancy of flower, from the streets of Mexico City, San Diego and Barcelona to entire avenues in Funchal, Johannesburg and Sydney. In some cities – such as Australia's Grafton, in New South Wales – the arrival of the jacaranda's striking blossom is welcomed with annual festivities to rival even Japan's famous sakura (cherry blossom) celebrations, with jacaranda-inspired events that include parades, tree illuminations, concerts and food markets. For perhaps the most authentic experience, however, the spring blooms are best admired in a city a little closer to the tree's native territory: Argentina's Buenos Aires, where mature specimens of over 100 years old carpet the pavements with indigo petals each November. Here in the capital, jacarandas have been planted since the late 19th century; they are the city's symbolic tree, colouring its broad streets, parks and plazas in great swathes during spring and, come summer, offering valuable shaded respite from the high and humid heat of the day.

In contrast to this widely cultivated and naturalised distribution, where in some areas the jacaranda is even termed invasive, the species is sadly under threat in the wild. Native to parts of northwest Argentina, Paraguay and Bolivia, the upland forests in which it naturally grows are considered vulnerable to increasing agricultural clearance.

LEFT CYCLE THROUGH CENTRAL BUENOS AIRES WHEN THE JACARANDA TREES BLOSSOM

How to See

J mimosifolia can be found growing wild in warm temperate forests across Argentina and Bolivia, but its vibrant, blue-lilac flowers are most strongly associated with an urban setting: Ave Figueroa Alcorta in Buenos Aires, Argentina's tango-soundtracked capital, which explodes with jacaranda blooms in early summer.

Few sights capture the magic of Buenos Aires quite like heading out in the late afternoon for a stroll or drive along this landmark thoroughfare, with locals stepping out to enjoy a night of dancing at one of the city's *milongas* (tango events). Ave Figueroa Alcorta also connects many of the city's most famous landmarks, so there are more reasons to visit than just blossom spotting.

This signature street tracks the coast for 4.6 miles (7.4km) along the north side of Buenos Aires, linking the upmarket district of Recoleta in the east to the less showy Belgrano neighbourhood in the west. Along its length, you can stop in at the grand, neoclassical University of Buenos Aires Faculty of Law, the National Fine Arts Museum, the Latin American Art Museum of Buenos Aires (MALBA) and the Buenos Aires Japanese Gardens.

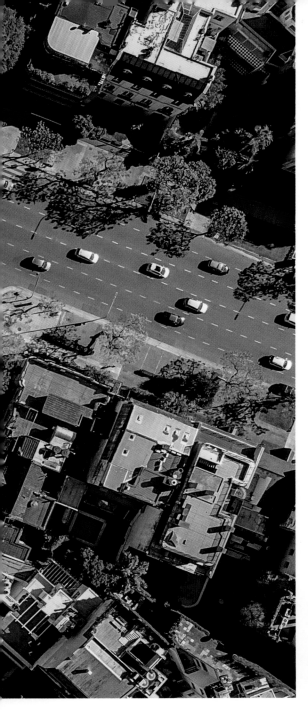

How to Identify

J mimosifolia forms a large deciduous tree with a dark grey trunk, arching branches and reddish twigs. Outside of blooming season, when it displays wisteria-like clusters of violet-blue, tubular flowers, the tree is identifiable by its large compound leaves which appear like feathers or the fronds of a fern (*mimosifolia* refers to its mimosa-like foliage). The tree produces round, semi-flattened seed pods in dusky brown, which contain multiple seeds encircled with a wing for wind distribution.

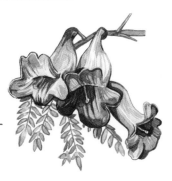

LEFT AN AERIAL VIEW OF A NEIGHBOURHOOD IN BUENOS AIRES IN SPRING;

BELOW JACARANDA BLOSSOM CAN LAST FOR UP TO TWO MONTHS, INTO EARLY SUMMER

WHEN

Buenos Aires' many jacaranda trees become a riot of purple-blue flowers during the South American summer, starting at the beginning of November. By December, the show is over, and the trees return to their more modest year-round raiment of bright green foliage.

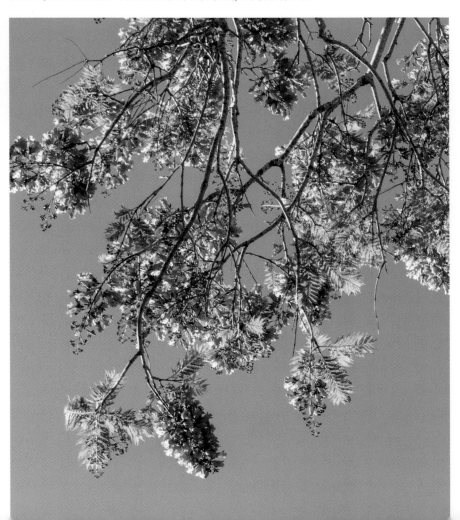

Ponderosa Pine

Pinus ponderosa

Vitals

RANGE

Western North America and Northern Mexico

STATUS

Least Concern

LIFESPAN

<500 years

AVERAGE HEIGHT

60ft-120ft (18m-37m)

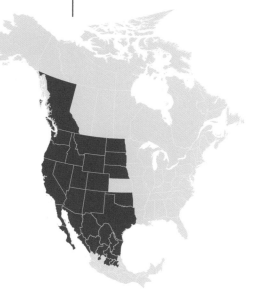

AN EMBLEM OF THE AMERICAN WEST, THIS ICONIC AND MULTI-DIMENSIONAL PINE STANDS AMONG THE CONTINENT'S TALLEST

Long before the Scottish botanist-explorer David Douglas encountered what's now western America's most commercially important pine, and committed its heavy, 'ponderous' wood to botanical nomenclature, the towering ponderosa was well-known among the Indigenous peoples of western North America. While the inner bark and nutritious nuts were consumed across its native range – which extends through all US states west of modern-day Nebraska – its arrow-straight trunk provided dependable timber for camp lodgepoles and dugout canoes. In fact, Indigenous knowledge of the latter offered a vital lifeline during what was perhaps the most famous of domestic American explorations into the Pacific Northwest. In 1805, when members of the Lewis and Clark Expedition were stationed on the banks of the Clearwater River and weakened with illness, Nez Perce peoples showed them the less-exertive boatbuilding technique of burning out ponderosa logs to make canoes. This was a momentous occasion in the early 19th-century unveiling of the 'American West'; an encounter in which – much like Francis Parkman Jr watching the Sioux source tent poles from the ponderosa pines of South Dakota's Black Hills (so named for the darkness cast by these conifers) – ancient knowledge was seen demonstrated upon one of the region's most significant trees.

Numerous natural variants make up the ponderosa's widespread range, including the Pacific, the Rocky Mountain and the Arizona ponderosa, which is prevalent in the dramatic setting of the Grand Canyon. They are united, however, in the attractively scaled yellow-orange bark that adorns their trunks, the height of which has been known to reach over 250ft (76m).

RIGHT PONDEROSA PINES SURROUND DEVILS TOWER, A NATIONAL MONUMENT IN WYOMING

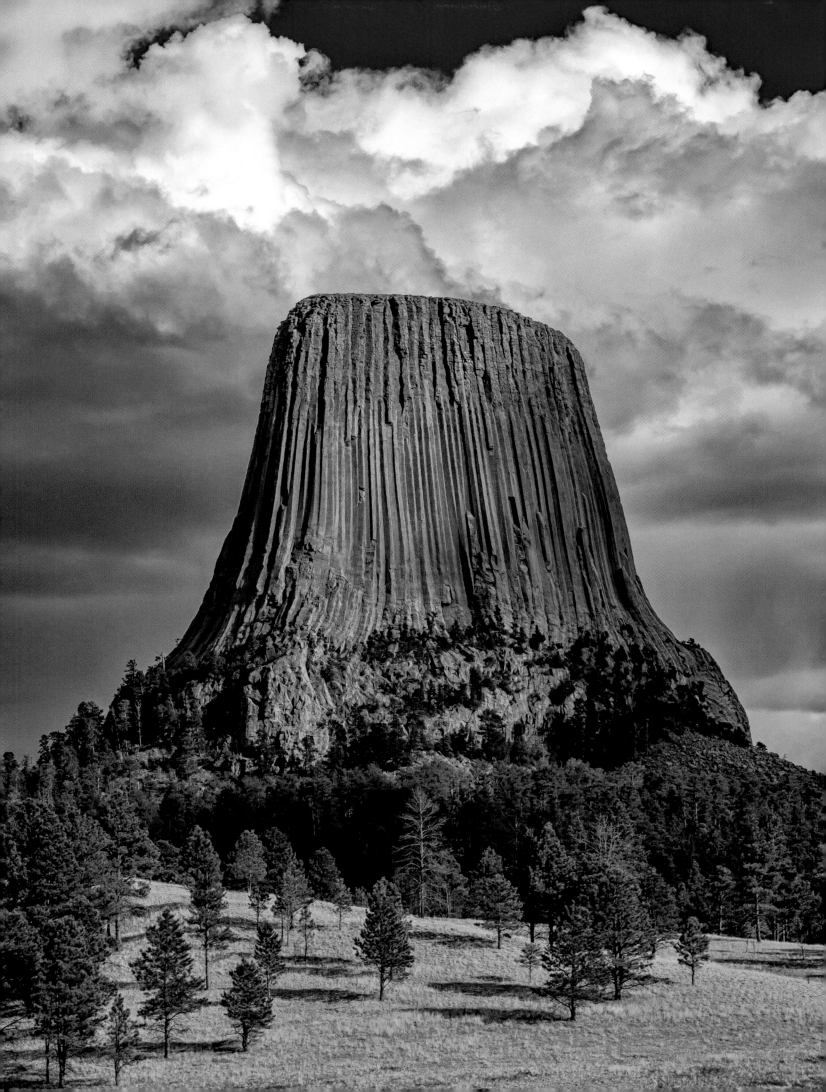

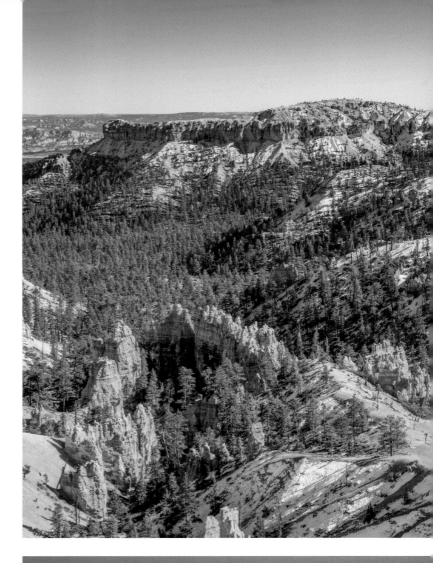

How to See

WHERE

The Ponderosa pine may be ponderous, but it's rarely lonesome. In its native ranges, this is the most widely distributed pine species in North America, and a celebrated symbol of the American West, particularly in Montana, where it's the state tree.

The good news is that there plenty of spots across the western United States where you can see ponderosa forests rising from the slopes of rugged frontier mountains. The vistas of green pines and grey rockfalls are particularly spectacular in the Black Hills of South Dakota – particularly if you follow Interstate 90 to Mt Rushmore and Devils Tower, just over the border in Wyoming.

For prime ponderosa country closer to the west coast, steer your packhorse towards Arizona. Easily accessible by hire car from Flagstaff, via Interstate 40 and State Rte 64 ,are the fragrant ponderosas forests of Grand Canyon National Park and quieter Kaibab National Forest (where you stand a better chance of being lonesome amongst the pines). Try Kaibab's 11-mile (18km) Sycamore Rim Trail for a satisfying mix of ponderosa forests and ridge-top lookouts.

WHEN

June to August sees peak crowds at top sights like the Grand Canyon and Mt Rushmore. Come either side of the summer crush in May or September and October and you can ponder the pines without having to make space for hordes of hikers.

TOP PONDEROSA PINES AND LIMESTONE HOODOOS IN BRYCE CANYON NATIONAL PARK, UTAH;

RIGHT A PONDEROSA PINE IN LASSEN VOLCANIC NATIONAL PARK'S STARK LANDSCAPE;

OPPOSITE RIGHT ADMIRE THE DETAIL OF PONDEROSA PINE CONES AND BARK

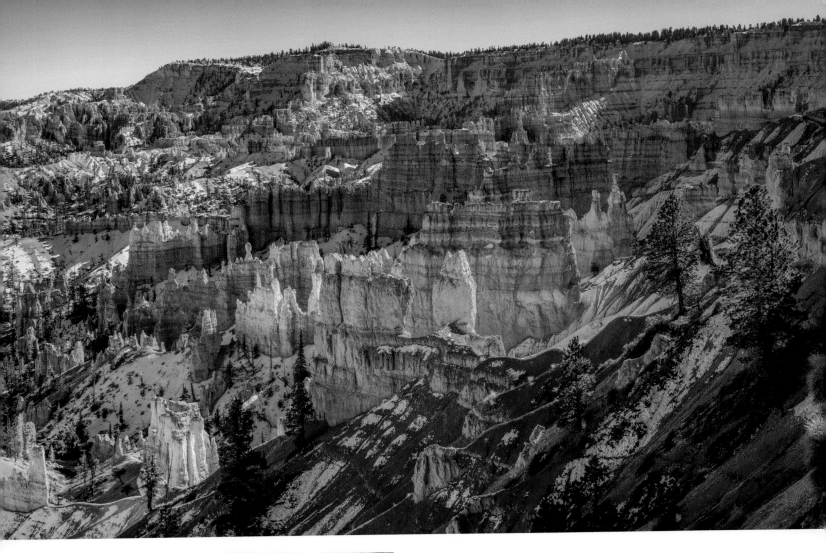

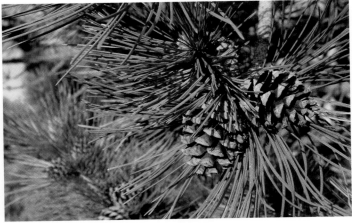

How to Identify

The most widely distributed – and most attractive – of western American pines, the ponderosa is also one of the largest pine species, surmounted only by the sugar pine, which lacks the distinctively thick, fissured, rust-coloured and vanilla-scented bark plates of the mature ponderosa. Its deep green needles are very long (4in-6in /10cm-15cm), typically bunched three (or sometimes two) to a fascicle, while the 3in- to 6in-long (8cm-15cm) cones bear stout prickles at the end of their scales.

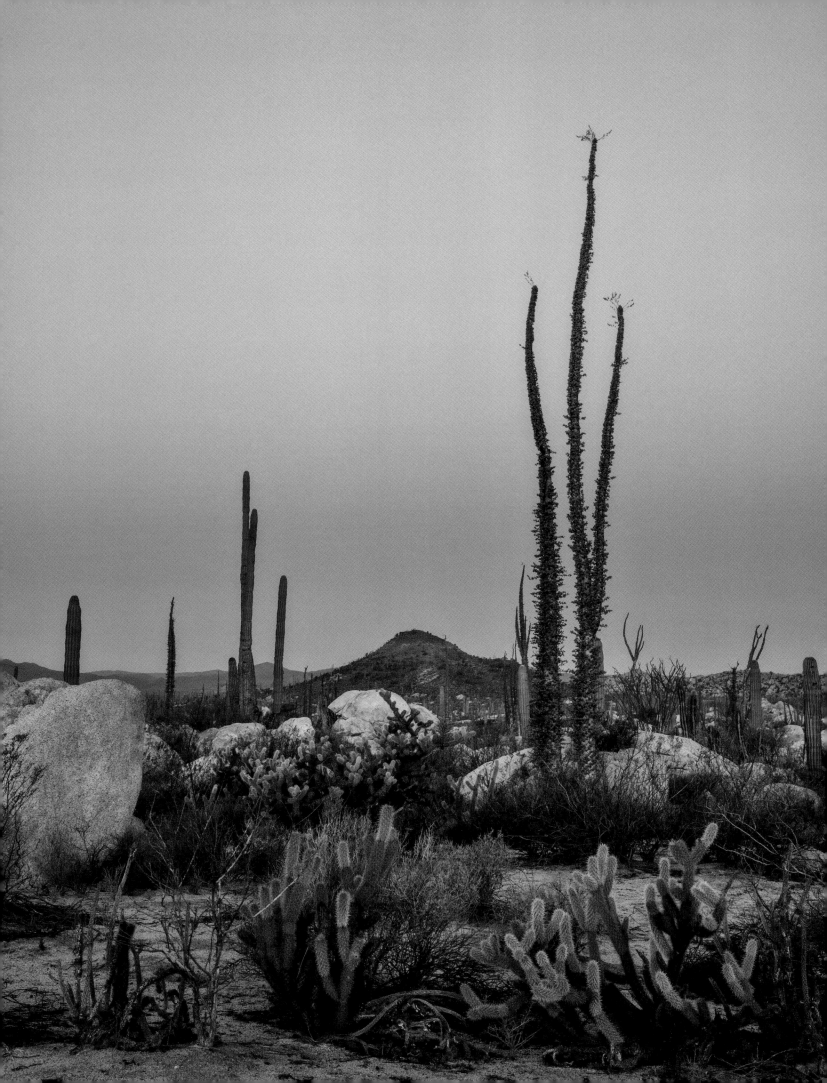

Boojum Tree

Fouquieria columnaris

Vitals

RANGE
Baja California, Mexico

STATUS
Vulnerable

LIFESPAN
<300 years

AVERAGE HEIGHT
50ft-60ft (15m-18m).

THE DESERT-DWELLING BOOJUM MIGHT BE THE WORLD'S MOST PECULIAR TREE, BUT IT'S ALSO ONE OF THE TOUGHEST

The desert is responsible for producing many of the world's strangest and most remarkable plants, from the Sonoran's barrel and saguaro cacti to the Mojave's angular Joshua trees. Perhaps the most compelling of all, however, can be found along northern Mexico's Baja California peninsula: the boojum, a towering tentacle of a tree that more closely resembles a fibrous taproot protruding from the ground than a sylvan specimen. Native to a slim central region of this hot and dry but sea-fog-misted environment (and an even smaller tract of the western Sonoran across the Gulf of California), the tree bears a local name of cirio, meaning 'candle' – a resemblance all the more apparent when summer flowers colour its trunk-tip flame yellow.

The boojum's columnar trunk is almost its sole feature, seen growing out from arid hillsides at bizarre angles, and clothed in short, bristled, thorn-covered branches. Irrigated in part by sea fog, its wood is succulent-like in its capacity to absorb and store water – the primary concern of all desert dwellers. But it is with the strategic conservation of energy that the boojum triumphs in the desert, balancing periods of active growth with instances of dormancy across the seasons. When the heat extremes of summer set in, the leaves are shed, limiting water loss; they will reappear after sufficient rain in the cooler months that follow. The downside? Astonishingly slow growth – boojums are in no hurry. It's estimated that these curious trees put on a meagre 1in to 2in (2.5cm to 5cm) of height per year.

LEFT BOOJUM TREES AT SUNSET IN VALLE DE LOS CIRIOS, BAJA CALIFORNIA, MEXICO

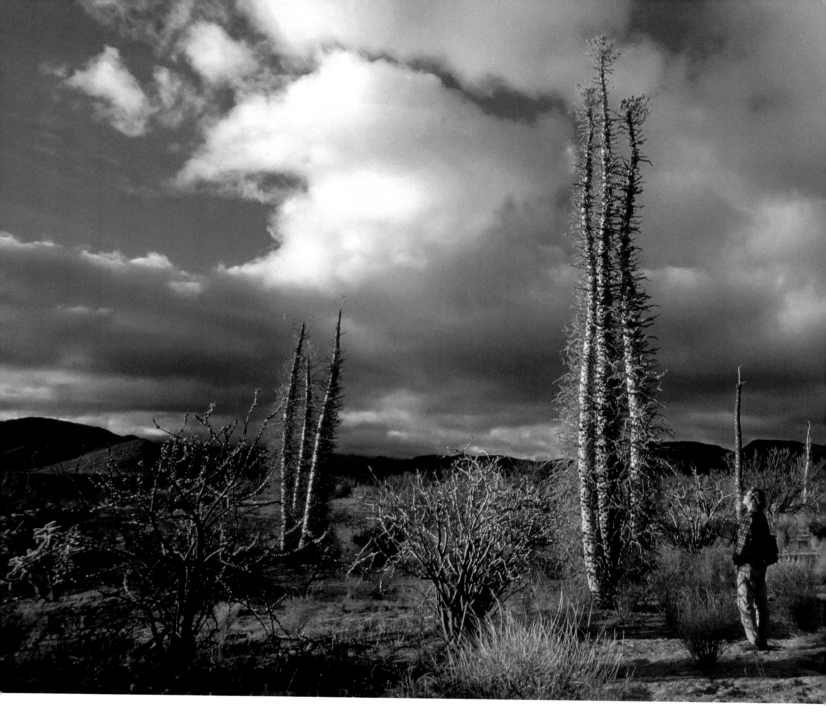

How to See

An otherworldly desert deserves an otherworldly tree. In Baja California, that tree is the boojum, which looks like a collection of cactuses got together and stacked themselves into a tree shape just to confuse passers-by. The curving shapes of boojum trees rise sculpturally over the desert all along the peninsula, with smaller stands across the gulf in Mexico's Sierra Bacha mountains.

The tallest boojum specimens are found in the Valle Montevideo, between Bahía de los Ángeles and Misión San Borja, but the densest stand of boojum trees lies in the Valle de los Cirios, a short drive off Hwy 1 to the north of Bahía de los Ángeles. The easiest way to get here is on a tour or with a rented vehicle; carry food and plenty of water, plus sunscreen and a hat – this is proper desert country!

To see boojum trees up close, the 6-mile (10km) Sendero Valle de los Cirios hiking trail gives an impressive overview of the valley, with boojum trees and cardon cactuses creating alien shapes against the intense blue of the sky. Pick up the trail just north of Cataviña.

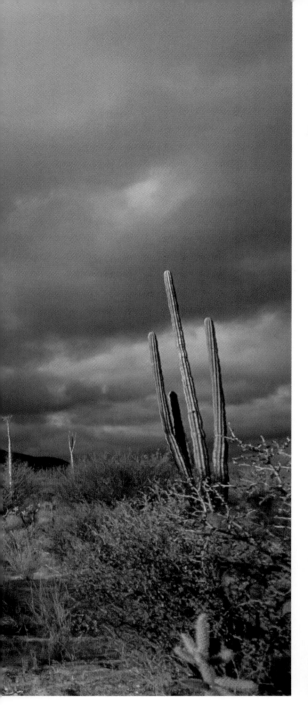

How to Identify

Beginning life as a dense bush, the boojum develops a rough, conspicuously grey-white trunk which can be both erect (rising up to 70ft/21m) and dramatically arched, and both single-stemmed or branching. This trunk is comprehensively clad with short, very straight thorny branches, bearing fleshy yet thin oval leaves in glaucous green and yellow. Leaves are shed during periods of drought. Summer flowers in yellow-orange bloom in stalked clusters at the trunk's tip.

LEFT FLOWERING BOOJUM TREES IN BAHÍA DE LOS ÁNGELES, BAJA CALIFORNIA;

BELOW A BOOJUM TREE'S TRUNK CAN STORE WATER AND SMALL LEAVES LIMIT WATER LOSS

WHEN

The summer heat in Baja can be stifling and hurricanes are a risk from July to September, but August and September are the best months to catch the boojum trees in bloom, with alien-looking inflorescences emerging from their trunks.

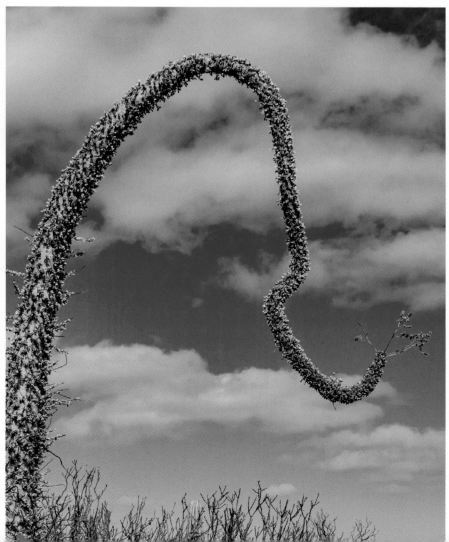

Western Redcedar

Thuja plicata

Vitals

RANGE
Pacific Northwest, Canada and USA

STATUS
Least Concern

LIFESPAN
<1000 years

AVERAGE HEIGHT
150ft-220ft (46m-67m)

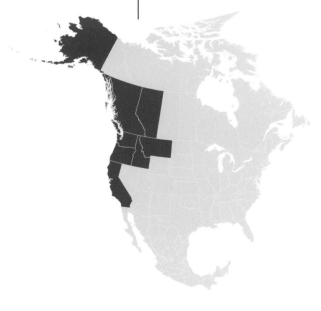

A LEGEND IN A LAND OF GIANTS, THE LAUDED WESTERN REDCEDAR IS FAR MORE THAN A STATISTIC

It's fitting that the western redcedar has been adopted as a provincial symbol of British Columbia. Here in the lush upper Pacific Northwest, where the fertile soil and frequent rain produces coniferous behemoths reaching over 300ft (91m) in height, the Sitka spruce and the Douglas fir might grow taller, but the Western redcedar is a provincial treasure. To the region's Indigenous Coast Salish peoples, it has long been regarded a cultural wellspring of a tree, borne of a Great Spirit and considered a great friend by many: to stand in its presence, to lean against its trunk, is to gain strength. For utility, in practices ancient and contemporary, it is unmatched: a source of clothing, tools, cooking utensils, boats and paddles to the Salish, its roots crafted into baskets, its bark fibres into rope. Today, the easily split, straight-grained and aromatic wood is favoured as construction cladding, the robust timber proving long-lived and naturally rot resistant owing to preservative compounds present in the wood.

As a species, the western redcedar remains abundant, as its shade-tolerant seedlings develop with ease on the forest floor. However, ancient old-growth specimens have historically been threatened by extensive forestry logging and these precious relics must continue to be championed. Among those growing in a stretch of temperate rainforest on Vancouver Island is the Cheewhat Giant, Canada's largest tree by trunk volume. Testament to the ruggedness of this remote and wild stretch of forest, this vast specimen, with a trunk spanning 20ft (6m) in diameter, was only officially identified in 1988: estimates suggest it has thrived here, unhampered, for well over a millennium.

RIGHT A WESTERN REDCEDAR ON THE CANOE CREEK GIANT CEDAR TRAIL IN BRITISH COLUMBIA

Alerce

Fitzroya cupressoides

Vitals

RANGE
Chile and Southern Argentina

STATUS
Endangered

LIFESPAN
<4000 years

AVERAGE HEIGHT
130ft-150ft (40-46m)

A CONTENDER FOR BOTH THE LARGEST AND OLDEST TREE SPECIES IN SOUTH AMERICA, THE ALERCE IS PATAGONIA'S ANSWER TO THE GIANT SEQUOIA

Encountering a Patagonian alerce for the first time, in the lush temperate rainforests of coastal Chile, the temptation might be to compare it to other conifers. There are certain resemblances: in its soaring height, wide girth and reddish-ness of bark, there is an echo of California's redwoods; in the elegant swoop of its airy branches something of the European larch (indeed 'alerce' is Spanish for larch). The compact leaves could be confused with those of the juvenile juniper, and its closest relation is the cypress, evident in the diminutive cones that dangle at the leaf terminals. And yet, the alerce is wholly unique, the sole surviving member of an ancient and all but expired genus of trees: a species that continues to both excite and baffle naturalists.

Bathed in coastal rain, sulphurous-green with moss and lichen and bearing a trunk as craggy as a cliff face, South America's giant larch is a noble national treasure that's lamentably overshadowed on the global stage by the sequoia. However, the tree recently revealed its trump card. An innovative 2022 study of Chile's largest alerce – Gran Abuelo, the 'great-grandfather' tree – has led scientists to reconsider just how ancient these trees really are. Formerly estimated at just over 3500 years of age, Gran Abuelo is now thought to be closer to 5400 years, making it the oldest living tree in the world – topping California's Methuselah bristlecone pine (see page 54) by some 500 years. It's hoped that such special status will further aid efforts to conserve this precious species, long-threatened by deforestation.

LEFT LOOKING UP AT ALERCE TREES IN PUMALÍN DOUGLAS TOMPKINS NATIONAL PARK, CHILE

How to See

Just as North America has the giant sequoia and the coast redwood, so South America has the alerce. Stands of *F cupressoides* were once found all over South America, but today the largest tree species south of the Darien Gap only survives in pockets of ancient woodland in the Chilean and Argentinian Andes and along Chile's coastal plain.

Without doubt, the best place to view these long-lived behemoths is Parque Nacional Alerce Costero, high in southern Chile's Cordillera Pelada. The town of Valdivia has the closest airport, and buses can transport you the 52 miles (83km) to La Unión, where you can charter a private 4WD to cover the final 30 miles (49km) to the reserve.

Various trails start from near the Corporación Nacional Forestal ranger station at Los Altos del Mirador in the Reserva Costera Valdiviana, the coastal nature reserve fringing the national park. From the T-80 access road, you can hike along the 3-mile (4.8km) Sendero Alerce Milenario to view the single biggest tree in the park, the Gran Abuelo; some 197ft high (60m) and with a 14ft (4.26m) diameter, it may have sprouted 5000 years before Ferdinand Magellan reached the shores of Chile in 1520

How to Identify

This tall-growing evergreen has a large, often buttressed trunk that can exceed 9ft (2.7m) in diameter; its reddish-brown bark is fibrous and runs in fissured strips. Branches are rough, displayed horizontally or in a drooping formation, and are often mossy in coastal rainforests. The young leaves are very short and arranged in whorls of three, streaked under-leaf with two white lines, and become scaly as they age. Cones are small and mostly solitary. As with many ancient conifers, the crown can become splintered and uneven with age.

LEFT THE SPECTACULAR LANDSCAPE OF LOS ALERCES NATIONAL PARK IN ARGENTINA;
BELOW DISCOVER 2000-YEAR-OLD ALERCE TREES ON THE SENDERO LOS ALERCES IN
PUMALÍN DOUGLAS TOMPKINS NATIONAL PARK, CHILE

WHEN

Roads into and around the park are mostly unsurfaced, making visiting a spring and summer activity – during the southern hemisphere autumn and winter, rain and snow can make access impossible. To be safe, come by 4WD at any time of year.

Joshua Tree

Yucca brevifolia

Vitals

RANGE

Southwest USA to Northwest Mexico

STATUS

Least Concern

LIFESPAN

<150 years

AVERAGE HEIGHT

20ft-40ft (6m-12m)

THOUGH IT CASTS AN UNGAINLY FIGURE, THE JOSHUA TREE PERSONIFIES THE DESERT: RESILIENT AND ARMOURED, YET FLEETINGLY BEAUTIFUL

Like the great majority of desert flora, the Joshua tree is a product of its native environment. Long before *Y brevifolia* gave its widely familiar common name to a national park (and to one of the best-selling rock albums of all time), the arid conditions of the Mojave Desert shaped its unwieldy, otherworldly physiology: a fibrous, water-storing trunk; shallow roots that spread a great distance; and needle-sharp leaves – pointed skyward to redirect rainfall – that form defensive evergreen spears around its spring blooms. All of this is to say that, among trees, the Joshua is no graceful beauty. Then again, it isn't technically a tree, rather 'tree-like' – the largest among many species of yucca, a genus of succulent plants more readily associated with mountainside scrubland and cossetted conservatory houseplants.

So synonymous is the Joshua tree with the Mojave that its presence is an indicator of this distinct environmental region, which lies predominantly within southern California but extends into Nevada, Arizona and Utah. So the story goes, it was Mormon pioneers, travelling through this most testing of landscapes – where summer temperatures typically exceed 38°C (100°F) – who attributed the name 'Joshua'. They saw in the tree's humanoid limbs something of the biblical Joshua, with arms raised to the heavens: an encouraging sign amid the barrenness of the desert. Divine inspiration notwithstanding, there is divinity aplenty in the monumental blooms that occur following the favourable conditions of a cold winter with good rainfall: great clusters of white flowers in 20in-long (50cm) panicles, opening at night for pollinating yucca moths.

RIGHT THANKS TO THE EFFORTS OF LOCAL RESIDENT MINERVA HOYT, JOSHUA TREE NATIONAL MONUMENT WAS ESTABLISHED IN 1936 AND IT WAS MADE A NATIONAL PARK IN 1994

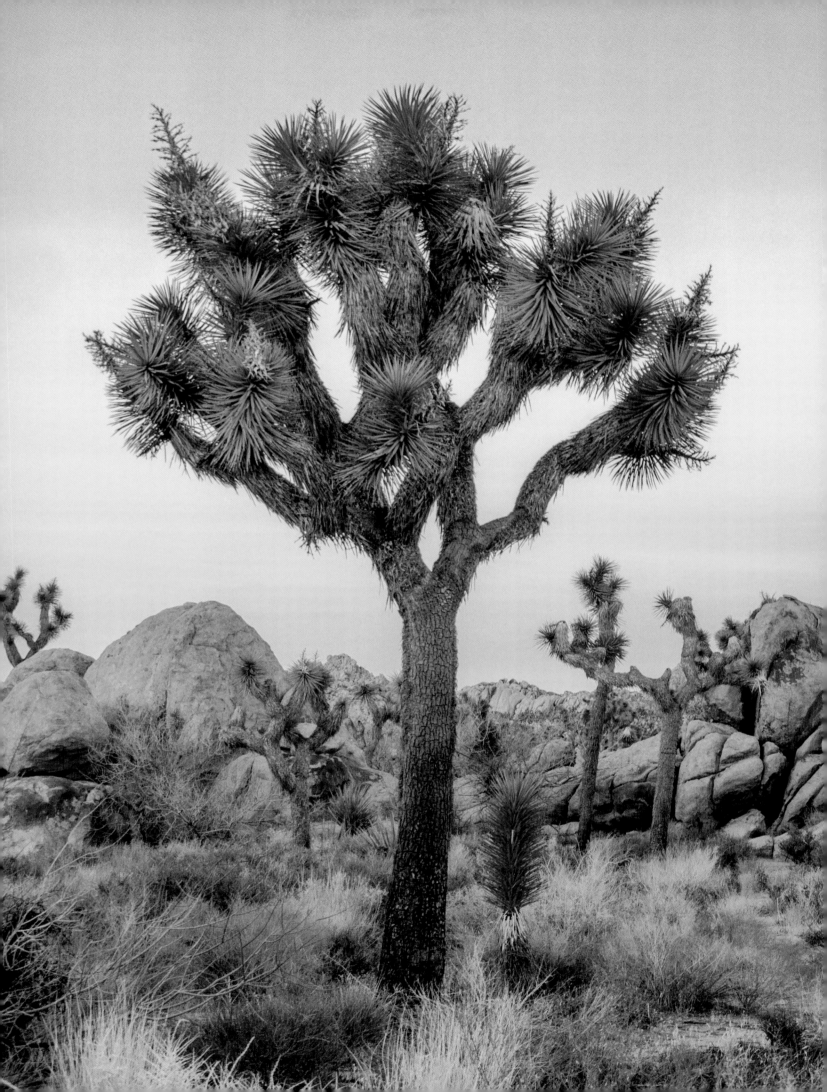

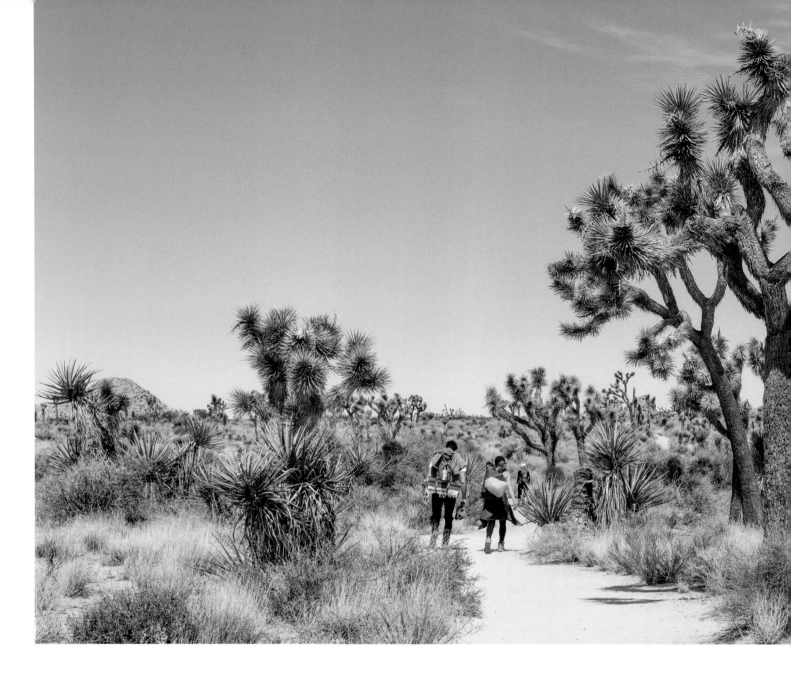

How to See

WHERE

The US National Park Service provides a handy hint to where you might find Joshua trees in the form of the wonderful Joshua Tree National Park in California, but these remarkable yuccas are found in pockets all over the Mojave Desert, from southern Nevada to western Arizona. If you can't get to California, following US Rte 93 through Arizona comes a close second.

But California is the location most strongly associated with the Joshua tree (and where U2 came for their famous album cover shoot in 1986), and Joshua Tree National Park is this celebrity yucca's most iconic home. Finding the national park is easy; coming by road from either Los Angeles or Palm Springs, follow Interstate 10 and turn off onto Hwy 62.

The best Joshua tree viewing is in the northwest of the park, along Park Blvd and Keys View Rd. For a shorter driving time from LA, head north to view the scattered Joshua trees in Saddleback Butte State Park near Lancaster (follow State Rte 14 north, then branch east).

WHEN

March to May and October to November are optimal times to visit the Mojave Desert: you'll avoid the pizza-oven temperatures of high summer, and the somewhat chilly nights of mid-winter. Joshua trees flower erratically – blooms are most likely from April to May, but with climate change, this can be earlier.

How to Identify

Found in the company of hardy pinyon pines and California juniper, mature Joshua trees are distinctive in their uneven, somewhat jagged appearance. Like the saguaro cactus, they remain a single stem for some years before branching off at odd angles following the blooming of their cream-white flowers, resulting in a unique and distinctive shape. Bayonet-shaped and bunched at the ends of the branches, their deep-green, serrated leaves are stout compared with other yuccas (*brevifolia* means short-leafed).

LEFT HIKE THE BOY SCOUT TRAIL IN JOSHUA TREE NATIONAL PARK, PERMITS REQUIRED FOR CAMPING; BELOW LEFT JOSHUA TREES ARE AFFECTED BY DROUGHT WITH FEWER SEEDLINGS SURVIVING; BELOW BE SPELLBOUND BY THE SUNRISE IN JOSHUA TREE NATIONAL PARK

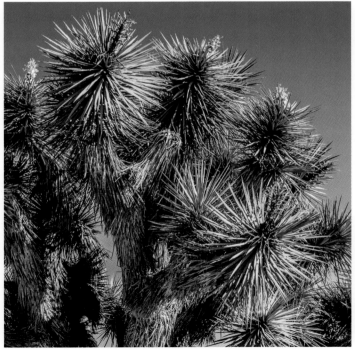

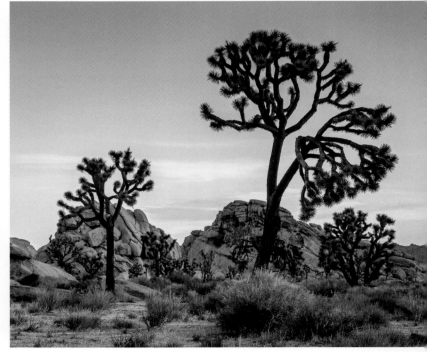

Asia

Black Mulberry

Morus nigra

———

Vitals

RANGE
Western Asia

STATUS
Unclassified

LIFESPAN
<250 years

AVERAGE HEIGHT
25ft-30ft (7.6m-9m)

ITS FRUIT DEVOURED YET ITS ANCIENT ORIGINS UNCERTAIN, THE MULBERRY HAS BECOME A BELOVED GARDEN STAPLE

A lesser-known blunder in the history books of Britain is the attempt, by King James I, to establish a silk plantation in England during the early 17th century. In the event, the thousands of trees he had planted across the country were the wrong species – the silkworm, from which silk is derived, thrives on the leaves of the white mulberry, rather than the black. Nonetheless, a happy outcome was the introduction of a tree that would become a favoured fixture of Britain and Western Europe, its fruit all the more delectable than the white mulberry, the tree itself a cherished ornamental.

This debt of beauty and bounty alike is owed to western Asia, where it's thought the black mulberry might have originated, likely in the region of the former Persian Empire, though its specific native range has been lost in the mists of time. Today, mulberries remain culturally significant in the area, including in Armenia, where they're planted domestically as a symbol of good neighbourly relations, and their stout frame is a regular sight in towns and cities as a street and parkland tree. Widely enjoyed in sweet pastries, jams and syrups, the fruit is also used to make a strongly alcoholic Armenian spirit known as *oghi*.

As a garden tree, the black mulberry is among the most revered. Its bark ages almost prematurely, showing gnarls and fissures that give it a veteran look, while its autumn leaves, softened to velvet, turn an eye-catching golden yellow.

RIGHT THE BLACK MULBERRY IS NATIVE TO ASIA BUT HAS SPREAD TO EUROPE AND NORTH AMERICA

How to See

To go around the mulberry tree in real life, head to Armenia. Mulberries are grown widely in Mediterranean Europe, North Africa, the Middle East and the Indian subcontinent, but the mulberry plays a special role in Armenian culture, where mulberries are celebrated as a symbol of fertility and grown to nourish both humans and silkworms – part of a silk-producing tradition dating back 1500 years in the Caucuses.

Fly into Yerevan during the harvest season and you'll see mulberry stalls in the streets and trees laden with berries dotted around the city streets. For the full mulberry experience, though, head to the Syunik region in the far south of Armenia, where the village of Karahunj near the regional town of Goris hosts a lively mulberry festival in July, with singing and dancing and all sorts of mulberry-based eatables and drinkables.

Using Goris as a base, you can roam into the countryside by hire car or chartered taxi to see farms growing black, red and white mulberries on the outskirts of surrounding villages. If you time your visit right, in the late spring or early summer, you can observe the harvest, when workers shake the berries off the trees onto tarpaulins.

WHEN

The main months of the mulberry harvest season in Armenia are May and June, leading up to fun-filled mulberry festivals in July. However, mulberry treats – from dried berries to mulberry vodka – are sold year-round.

ABOVE AN OLD BLACK MULBERRY, SOME OF WHICH LIVE FOR 500 YEARS OR MORE;

RIGHT BLACK MULBERRY FRUIT ARE RICH IN VITAMINS AND IRON, EVEN FOR BIRDS;

OPPOSITE RIGHT THE BARK OF THE BLACK MULBERRY CAN HAVE BURRS AND FISSURES

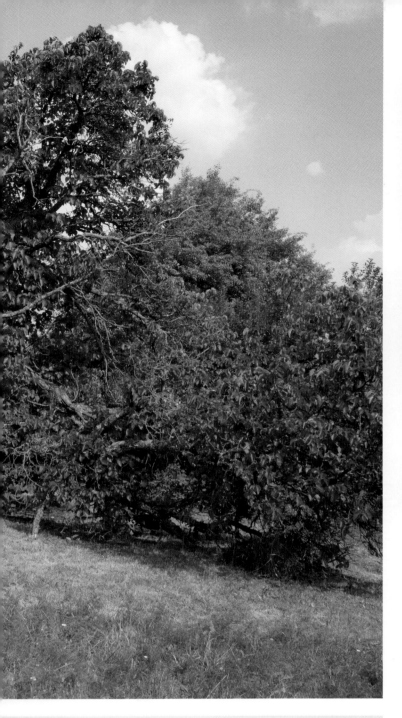

How to Identify

As broad – if not broader – than its height, the black mulberry supports a heavy crown on a squat and muscular orange-brown torso. Leaves are large, coarse and oval to cordate (heart-like) in shape, toothed at the edges. In autumn they become a striking yellow before shedding. The sweet, juicy fruit deepens from scarlet to rich purple in late summer, attracting a diversity of birdlife wherever the tree is grown.

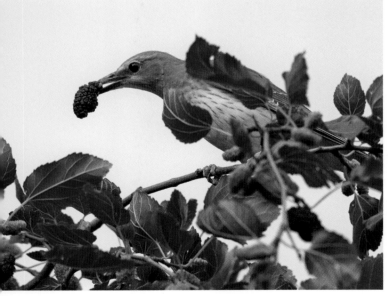

Tree Rhododendron

Rhododendron arboreum

Vitals

RANGE

China, India, Myanmar, Nepal, Sri Lanka, Pakistan, Vietnam and Thailand

STATUS

Vulnerable

LIFESPAN

<100 years

AVERAGE HEIGHT

30ft-70ft (9m-21m)

PAINTING MOUNTAINOUS REGIONS RED DURING THE SPRINGTIME, THE RESILIENT RHODODENDRON BRINGS BRIGHT COLOUR TO THE HARSH HIMALAYA

Commonly known as the tree rhododendron, *R arboreum* is a small evergreen that thrives in high-altitude areas. It grows across the Indian subcontinent, in particular the hills and mountains of the Himalaya, and holds great cultural significance in the countries of its endemic range. In Nepal, for example, where hillsides are coloured red during the blooming season, the tree rhododendron – known locally as lali gurans – is celebrated as the national flower and is a folkloric symbol of beauty and resilience. Over the Nepalese border in the northern Indian state of Uttarakhand, *R arboreum* is the state tree, and it is also the state flower of Nagaland in northeastern India.

The tree rhododendron's floral clusters consist of bell-shaped flowers held together in a truss, sometimes bearing up to 20 blossoms that can range in colour. Deep-crimson red is the most typical shade for *R aboreum* blooms, although colours can vary to pale pink or white according to both soil acidity and the growing conditions at different altitudes, with the crimson blooms appearing at lower elevations. Peak flowering usually takes place between February and April, when the harvesting and collecting of the blooms takes place; tree rhododendron garlands are then used to decorate shrines and doorways of temples and other religious sites, as well as featuring prominently in festivals and celebrations across the country. The flowers of *R arboreum* are also used to make jams, jellies and a local drink, taken as a refreshing appetizer or for its ability to help to prevent altitude sickness.

LEFT RHODODENDRONS FLOWERING IN THAILAND'S HIGHLANDS

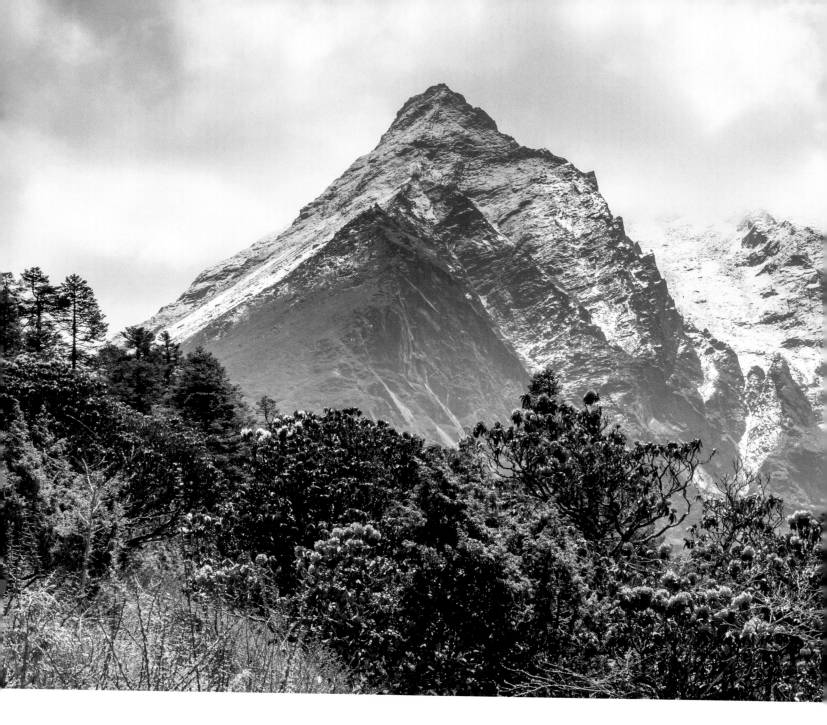

How to See

WHERE

Loved by gardeners and owners of grand European houses, the rhododendron is the signature tree of the Himalayas. Indeed, this famous belt of snowcapped mountains is where many owners of those country mansions first picked up the rhododendron habit. Understandably, travellers to India and Nepal wanted to bring a little of this uplifting mountain wonderland home with them, and so the first European rhododendron gardens were born.

Seeing rhododendrons in their native hills is something else entirely. In central and eastern Nepal, whole mountainsides are covered in rhododendron forests, which bloom in waves as the spring temperature hits the sweet spot for flowering at each elevation. Some thirty species are found here, and pretty much every high-altitude trekking trail passes through at least one section of rhododendron forest en route to the snowline.

Some routes serve up more rhododendrons than others; the easy, four- to five-day trek from Ghorepani to Poon Hill in the Annapurna Range is a rhododendron-spotting bonanza. Further east, the treks to Kanchenjunga Base Camp and Makalu-Barun National Park pass through beautiful rhododendron forests well off the tourist circuit.

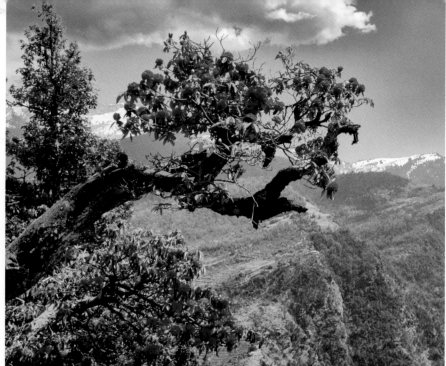

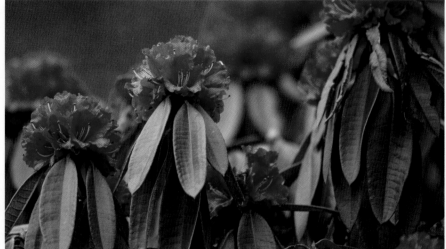

WHEN

Spring is the season to see
rhododendron trees burst into
a riot of red, pink, purple and
white blooms. February to April
is flowering season, but the exact
timing depends on the elevation
and weather, with trees at lower
altitudes flowering first.

ABOVE RHODODENDRON TREES FLOWERING AGAINST NEPAL'S HIMALAYAN

MOUNTAINS; TOP RIGHT THE TREE RHODODENDRON IS THE LARGEST SPECIES;

LOWER RIGHT THE NECTAR OF SOME RHODODENDRONS CAN BE TOXIC

How to Identify

This evergreen tree typically grows in a shrub-like shape,
usually to around 40ft (12m) high – although heights of up
to 70ft (21m) are not unusual. The trunk is reddish-brown
in colour, usually smooth, and is typically hidden by bushy
growth. Dark green elliptical leaves measure 3in to 7in (8cm
to 18cm), and are firm and leathery to the touch. Clusters of
bell-shaped flowers bloom in late winter to early spring.

Ginkgo

Ginkgo biloba

Vitals

RANGE
China

STATUS
Endangered

LIFESPAN
<2000 years

AVERAGE HEIGHT
65ft-110ft (20m-33m)

THE GINKGO IS A SURVIVOR, OUTLIVING THE DINOSAURS TO BECOME ONE OF THE WORLD'S MOST ADORED ORNAMENTALS

To place this most beloved and idiosyncratic of trees within Asia is to date it to a particular and more recent epoch, for in millennia past, the ginkgo ranged across a far wider intercontinental realm than the mountainous forests of China in which it grows wild today. In fact, the ginkgo is one of the Earth's oldest surviving trees, with related species dating as far back as the Jurassic era. Leaves fossilized in the Eocene, which lasted until 34 million years ago, are notably similar to those of the single surviving species, *G biloba* – and what a leaf this is. *Biloba* – two-lobed – denotes its distinguished anatomical form, a leaf shape all but exclusive to this tree and the dainty maidenhair fern, *Adiantum* (hence the ginkgo's often-used common name, maidenhair tree). Bearing antioxidant qualities, the leaves are used to make a medicinal extract that's taken to aid memory – but it's in autumn that they demonstrate their most spectacular quality. Though the ginkgo is a gymnosperm, and is therefore more closely related to conifers, its fall colour rivals the best of the broadleaves, flaring a rich and bright yellow from top to bottom before the leaves float to the ground

Veteran examples of *G biloba* demonstrate that this not just a long-surviving species. London's Kew Gardens boasts one of the UK's oldest known examples, planted in the mid-18th century, but there are specimens in China thought to be over 3000 years old. Recent studies have attributed this longevity to protective chemicals in the tree that remain as present in very old specimens as in young, preserving natural vitality.

RIGHT A GINKGO TREE IN GYEONGJU, SOUTH KOREA, WHERE IT IS WIDELY DISTRIBUTED

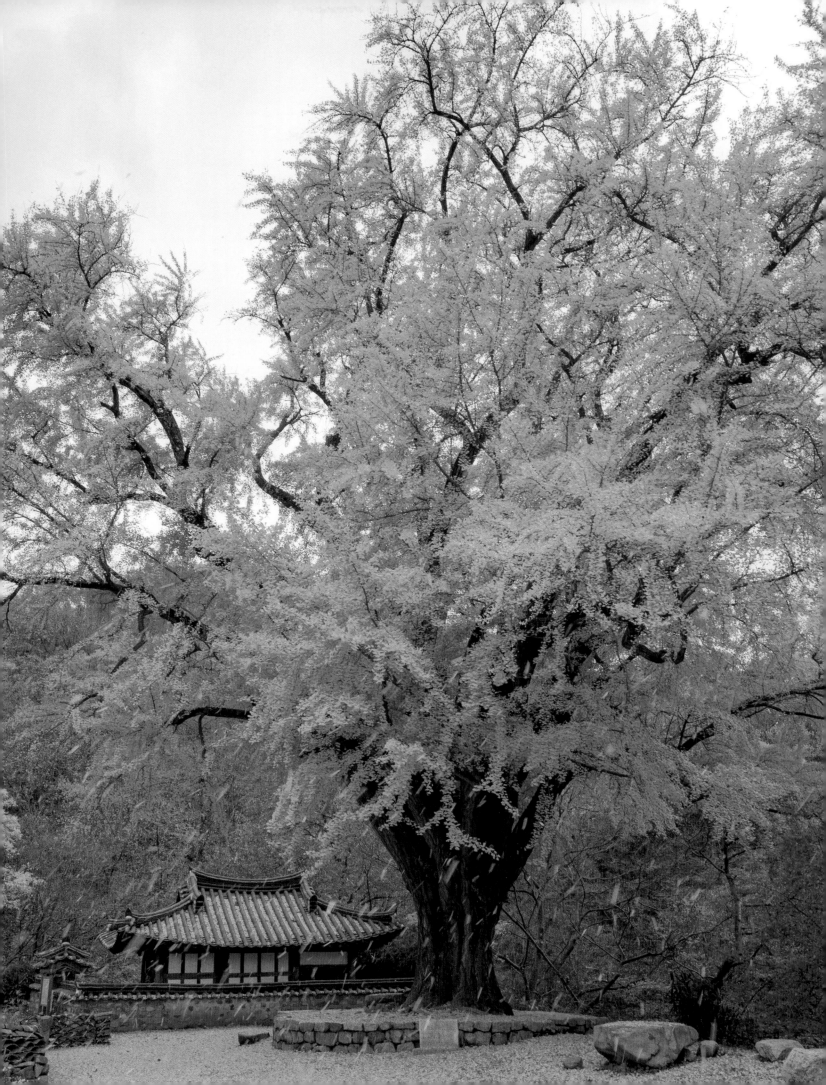

How to See

View the elegant ginkgo trees of China, Japan and Korea from afar in their yellow autumn raiment and you'll wonder why people don't plant more of these eye-catching, primordial trees outside of East Asia. The beauty comes with a catch, though; those who plant female ginkgo trees must contend with the plum-like fruit, which are pungently fragrant, bringing the smell of vomit vividly to mind.

In the Chinese tradition, however, the ginkgo is a symbol of resilience, healing and long life, and you'll find these trees widely planted in city streets and temple gardens. The colossal, 1400-year-old ginkgo at Shengshui Temple in Rongcheng in Shāndōng Province fills the temple grounds with yellowy fallen leaves every autumn, triggering a flurry of photos and drone videos on social media.

Rongcheng lies at the tip of a peninsula jutting out into the Yellow Sea southeast of Beijing; get here by train from Yantai or Qingdao, the nearest cities with airports and major rail hubs, and travel to the Shengshui Temple by taxi. There are more memorable ginkgos in Shāndōng at Wufeng Mountain in Jinan city and Dinglin Temple in Rizhao, on the east coast south of Qingdao.

WHEN
China's *G biloba* are at their most glorious in autumn, from October to November, when the trees change from green to brilliant yellow and fallen leaves carpet the ground beneath.

RIGHT STROLL DOWN LIANGZHOU GINKGO AVENUE IN NANJING, CHINA;

OPPOSITE BILOBA REFERS TO THE TWO LOBES OF THE GINKGO LEAF

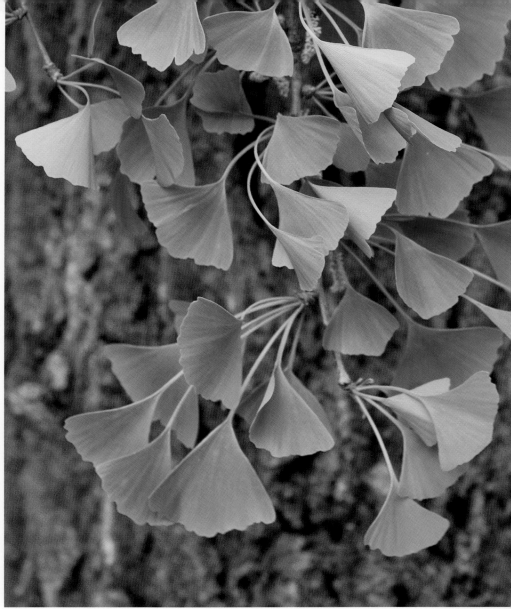

How to Identify

The ginkgo is a large tree with a grey-brown trunk that
fissures with age; its crown is loose and often irregular in
shape. Ginkgos are dioicous, meaning they are either male or
female: as the spherical, crab-apple-like fruit of the female is
offputtingly pungent, those planted as street trees tend to be
male, bearing light-green pollen cones. The green leaves are
fan-shaped, divided into two lobes – and sometimes more –
turning a vibrant yellow in autumn.

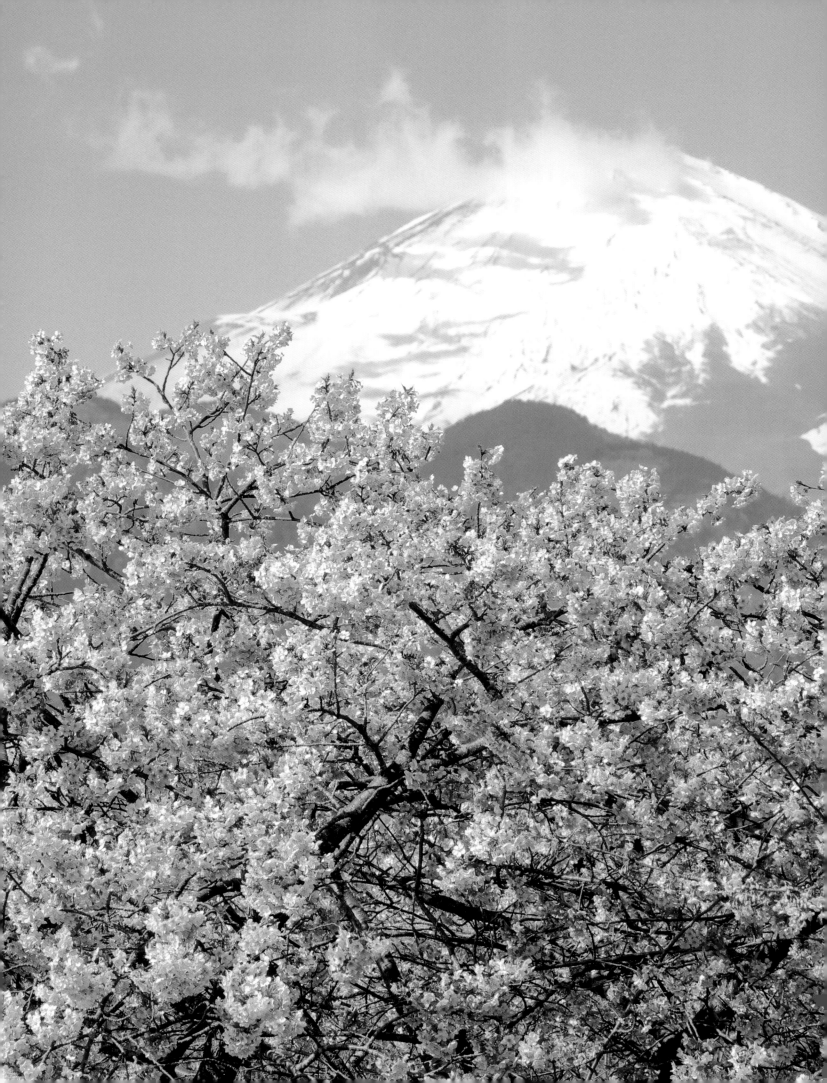

Cherry

Prunus serrulata

Vitals

RANGE

Japan, China, Vietnam and North and South Korea

STATUS

Least Concern

LIFESPAN

<25 years

AVERAGE HEIGHT

20ft-50ft (6m-15m)

FAMED FOR ITS TRANSIENT BLOSSOM, THE CHERRY IS PERHAPS THE WORLD'S FAVOURITE FLOWERING TREE

Pink clouds of cherry blossom enchant onlookers every year, if only for a fleeting moment. The tree's ephemeral beauty is most celebrated in Japan, where the blossom of *P serrulata* – one of the many flowering cherry species that grow across the Japanese islands – has attained legendary status and is known as *sakura*. The white or pink flowers emerge early in the year, from late winter to early spring depending on location: cherry trees growing in the cooler northern regions of Japan will flower much later than those on the tropical southern islands.

Flowering takes place before any foliage has unfurled, ensuring that nothing can detract from the performance of the blossom. As is characteristic of members of the rose genus, Rosaceae, each *P serrulata* flower has five petals, though they can be cultivated to have double flowers. And as the blossoming period typically lasts just one to two weeks, seeing the *sakura* bloom represents a very special and transient moment. All across Japan, the occasion is celebrated by the age-old custom of *hanami*, whereby people gather with family and friends to view the cherry blossom, often drinking tea or enjoying a picnic under the blooms.

This celebration is an ancient practice in Japan, with the *sakura* holding deep spiritual meaning and importance in the Shinto religion. The cherry blossom is associated with the impermanence of human existence, encouraging us to appreciate the beauty of transience, and embrace the present moment before it disappears – much as the cherry blossom comes and goes every year.

LEFT TWIN JAPANESE ICONS OF CHERRY BLOSSOM AND MT FUJI

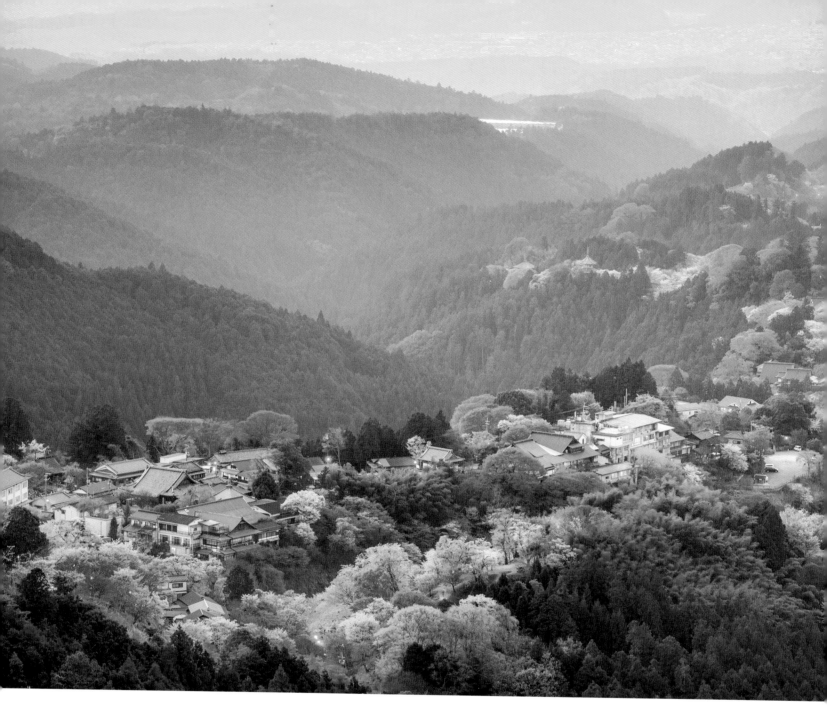

How to See

WHERE

Not every tree has its own subculture, but that's certainly the case for cherry trees in Japan and the ritual of *hanami*. It's one of the world's – and certainly Japan's – most iconic natural spectacles, attracting tourists and Japanese expats nostalgic for home in droves.

Botanical gardens and public parks around the world have tried to recreate the Japanese *sakura* experience with varying degrees of success, but there's no substitute for witnessing *hanami* at source. Riverside pathways and parks in major cities such as Tokyo and Kyoto fill with picnickers, tea-drinking parties and promenading couples as *sakura* fever sweeps the nation, and everyone gets carried away by the carnival mood.

Some cherry blossom locations have a particular magic. Tokyo's Shinjuku-gyoen and Ueno-kōen parks are glorious places to observe the social side of *hanami*, as well as copious cascades of cherry blossom. For *sakura* in a more natural setting, hike the forested slopes of Mt Yoshino, accessible from Nara via the JR train to Yoshino-guchi, then the Kintetsu Railway to Yoshino Station.

How to Identify

The bark of *P serrulata* appears a reddish-brown colour, typically smooth on younger trees. As the tree matures, deep fissures produce a rough texture. Five-petaled cherry flowers emerge in shades of pink or white, quickly dropping and carried by the wind. After flowering, the serrated, toothed leaves unfurl, each measuring 2in to 3in (5cm to 8cm), but notable for their veining. As a deciduous tree, the leaves will turn yellow or red before shedding in the autumn.

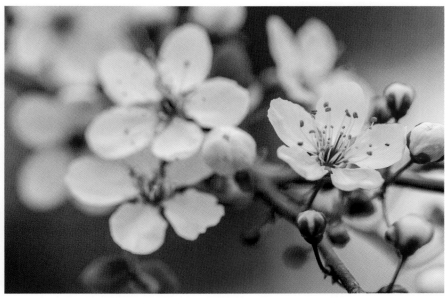

WHEN

The mid-March to mid-April *sakura* season is a prime time to visit Japan, and you'll need to book well ahead to secure flights and accommodation at a reasonable price. If you arrive late, try a higher altitude setting such as Mt Yoshino.

ABOVE MT YOSHINO IN NARA PREFECTURE IS A FAMOUS SPOT FOR SEEING CHERRY BLOSSOM; TOP RIGHT CHERRY TREES BLOSSOM IN SPRING, TYPICALLY FROM APRIL; LOWER RIGHT SAKURA (CHERRY BLOSSOM) VIEWING IS A HIGHLY SOCIAL TRADITION IN JAPAN; OVERLEAF SAKURA STARTS ON KYUSHU, THE SOUTHERNMOST ISLAND

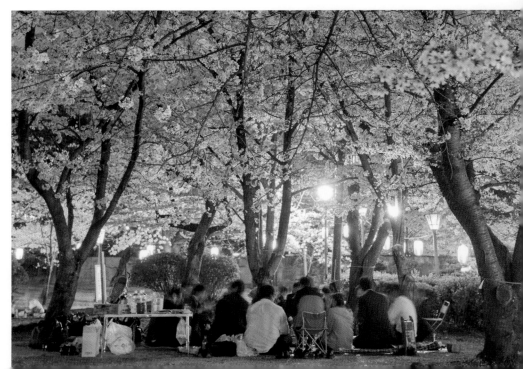

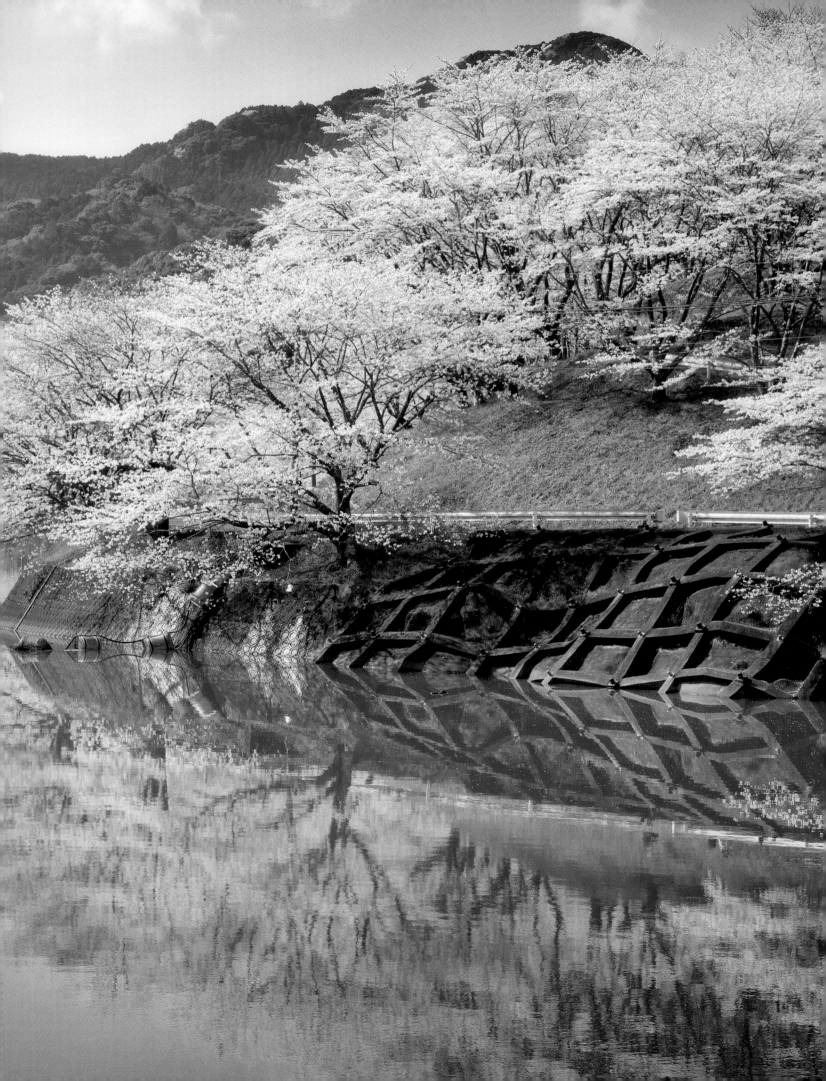

Indian Banyan

Ficus benghalensis

Vitals

RANGE

China, Malaysia, Myanmar, India, Sri Lanka and Thailand

STATUS

Unclassified

LIFESPAN

<500 years

AVERAGE HEIGHT

65ft-100ft (20m-30m)

THIS EXTRAORDINARY AND EXPANSIVE TREE HAS LONG BEEN CONSIDERED SACRED ACROSS ITS NATIVE RANGE

Revered across the Indian subcontinent, the Indian banyan is an iconic species, renowned for producing a vast canopy from which numerous aerial roots descend. This majestic and mighty tree is of cultural and religious significance across the region, deeply embedded in both traditions and folklore.

As a strangler fig tree, *F benghalensis* begins life by germinating in the branches or canopy of another tree, its seed deposited there by an animal. As it grows and more aerial roots descend, it slowly envelops and shrouds the host tree, eventually killing it. What appears as the banyan tree 'trunk' is actually a cylinder of tightly knitted roots, often in a lattice-like pattern. Banyan canopies are often expansive, and many known specimens are today of a staggering size. Notably, the Great Banyan, in the Acharya Jagadish Chandra Bose Botanical Gardens near Kolkata, has been officially declared the world's widest tree, covering approximately 3.5 acres (1.4 hectares) of land. It's more a copse than a single specimen, but walking under its vast canopy and maze of aerial roots is nothing short of extraordinary.

Considered sacred, the Indian banyan serves as a focal point for community gatherings and religious ceremonies across the subcontinent, and is the de facto national tree of India. Hindus regard it as the 'tree of immortality', because of its ever-expanding branches and roots. It is widely believed to have wish-fulfilling properties, and offerings and prayers are often made under its branches in the hope of good health and fortune in the future.

RIGHT INDIA'S BANYAN TREES ARE REFERENCED IN HINDU TEXTS FROM 2500 YEARS AGO

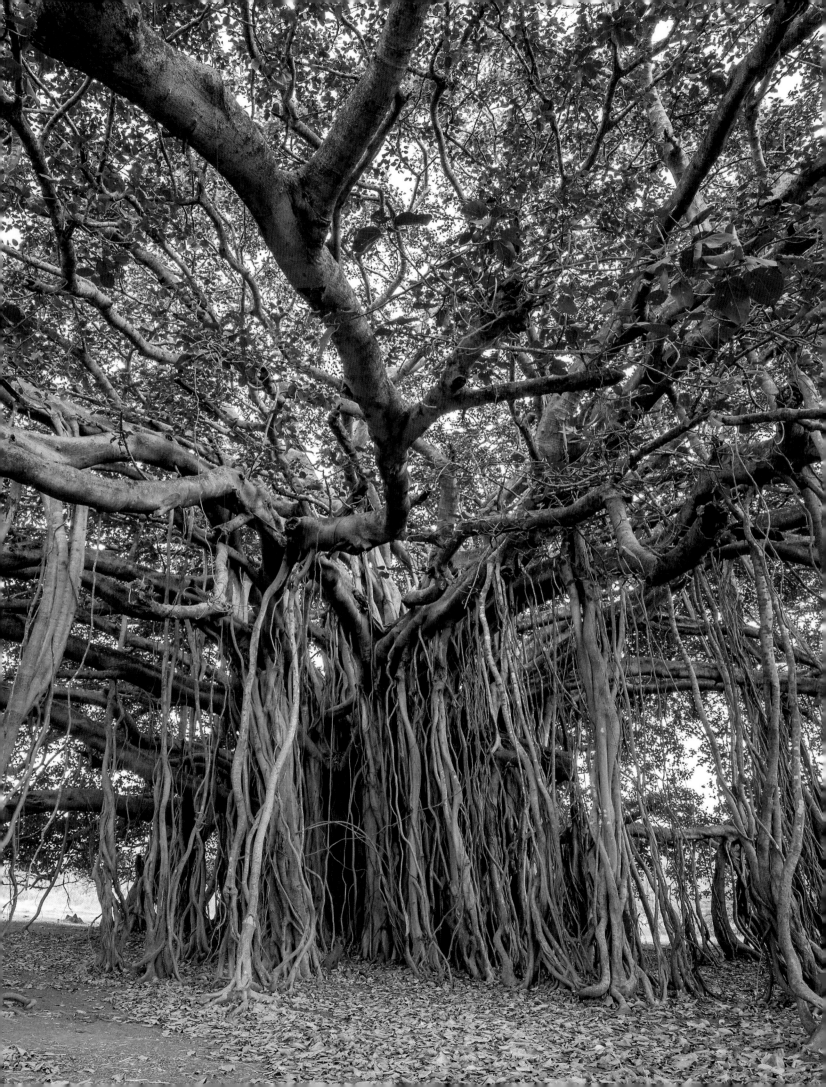

How to See

WHERE

The banyan fig is Asia's signature tree, and its tangled boughs and dangling aerial roots dominate shrines, pathway rest stops and village marketplaces from Pakistan to New Guinea. Banyan species also thrive in Australia, Central and South America and the Caribbean, but Asia is where the banyan is most tightly woven into the spiritual culture. Technically, the term banyan should be reserved for the endemic Indian *F benghalensis*, but the name is sometimes applied to related species like *F religiosa*, which lacks the curtain of aerial roots.

F benghalensis can be found all over India, and the South has some particularly magnificent specimens. The Thimmamma Marrimanu banyan near Anantapur in Andhra Pradesh was for a time hailed as the world's largest tree, while philosophical discussions still take place under the 500-year-old banyan in the grounds of the Theosophical Society in the Adyar district of Chennai (get here by city bus, or take an autorickshaw from Mandaveli railway station). Over in eastern Bengal, the Great Banyan in Kolkata's Acharya Jagadish Chandra Bose Indian Botanic Garden sits in a lush tropical setting on the north side of the Hooghly River – get here by chartered taxi or (slowly) by city bus from central Kolkata.

WHEN

With warm, not baking temperatures, the dry winter months, from October to March, are the optimum time to appreciate Andhra Pradesh and Chennai. Kolkata is also best visited in winter: the city swelters in April and May, and the monsoon often brings flooding from June to September.

TOP AN INDIAN BANYAN TREE IN TAMIL NADU; ABOVE BANYAN TREES HAVE SPIRITUAL IMPORTANCE IN INDIA AND FOR THE VAT PURNIMA CELEBRATION MARRIED WOMEN TIE A THREAD AROUND A BANYAN TREE; OPPOSITE RIGHT YOU'LL FIND THIS BANYAN TREE IN NEW DELHI'S BUDDHA JAYANTI PARK

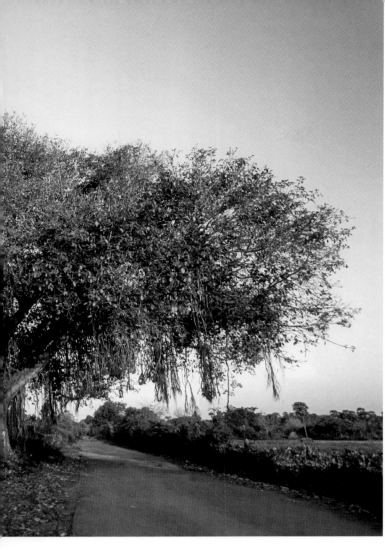

How to Identify

With an expansive canopy, the Indian banyan is unmissable, appearing as a dense thicket of root and trunks. Sizeable, spreading aerial roots descend from the canopy to the ground. The bark appears smooth and grey, although will darken as the tree matures. This evergreen has large, leathery leaves that are elliptical in shape with prominent veins, measuring 4in to 6in (10cm to 15cm).

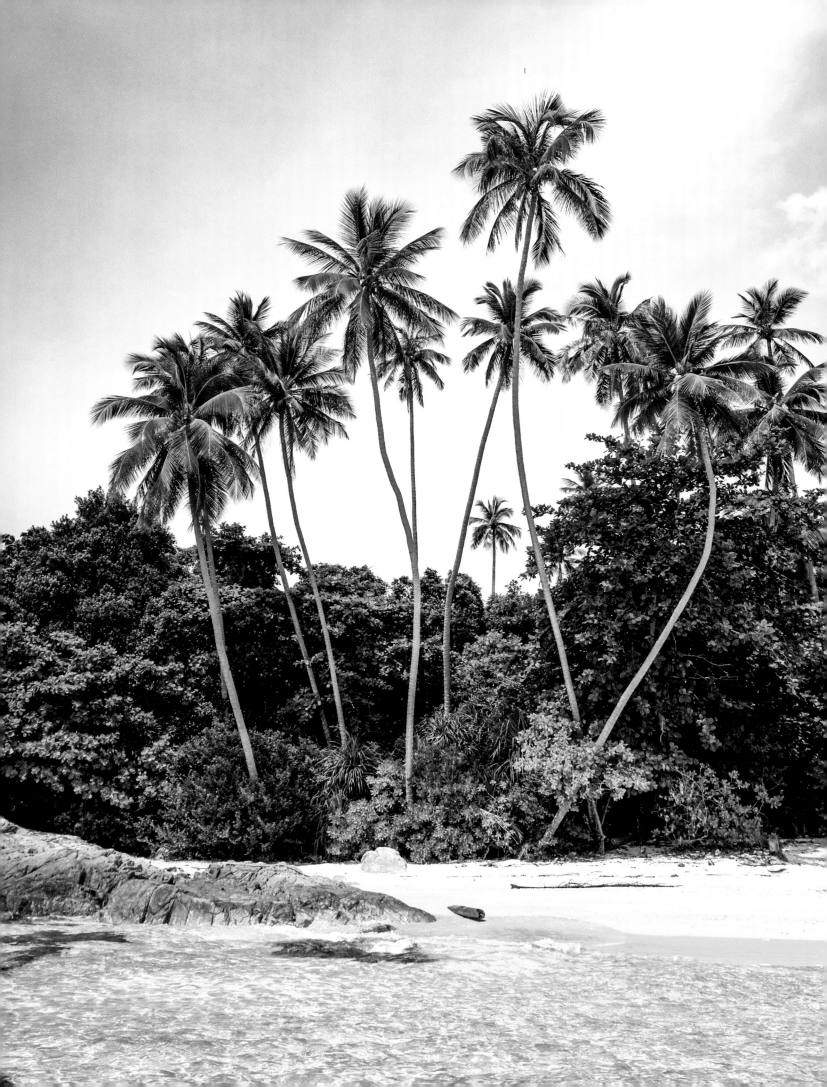

Coconut Palm

Cocos nucifera

Vitals

RANGE
Indo-Pacific region

STATUS
Least Concern

LIFESPAN
<100 years

AVERAGE HEIGHT
60ft-100ft (18m-30m)

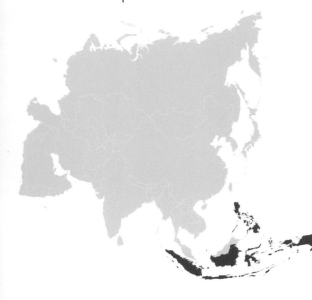

FEW OTHER TREES CAN RIVAL THE COCONUT FOR THE VERSATILITY AND UTILITY OF ITS MANY PARTS

Soft, white sand between your toes. The soothing sound of breaking waves. And the unmistakable silhouette of the coconut palm, its slim and smooth trunk crowned by familiar foliage. All evoke a tropical paradise. Endemic to the equatorial regions of Southeast Asia, the coconut palm has today spread through most of the world's tropical and subtropical zones. This tree has a preference for abundant levels of sunlight and consistent, regular rainfall, making the shorelines of the tropics an ideal habitat.

The coconut palm is celebrated for the utility of both the tree and its fruit; one Southeast Asian proverb declares that it has a different use for every day of the year. The fruit, the famed coconut, is encased in a fibrous husk, but when cut open – or smashed open, as the case may be – inside is found a sweet, refreshing water that is perfectly sterile and safe to drink. This is surrounded by delicious and nutritional coconut flesh. Today, products made from the fruit, including coconut milk and coconut oil, are not only a staple of many people's diets in the Southeast Asian tropics, but are enjoyed worldwide.

In addition to culinary delights, the fibres of the coconut husk, known as coir, are used to make ropes and brushes, while baskets and mats are crafted from the woven leaves. Although many palms are curved, straight coconut palm trunks are often harvested for their timber: it's renowned for its strength and is used in construction, notably for building bridges and huts.

LEFT COCONUT PALMS ON A BEACH IN MALAYSIA'S PERHENTIAN ISLANDS

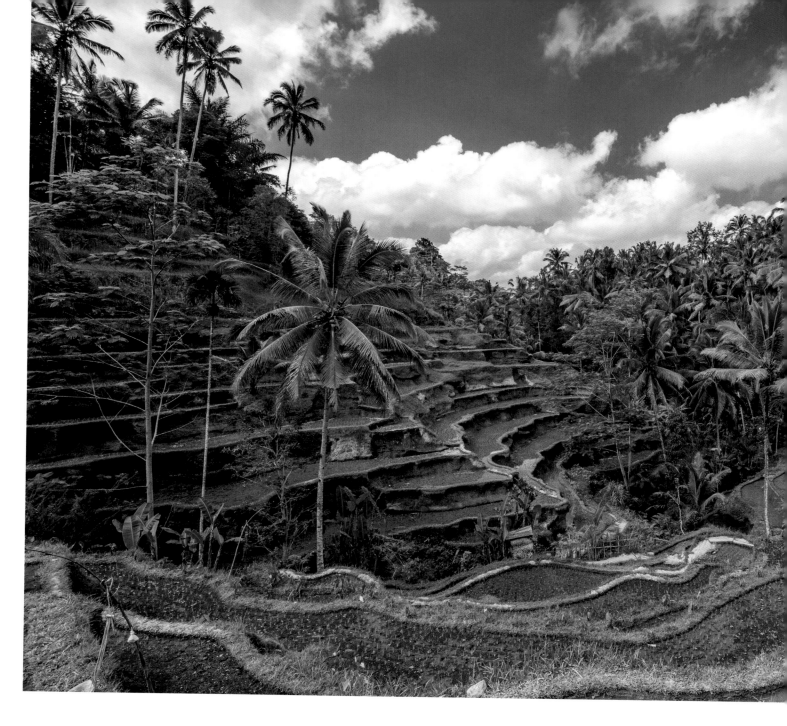

How to See

The drooping fronds of the coconut palm are the definitive image of tropical paradise, and beaches across Southeast Asia are backed by this shoreline-adapted palm. Coconuts fall naturally when ripe and many are carried away by the sea thanks to their buoyant husks, allowing the tree to colonise new settings when they wash up on distant shores.

Don't assume all palms are coconut palms in this part of Asia; environmentally problematic oil palms (*Elaeis guineensis*) are grown in huge plantations across the region. You're most likely to see *C nucifera* by the beach: the islands of Malaysia and the Philippines are particularly blessed with coconut trees – the smell of coconut oil wafts along the coastline and coconut milk is a key cooking ingredient in local kitchens.

In the Philippines, the leaning coconut palm on Bulabog Beach on the island of Boracay has become an Instagram celebrity, as has the charmingly crooked palm along the Maasin River on Siargao island, north of Mindanao. The international airport at Cebu is the nearest hub to both locations; connect to Boracay and Siargao by local bus and outrigger ferry.

How to Identify

The tall, slender trunk of the coconut palm is crowned by a canopy of fronds, typically measuring up to 15ft (4.5m). The trunk can be straight but is more often seen with a slight curve, with horizontal scarring showing where old palm leaves have since shed. Coconut fruits are ovoid in shape, typically 12in to 18in (30cm to 46cm) in length and grow in clusters at the top of the tree underneath the palm leaves.

WHEN

January to May is the optimum time to visit the central Philippines. Rainfall is moderate for these tropical islands and the sun sizzles – perfect for relaxing under a palm tree with a glass of Tanduay rum. Just make sure no coconuts are waiting to drop!

ABOVE PALM TREES PUNCTUATE THE RICE FIELDS OF UBUD IN BALI; TOP RIGHT A RAILWAY IN KERALA, INDIA, PASSES BY PALM TREES; RIGHT 60 MILLION TONS OF COCONUTS ARE HARVESTED ANNUALLY

Yulan Magnolia

Magnolia denudata

Vitals

RANGE
Central and Eastern China

STATUS
Least Concern

LIFESPAN
<300 years

AVERAGE HEIGHT
30ft-40ft (9m-12m)

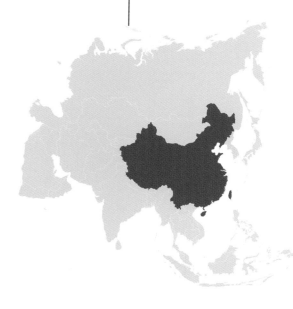

THE MAGNOLIA BLOOM IS A TIME CAPSULE OF EARLY FLORAL EVOLUTION, YET ITS SIMPLICITY OF FORM REMAINS HIGHLY VALUED IN THE MODERN AGE

The magnolia flower is universally revered, not only for the beauty and boldness of its shape and size, but for its remarkable lineage. Magnolias were among the Earth's earliest flowers, originating some 95 million years ago during the Cretaceous period. They date back to an early development in angiosperms – plants that flower and fruit – which would come to outshine the wind-pollinated conifers that had previously dominated. Though bees hadn't yet arrived, the magnolia's large and sturdy blooms evolved to be pollinated by ancient insects, their primitive cup-shaped flowers brightly visible and sweetly scented, their pollen-bearing stamens pronounced.

Spectacular magnolias grow on both sides of the Pacific: the southern magnolia *M grandiflora*, native to the southeastern American states, gained its botanical name for good reason. But of the Asian species, the Yulan – *M denudata* – is widely championed: in temperate gardens across the world it is a favoured springtime tree; in its native China, it is a species all the more esteemed. For centuries, the Yulan's graceful cream-white blooms have been regarded as a symbol of purity, opening in the early weeks of spring to festoon palaces, temple gardens and city streets alike. In northwestern Beijing, an ageing Yulan growing at the Buddhist Dajue Temple is a source of annual festivities; in Shanghai it is the official flower of the city. But this most beloved of blooms owes much to the elegant architecture of the tree's broad branches, which display the profuse flowers as a cloud of white, marking winter's end.

RIGHT A MAGNOLIA TREE BLOSSOMS IN THE COURTYARD OF A TEMPLE IN HANGZHOU, CHINA

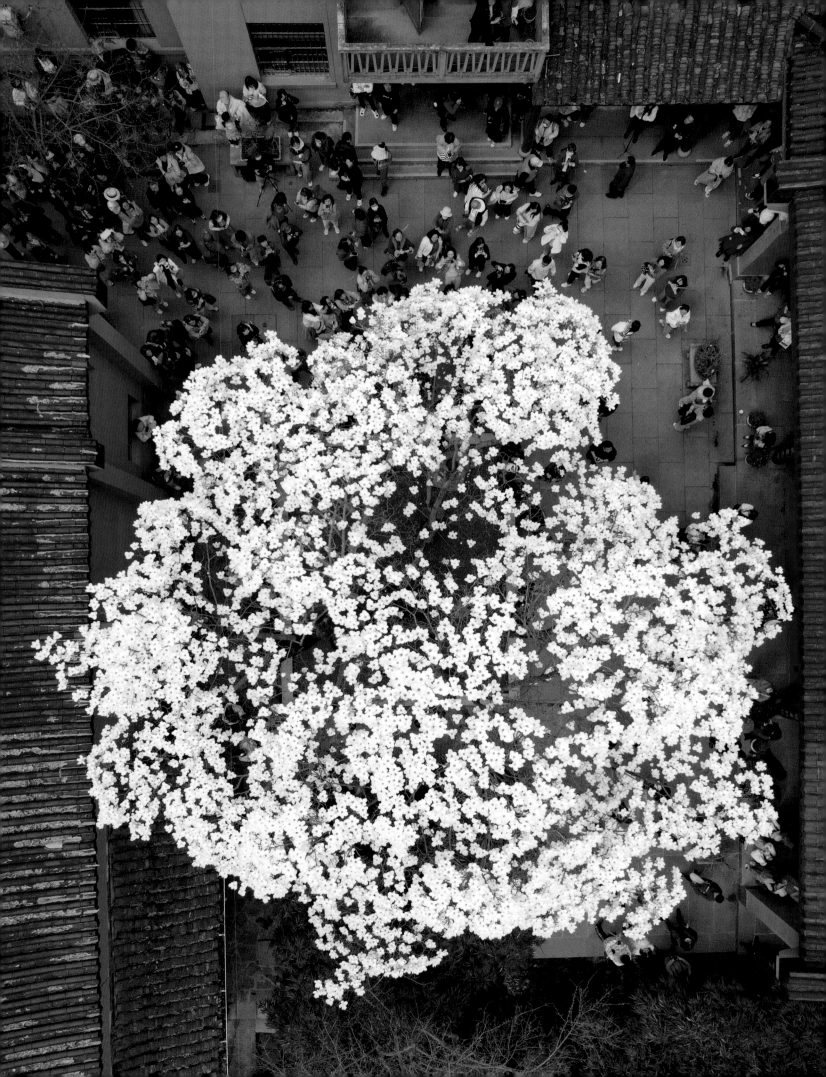

How to See

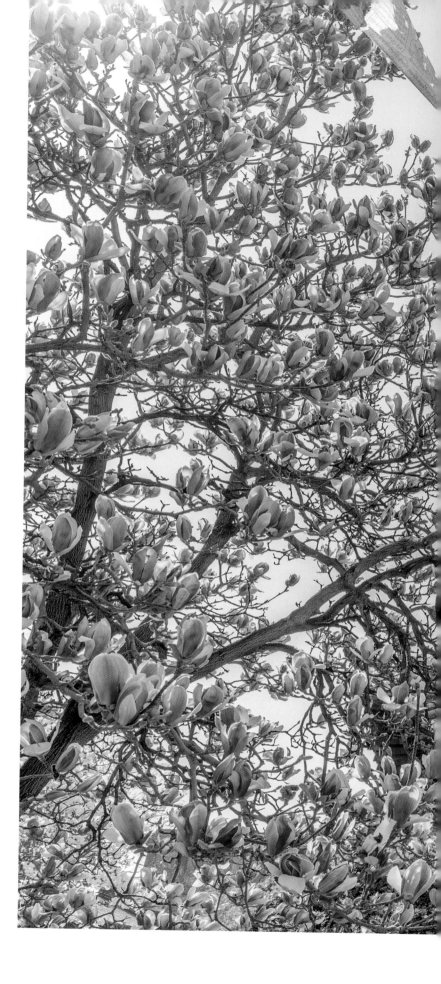

WHERE

The evergreen magnolia tree is a landmark in the US South, but China's Yulan magnolia has a far older backstory. This elegant tree has been grown in the gardens of Chinese Buddhist temples since at least the 6th century, a horticultural symbol of purity and nobility – something you'll definitely appreciate if you see the magnolias in bloom.

Come to Beijing in spring and visit the famous Dajue Temple – founded in the 11th century but much embellished under the Ming emperors – and you'll witness a scene plucked from a Chinese watercolour painting, with the temple's brilliant red facade enveloped by bursts of brilliant white blooms from the flanking magnolia trees, like a firework display frozen mid-explosion.

A taxi is the easiest way to reach Dajue Temple from central Beijing, but you can also get here by on buses 330 or 346 from the Summer Palace, changing to bus 633 at Wenquan and walking the final kilometre or so from the Dajuesi bus stop. Beijing has many more places to see magnolias – Tanzhe Temple, the Beijing International Sculpture Park and Chang'an Ave are all impressive when the trees are in bloom.

WHEN

Magnolias in Beijing bloom from early to mid-April, coinciding with the Magnolia Festival at Dajue Temple. Trees at higher elevations bloom slightly later, so if you miss the show at Dajue, try Tanzhe.

RIGHT SPRING BLOSSOMS AT THE BUDDHIST GUANGREN TEMPLE IN XI'AN, CHINA;

OPPOSITE RIGHT MAGNOLIA BLOSSOMS IN THE STREES OF SHANGHAI, CHINA

How to Identify

The Yulan is a small to medium-sized magnolia with a densely branched canopy and a smooth grey trunk. Leaves are deciduous, dark green and roughly egg-shaped, and arranged alternately. The goblet-shaped flowers are large – around 3in to 5in (8cm to 13cm) – pure white (though sometimes pink-tinged) and richly lemon scented, similar to a lily flower in their upright, gradually splaying development. The Yulan's autumn fruit is pink in colour and cone-shaped, containing red-coated seeds.

Flame of the Forest

Butea monosperma

———

Vitals

RANGE
Southern Asia

STATUS
Least Concern

LIFESPAN
No Data

AVERAGE HEIGHT
30ft-40ft (9m-12m)

LIKE A FLARE OF RED SMOKE, FLAME OF THE FOREST BURSTS INTO VIBRANT COLOUR BEFORE ITS LEAVES CLOTHE THE BRANCHES

Red-flowering trees are rare. You can seek out the 3in-long (8cm) blooms of Madagascar's phoenix flower (aka poinciana), for example, or the festive flowering of New Zealand's popular Pōhutukawa. But there is an incomparable brightness in the orange-tinted, flame-shaped blooms of southern Asia's flame of the forest – a familiar colour in garden plants perhaps, but unexpected in a tree. In early spring, prior to leaf-break, this appropriately named specimen flushes radiant red with the most extraordinary of blooms, in appearance resembling something avian, with curled-back beak- or claw-like centres and winged petals. Indeed, they attract a great diversity of birdlife, though it's fitting that only the most exotic among them should successfully pollinate these most ostentatious of flowers: the purple sunbird, whose slender beak can access the tree's nectar without damaging the flowers.

Given the flame of the forest's wide native distribution across Asia, from India and Pakistan to Vietnam and southeastern China, it is a tree that bears many different names and deep-rooted cultural associations and uses. *B monosperma* is sacred to Hindus, its flowers providing a vivid dye used for textiles and ceremonial markings, but it's perhaps best known for its contribution of shellac, the resin secreted by the lac bug, for which the tree is a key host plant. Scraped from the branches and heat-treated, shellac has long been farmed in India for the production of glue, wood lacquer and, famously, the pressing of early gramophone records.

LEFT **A FLAME OF THE FOREST TREE FLOWERING IN RANTHAMBHORE NATIONAL PARK, INDIA**

How to See

Though common names for the flame of the forest also include the rather insulting 'bastard teak', you'll find yourself leaning towards the former once you glimpse its fire-red flowers. The tree grows wild in forests across Asia, from Nepal and Pakistan in the north and west to the southern tip of India and Sri Lanka and most of mainland Southeast Asia.

The birthplace of *B monosperma* is thought to be the Doaba region in northern India, but the extensive forests between the Ganges and Yamuna Rivers were cleared in the 19th century as the British East India Company sought to maximise the agricultural value of its Indian territories. Today, West Bengal has some of the most extensive groves.

One of the best spots to see flame of the forest trees – known in India as palash – is the campus of polymath and poet Rabindranath Tagore's Visva-Bharati University at Santiniketan, which radiates colour when the trees flower in spring. To get here, take the train from Kolkata to Bolpur, then a local bus or autorickshaw for the short final leg to Santiniketan.

142

How to Identify

In contrast to its flowers, the bark of *B monosperma* is a dull light brown and notably cracked, the trunk misshapen and often leaning. Leaves are distinctly trifoliate – three large oval leaflets on a slender stalk – and are shed during the dry season. The clusters of 1in (3cm) flowers appear in late winter to early spring. The fruit is a flattened, hirsute, pale-brown pod, 7in to 9in (10cm to 23cm) long and containing a single seed.

OPPOSITE LEFT ROSE-RINGED PARAKEETS FEED ON THE FLAME OF THE FOREST TREES; LEFT A BURST OF COLOUR IN GOA'S RAINFOREST; BELOW THE FLOWERS ARE USED IN TRADITIONAL INDIA HEADDRESSES, SUCH AS HERE IN KOLKATA, INDIA

WHEN

Come in the flowering season, from January to March in most of Asia. In India, this coincides with the festival of Basanta Utsav, the Bengali version of Holi, when women adorn their hair with flame of the forest flowers.

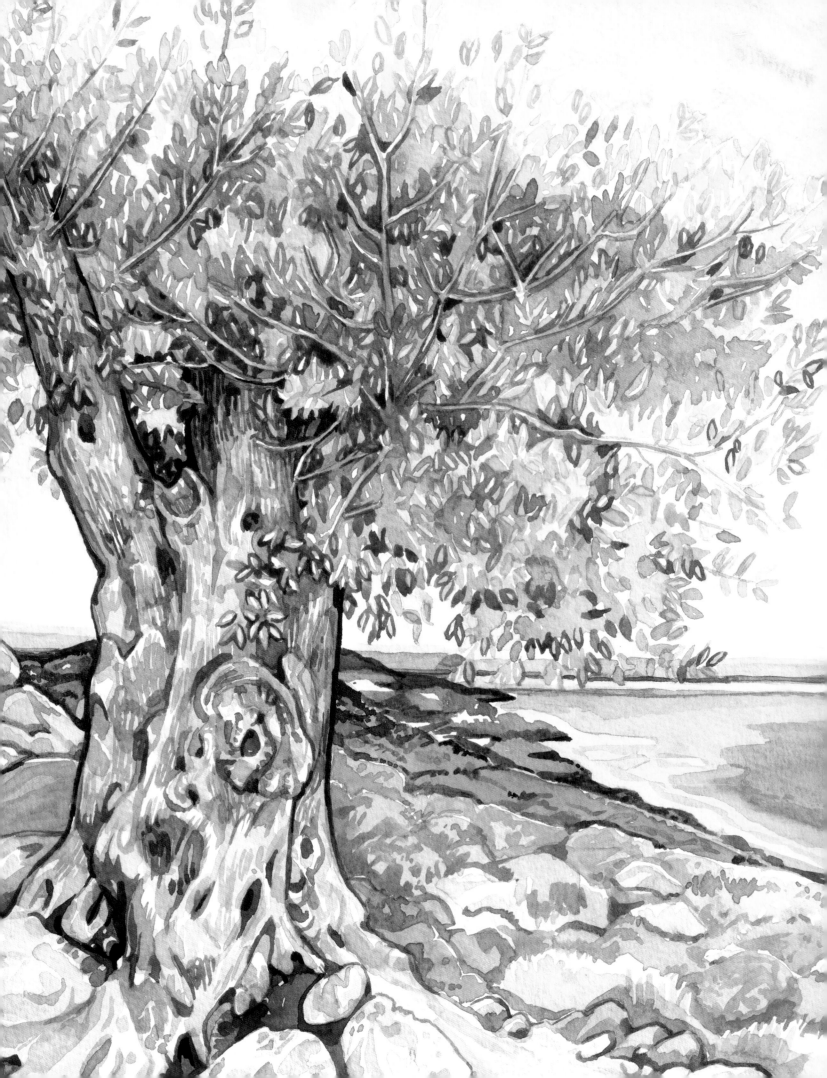

Europe

Silver Birch

Betula pendula

Vitals

RANGE
Europe-wide

STATUS
Least Concern

LIFESPAN
<150 years

AVERAGE HEIGHT
60ft-80ft (18m-24m)

WITH UNUSUAL WHITE BARK, THE SILVER BIRCH CUTS AN ELEGANT YET SPECTRAL PRESENCE IN EUROPEAN FORESTS

In its appearance, the silver birch contrasts sharply with other tree species found in Europe. With its narrow form, pendulous branches and ghostly silver-white bark, this is a tree of unique aesthetic appeal. Found across much of Europe, *B pendula* can happily grow in the boreal regions of the north as well as further south, in Greece and across the Iberian Peninsula. Though it's noted for having a wide distribution and tolerance for a range of altitudes and climates, its preference is for the wet and cold of the north rather than the relative aridity and warmth of the south.

The silver birch is one of the only deciduous tree species that looks its best in winter, when the last leaf has fallen and its branches hang bare, allowing the graceful elegance of the silvery-white bark to take centre stage. When seen in a forest, these statuesque specimens create an otherworldly and eerie atmosphere. This bark shines especially bright when the trees are young; this is a natural adaption to reflect sunlight, which in turn helps to regulate the core temperature by minimising heating and cooling fluctuations.

Unsurprisingly, given its ethereal appearance, the silver birch has become emblematic in various European cultures and in folklore, symbolizing both purity and renewal. In Celtic traditions, birch branches were used in druidic ceremonies dating back millennia, while boughs of birch were hung over doorways every Midsummer's Eve to protect against evil spirits and bring good luck for the year ahead.

RIGHT AN ISLAND ON A FINNISH LAKE DAZZLES WITH SILVER BIRCHES

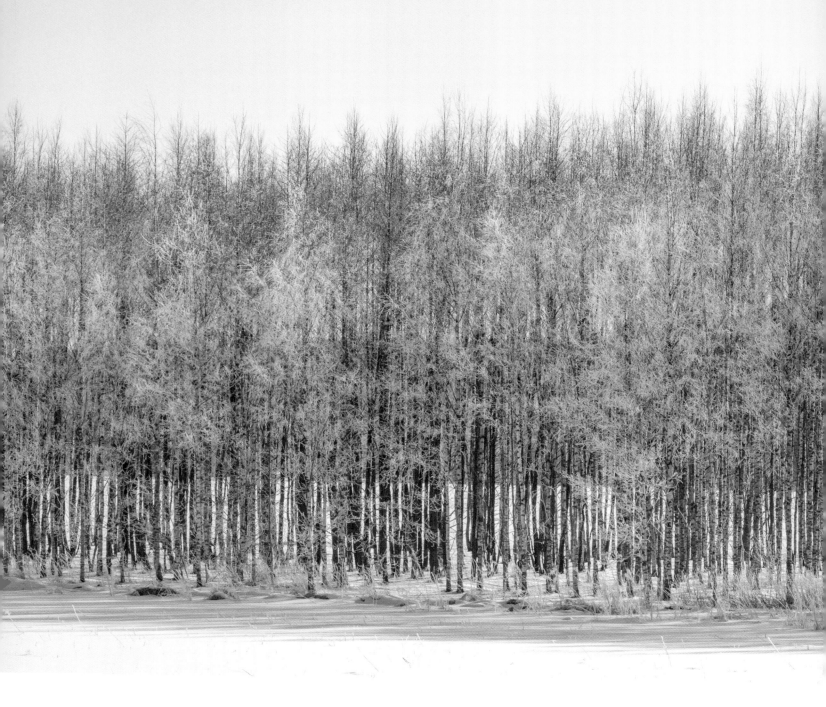

How to See

Shimmering like elvish battalions in silvery armour, the birch forests of central and western Europe could have been plucked from a woodcut of a Brothers Grimm fairy tale. But that's only part of the picture – these striking trees are actually found as far afield as eastern Siberia and Xinjiang in China.

However, the temperate forests found close to the shoreline of the Baltic Sea are particularly evocative places to see silver birches – a source of inspiration for masters of the fairy tale from the Grimms to Hans Christian Andersen and Tove Jansson. Perhaps the most stunning tracts of silver birch forest are found in southern Finland, where an invigorating slapping with birch twigs is an integral part of the traditional sauna experience.

Conveniently close to Helsinki, Nuuksio National Park is a fine spot to get your silver birch fix. Come here by hire car via National Road 1 and Regional Road 110, or visit by public transport. Trains run from Helsinki to Espoo, from where local buses can drop you close to the Haukanpesä (Hawk Nest) sauna at Haukkalammentie, starting point for forest hikes such as the 4.5-mile (7.2km) Korpinkierros Trail.

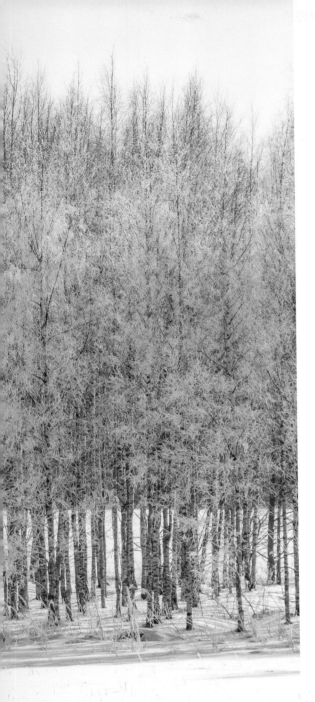

How to Identify

The young branches of the silver birch exhibit a pendulous, weeping appearance, gracefully hanging down from the typically upright trunk. The bark is smooth and silvery when the tree is young, gaining dark fissures which appear as scarring as it ages. The leaves, triangular in shape and serrated along the edges, measure no more than 2in (5cm), and move elegantly in the wind due to the drooping nature of the branches.

LEFT BIRCH TREES ARE SUITED TO COLD TEMPERATURES AND RESIST THE HEATING AND COOLING THAT DAMAGES CELLS; BELOW IN SPRING, SILVER BIRCH TREES PRODUCE MALE OR FEMALE CATKINS

WHEN
The short, warm Finnish summer (June to August) is an excellent time to explore the silver birch and pine forests and swim in the tree-framed lakes of Nuuksio National Park, and by August, wild blueberries and lingonberries appear.

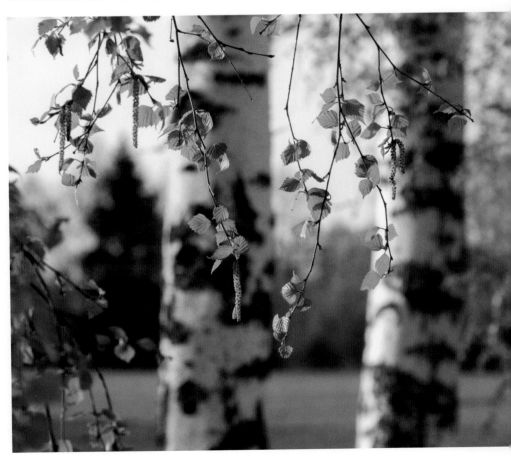

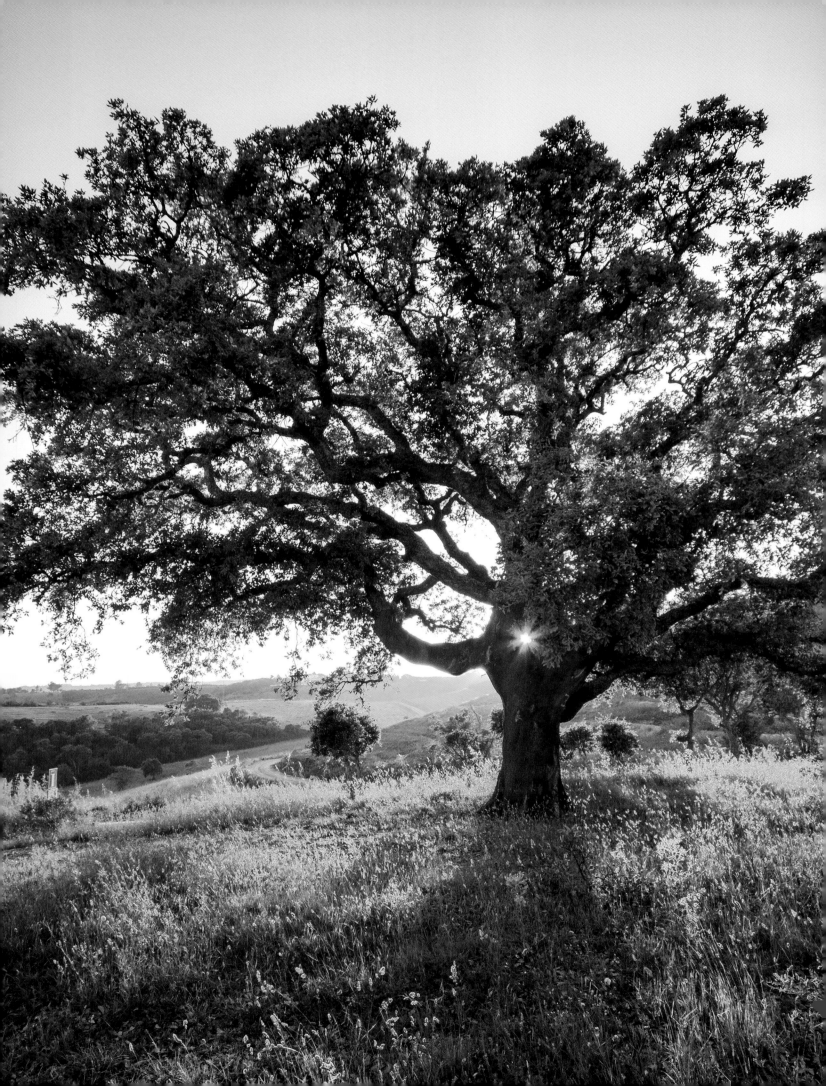

Cork Oak

Quercus suber

Vitals

RANGE
Southwest Europe

STATUS
Least Concern

LIFESPAN
<200 years

AVERAGE HEIGHT
<40ft-66ft (12m-20m)

POP OPEN A BOTTLE OF WINE AND CELEBRATE THE UTILITY OF THE CORK OAK, WHICH REMAINS A REMARKABLE AND SUSTAINABLE RESOURCE

Native to southwest Europe (and northwest Africa), the cork oak thrives in hot, dry climates. Famous not for its leaves or fruit but for its unique bark, *Q suber* has been a tree of economic significance for centuries – and nowhere is this more evident than in Portugal, where the cork industry has thrived since the 18th century. Today, the country remains the world's leading cork producer.

Portugal boasts an extensive mass of cork oak forests, particularly in the southern Alentejo region, where thickets of these gnarled old trees create a unique habitat. Spanish imperial eagles and the endangered Iberian lynx hunt small mammals in the shady groves, and conservation efforts are ongoing to support populations of these endemic Iberian Peninsula species.

The Portuguese have long since mastered sustainable farming techniques, establishing a renewable industry by ensuring that cork forests can regenerate after harvesting. The first harvest is possible when a cork oak tree reaches around 25 years old: expert bark extractors strip the trees by hand in a meticulous process, removing the outer covering of cork without causing damage to the underlying layer. Harvesting can then occur every 9–12 years, allowing enough time for the tree to regrow its upper bark layers. The harvested cork possesses remarkable properties, being lightweight, buoyant and impermeable to liquids, making it a versatile material in many industries. Best known for its use as a stopper in wine bottles, cork has also been used in shoe manufacturing, flooring and even as thermal insulation in space rockets.

LEFT CORK OAKS THRIVE IN SOUTHERN PORTUGAL'S ALENTEJO REGION

How to See

WHERE

To prime yourself for a trip to see cork oaks in their natural habitat, grab a copy of *The Story of Ferdinand*, created by Munro Leaf and Robert Lawson in 1936. Both were American, but Lawson's line drawings of village scenes and cork oaks (depicted with actual wine corks dangling like fruit) conjure up the full charm of the Iberian countryside.

There are dozens of places where you can walk amongst cork oaks on the Iberian Peninsula, but the Alentejo in Southern Portugal is particularly rich in *Q suber* trees. The ancient cork forests here, known as the Montados, are the largest in Europe; the trail-crossed Serra d'Ossa peak between Redondo and Estremoz is a good starting point.

Countryside drives from most towns in the region will take you through areas of cork oak forest, or you can indulge in a spot of 'corktrekking' – a walk combined with vineyard visits and wine tastings. Off the A6 highway east of Évora, Redondo is a great hub for hikes, with numerous *herdados* (farmsteads) where you can sample local wines, and cork farms where you can see the traditional cork production process. Portugal Farm Experiences (www.portugalfarmexperience.com) is one operator arranging trips.

WHEN

The cork harvest takes place in September and October, coinciding with perfect weather for hikes through the Montados, with lingering traces of summer warmth by day, followed by cool, fresh evenings.

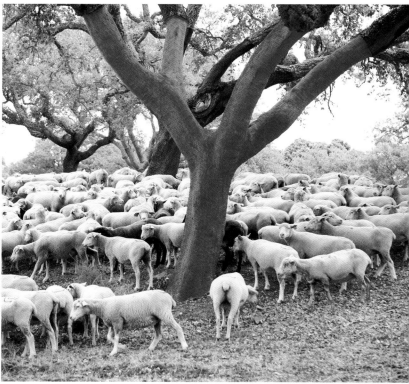

TOP RIGHT A MEADOW OF CORK OAKS NEAR ÉVORA IN THE ALENTEJO;

RIGHT BARK IS STRIPPED FROM THE TREES TO MAKE CORK FOR PRODUCTS;

OPPOSITE RIGHT PORTUGAL IS THE WORLD'S LARGEST EXPORTER OF CORK

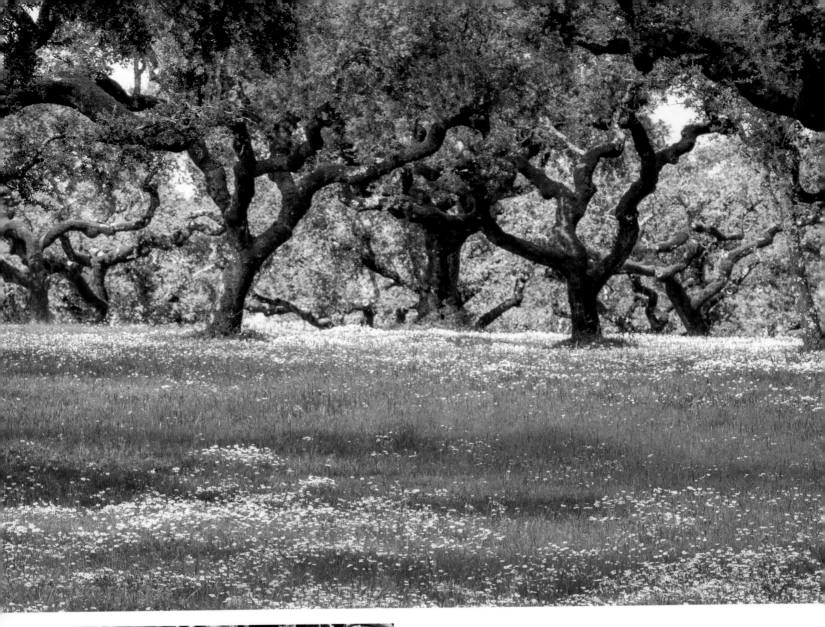

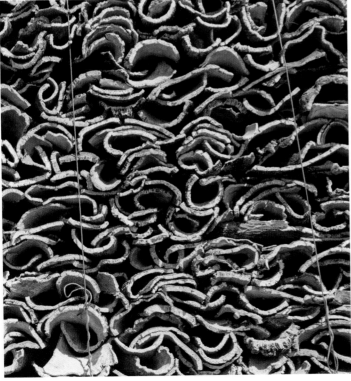

How to Identify

Mature cork oaks are renowned for their textured, fissured grey bark, yet when they're stripped for harvesting, the exposed inner layer has a distinctive reddish colour. Their stout trunks support broad canopies that can be divided into several smaller crowns. Unlike other oak varieties, cork oaks are evergreen, and while the leaves are less defined than other oaks, the teeth-like points along the edges of the leaf are a helpful identifying marker.

Maritime Pine

Pinus pinaster

Vitals

RANGE

Western Mediterranean Basin and Atlantic Coast

STATUS

Least Concern

LIFESPAN

<300 years

AVERAGE HEIGHT

80ft-120ft (24m-36m)

WITH ITS ARMOUR-LIKE BARK, THE RESILIENT MARITIME PINE CAN WITHSTAND BOTH FOREST FIRE AND ROARING COASTAL WINDS

Endemic to the Mediterranean region, this hardy conifer can grow in a wide range of geographic locations, thriving in both temperate and warm climates and equally at home in low-lying littoral regions as it is in mountainous terrain. But it is *P pinaster's* ability to withstand harsh coastal environments, with their siliceous and sandy soils, that has earned it the common name of maritime pine – a testament to its success in challenging ecosystems. With tall, narrow trunks supporting both conical and ovoid crowns, maritime pines boast an impressive shape, and when seen in a group, pine needles rustling in the salty breeze, it's hard not to admire their elegance and endurance.

The maritime pine is a pyrophyte, meaning it has adapted to tolerate and survive fire events. It is renowned for its distinctive bark, with a reddish-brown hue and a deeply fissured texture, and it's this rugged bark that serves as its primary protection, insulating the tree's cambium layer (the inner, growing part of the trunk) from intense heat and flames. This fire-resistant adaption is not unique to this species – other pines, including *P ponderosa* (see page 88), have evolved similar survival strategies – but the maritime pine's capabilities extend beyond its bark. Sudden temperature increases, for example, trigger the release of seeds from its cones, ensuring that maritime pine populations can quickly regenerate in fire-affected areas, and that these remarkable trees not only endure in such challenging landscapes, but thrive in the aftermath of a forest blaze.

RIGHT FRANCE'S FLAT LANDES REGION, IN ITS SOUTHWEST, HAS FORESTS OF MARITIME PINES

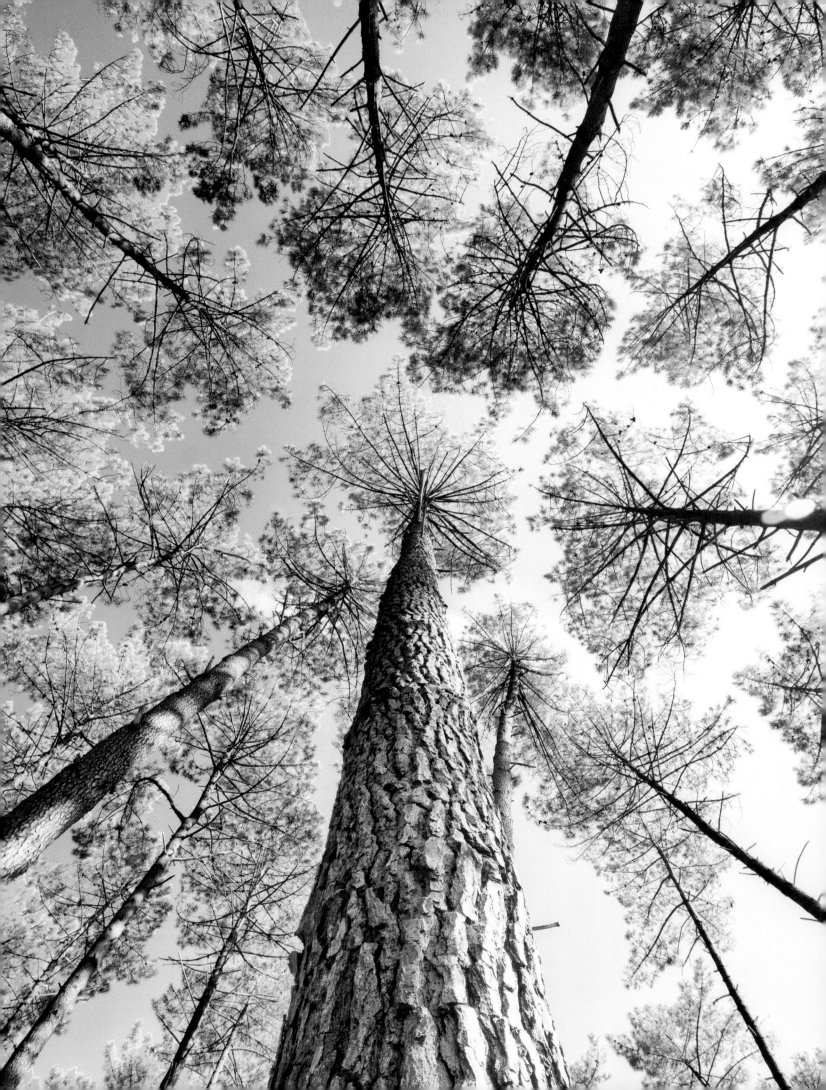

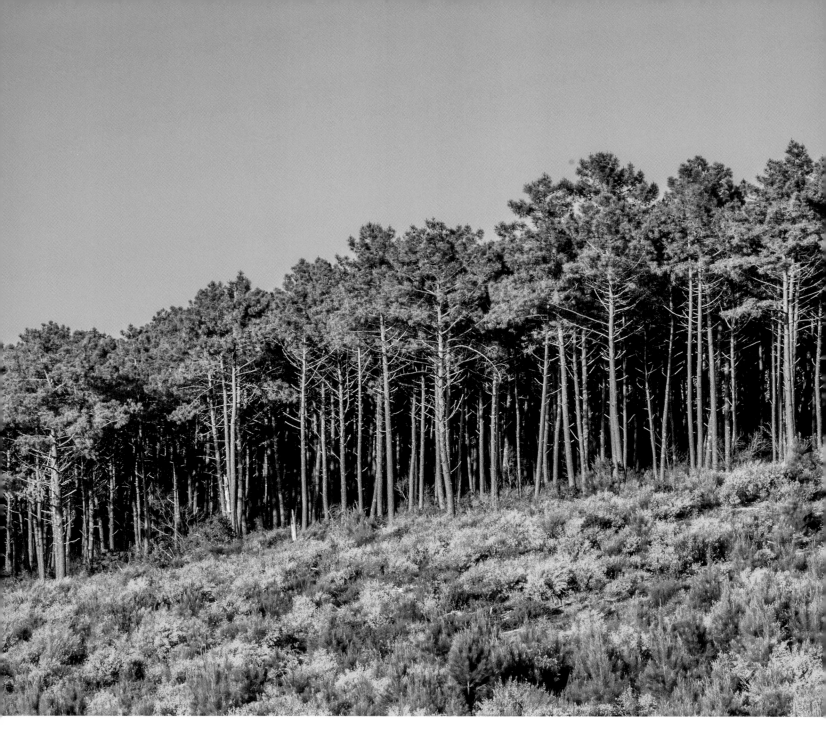

How to See

Depending on where you live, *P pinaster* – about as piney a name as anyone could come up with – is either a wonder or a menace. In the forests of the southern Europe, the tree is loved for its tall, straight trunk and resinous wood – perfect characteristics for shipbuilding. In South Africa, where invasive maritime pines are threatening native fynbos shrublands, people curse the day that the trees were introduced.

We'll stick to southern Europe when recommending a place to see this pin-straight pine. Forests containing maritime pines track the coastline from Portugal and Spain to Western France, but the Landes Forest south of Bordeaux is composed almost entirely of this single species, planted as a source of wood, paper and resin in the 19th century.

To reach the forest, drive south from Bordeaux along the A63, or take the train to Dax or Morcenx. In summer, buses connect the train stations to the forest reserve access points at Contis Plage and Lit et Mixe. Inside the reserve, 10 walking trails meander between the pines, and EuroVelo Route 1 takes cyclists through some gorgeous sections of forest.

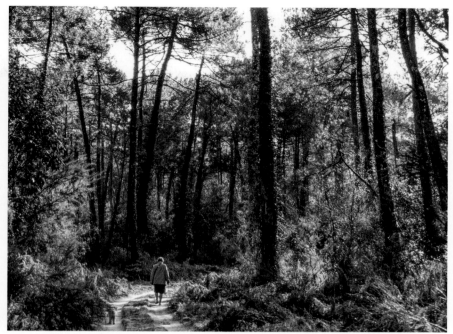

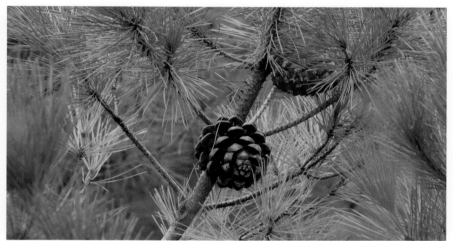

From June to September, daytime temperatures in Côte Landes reach a balmy 25°C (77°F) and skies are clear – ideal conditions for forest walks, cycle rides and cooling off in the sea afterwards at Contis Plage.

ABOVE A PLANTATION OF MARITIME PINES IN NORMANDY;

TOP RIGHT WALKING THROUGH A MARITIME PINE FOREST IN LANDES, FRANCE;

LOWER RIGHT CONES CAN REMAIN ON THE TREE FOR SEVERAL YEARS

How to Identify

P pinaster has a recognisable silhouette, characterised by a tall, straight trunk with either a rounded or pointed crown. The armour-like bark appears deeply furrowed and scarred, often with a reddish-brown colouring. Its long, slender needles are arranged in pairs and typically measure 8in to 10in (20cm to 25cm) long.
The cones are conical, initially green and maturing to brown over a two- to three-year year period before eventually open-ing to release seeds.

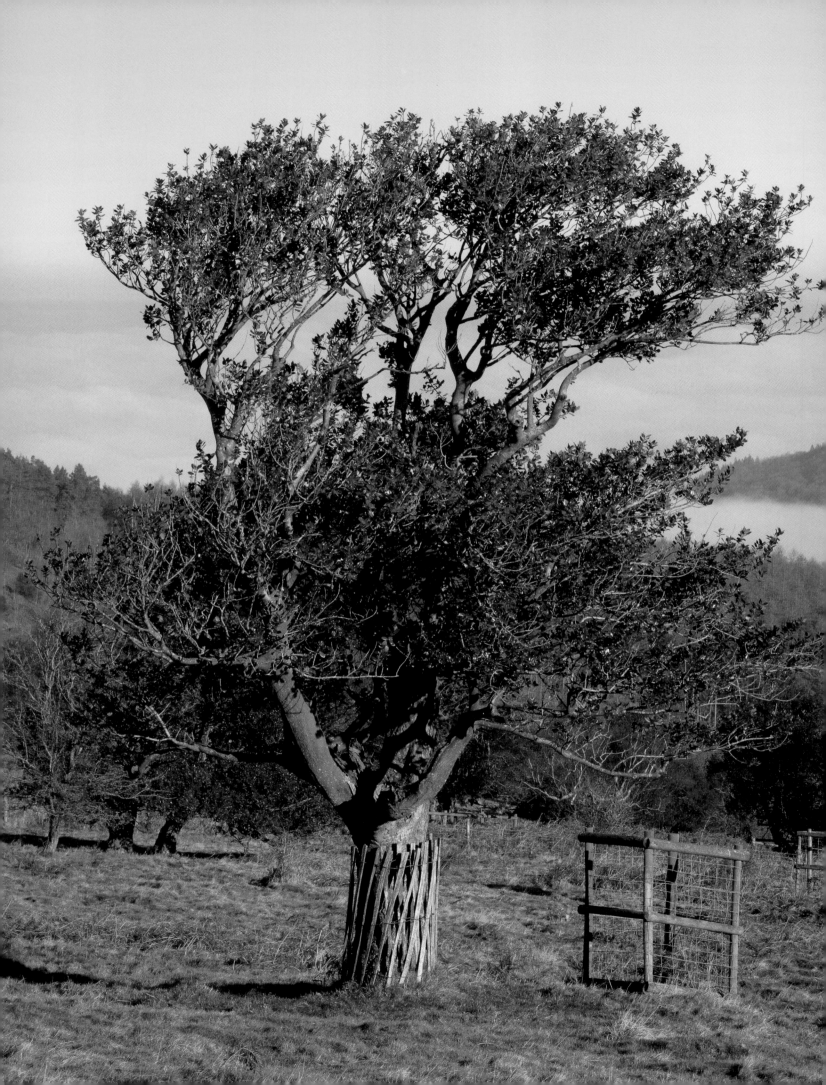

Holly

Ilex aquifolium

Vitals

RANGE
Europe-wide

STATUS
Least Concern

LIFESPAN
<300 years

AVERAGE HEIGHT
30ft-50ft (9m-15m)

AN ENDURING SYMBOL OF FESTIVITY, THE VIBRANT RED BERRIES OF THE SPIKY HOLLY TREE ARE A SEASONAL WONDER

Holly trees have long been synonymous with Europe's folklore and festivities. For druids and pagans, their evergreen leaves and red berries carried sacred significance, thought to symbolise fertility and protection and used in rituals and celebrations during the winter months, when life was challenging amid the harsh conditions of the season. In the Christian faith, the spiked leaves of *I aquifolium* symbolise the crown of thorns placed on Jesus' head before he died on the cross, while the festively hued berries and deep-green foliage endure as a symbolic decoration during Christmas celebrations across the world. In Celtic mythology, the Holly King personifies winter until the Oak King of summer takes over at the spring equinox.

In woodlands across Europe, the holly happily coexists with other broadleaf trees, including oak, beech and birch. Blackbirds and robins feed on its berries during the winter months when food sources are scarce, while small mammals such as dormice build nests amid its dense and prickly leaves, which provide protection from predators.

Interestingly, holly leaves are dynamic in that they respond to their environment. In recent years, scientists have discovered the holly is capable of adjusting its foliage, from rounded to spiked, in response to damage and over-grazing by animals. A holly might produce spiked leaves lower down the tree, to defend against and deter herbivores, whilst higher-up leaves that are safer will remain smooth. This arboreal metamorphosis is testament to the holly tree's ability to adapt and survive.

LEFT HUNDREDS OF CENTURIES-OLD HOLLY TREES GROW IN THE HOLLIES NATURE RESERVE IN SHROPSHIRE, ENGLAND

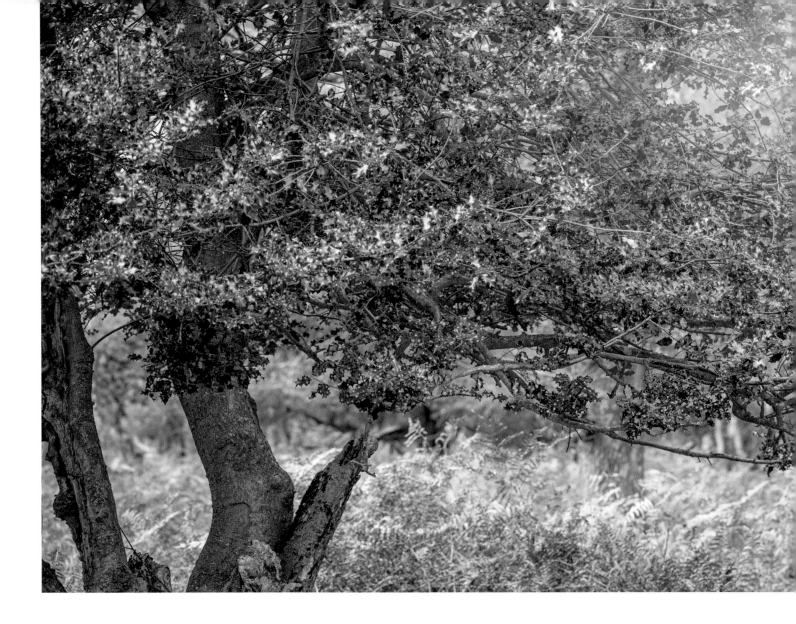

How to See

WHERE

If ever a tree had a season, it would be the holly – forever associated with red berries in midwinter. But there isn't just one kind of holly: there are more than 570 species found from western Europe to Asia and the Americas. In fact, Europe is an outlier, with just one species, *I aquifolium* – China alone has 149 endemic species of holly.

But for the full festive holly experience there's no substitute for England, where the woodlands fill with walkers in the winter, discretely snipping off berry-laden branches to top Christmas puddings and adorn Christmas wreaths. You'll find people participating in this unofficial holly harvest even in the middle of London at sites such as Hampstead Heath and Queen's Wood.

However, one of the most interesting spots to see holly is Shropshire's Hollies Nature Reserve, a scattering of centuries-old trees that are all that remains of one of Britain's medieval *hollins* (holly woods). Here, spiny holly trees frame sweeping views across the English border into Wales. Reach this Lottery-funded nature reserve by car from Shrewsbury, following the signs for Stiperstones off the A488 to Bishop's Castle.

WHEN

Winter, of course – though England's holly trees can produce their distinctive red berries as early as November and berries can linger as late as March. If you plan on taking some home, harvest early before the birds devour them all.

ABOVE A HOLLY TREE LADEN WITH WINTER BERRIES IN LYMINGTON, HAMPSHIRE, ENGLAND; TOP RIGHT HOLLY TREES ARE OFTEN FOUND IN CHURCHYARDS, SUCH AS THIS ONE IN ENGLAND'S COTSWOLDS; BELOW THE BERRIES ARE A KEY WINTER FOOD FOR BIRDS

How to Identify

Recognisable by its glossy, dark green foliage, the holly will usually show a combination of spiky and rounded leaves, each with a waxy texture and robust structure. White four-petalled flowers typically bloom in spring through to early summer. The smooth grey bark stands out in wooded areas when compared to other trees, and during the winter months red berries fill the branches, contrasting attractively with the dark green of the leaves.

European Larch

Larix decidua

Vitals

RANGE
Northern and Central Europe

STATUS
Least Concern

LIFESPAN
<800 years

AVERAGE HEIGHT
130ft-148ft (40m-47m)

PAINTING THE ALPINE LANDSCAPE IN SHADES OF YELLOW AND GOLD, EUROPE'S ONLY DECIDUOUS CONIFER IS AN AUTUMN SPECTACLE TO BEHOLD

Native to mountainous areas of northern and central Europe, the stately larch is a shining example of the resilient and adaptable trees that grow at high altitudes. This long-lived and fast-growing conifer thrives in alpine climates, tolerating frigid winter temperatures with ease; and at these lofty heights, the European larch faces less competition from other trees, allowing it to dominate where other species are unable to grow. It's a typical 'pioneer tree', able to quickly colonise land following disturbances such as flooding, fire or snow damage, the latter being a frequent challenge in the mountainous regions of northern and central Europe. In addition, the remarkably flexible trunks of younger *L decidua* help the trees to survive avalanches, with trunks and stems forced into horizontal positions under the weight of snow only to grow upright again following a thaw.

The European larch is unusual as a conifer in being a deciduous tree, dropping its needles in winter and growing them anew in spring. It is celebrated for its seasonal transformation of the landscape, with a dramatic change in needle colour from bright green during spring and summer to golden-yellow hues in autumn, before finally shedding its needles in winter. Offering a vivid spectacle for mountain hikers and winter-sports enthusiasts, *L decidua*'s gilding of the alpine regions and boreal forests is a painterly reminder of seasonal transition: as the mountains and hills turn yellow, they serve as a marker of the colder and darker months soon to come.

RIGHT BESIDE LAGO DI VAL VIOLA IN SWITZERLAND, A EUROPEAN LARCH IN AUTUMN FINERY

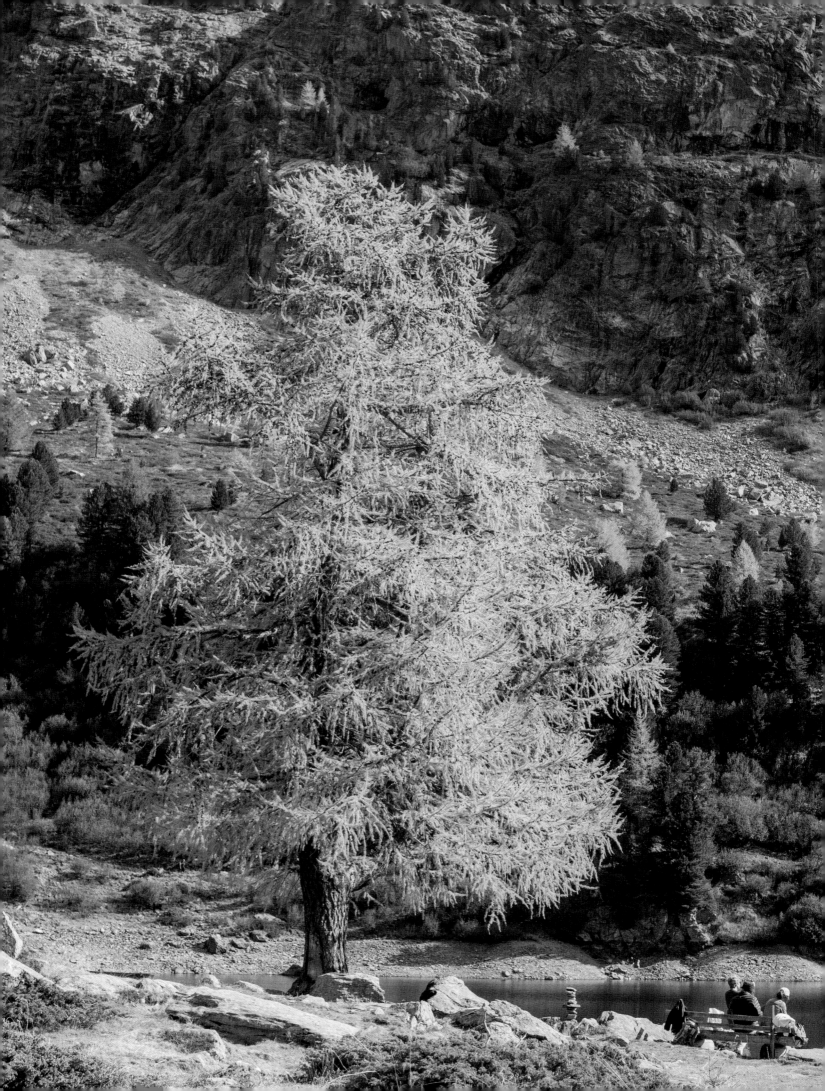

How to See

WHERE

European larches fill the forests with last-light-of-the-sun gold as their needles change colour with the onset of cold weather – one of the tree world's loveliest spectacles. This shapely species is found everywhere from China and Japan to North America and central Europe, but Switzerland is particularly rich in larch forests.

The chic ski resort of St Moritz is the highest town with a railway station in Switzerland, and larches grow almost to the banks of its fringing lake, St Moritzersee. In winter, the surrounding mountains are all about skiing, including on cross-country trails amidst forests of larches and pines; from spring to autumn, the same routes become walking trails through stunning mountain forest scenery.

Starting from the railway station in St Moritz, the (4.5-mile) 7.4km Lej da Staz Trail follows an easy gravel path along the shores of St Moritzersee before diving into the trees for a loop around tree-encircled waters of Stazersee. Get to St Moritz by rail, ideally on the Glacier Express from Zermatt, or the Bernina Express from the Swiss town of Chur or the Italian town of Tirano.

WHEN

Autumn is the time to see larches putting on their golden foliage show. Above 4922ft (1500m), larches start to change colour from mid-October; at lower elevations, the change can happen as late as November.

RIGHT LARCHES IN LOMBARDY'S WINTRY VALTELLINA IN ITALY; OPPOSITE TOP A MOUNTAINSIDE OF LARCHES NEAR BELLUNO IN ITALY'S VENETO REGION; OPPOSITE BELOW YOUNG LARCH CONES MATURE THEN DISPERSE THEIR SEEDS DURING WINTER

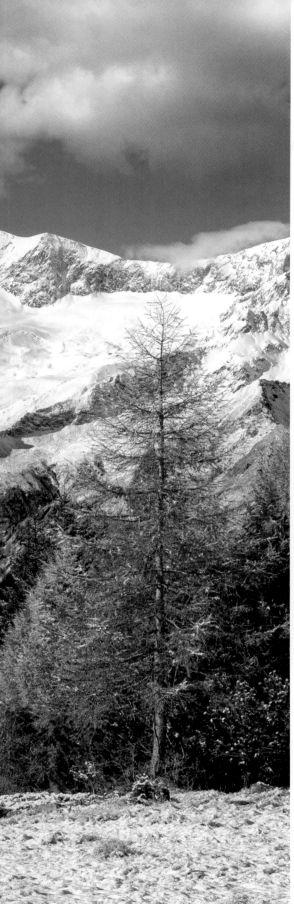

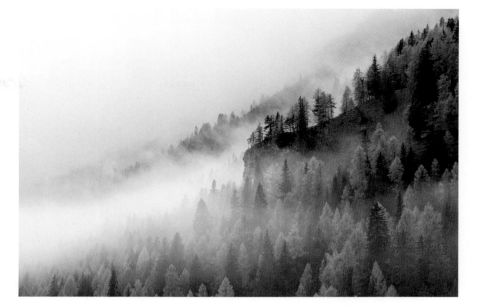

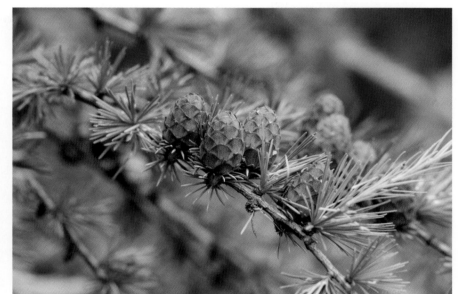

How to Identify

The slender, conical shape of the European larch is a familiar sight in alpine regions, soaring high and punctuating the landscape. Seasonal colour changes that take place before needle-shed make this tree easily distinguishable from Europe's other evergreen coniferous species. Needles are clustered in bunches of 20 to 40, measuring 0.5in to 2in (1.5cm to 4cm) long. The reddish-brown bark develops vertical scars or fissures as the tree ages.

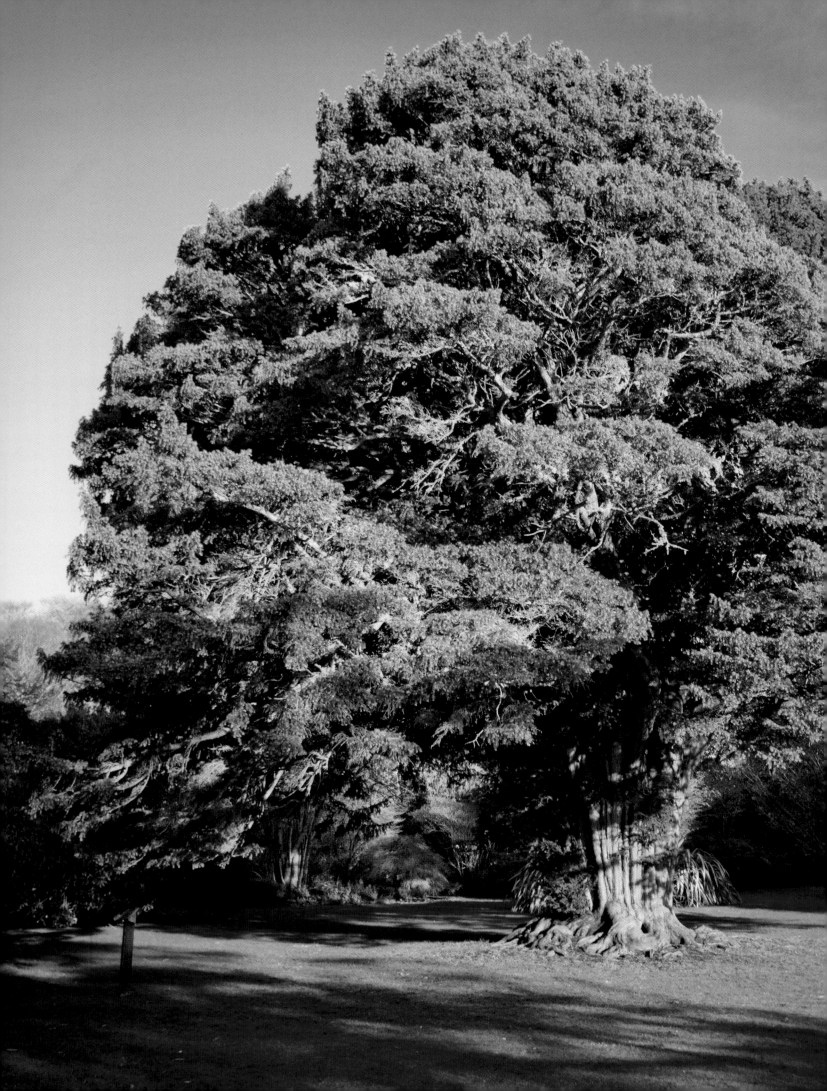

Yew

Taxus baccata

Vitals

RANGE
Europe-wide

STATUS
Least Concern

LIFESPAN
<600 years

AVERAGE HEIGHT
33ft-66ft (10m-20m)

FROM MEDIEVAL WEAPONRY TO MODERN MEDICINE, THE LONG-LIVED YEW BOASTS A RICH HISTORY OF VERSATILE APPLICATION

The yew has long been revered as a sacred tree, valued for its evergreen longevity and often associated with immortality. It is celebrated for the practical utility of its timber, used to make various valuable products over thousands of years: the Clacton Spear, discovered in 1911 in Britain's Clacton-on-Sea, is estimated to have been hewn from yew some 400,000 ago, and is considered the world's oldest known worked wooden tool. The Battle of Agincourt in 1415 was won by English archers and their longbows of yew. Modern medicine has also greatly benefitted from this marvellous tree, with a compound extracted from yew bark used in cancer treatment.

Yew trees can grow for a very long time, and though their average lifespan is up to 600 years, many specimens are dated as much older. In the southern county of West Sussex, Kingley Vale is Britain's largest area of yew woodland, with many ancient trees that are estimated to be over 2000 years old. This venerable forest has a mystical atmosphere, with the yews' hollow trunks, fallen limbs and low-hanging branches creating what sometimes feels more like a maze than a woodland.

Across Britain, similarly ancient yews stand in churchyards, their age often predating the construction of these millennia-old places of worship. This repeated intentional planting close to church buildings might hint to the sacred value once ascribed to these trees; more prosaically, their poisonous leaves may have been valued for their ability to deter grazing cattle. Whatever the reason, the yew remains a constant feature of the British landscape.

LEFT YEW TREES, SUCH AS THIS ONE IN SCOTLAND, ARE ONE OF THE UK'S THREE NATIVE CONIFERS

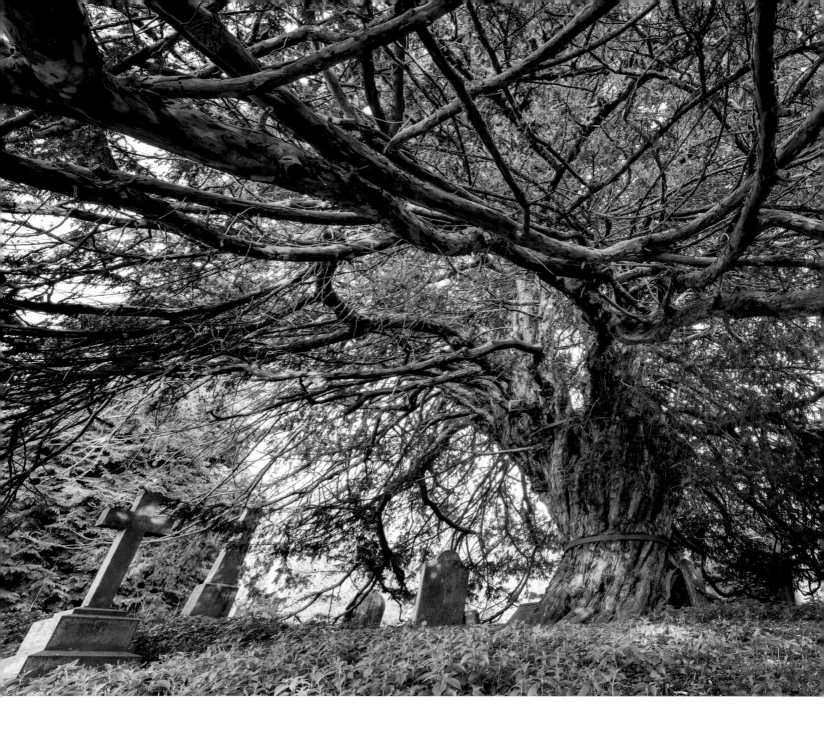

How to See

WHERE

Anyone growing up in the European countryside knows all about yew trees and the extreme inadvisability of eating their fleshy, poisonous berries. Britons of certain centuries also knew the yew as the best source of wood for making longbows – something that gave Britain the fighting edge in more than a few battles with its continental neighbours.

Today, yew trees pop up in gardens, hedgerows and church-yards across rural England, but to see traces of the yew forests that once covered large areas of the South Downs, head to King-ley Vale near Chichester. This Site of Special Scientific Interest is conveniently close to Bosham on the Brighton–Southampton railway line, so take the train, and walk or cycle the last 3.5-miles (5.6km) via East Ashling and West Stoke.

On arrival, you'll find an environment that feels tangibly medieval, with knotted, wide-trunked yew trees rising from a red carpet of fallen needles. Explore on the 5-mile (8km) Kingley Vale Trail, starting from Stoughton or West Stoke and visiting various Bronze Age, Iron Age and Neolithic sites along the way.

How to Identify

This evergreen conifer exhibits dark green, needle-like leaves with a sharp point, measuring no more than 2in (5cm). After pollination, the green, bud-like flowers of female yews go on to produce red berries. The yew's bark is reddish-brown and peels away from the trunk in thin strips. Younger trees typically have a compact, bushy form, and are often used for hedging; older trees may develop a more upright habit.

LEFT ANCIENT YEWS ARE OFTEN FOUND IN CHURCHYARDS, SUCH AS BELTINGHAM, NORTHUMBERLAND;
BELOW THE YEW TREE AVENUE AT CLIPSHAM, LEICESTERSHIRE IS OVER 200 YEARS OLD AND
CONSISTS OF 150 CLIPPED YEW TREES; BELOW THE BARK OF YEW TREES IS RED AND FLAKY

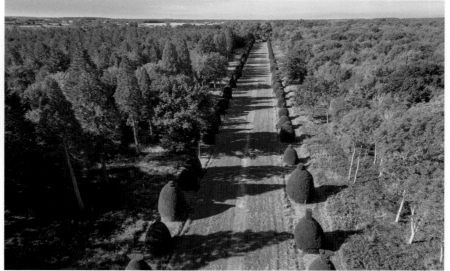

WHEN

Anytime from April to October is ideal for the walk to and through Kingley Vale. Yews burst into berry from June to September, but they're also striking in winter, though you may face a chilly wait for a train at Bosham station at the end of the walk.

Common Beech

Fagus sylvatica

———

Vitals

RANGE
Central and Western Europe

STATUS
Least Concern

LIFESPAN
<350 years

AVERAGE HEIGHT
80ft-120ft (24m-35m)

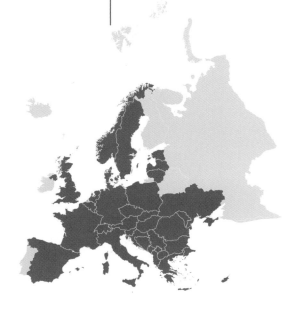

WITH ITS TIMBER AND TRUNK REVERED AS A
SURFACE FOR ANCIENT WRITING, THE BEECH HAS
PLAYED A KEY ROLE IN THE EVOLUTION OF LANGUAGE

Native to the European continent, the deciduous beech tree exhibits a remarkable degree of adaptability. From the mellow woodlands of the United Kingdom to the deep forests of Spain, the common beech is an almost omnipresent character of the central and western European landscape. Growing well in different climates and in both acidic and alkaline soils, this species exemplifies resilience and versatility.

The beech is also linked to the evolution of communication and has a fascinating etymological legacy: originally the tree was named *boc* in Old English, a word that later morphed into today's English noun 'book'. Before the invention of paper, both the living tree and tablets made from its timber served as a canvas for arborglyphs, with the art of carving runes, symbols and letters made easier by the wood's softness.

The young leaves of the beech tree unfurl in early spring in a vivid lime-green colour, often considered a harbinger of the changing seasons, and go on to gradually mature through the summer months to a darker shade of green. Come autumn, beech forests dazzle as a spectacle of gold and copper hues. The leaves slowly fall through the autumn and winter to carpet the forest floor. In the Basque regions of France and Spain, such mythic beings as Basajaun, the Lord of the Woods, and Mari, the Queen of Nature, dwell in beech forests and keep natural forces in balance.

RIGHT SPRING BRINGS GREEN LEAVES TO THE BEECHES OF GERMANY'S HAINICH NATIONAL PARK

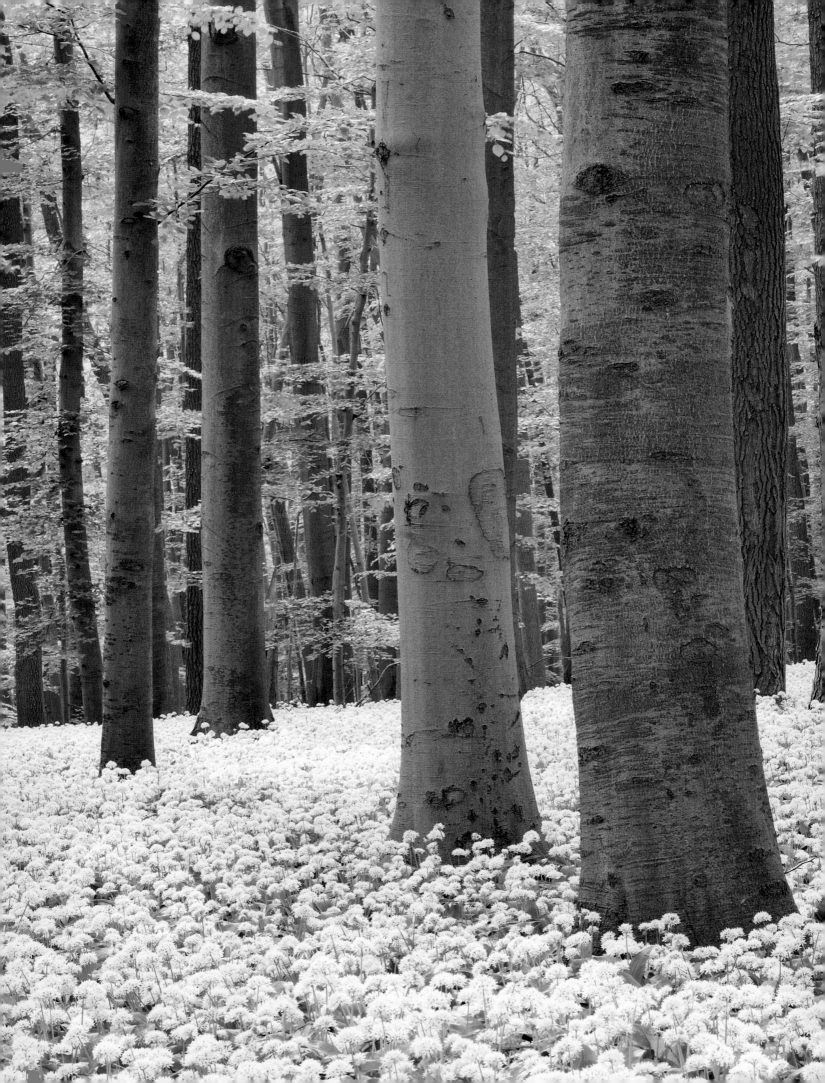

How to See

WHERE

The beech tree is a tangible part of prehistory, a relic of wild woodlands before horticulturalists started shifting tree species from continent to continent. Thought to have been cultivated for its edible nuts from the end of the last ice age, beeches are found in old-growth deciduous forests across a broad swathe of Europe from Britain to Scandinavia, with a different (but related) species found in North America.

Beech forests are characterised by a lack of undergrowth beneath their canopies (a result of a dense shade cast by their leaves), making them ideal for forest walks. The beech forests of Spain's Basque country are particularly gorgeous in late summer and early autumn, when the forest floor is painted coppery red by fallen leaves, contrasting vividly with the green moss that flourishes on the trees' knotted roots.

Try a leisurely afternoon walk amongst the beeches in the Otzarreta forest in Parque Natural de Gorbeia, accessible by hire car from Bilbao. Just follow the N640 south past Areatza and look for signs to the Otzarreta parking area, where the forest trails begin. Get more inspiration at the visitor centres in Sarria (Central de Baias) and Areatza.

WHEN

Spain's beech forests are particularly beautiful at the end of the summer, in September, when branches are ornamented by beechnuts and leaves begin their shift from green to intense red, making the woods feel magical and mysterious.

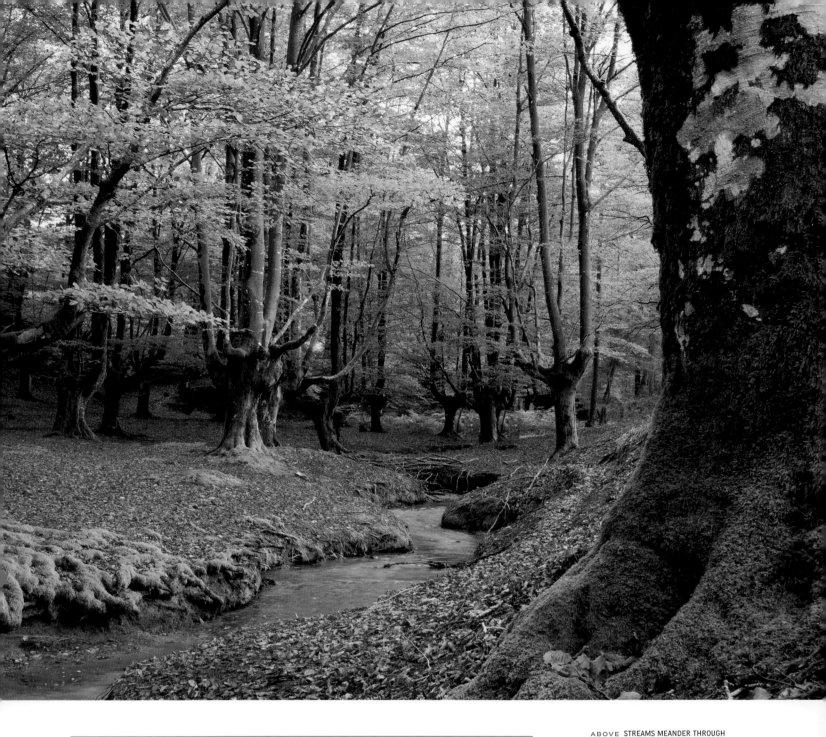

How to Identify

Beech leaves are oval in shape and slightly toothed, changing colour from bright green in spring to golden yellow and red in the autumn. Beechnuts, encased in prickly husks, ripen through the summer before dropping and blanketing the immediate ground. In a winter forest devoid of colour, the beech is easily distinguishable by its grey bark and pointed leaf buds lying in wait for the warmth of spring.

ABOVE STREAMS MEANDER THROUGH THE OTZARRETA BEECH FOREST IN THE BASQUE REGION'S GORBEIA NATURAL PARK; OPPOSITE THE DISTINCTIVE SMOOTH BARK OF A BEECH TREE; OVERLEAF AUTUMN IN THE UNESCO-RECOGNISED BEECH FORESTS OF CASTILE AND LEÓN IN SPAIN

Olive

Olea europaea

Vitals

RANGE
Mediterranean Basin

STATUS
Least Concern

LIFESPAN
<500 years

AVERAGE HEIGHT
20ft-30ft (6m-9m)

CULTIVATED FOR THOUSANDS OF YEARS, EUROPE'S OLIVE TREES ARE A REMINDER OF THE TIMELESS SYMBIOSIS BETWEEN HUMANS AND NATURE

Imagine the stories that an olive tree 2000 years of age or more could tell. In Greece, some may have witnessed Alexander the Great's conquests or, in Italy, the fall of the Roman Empire. And today those same gnarled trees, with thick, scarred trunks, still stand in southern European villages, an evocative part of a weather-beaten landscape.

Revered since ancient times, olive trees play a significant role, both culturally and economically, within the Mediterranean region. The cultivation of *O europaea* remains an important agricultural practice. The olive's hardwood has long been used for utensils and its fruit and oil are sold around the world. Many family-run farms uphold age-old traditions and techniques – such as the harvesting of fruit by hand with wooden ladders and rakes every October and November – and preserve a connection with the olive tree that has existed for millennia.

In Greece, olive groves are a common sight. Often, they are planted in terraces, with the silver-green foliage reflecting the Mediterranean sun. Young trees do not produce olives until they're about five years old; thereafter, they bear more fruit year on year. Closely tied to Athena, the goddess of wisdom and warfare, the olive tree is embedded in Greek mythology: Athena is said to have gifted the olive tree to the city of Athens, earning her the city's patronage and confirming the olive as a sacred tree and a symbol of peace and prosperity. It has been immortalised in ancient texts, paintings and religious symbolism, with olive branches famously found in the tomb of Egyptian pharaoh Tutankhamun, as well as being crafted into wreaths presented to winners at the ancient Olympic Games, symbolising both prowess and harmony.

LEFT THE GREEK ISLAND OF NAXOS IN THE CYCLADES IS HOME TO MANY OLD OLIVE TREES

How to See

No tree says 'The Med' quite like the olive. Indeed, it's hard to avoid these silver-leaved charmers if you travel anywhere between the south of France and the Mediterranean coastlines of Turkey, the Levant and North Africa.

On almost any countryside drive along northern Mediterranean shores, you'll spot the distinctive stunted trunks and silvery crowns of olive trees dotted across the landscape; from October to February, you might see village farmers harvesting the fruit that made the region's fortunes.

The wild olive tree, *O sylvestris*, is most easily spotted in the far south of Spain, but one of the most atmospheric places to see cultivated groves of *O europaea* is the Greek island of Lesvos, where soils rich in the minerals spewed up by long extinct volcanoes nourish more than 11 million olive trees.

Finding atmospheric olive groves is just a case of pointing your car towards any rural road on the island – we recommend a trip to the village of Agia Paraskevi, where you can hike through groves of truly ancient olive trees to the ruins of the 6th-century Sanctuary of Apollo at Klopedi.

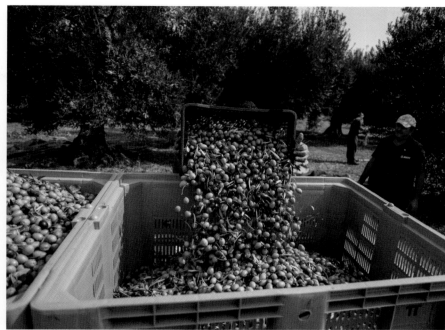

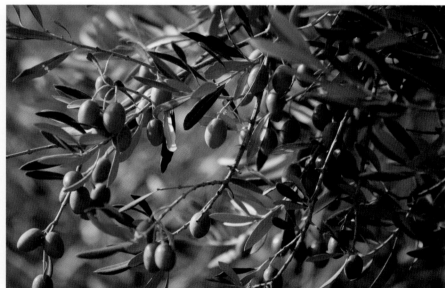

WHEN

Countryside walks can be hard going on Lesvos in the baking Mediterranean summer. Stick to the spring or autumn months, when the climate is more conducive to exploring and you can stay in village guest-houses without the need for air-conditioning.

ABOVE SPAIN IS THE WORLD'S LARGEST PRODUCER OF OLIVES;

TOP RIGHT HARVESTING OLIVES IN THE VILLAGE OF YERAKINI, HALKIDIKI,

GREECE; LOWER RIGHT GREEN OLIVES ARE LESS RIPE THAN BLACK FRUIT

How to Identify

The olive tree's distinctive silver-green leaves are narrow, lance-shaped and rigid to the touch, measuring 2in to 4in (5cm to 10cm) long. Olive trees are pruned to form a willow-like, pendulous shape, yet even more striking is the gnarled and twisted trunk, aged and weathered, and often with a greyish tint to the bark. Flowering occurs in spring, with small, cream-white blooms going on to produce fruit in summer and autumn.

179

English Oak

Quercus robur

Vitals

RANGE
Europe

STATUS
Least Concern

LIFESPAN
<800 years

AVERAGE HEIGHT
65ft-130ft (20m-40m)

FROM THE VERSES OF SHAKESPEARE TO TALES OF ROBIN HOOD, THE OAK HOLDS A SPECIAL PLACE IN THE ENGLISH IMAGINATION

No other tree in England is imbued with such meaning and symbolism as the oak. William Shakespeare referenced these steadfast trees in 18 of his plays, while the mythic Green Man, associated with rebirth and the coming of spring, has been carved into stone since medieval times, often bearing the adornment of oak leaves. The pagan symbol was absorbed into Christian churches and cathedrals. In 1651, King Charles II famously hid in an oak tree, hence the number of Royal Oak pubs. Today, the oak is a symbol of strength, its distinctive form deployed in the logos of charities and organisations across the UK.

As one of England's most prevalent native trees, oaks are a common sight across the country, particularly in lowland areas. Boasting one of Europe's largest collections of ancient English oaks (those over 400 years old), Nottinghamshire's Sherwood Forest serves as a prominent home for many of the most majestic specimens. These are trees of character, with an imposing stature and a distinctive shape, often spreading as wide as they are tall. Of all the exemplar ancient oaks to be found in England, Sherwood's Major Oak is surely the one to see. Estimated to be between 800 and 1100 years old, and with a 91ft-wide (28m) canopy and a 36ft (11m) trunk circumference, this arboreal giant is England's largest oak tree. It's found in a clearing of its own, and legend tells that Robin Hood and his Merry Men sought refuge beneath its canopy and concealed themselves within its trunk. Today, visitors cannot clamber on it: this ancient tree is securely propped up and protected, and remains a symbol of fortitude.

RIGHT AN OAK TREE REFLECTED IN ELTERWATER IN ENGLAND'S LAKE DISTRICT

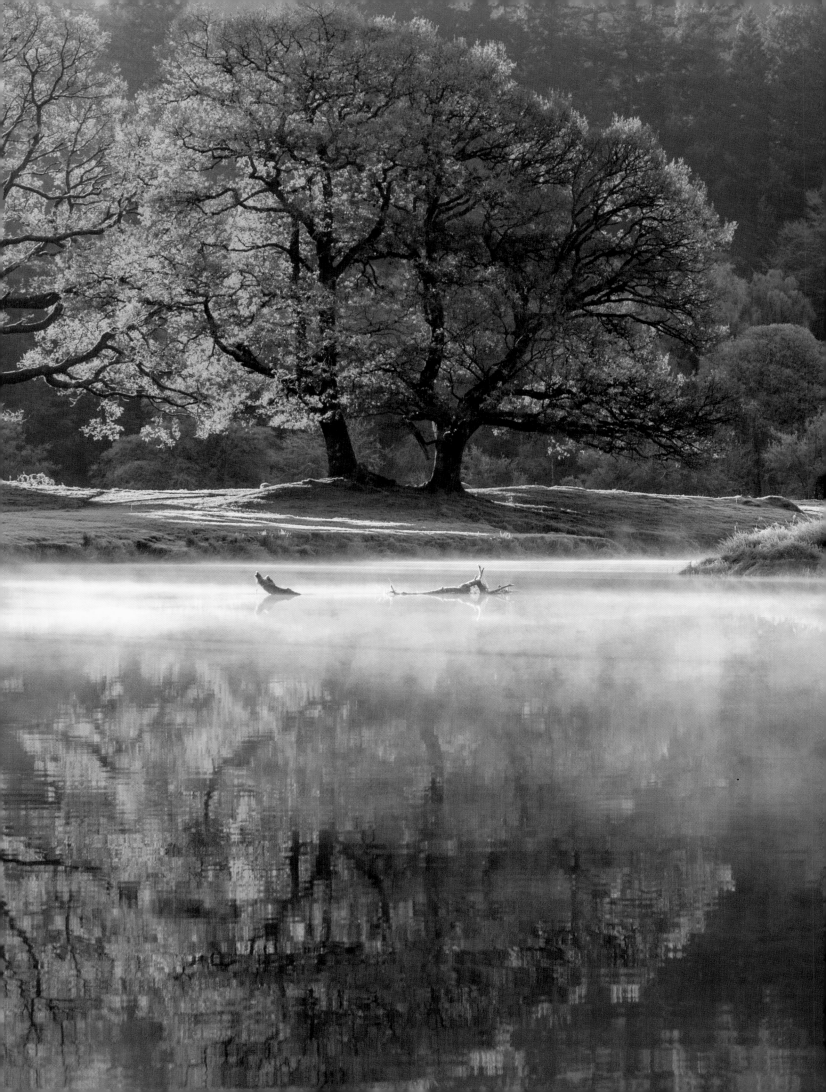

How to See

WHERE

If we're being 100% honest, the English oak is English in name only, as the tree is found in temperate woodlands everywhere from Europe to western Asia. It is however fair to say that this is a tree deservedly associated with the ancient forests of England, which once covered vast areas of countryside, before untold millions of trees were felled for construction, agriculture and shipbuilding.

Some dramatic English oak forests still survive, however, many preserved in royal hunting estates that later became public lands. Just outside Nottingham, Sherwood Forest has hosted robust English oaks since the end of the last ice age, and it was a hunting ground for every royal worth their crown, from William the Conqueror to the notorious King John.

This storied woodland is easily accessible from Nottingham via the M1 and A617, then the A6075 to Edwinstowe. To get close to the forest's grandest oaks, walk the 1.5-mile (2.4km) trail that threads through the forest to the Major Oak. Longer hikes include the 2-mile (3.2km) Greenwood Trail and the 4-mile (6.4km) Wildwood Trail.

WHEN

The warm afternoons of late summer are a great time to explore Sherwood, but with kids in tow, come in autumn, from September to October, when the oaks' branches are encrusted with acorns.

TOP RIGHT SOLITARY OAK TREES IN BRITISH FIELDS CAN PROVIDE SHADE FOR
LIVESTOCK; RIGHT ACORNS ARE VALUABLE FOOD FOR WILDLIFE;
CENTRE A GRANITE CARVING OF THE GREEN MAN RINGED WITH OAK LEAVES
OPPOSITE RIGHT THE MAJOR OAK IN SHERWOOD FOREST, NOTTINGHAMSHIRE

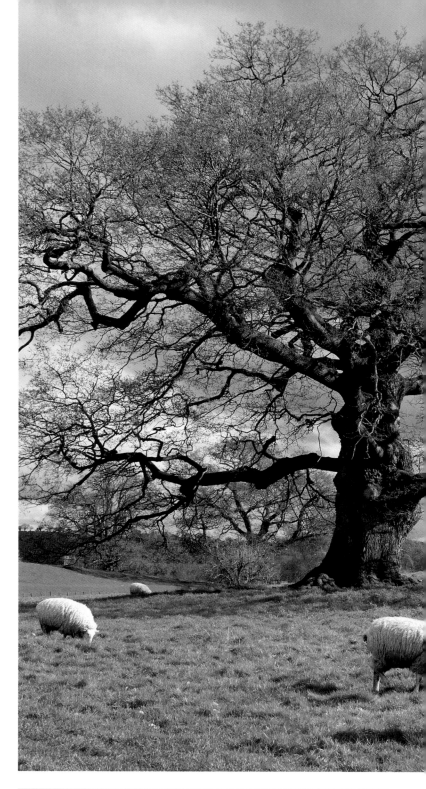

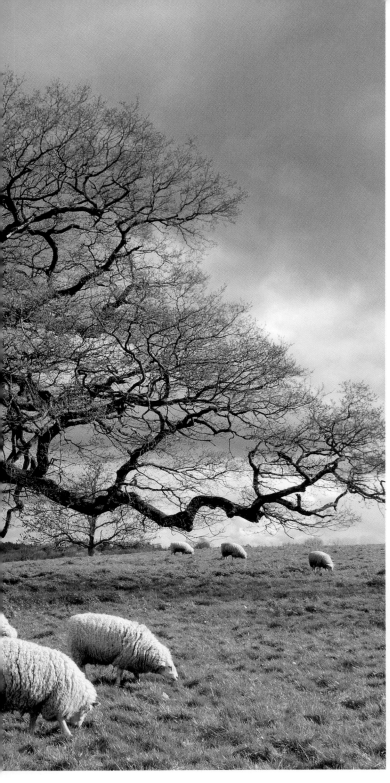

How to Identify

The distinctive lobed leaves of the English oak will be familiar to many, measuring 3in to 5in (8cm to 13cm) and displaying a rich green hue in spring that transitions to various shades of yellow and then brown in autumn. Mature trees have a textured, fissured grey bark, while their relatively short trunks provide support for a broad canopy. Green acorns develop at the end of summer before turning brown in the autumn.

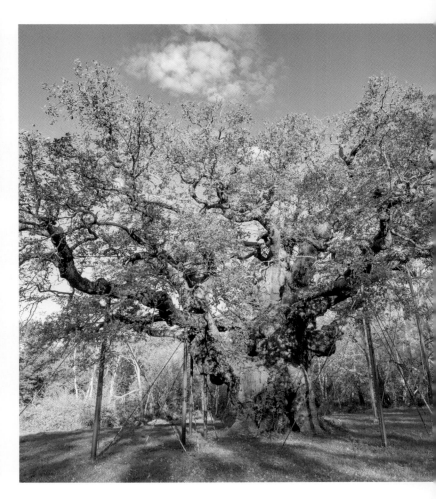

Norway Spruce

Picea abies

———

Vitals

RANGE

Northern, Central and Eastern Europe

STATUS

Least Concern

LIFESPAN

<300 years

AVERAGE HEIGHT

98ft-131ft (30m-40m)

EVOKING WINTER FESTIVITIES, THIS CONIFER ALSO REPRESENTS REMARKABLE LONGEVITY, PRACTICALITY AND ADAPTABILITY

Gracing the northern landscape with its towering, conical form, the Norway spruce stands as an emblem of winter – this resilient evergreen can happily tolerate both frozen ground and icy winds. To most, it is a symbol of the Christmas holidays, with its triangular shape readily drawn by children when imagining the perfect festive tree. However, the Norway spruce isn't just cultivated for Christmas celebrations. Its timber has been highly valued since the 1800s, used for furniture, flooring and even violins. Today it remains one of the most important coniferous species of the European forestry industry.

P abies is the main tree species in the boreal regions of northern Europe, shaping and dominating the landscape. Up in the mountains here, forests of Norway spruce stretch on as far as the eye can see, washing over the high ground and hills with a dense canopy of green that darkens the landscape.

The Norway spruce is renowned for its remarkable longevity, often living for several centuries in challenging – and chilly – environments. One such example, named as Old Tjikko, can be found hanging in on a mountain top within Sweden's Fulufjället National Park. It is one of the oldest clonal trees in the world, meaning that its many genetically identical stems have been produced by a singular root system, estimated to be over 9000 years old. This ability to regenerate enables the Norway spruce to survive extreme environmental events, such as wildfires or significant snowfall, and is a testament to the species' incredible resilience.

LEFT A NORWAY SPRUCE STANDS OUT AGAINST A WINTRY LANDSCAPE

How to See

There are no prizes for guessing the best place to see the Norway spruce. This iconic conifer – the most popular Christmas tree until the rise of the needle-retaining Nordmann fir – is found all the way from Scandinavia and central Europe to North America, but in the evergreen spruce forests of Norway, it feels like Christmas year-round.

Southwest of Oslo, Lake Fyresvatn is a stunning setting for spruce spotting, with glacier-sculpted hills covered by sprawling spruce forests wrapped around a still and silent lake, and winding trails thronged by hikers in summer and Telemark skiers in winter. There's no public transport, so reach Fyresvatn by car from Oslo, following the E134 and FV355 to the village of Fyresdal on the lakeshore.

For an easy warm-up before you dive deeper into the forests, the 2-mile (3.5km) Hamaren Trail from Fyresdal is suitable for pedestrians, cyclists, pushchairs and wheelchairs, with a boardwalk that climbs into the canopy and offers great views out over the lake. For a meatier forest hike, head to the top of 1125ft-high (343m) Klokkar-hamaren, the highest peak at Hamaren.

How to Identify

Seeking out this tall evergreen, with its unmistakable silhouette, should be a straightforward task. Branches typically hang down, and from a distance the tree will appear perfectly conical, with a straight and regular trunk. Dark green needles fill the branches, sharp to the touch and approximately 1in (2.5cm) long. The cones of the Norway spruce appear red-brown in autumn and are pendulous, hanging down from the branches.

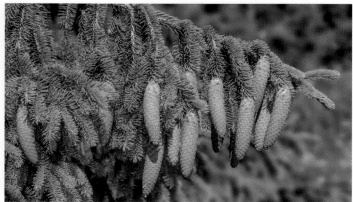

WHEN

Summer and early autumn are the prime times to walk around Lake Fyresvatn, with barbecue huts and outdoor kitchens for outdoor grills and picnics, and a treetop trampoline for the kids. Wrap up warm for winter visits: temperatures regularly drop below -5°C (23°F).

ABOVE A SPRUCE FOREST IN THE GLACIAL LANDSCAPE OF NORWAY'S NORDLAND;

TOP RIGHT DRIED SPRUCE CONES ARE SOMETIMES USED FOR CHRISTMAS DECORATIONS;

RIGHT BIRDS, SUCH AS THE SIBERIAN JAY, FEED ON THE SEEDS INSIDE SPRUCE CONES

Horse Chestnut

Aesculus hippocastanum

Vitals

RANGE
Southeastern Europe

STATUS
Near Threatened

LIFESPAN
<300 years

AVERAGE HEIGHT
60ft-80ft (18m-24m)

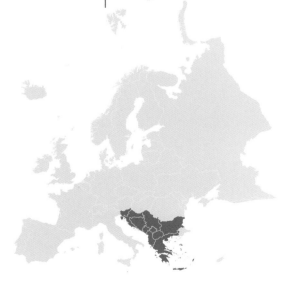

THE HORSE CHESTNUT IS A FAMILIAR FEATURE OF CITY PARKLANDS AND STREETS, FAMED FOR BOTH ITS CANDELABRA-LIKE FLOWERS AND ITS CONKERS

Endemic to the Balkan Peninsula, this relict species boasts a history spanning over a million years to the Pleistocene epoch. The horse chestnut was once widespread across Europe, but its dwindling native populations are today restricted to Greece, Albania and Bulgaria. Although numbers of *A hippocastanum* are much reduced in forests, its presence in urban landscapes and parklands worldwide attests to its enduring popularity.

In its native habitats, such as the Preslav Mountains in eastern Bulgaria, the horse chestnut is found in broadleaf deciduous forests, standing tall and majestic even in a crowded woodland. The show begins in early spring (it's often one of the earliest deciduous trees to awaken), when bare branches burst into a riot of colour with the unfurling of pleasingly palmate lime-green leaves. Soon after, candelabra-like flowers adorn the tree in hues of white and pink.

Yet the true treasure comes in autumn, when the seeds – commonly known as conkers – develop within spiky green casings. Although inedible, conkers hold a special place in the collective memory within the UK and Ireland. Traditionally, they have been used as a remedy for varicose veins and for helping with blood flow in ageing legs. Conkers have also been an important symbol in folklore, thought to ward off evil spirits and even deter spiders from coming inside homes. Today, these shiny seeds preserve a nostalgic and folkloric charm, thanks to cherished childhood memories of tournaments armed only with conkers threaded on to string, evoking simpler times from long ago.

RIGHT HORSE CHESTNUT TREES ARE MAGNIFICENT IN BLOSSOM

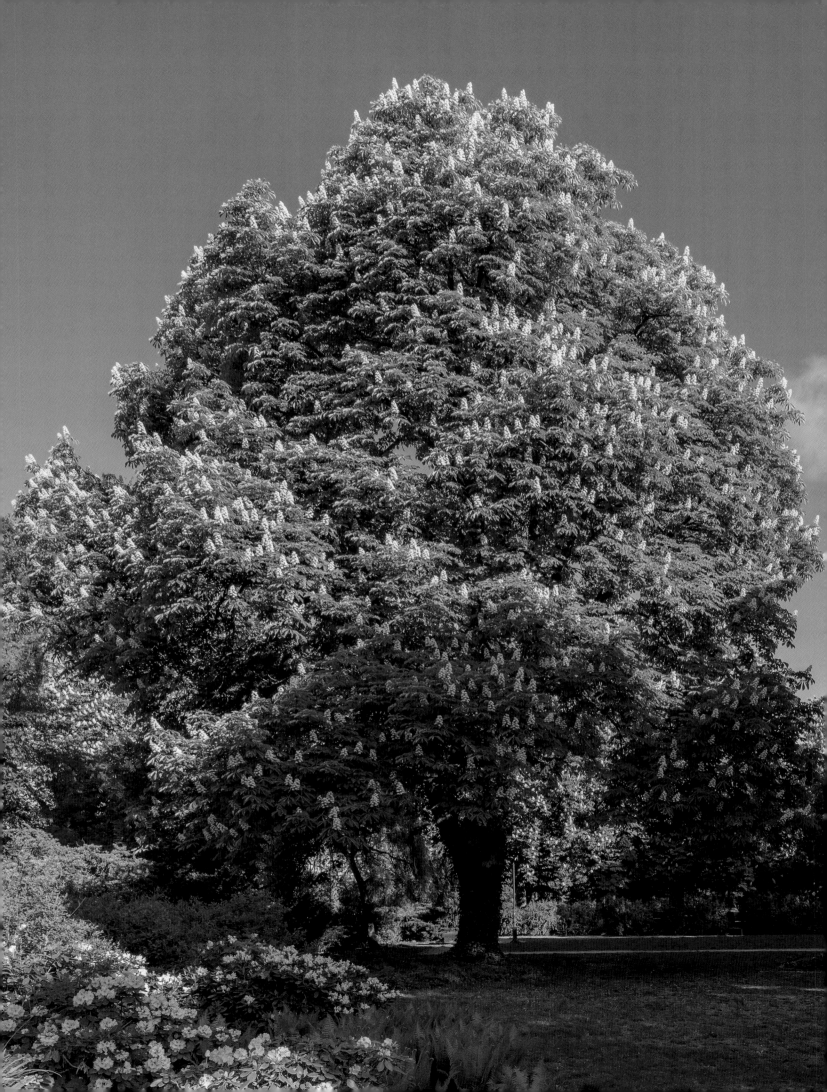

How to See

WHERE

For a common tree, the horse chestnut delivers plenty of year-round spectacle. Sticky buds in spring; white or pink panicle-mounted flowers in early summer; spiky green capsules bursting to reveal rich brown nuts in late summer; and dramatic, rust-coloured autumn foliage from September to October.

The British like to claim the horse chestnut and conkers, the game played with its nuts, but the tree was actually imported from the Balkans and Eastern Europe in the 16th century. To see horse chestnuts trees on their home turf, head to the Preslav Mountains in eastern Bulgaria, rising south of the city of Shumen.

The dense forests south of Veliki Preslav, the first capital of Bulgaria in the early Middle Ages, are full of mature, centuries-old horse chestnut trees, particularly in the Dervisha Managed Nature Reserve. With a guide from Veliki Preslav, you can hike out to the ruins of the 9th-century capital, then penetrate deep into forests that were ancient when the nations of Eastern Europe were first conceived.

WHEN

The weather from spring through to autumn is great for hiking in Bulgaria, so you can take in all the stages of the seasonal horse chestnut show. Our favourite time is autumn, when the fat, spiny conker capsules drop the forest floor and split, revealing the jewel-like nuts inside (bring some string and an awl if you have your heart set on playing conkers).

RIGHT A RED HORSE CHESTNUT TREE GROWING IN SOFIA, BULGARIA;

OPPOSITE TOP AUTUMN FOLIAGE ON A HORSE CHESTNUT TREE;

OPPOSITE LOWER CONKERS ARE STREWN BENEATH HORSE CHESTNUTS

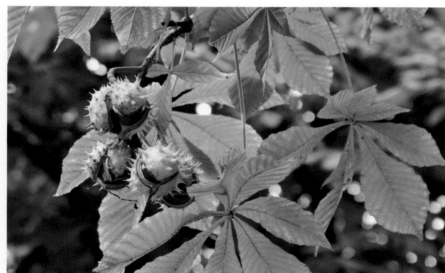

How to Identify

The bark of the young horse chestnut tree will appear smooth and grey whilst developing distinctive ridges with age. In spring and summer, the expansive canopy is made up of attractive palmate leaves, usually with five to seven leaflets and lime-green in colour. Clusters of candelabra-like white and pink flowers bloom in the spring months. Spiky husks develop in autumn, containing the infamous conker seeds, glossy brown and approximately 1in (2.5cm) in length.

Almond

Prunus dulcis, syn. Prunus amygdalus

Vitals

RANGE

Southern Europe, Mediterranean Basin

STATUS

Least Concern

LIFESPAN

<50 years

AVERAGE HEIGHT

13ft-40ft (4m-12m)

WITH ITS DELICATE PINK-AND-WHITE BLOSSOM, THE ALMOND TREE PUTS ON A BEAUTIFUL SPECTACLE EVERY SPRING

Introduced to Spain from Iran during the 800-year Moorish occupation of the Iberian Peninsula and its surrounding islands, almond trees have since become an integral part of southern Europe's agricultural heritage. The almond has profoundly influenced the Mediterranean landscape, most notably on the Balearic island of Mallorca, where over seven million trees have helped Spain to become one of the world's leading suppliers of almonds. Today, almonds from Mallorca and across Spain are exported throughout the world.

In early spring, almond orchards across southern Europe burst into flower, painting hills and valleys a sea of white and pink. On Mallorca, the blossom season has become a cultural and touristic event, with visitors descending to seek out the beauty of the flowering orchards. This phenomenon bears resemblance to Japan's *sakura* festivals, which honour the blossom of another member of the Prunus family, the cherry tree (see page 123). Perhaps not as celebrated as the cherry, the blossoming almond is no less beautiful at this time of year.

As spring transitions to summer, the almond orchards transform as they come into leaf, a green canopy forming where the blooms briefly frothed. Sheep and goats often graze in the shade beneath the trees. Later in the year, the trees bear fruit, otherwise known as drupes, consisting of a fleshy outer hull surrounding a smaller, hard casing within which the delicious almond seed is found. Harvesting traditionally takes place from August, depending on the variety, completed by mechanical tree-shakers that help to loosen the drupes. The fallen fruit can then be collected and processed.

LEFT ALMOND BLOSSOM SWEEPS MALLORCA IN JANUARY AND FEBRUARY

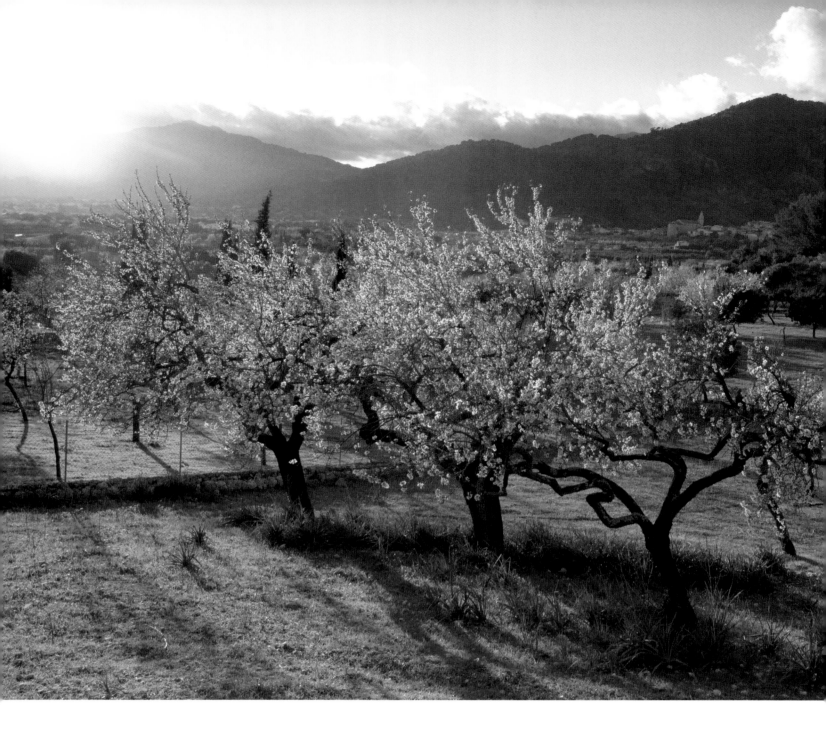

How to See

Native to Iran and the Levant, the almond has fuelled a thousand Middle Eastern and southern European desserts, from Iranian *kayk-e eshgh* (almond love cake) to Spanish marzipan, alongside a host of savoury dishes from Persian *khoresh chaghaleh badoom* (green almond stew) stew to French *truite aux amandes*.

Today, the tree that provides these versatile nuts is cultivated across the globe, from California to Morocco, but Spain is Europe's biggest producer of almonds. The dry landscape of Mallorca comes alive every spring as millions of almond trees burst into flower, and alive with human activity in autumn during the nut harvest.

The densest almond orchards are found in the middle of Mallorca, around the villages of Sant Llorenç, Santa Maria, Selva, Sencelles, Bunyola, Marratxí and Lloseta, in the shadow of the Serra de Tramuntana. This small island measures just 62 miles by 47 miles (100km by 75km), so rent a car in Palma to explore the almond country, stopping in at village patisseries to sample Mallorca's famous *gató mallorquín de almendra* (almond cake with lemon zest).

How to Identify

Almond trees are deciduous, losing their leaves in autumn. During early spring, they showcase exquisite white or pink blossoms, before rounded, oval-shaped leaves unfurl, approximately 3in to 5in (8cm to 13cm) in length. Later in the summer, distinctive drupe fruits emerge, enclosing the coveted nuts. With an upright spreading shape, and grey bark that darkens and becomes ridged with age, almond trees rarely reach heights in excess of 40ft (12m).

LEFT IN THE FOOTHILLS OF THE TRAMUNTANA RANGE, FIND THESE ALMOND ORCHARDS BETWEEN THE VILLAGES OF MOSCARI AND CAIMARI; BELOW AFTER THE FLOWERS ARE POLLINATED, ALMONDS ARE HARVESTED FROM AUGUST AND SEPTEMBER

WHEN

Millions of almond trees explode into bloom on the island of Mallorca between January and March, but the spring weather can be a little chilly for orchard walks and sitting outside in pavement cafes. The harvest season from August to September is a better proposition, with lingering heat and thinning crowds once the schools go back in September.

Oceania

Mountain Ash

Eucalyptus regnans

Vitals

RANGE
Southeast Australia

STATUS
Least Concern

LIFESPAN
<400 years

AVERAGE HEIGHT
200ft-300ft (61m-91m)

A TITAN AMONG TREES, THE MONUMENTAL
MOUNTAIN ASH SOARS ABOVE ALL OTHERS ACROSS
THE FORESTS OF SOUTHERN AUSTRALIA

Exploring a forest of mountain ash eucalypts in a place like Victoria's
Yarra Ranges National Park is a sensory experience like no other. First,
you'll feel awed by the scale of these trees, their crowns often draped
in mist or cloud, since they prefer higher elevations in cool temperate
regions. Underfoot, thick scrolls of their bark crunch (beware snakes
near water). The raucous calls of parrots ricochet around the trees. And
the air is filled with the zingy scent of Australia's flora. Bushes of wattle
bloom yellow in spring and giant ferns unfurl vivid green shoots.

The mountain ash rules over the mild and wet mountainous areas of
southeast Australia and Tasmania. It is a tree of staggering proportions,
rivalling both the redwood and Douglas fir in the western United
States. It is – without question – the tallest of any flowering tree or
plant (angiosperm) and is decorated each spring with dainty white
flowers. In southern Tasmania's Huon Valley, the aptly named Centu-
rion, at over 330ft (101m) high, is the third-tallest living tree on Earth.

The evergreen, lance-shaped foliage is leathery and hard to the touch,
with a distinct aroma due to the essential oil that the tree produces.
This oil is extremely flammable, helping to explain why eucalyptus
forests are so prone to fire. Yet the mountain ash has a clever evolu-
tionary adaptation, encasing its seed in sturdy capsules that are trig-
gered to open following high-intensity forest fires. The newly released
seeds can then exploit the growing opportunities after the fire, with
greater light and nutrient-rich ash feeding the soil.

RIGHT FEEL DWARFED BY MOUNTAIN ASH TREES IN VICTORIA'S YARRA RANGES NATIONAL PARK

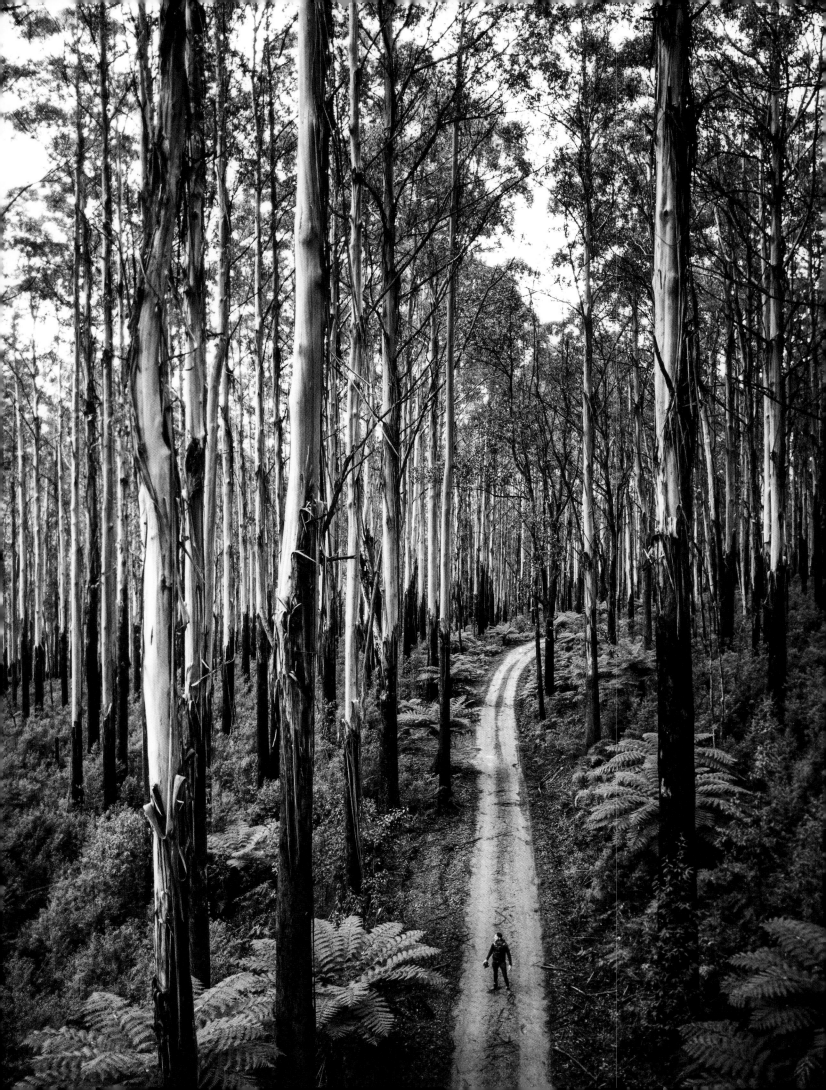

How to See

Walk through forests of mountain ash trees in several national parks across the state of Victoria. Within easy reach of state capital Melbourne, top options are Dandenong Ranges National Park to the east, reached by train to Upper Ferntree Gully station and then buses. This park is notable for having trails with excellent access for people with a disability and free TrailRider all-terrain wheelchairs available to use.

Northeast of Melbourne, the wonderful Yarra Ranges National Park can be reached via the Warburton Rail Trail from Lilydale train station. Here, walk or ride through cool, temperate mountain ash forest on undulating but surfaced tracks such as the O'Shannassy Aqueduct trail. Cyclists can also pedal up to the Acheron Gap on gravel roads, passing the Rainforest Gallery, which is a viewing platform deep in the forest canopy. Stay in the town of Warburton on the edge of the forest.

And west of Melbourne, the diverse habitat of the Great Otway National Park is home to mountain ash trees. You can take to the forest canopy at the Otway Fly visitor attraction. Apollo Bay or the town of Forrest are good bases and can be reached by bus.

WHEN
Mountain ash are magnificent all year round but unless you have a high tolerance for cold and rain, avoid June, July and August. From September, spring brings blossom to the trees and surrounding wattle bushes, and wildlife wakes up. Late summer from January crackles with heat and increased risk of bushfires.

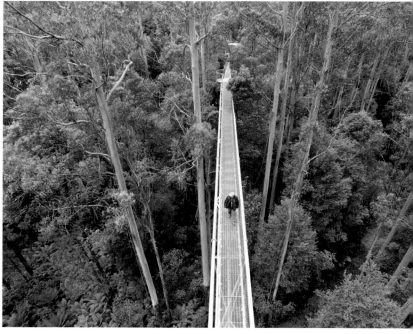

How to Identify

Recognisable by its towering stature, this fast-growing evergreen tends to have a smooth, straight trunk, its grey bark often seen peeling away in long strips. At 3in to 9in (8cm to 23cm) long, the large, glossy, lance-shaped green leaves stay on the tree year-round, and produce an earthy, herbal aroma. In spring, the tree is adorned with small, delicate white flowers.

ABOVE WALKING THE O'SHANNASSY AQUEDUCT TRAIL WILL TAKE YOU THROUGH THE YARRA RANGES NATIONAL PARK'S TEMPERATE RAINFOREST; LEFT THE OTWAY FLY ATTRACTION NEAR THE GREAT OTWAY NATIONAL PARK, WEST OF MELBOURNE, FEATURES A CANOPY WALK

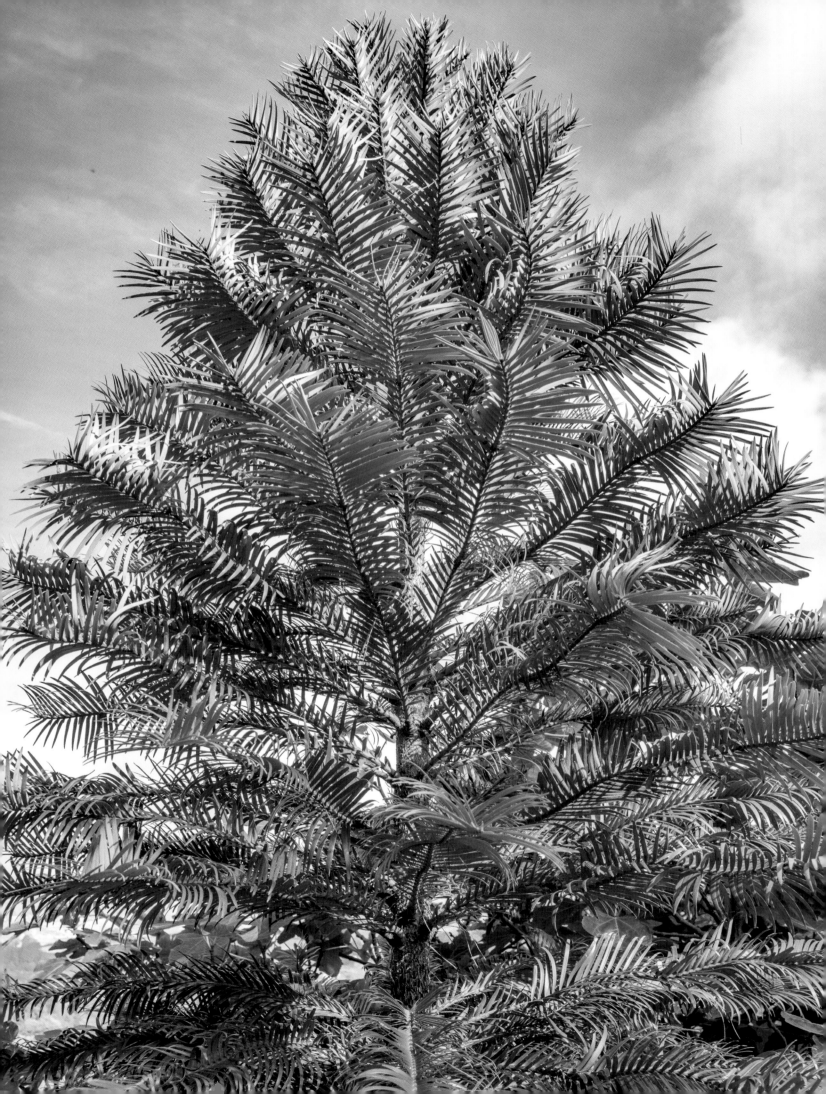

Wollemi Pine

Wollemia nobilis

Vitals

RANGE
New South Wales, Australia

STATUS
Critically Endangered

LIFESPAN
<1000 years

AVERAGE HEIGHT
40ft-65ft (12m-65m)

THOUGHT OF AS A 'LIVING FOSSIL', THE WOLLEMI PINE WAS UNTIL RECENTLY THOUGHT TO BE EXTINCT

In September 1994, while out bushwalking, national park ranger David Noble abseiled into a gorge in the rainforests of Wollemi National Park, a mere 92 miles (150km) from Sydney. By chance, he'd stumbled across a group of strange-looking ancient trees. The discovery of the Wollemi pine was the botanic find of the century because the tree was thought to have been extinct for two million years. If you think that the exploration of Earth is a finished project, think again!

Nicknamed the 'living fossil', the Wollemi pine would have been ubiquitous during the time when dinosaurs roamed the earth, and provides a link to the prehistoric natural world. Many of its characteristics are unique: unlike the conifers we're familiar with today, which typically have needle-like leaves, this false pine has dark green, cycad-like foliage. When considering and comparing this ancient species to what we think of as a conifer today, the Wollemi pine sheds light on the evolution of coniferous plants over millions of years.

Despite its remarkable survival, the Wollemi pine is critically endangered in its natural habitat, with fewer than 100 specimens currently growing wild in Wollemi National Park. Climate change and habitat destruction endanger the survival of this ancient species, but conservation efforts, including propagation and the growing of Wollemi pines in botanic gardens across the world, are today underway to safeguard its future. Translocation sites have been established in Australia since 2019, in which more than 300 Wollemi pines have been strategically placed and planted (in undisclosed secret locations) as an insurance policy to protect this species.

LEFT WILD WOLLEMI PINES ARE NOW OUTNUMBERED BY EXAMPLES CULTIVATED WORLDWIDE

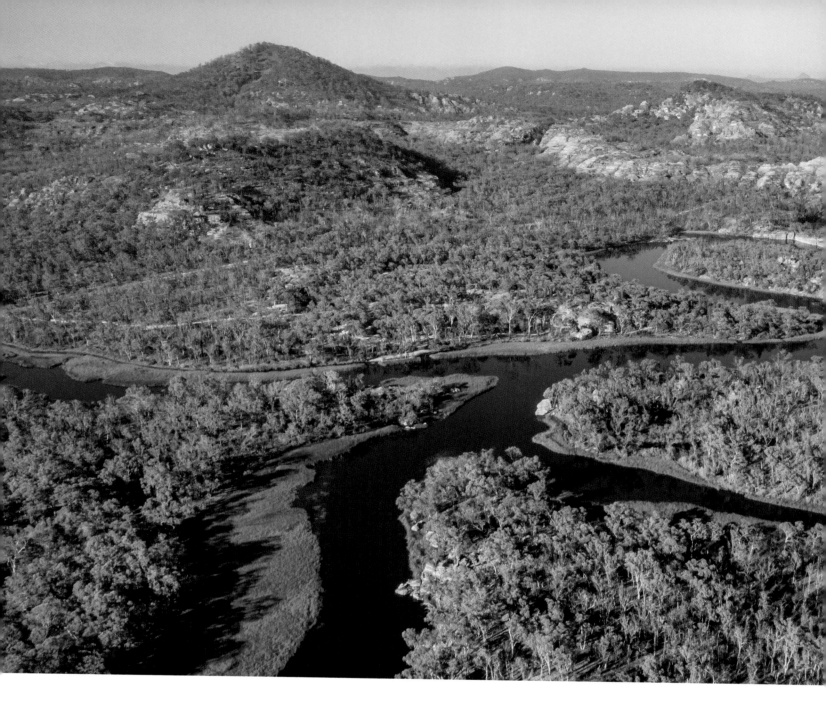

How to See

Although this tree has a national park named after it in New South Wales, the exact location of the original ancient trees discovered here is a secret known only to scientific researchers. Wollemi National Park is a couple of hours' drive northwest of Sydney towards Colo and Putty. There are no convenient public transport options but once there you can hike, camp and explore. Vast areas of the park are filled with gorges, swamps and forested canyons untouched by humans so to stay safe in this wilderness, stick to the tracks and campgrounds. Many trails require rock scrambling and abseiling skills. If you're planning a wilderness walk, contact the park's office for the relevant area (www.nationalparks.nsw.gov.au).

For a guaranteed sighting of a wollemi pine in New South Wales, head to the Royal Botanic Gardens in Sydney; Taronga Park Zoo; the Mt Annan Botanic Gardens in southwest Sydney or the Mt Tomah Botanic Gardens, set in the middle of the Blue Mountains National Park and the World Heritage Area. Sydney's Royal Botanic Gardens are in the heart of the city, overlooking the harbour and the Sydney Opera House. In the Blue Mountains, the Mt Tomah Botanic Gardens are a two-hour drive from Sydney (no public transport available). Entry is free to both Sydney's and Mt Tomah's botanic gardens.

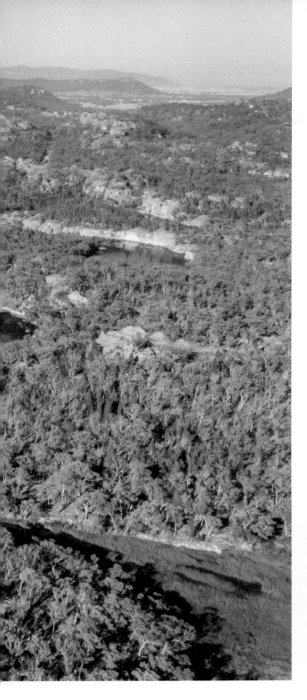

How to Identify

The foliage of the Wollemi pine is dark green, with cycad-like leaves that are arranged in spirals along its branches. The trunk is dark brown in colour, with a uniquely textured bark that appears to be 'bubbling'. Younger trees often take on a more conical shape, so readily associated with conifer trees, whilst mature specimens develop a broader, more rounded crown. Individual specimens can appear multi-stemmed, often with several established basal shoots growing happily.

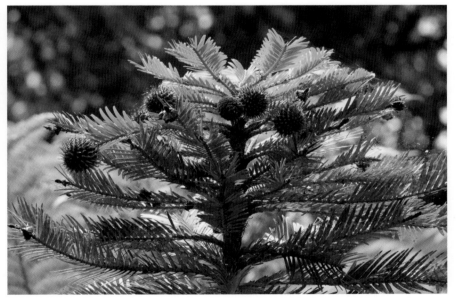

WHEN

Spring (September to December) and autumn (March to May) are ideal times to visit Wollemi National Park and the Blue Mountains. Summer heat can be extreme. Sydney is a year-round destination.

ABOVE WHERE'S THE WOLLEMI? DUNNS SWAMP IN WOLLEMI NATIONAL PARK; TOP RIGHT FEMALE CONES ON A WOLLEMI PINE, LONGER MALE CONES ALSO GROW ON THE SAME TREE; RIGHT A CLOSE-UP OF THE WOLLEMI'S DISTINCTIVE FLAT NEEDLES

Karri Tree

Eucalyptus diversicolor

Vitals

RANGE

Western Australia

STATUS

Least Concern

LIFESPAN

<400 years

AVERAGE HEIGHT

100ft-250ft (30m-76m)

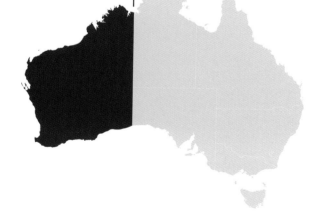

AUSTRALIA'S LOFTY KARRI TREE HAS DEMONSTRATED ITS USEFULNESS TO PEOPLE IN SEVERAL WAYS

What better location from which to watch for bushfires than the tops of the tallest trees in the region? Between 1937 and 1952, up to eight karri trees were fitted with pegs, up which observers could scramble in order to spot fire outbreaks. (Today, spotter planes are used.) Until recently, members of the public could climb some of these named trees, such as the Gloucester Tree, which was first scaled by forester Jack Watson, who took six arduous hours using just boots and a belt.

The karri is native to Western Australia and its name is of Aboriginal origin, bestowed by the region's Noongar people. This eucalypt giant is one of the tallest hardwood trees in the world and, despite average heights just below that of its cousin, *E regnans*, takes the prize as Western Australia's tallest tree. Huge trunks reach up to the sky, typically straight with only a handful of large limbs; to avoid wasting energy by producing limbs and leaves that must compete for light. *E diversicolor* is renowned for its deciduous bark, which changes colour as it ages and sheds from the trunk, creating a mottled pattern in different shades of white, grey and pink. Long strips of old bark often break away to reveal the smooth, fresh white trunk. Interestingly, the soil in these regions is classified as 'karri loam' due to the large quantities of the tree's bark that fall to the forest floor, decaying and adding nutrients over thousands of years.

Logging practices have much reduced karri tree populations across Australia. Today, karri trees are concentrated in the Warren bioregion in southwest Western Australia; fortunately, logging of the state's native hardwood trees has now been outlawed.

RIGHT A KARRI TREE FRAMED BY A CAVE IN WESTERN AUSTRALIA'S MARGARET RIVER REGION

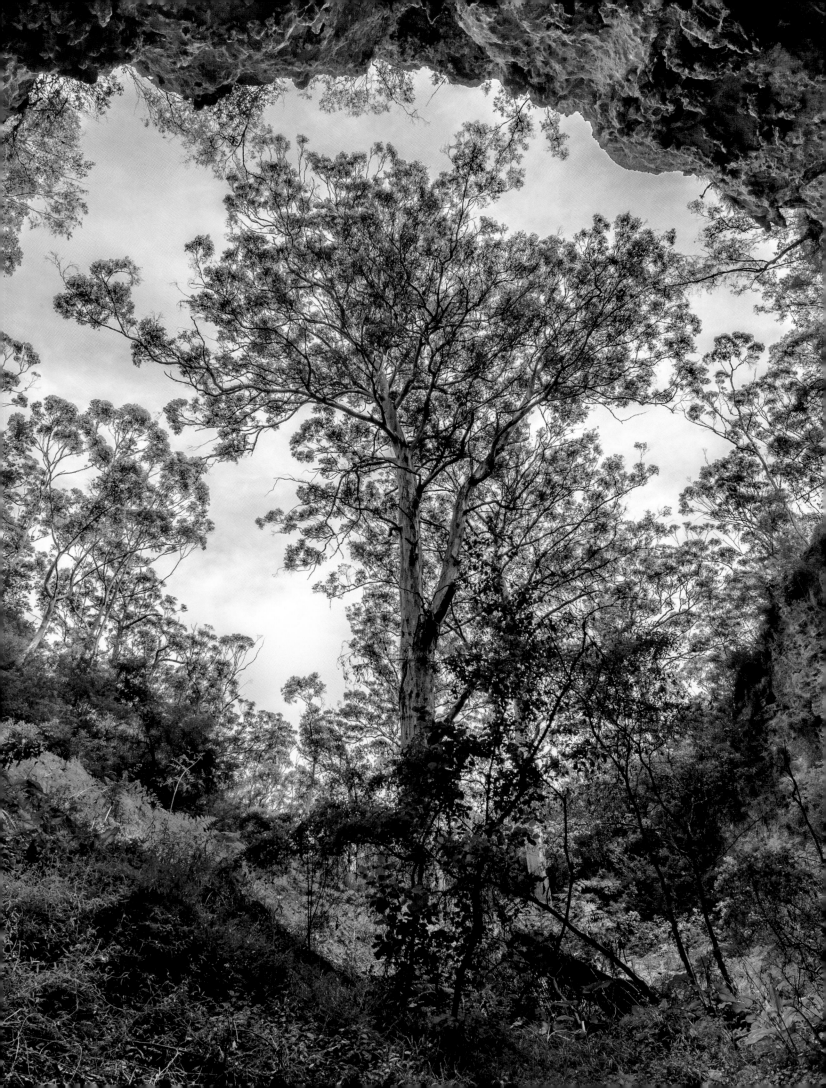

How to See

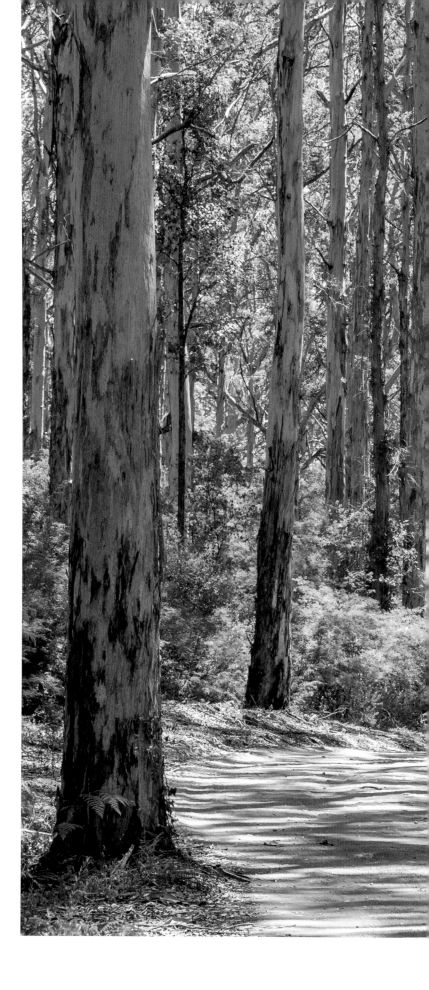

WHERE

Though the tallest eucalypt is the Australian mountain ash, the karri tree is a respectable runner-up, towering over the outback forests that surround the country town of Pemberton in Western Australia. There are some monster specimens here, from the 246ft-high (75m) Dave Evans Bicentennial Tree in Warren National Park to the 226ft-high (69m) 'Tyrant' tree in the Hawke Grove at Yeagarup. It used to be possible to climb some of these trees on pegs but check ahead for the latest situation.

The Valley of the Giants lies near Walpole, on the road towards Denmark, southeast of Pemberton. Here, a looping treetop walk, 130ft (40m) high in the canopy offers incredible vistas of the Walpole Wilderness, with its karri and tingle trees.

For more views of pristine karri forests, rent a 4WD and follow the Karri Forest Explorer trail from Pemberton, meandering along unsealed roads through the Greater Beedelup, Hawke, Warren and Gloucester National Parks. En route, you'll pass some of Western Australia's most imposing gumtrees; a PDF map can be downloaded from the Explore Parks WA website.

WHEN

November to March is the dry season in the south of Western Australia, and the best time for dirt-road driving and for camping out at the rustic national park campgrounds around Pemberton.

RIGHT THE BORANUP KARRI FOREST IN MARGARET RIVER IS A TREAT FOR THE SENSES; OPPOSITE RIGHT CLIMB THE BICENTENNIAL TREE NEAR PEMBERTON, SOME KARRI TREES WERE USED AS FIRE LOOKOUTS IN THE STATE

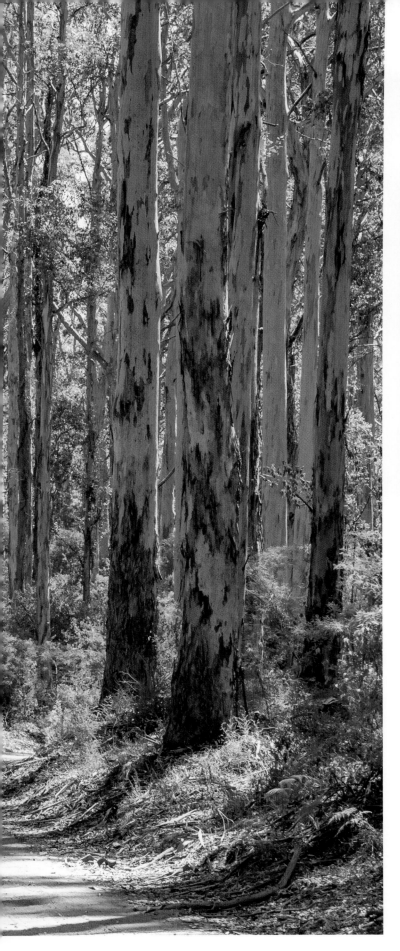

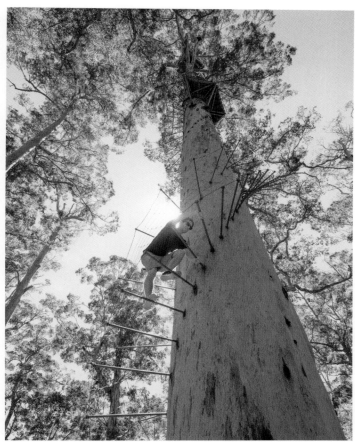

How to Identify

Mature karri trees are unmistakable in the forest. This stately evergreen is the only giant eucalypt in Western Australia, and towers above the forest canopy. The straight trunks appear mottled, more white than brown, and are always surrounded by bark remnants on the forest floor. Limbs tend to be fewer but larger than other eucalypt species. Leaves are lance-shaped and emit the distinctive eucalyptus fragrance.

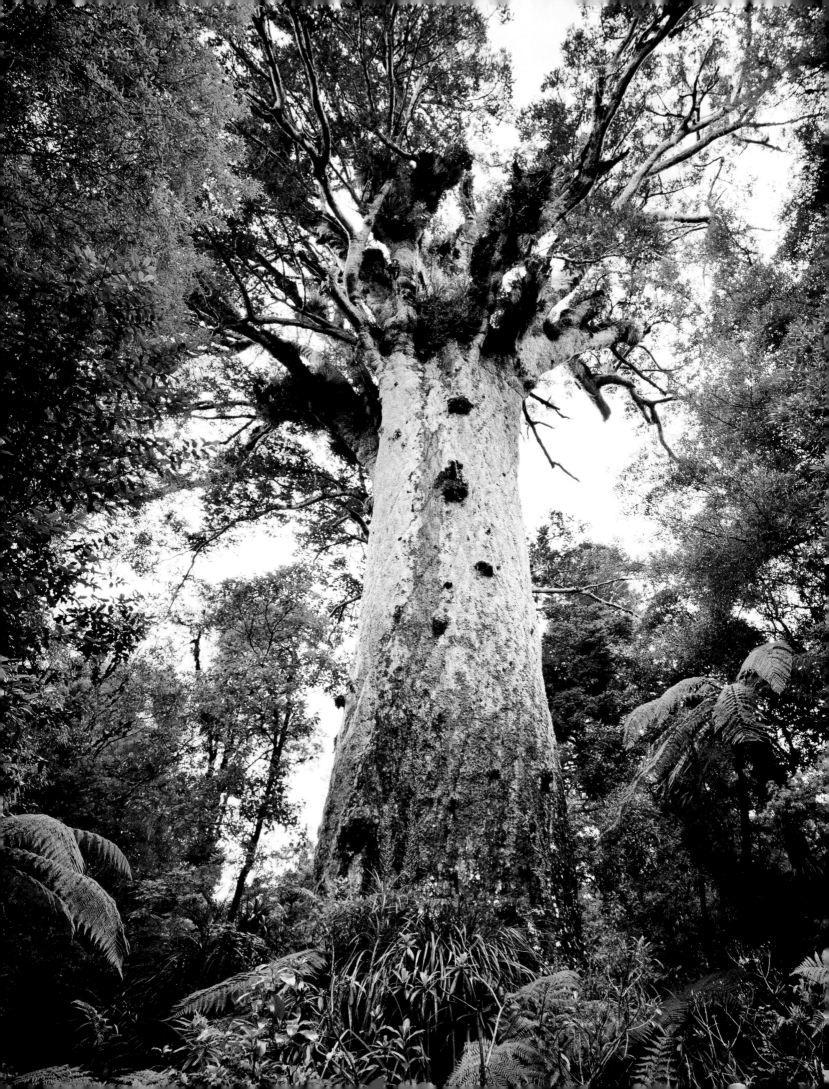

Kauri

Agathis australis

Vitals

RANGE

North Island, New Zealand / Aotearoa

STATUS

Least Concern

LIFESPAN

<1000 years

AVERAGE HEIGHT

130ft-200ft (39m-61m)

WITH ITS COLOSSAL STATURE AND ANCIENT LINEAGE, THE MIGHTY KAURI IS A TRULY AWESOME TREE

Ranginui, the Sky Father, and Papatūānuku, the Earth Mother, clasped each other so tightly, such was their love, that not a shaft of sunlight squeezed between them. But their children tired of living in darkness and so their son, Tāne, used his broad shoulders and powerful legs to prise his parents apart. He pushed Ranganui upward until the Sky Father arched above and light flooded throughout, creating the world. The rain that falls from the sky is Ranginui's grief but Tāne is still braced against Ranginui and Papatūānuku.

So goes the Māori creation myth. You can meet Tāne Mahuta in Waipoua Forest at the top of New Zealand. He's around 2000 years old and the largest of his kind: a kauri tree. He's testament to the endurance of New Zealand's ancient forests despite the efforts of logging companies and, latterly, the effects of kauri dieback, a soil-borne disease. The kauri belongs to the Agathis genus, a family of evergreen conifers, though its glossy, dark-green leaves are much broader than typical conifer needles. The tree produces both male and female cones; often imagined as dragon eggs, female cones appear round and scaly, and contain the seeds. These take three years to mature after fertilisation, with the cone crumbling when ready and scattering its seed.

The kauri remains a culturally significant tree for the Māori, who consider it a *taonga* (treasure) and a signifier of the health of forests. As well as using its timber to build *waka* (canoes), Māori traditionally deployed the kauri's gummy resin as a fire-starter and, when combined with soot from kahikatea trees, as a medium for the *tā moko* (tattoos) that serve as a unique expression of Māori cultural identity.

LEFT THE KAURI TREE KNOWN AS TĀNE MAHUTA IS A HIGHLIGHT OF THE WAIPOUA FOREST

IN THE NORTHWEST TIP OF NEW ZEALAND / AOTEAROA

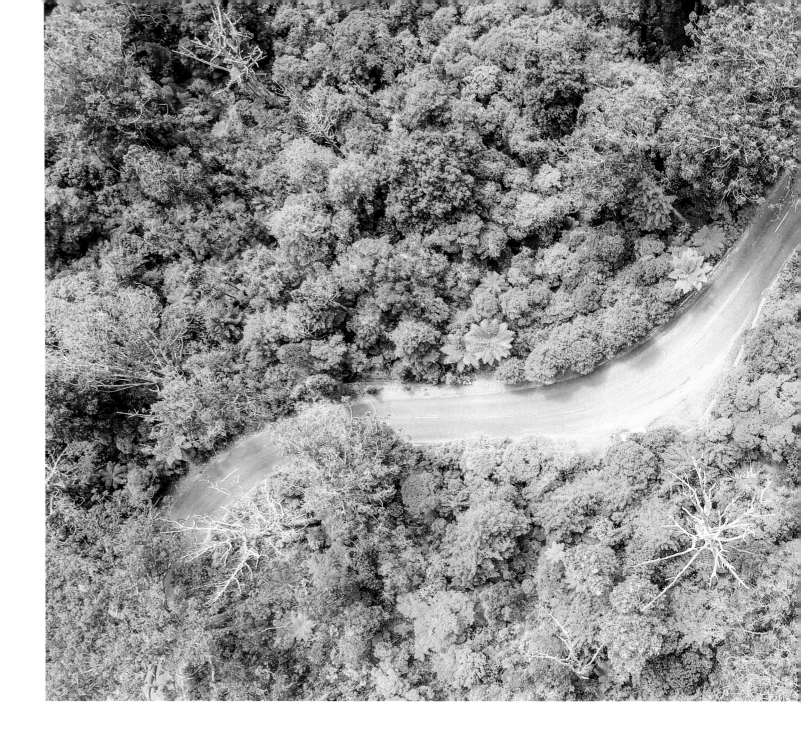

How to See

Kauri trees, the most southern-growing species of its family, exist in only a small area of the North Island: on the tropical Coromandel Peninsula southeast of Auckland and in Northland, at the top of the North Island. Northland's Waipoua Forest is where you'll find several of these giant trees, including Tāne Mahuta, New Zealand's largest kauri.

Waipoua Forest lies along SH12 highway on the northeast coast between logging town Dargaville in the south and beach town Ōmāpere to the north. Although there are regional bus services between Whangārei and Dargaville, the best option is to have your own transport. There's limited boutique accommodation and camping around Donnelly's Crossing near the forest but more options in Ōmāpere.

Several very short walks lead into the forest to see the stand-out kauri trees but many of the paths have been closed to protect the trees from the spread of disease. Always follow instructions on how to sanitise your footwear when visiting kauri forests.

On the Coromandel Peninsula, check out a grove of kauri trees around Waiau Falls, which lie near the dirt 309 Rd, deep in the interior.

How to Identify

Both the height and girth of the kauri are unmistakable, soaring upwards and outwards, often with a girth measuring up to 60ft (18m). Column-like trunks appear straight and are bare of branches, as the tree drops its lower limbs when it reaches the forest canopy. The bark is also distinctive, often peeling away in large flakes, producing a quilt-like effect, with smooth reddish-brown patches appearing beneath.

WHEN

New Zealand's summer, from December to March is the ideal time to visit but also the busiest. Avoid school holidays if possible and consider the shoulder seasons, although allow for wetter and windier conditions.

ABOVE YOU CAN DRIVE OR CYCLE ON THE ROAD THROUGH WAIPOUA KAURI FOREST; TOP RIGHT THE FEMALE CONES OF A KAURI TAKE ABOUT THREE YEARS TO MATURE; LOWER RIGHT OTHER PLANTS, INCLUDING TREES, LIVE ON KAURI TREES

Norfolk Island Pine

Araucaria heterophylla

Vitals

RANGE
Norfolk Island, Australia

STATUS
Vulnerable

LIFESPAN
<150 years

AVERAGE HEIGHT
160ft-220ft (48m-67m)

THE HISTORY AND FATE OF AUSTRALIA'S NORFOLK ISLAND HAS BEEN LARGELY DETERMINED BY THIS EPONYMOUS TREE

The history of the Norfolk Island pine is intertwined with the remote island to which it is endemic. This tiny Australian outpost in the South Pacific Ocean has a colonial history that began in 1774, when Captain James Cook first visited and noted the presence of these remarkable trees as a potential timber source for shipbuilding. But when the British established a penal colony here in 1788, these lanky giants ultimately disappointed, as their brittle wood was found to be unsuitable. Nonetheless, the allure of the Norfolk Island pine persists, with visitors to this isolated and remote corner of the world captivated by its majestic signature tree.

Though not a true pine – along with the monkey puzzle (see page 67), it's a member of the Araucaria genus – *A heterophylla* has risen to prominence as a popular ornamental species. They have been planted behind the beaches along the coast of New South Wales due to the their tolerance of salty conditions. Embraced as a symbol of Norfolk Island, it adorns the island's flag and continues to dominate its now largely pastoral landscape, often standing solitary against the backdrop of cliffs and seas. Notably, the Lone Pine, a tree of celebrity status, has withstood tempests, colonisation and logging for some 650 years.

Today, lone trees are a far more common a sight than Norfolk Island pine forests, with much of the subtropical rainforest felled in the years following European colonisation. Norfolk Island's native forest is now largely restricted to a region in the Mt Pitt area, declared a national park in 1986, where aged Norfolk pine specimens can still be admired.

RIGHT THE TOOTHPICK-STRAIGHT TRUNK OF A NORFOLK ISLAND PINE

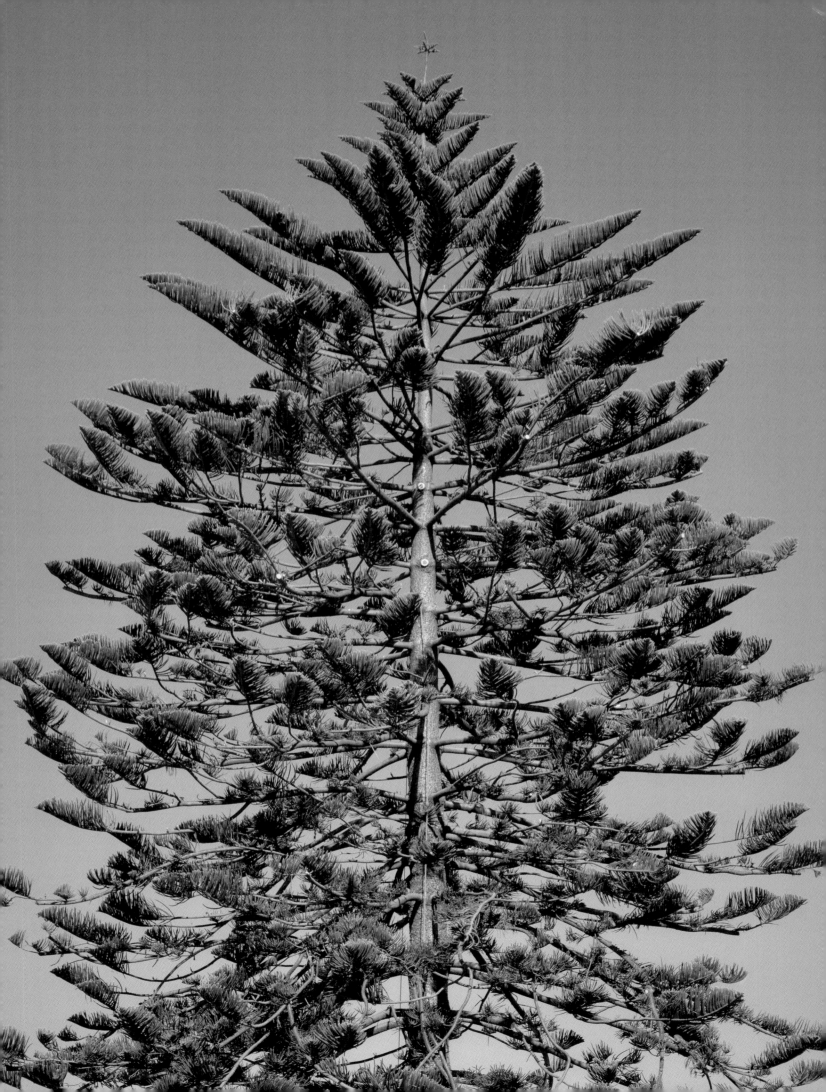

How to See

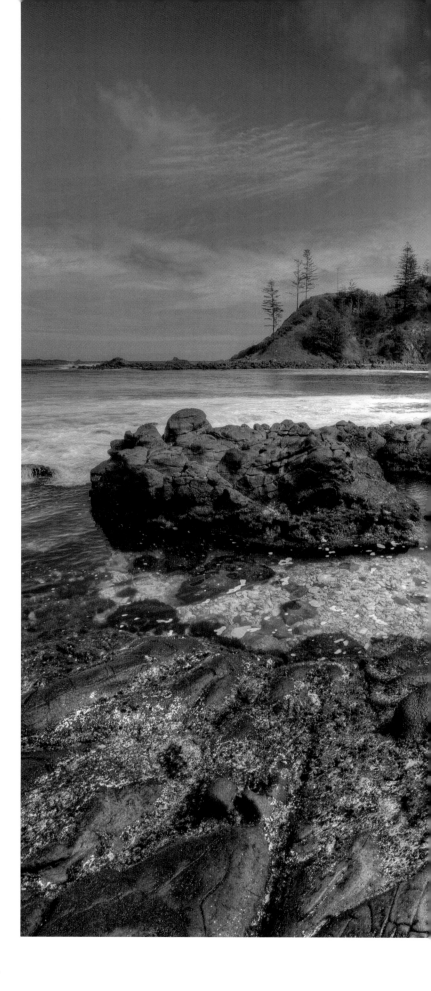

WHERE

The Norfolk pine is native to Norfolk Island, both named after England's Duchess of Norfolk. The island, lying to the south of New Caledonia and between the east coast of Australia and New Zealand's North Island, is the definition of remote. But it can be reached by flights from Brisbane and Sydney, taking just over two hours (and considered a domestic flight). There are also international flights from Auckland.

The central settlement, Burnt Pine, is next to the airport but there is accommodation across the small island. The Norfolk Island National Park protects much of the northern half of the island and is packed with the distinctive pine trees. Short walks in the park pass through forest, such as the Bird Rock Track and the Palm Glen Circuit. There is also a botanic garden filled with trees and ferns with some paths suitable for wheelchairs and strollers.

You don't need to travel so far to see Norfolk pines: many were planted along Sydney's northern bays, such as Manly, Dee Why and Whale beaches. Note that some of Sydney's Norfolk pines have been inadvertently replaced by Cook pines – see if you can spot the difference.

WHEN

Sydney's beaches are at their best for swimming and surfing during the summer months but the Norfolk pines can be appreciated throughout the year. Spring, from September, and summer are ideal for visiting Norfolk Island but try to stay outside of school holidays.

RIGHT NORFOLK PINES AROUND CRESSWELL BAY ON NORFOLK ISLAND;

OPPOSITE A CLOSE-UP OF THE NEEDLES OF A NORFOLK PINE TREE

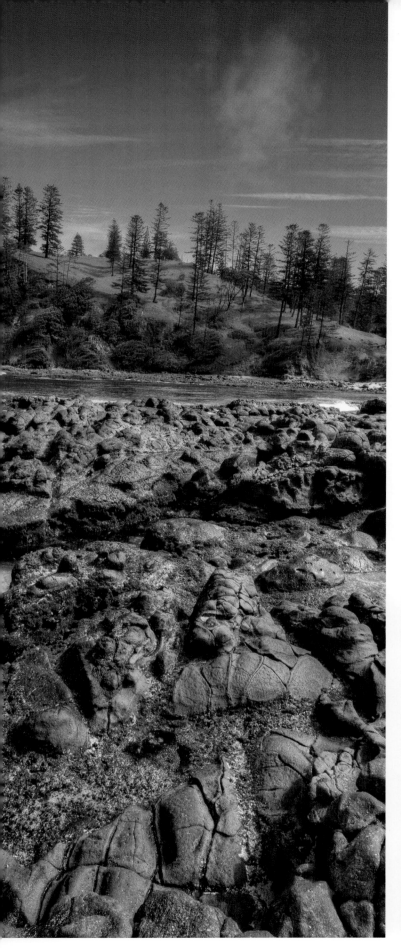

How to Identify

The bark of the Norfolk Island pine is smooth and grey when young, developing furrows and turning darker with age. The trunk is generally free from branches for the first 40ft to 60ft (12m to 18m), above which the branches of mature trees often exhibit a symmetrical, tiered arrangement, contributing to the iconic pyramidal shape. Its needle-like, bright-green leaves are arranged in whorls along the branches, appearing soft and feathery from a distance.

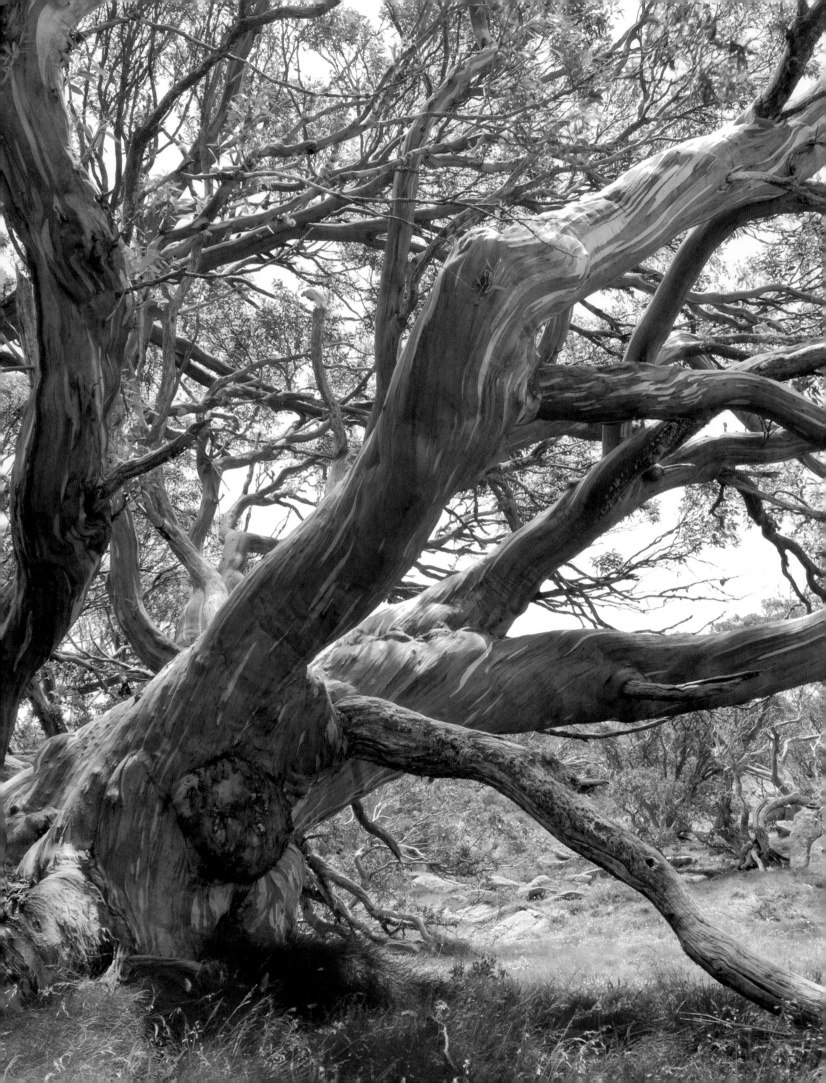

Snow Gum

Eucalyptus pauciflora

Vitals

RANGE

Queensland, New South Wales, Australian Capital Territory, Victoria and Tasmania, Australia

STATUS

Unclassified

LIFESPAN

<300 years

AVERAGE HEIGHT

80ft-120ft (24m-36m)

WITH A PROPENSITY FOR COLD, HARSH CONDITIONS, THE SNOW GUM THRIVES WHERE OTHERS CANNOT

Growing exclusively in the mountainous alpine regions of mainland Australia and the subalpine regions of Tasmania, the snow gum is unlike any other eucalypt species. *E pauciflora* thrives in harsh extremes – areas that are characterised by freezing temperatures, strong winds and heavy snowfall, and that commonly sit above 2300ft (700m). This ability to survive in such challenging places makes the snow gum a symbol of resilience and the hardiest of all eucalypts.

This evergreen species dominates the high-country landscapes of southeast Australia, boasting many adaptions that make growing in such places not only tolerable, but optimal. Like other eucalypts, it often displays a mallee growth form, characterised by multiple stems arising from a lignotuber, a woody swelling that forms just below ground level and allows the tree to store nutrients and rapidly regenerate in the case of fire or snow damage. Mallee trees are typically low-growing (usually no more than 100ft/30m), and have an enhanced ability to withstand stress from strong winds: the smaller density of trunk is less of a block to the wind, and the thinner stems provide enhanced flexibility, bending during storms without damaging the tree. In addition, heavy snow loads are distributed more evenly as opposed to one dense canopy supported by one trunk. This adaptation allows snow gums to continue growing despite frequent freezing weather and wildfires, quickly sprouting new shoots and regenerating using stored energy and nutrients. The snow gum exemplifies nature's adaptability even in the most unforgiving of alpine conditions.

LEFT AN OLD SNOW GUM GROWING IN DEAD HORSE GAP, KOSCIUSZKO NATIONAL PARK, NSW

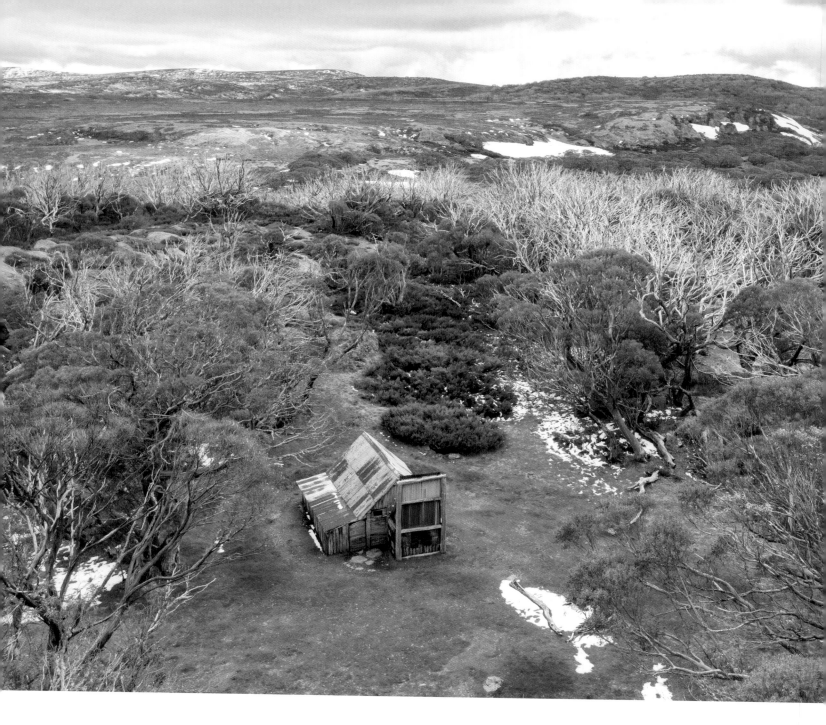

How to See

Australia's beautiful snow gums can be seen in highlands across the east and south of the country, including Kosciuszko National Park in New South Wales and the Green Triangle Forest near Mt Gambier, South Australia. However, some of the most spectacular specimens can be sought in Victoria. Head northeast from Melbourne to the Victorian Alps and start exploring. The gums prefer to live along the tree line.

Hiking to the summit of Mt Bogong, Victoria's highest summit, will take you through forests of snow gums, twisted and stunted due to the often cold and snowy conditions. Or try to reach the top of Mt Feathertop via the Razorback Ridge; many of the snow gums here suffered during a bush fire but are growing back quickly (and some escaped). Near the alpine town of Bright, Mt Buffalo National Park also has many snow gums,

for example along the Lakeside Walk and in the Gorge area.

Bright is a good base for trips into the Victorian Alps and can be reached by train to Wangaratta from Melbourne then a bus (or bicycle ride along the Murray to the Mountains Rail Trail). A car offers more freedom to reach trailheads. You can also mountain bike among snow gums in the High Country around Falls Creek and Mt Beauty.

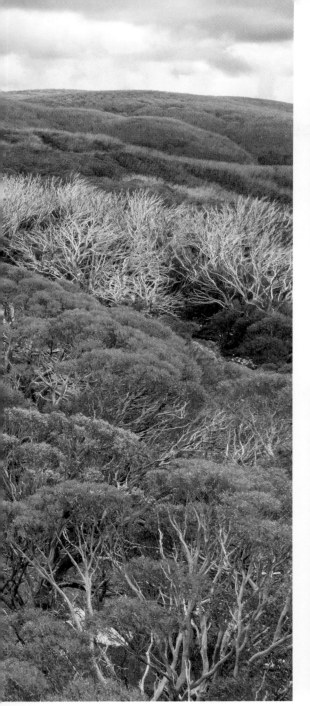

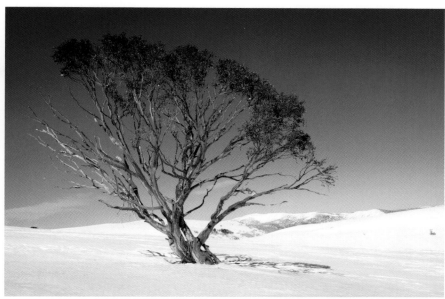

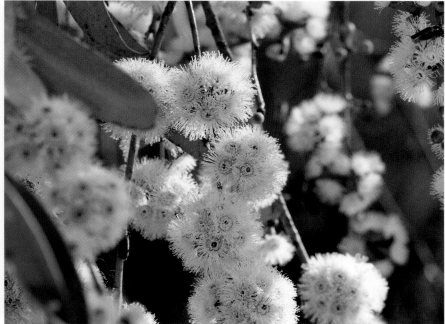

WHEN

Snow can fall any time in the Victoria's High Country from May to October, if you have the kit and skills for winter ascents. Otherwise, spring, summer and autumn are more hospitable seasons.

ABOVE SNOW GUMS GROWING AROUND WALLACE HUT NEAR FALLS CREEK IN VICTORIA'S ALPINE NATIONAL PARK; TOP RIGHT WINTER ON THE BOGONG HIGH PLAINS IN ALPINE NATIONAL PARK; LOWER RIGHT BLOSSOM LEADS TO GUMNUTS; OVERLEAF BAW BAW NATIONAL PARK, VICTORIA

How to Identify

Found in mountainous regions, snow gums often appear as multi-stem specimens, typically with several or more stems shooting from the base. Trunks tend to have a peeling, multicoloured bark that ranges from green to brown to grey, and offers an appealing a visual spectacle amid the stark landscape. This is an evergreen eucalypt with small, leathery green leaves. The tree produces white flowers from October to February.

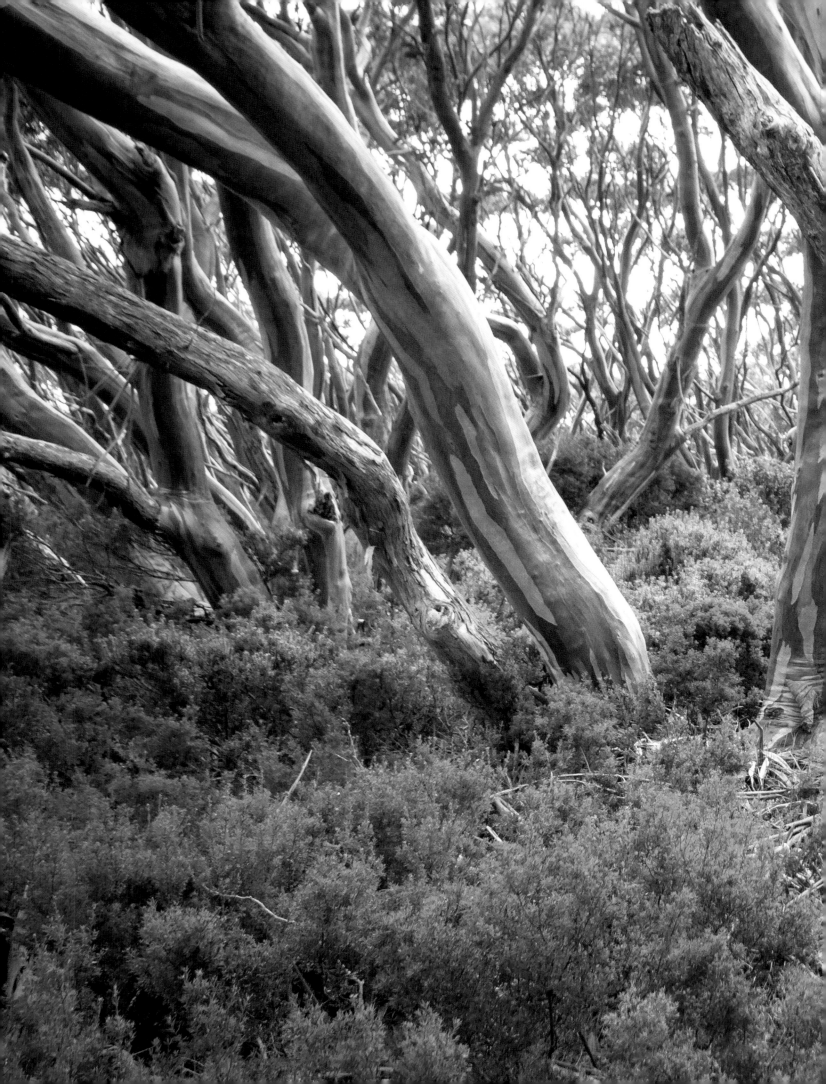

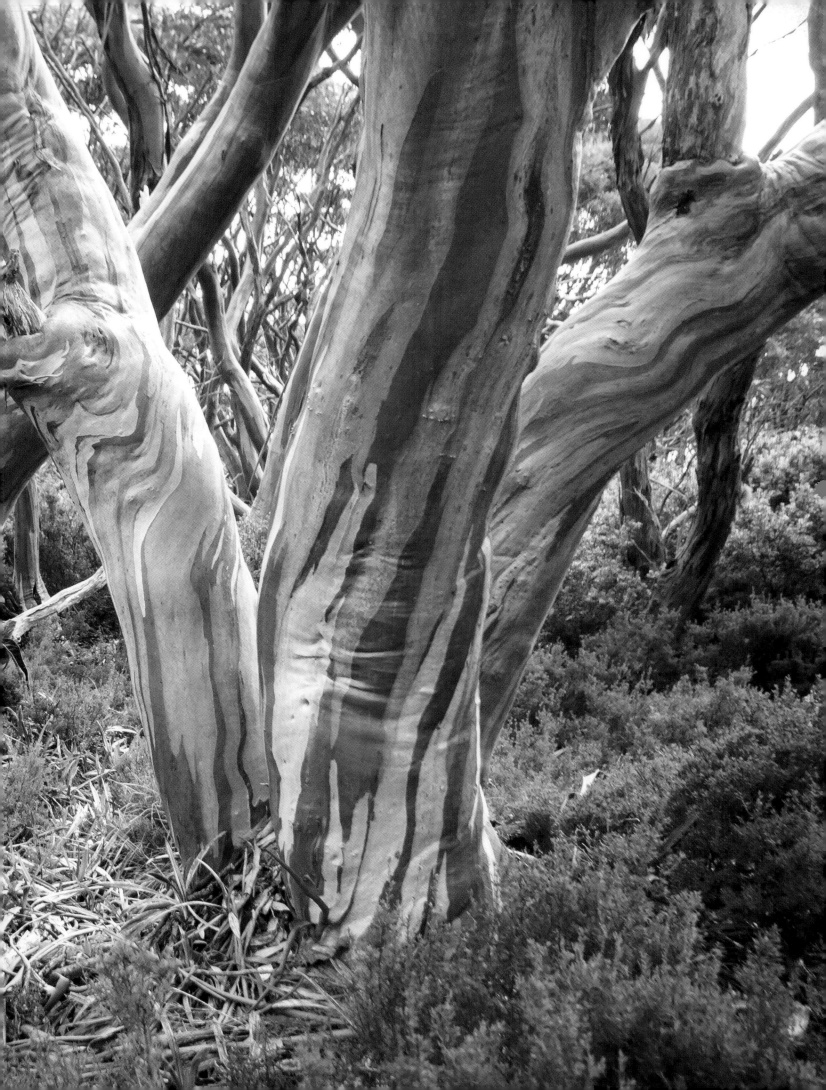

Pōhutukawa Tree

Metrosideros excelsa

Vitals

RANGE
North Island, New Zealand / Aotearoa

STATUS
Least Concern

LIFESPAN
<600 years

AVERAGE HEIGHT
50ft-80ft (15m-24m)

CHERISHED BY NEW ZEALAND'S MĀORI, THE SCARLET BLOOMS OF THE PŌHUTUKAWA PAINT THE NORTH ISLAND COASTLINE CRIMSON

Testament to the uniqueness of the native flora of Oceania, the pōhutukawa tree, *M excelsa,* is found along the coastal cliffs and sandy beaches of New Zealand. While its Māori name has many possible interpretations, one translation is 'splashed by the spray', in reference its habitat, growing happily at the edge of the land. Despite this challenging situation, with fast, salt-laden winds par for the course, the pōhutukawa tree thrives.

The vibrant red pōhutukawa blooms transform the landscape, with splashes of deep crimson visible from afar. The flowers exhibit characteristics that are typical of the myrtle genus, Myrtaceae, with long, curling stamens appearing soft and frothy, humming with insect and pollinator activity during the long, warm days of summer when this tree typically flowers. With a reputation for blooming over the months of November and December, there is no further explanation necessary for its nickname, the New Zealand Christmas Tree.

Revered by the Māori, who consider it a symbol of strength and connection to the land, the pōhutukawa has a long history of cultural significance. According to Māori mythology, the tree is regarded as sacred, embodying the spirit of mythical hero Tāwhaki, who fell to his death from the sky and whose split blood is represented by the pōhutukawa's red flowers. Perhaps most famously, the pōhutukawa tree at Cape Reinga marks Te Rerenga Wairua, from where Māori spirits depart the world. In addition, Māori have traditionally used the pōhutukawa for medicinal purposes: its bark contains ellagic acid, which has antioxidant and anti-inflammatory properties.

RIGHT A PŌHUTUKAWA TREE ON HUIA BEACH, NEAR TITIRANGI, SOUTH OF AUCKLAND

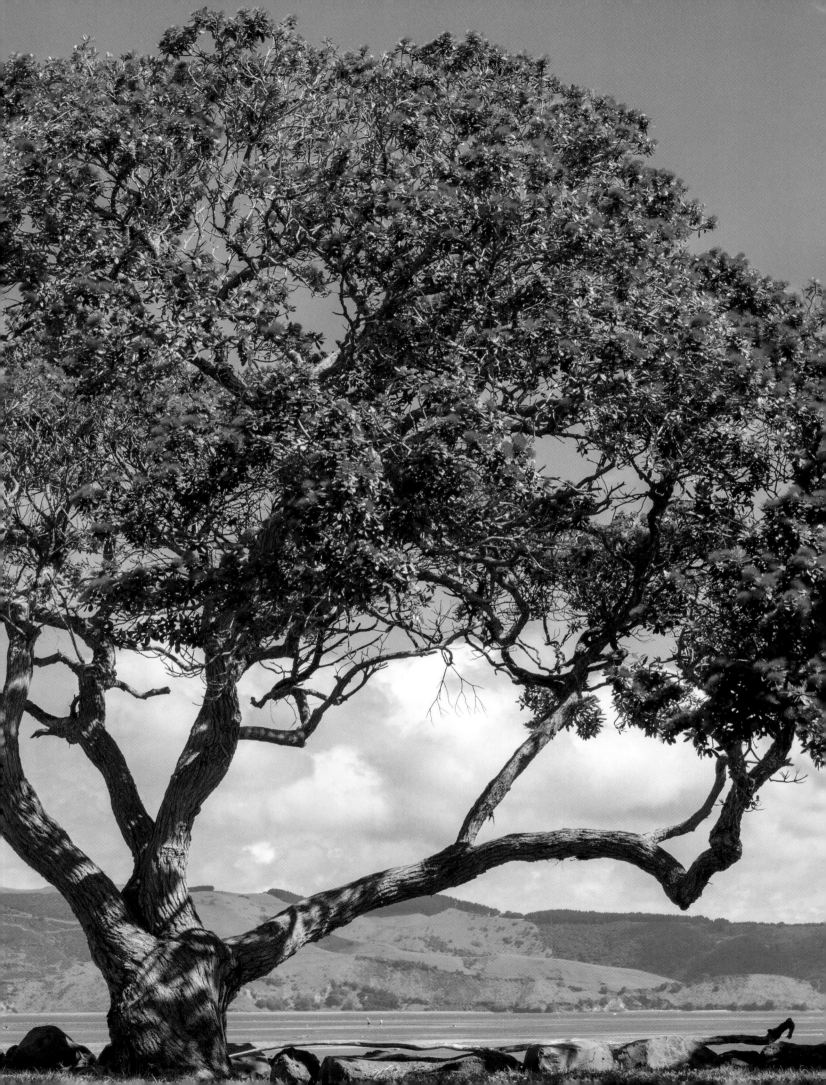

How to See

WHERE

The pōhutukawa favours the sheltered coasts of New Zealand's North Island, which means that it can often be found close to some superb beaches. The sandy bays of Mount Manganui, which is about a three-hour drive south of Auckland, are backed by pōhutukawa. Further south, there are plenty of pōhutukawa around Napier and Hawkes Bay, which is known for its mild climate and fruit and wine production. There are at least a couple on Napier's Marine Parade.

Closer to Auckland, the stretch of coast from Whitford to Duder Regional Park has been christened the Pōhutukawa Coast, thanks to the large number of these trees. This is a self-driving route that takes around 30 minutes. But you can also take a sea-kayak along the coast or just laze among the pōhutukawa on Whakakaiwhara Peninsula.

Some way north of Auckland, Northland's Cape Reinga is as far north as you can travel on mainland New Zealand and the pōhutukawa trees thrive in this tropical climate. Tour buses take travellers from local hubs of Paihia or Kerikeri in the Bay of Islands to the tip of Cape Reinga, where you might spot the small, old pōhutukawa clinging to the cliff.

WHEN

Although the pōhutukawa tree is known as the Kiwi Christmas tree, if you wish to see its red blooms in all their glory, it's better to start the search from the middle of November since most trees will have finished flowering by late December. They're beautiful at other times of the year too, of course.

TOP RIGHT PŌHUTUKAWA TREES IN FULL BLOOM ON TAKAPUNA BEACH, NORTH AUCKLAND; RIGHT THE BAY OF ISLANDS; CENTRE BIRDS AND INSECTS LOVE PŌHUTUKAWA BLOSSOM; OPPOSITE RIGHT SUMMER VIBES IN KAITERITERI, NEAR ABEL TASMAN NATIONAL PARK

How to Identify

This coastal evergreen tree has distinctive dark green, leathery leaves, which are elliptical in shape with a glossy appearance. During the early summer, from December, the tree produces crimson flowers with long, curling stamens. The trunk of older specimens will appear gnarled and twisted, with the bark taking on a dark brown colour, often with deep ridges and furrows. The large, spreading canopy is an important source of shade for wildlife during the summer months.

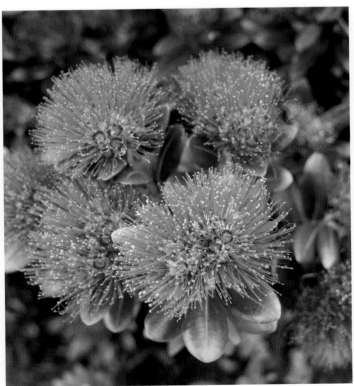

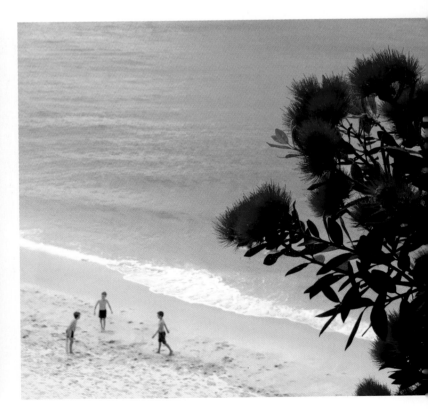

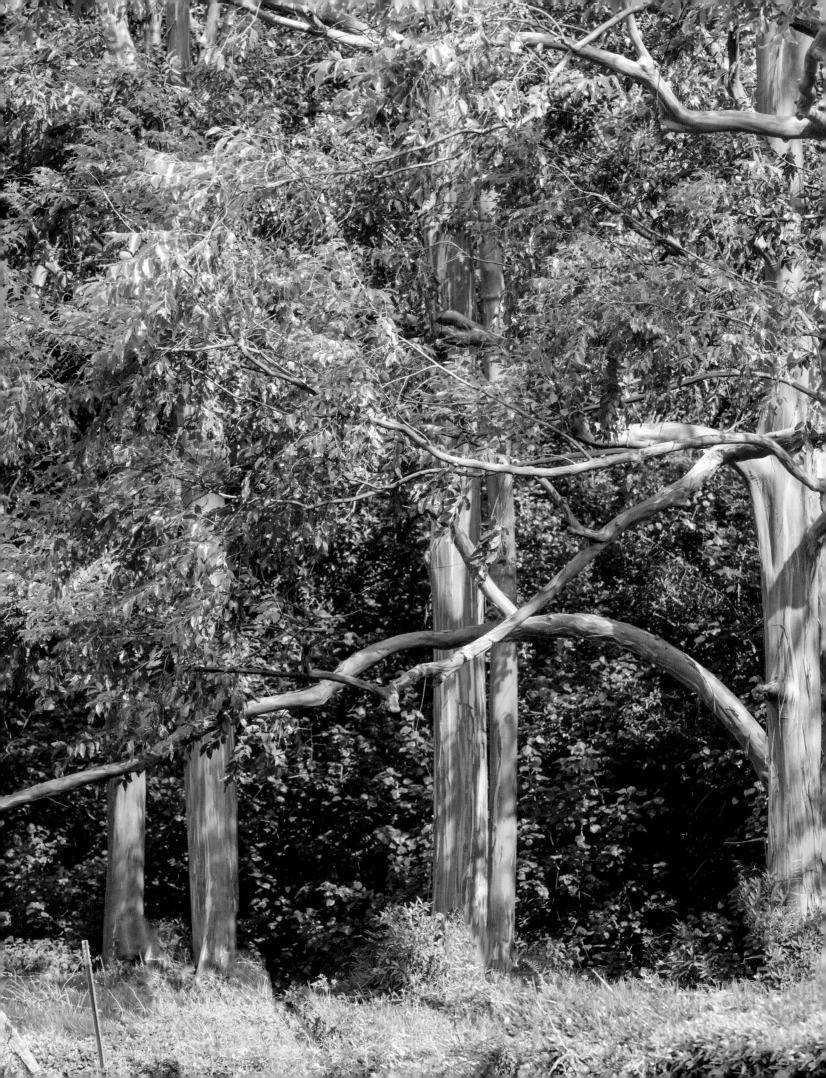

Rainbow Eucalyptus

Eucalyptus deglupta

———

Vitals

RANGE

Philippines, Indonesia and Papua New Guinea

STATUS

Vulnerable

LIFESPAN

<100 years

AVERAGE HEIGHT

197ft-246ft (60m-75m)

THIS CURIOUS TREE HAS LONG CAPTIVATED OBSERVERS WITH ITS STRIKING AND OTHERWORLDLY MULTICOLOURED BARK

It might sound fanciful, but there is such a thing as a multicoloured tree. *E deglupta*, commonly referred to as the rainbow eucalyptus, grows in tropical rainforests within equatorial regions of the Philippines, Indonesia and Papua New Guinea, and is the only species of eucalyptus that's native to both the northern and southern hemispheres.

Unsurprisingly, the rainbow tree was named for its multicoloured appearance, which seems almost unreal on first inspection. Its kaleidoscopic trunk and limbs appear painted in a variegated display of browns, purples, oranges, greens and yellows. The bark sheds in thin layers, revealing a neon-green layer beneath, and as it ages and weathers, different pigments are produced, resulting in the distinctive spectrum of colours. It is supposed that these pigments help to shield the inner layers from excessive sunlight and UV radiation, which can cause damage to the tree's tissues, particularly in the tropics. The patterns that form on the surface of the trunk appear to be almost brush-like, as if an artist of some abstract persuasion was seeking to create something surreal. Over time, the bark will gradually return to a brown colour, and at this stage, the shedding process is almost ready to begin once again.

While the rainbow eucalyptus has now been grown and planted in different countries across the world, its kaleidoscopic colouring is best seen where the tree thrives in its native tropical climate, where ideal growing conditions contribute to rapid growth and intensify the rainbow display.

LEFT THE UNIQUE PATTERNS OF THE RAINBOW EUCALYPTUS' BARK

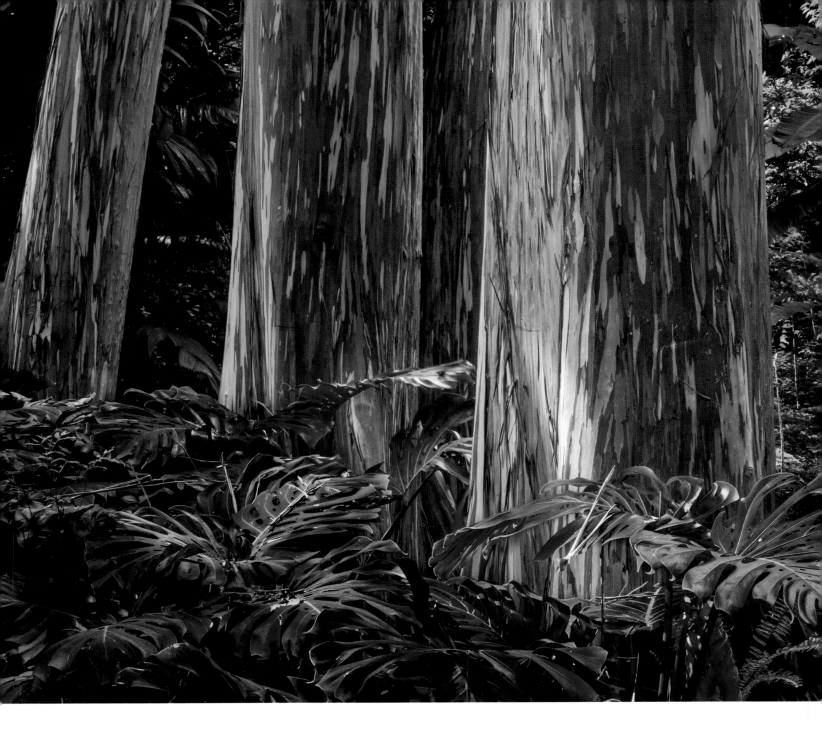

How to See

WHERE

Imagine an Impressionist painting manifested as a tree. That's *E deglupta*, more commonly known as the rainbow eucalyptus. The only eucalypt evolved to thrive in a rainforest habitat, this striking tree has a limited natural range, restricted to Papua New Guinea and areas of the Philippines and Indonesia, but its multicoloured bark makes it a favourite of botanical gardens worldwide.

Finding rainbow trees in the wild requires a little effort. In Papua New Guinea, the trees grow from close to sea level up to 8200ft (2500m), but there are no trails dedicated specifically to spotting this colourful species, so you'll have to keep your eyes peeled on rainforest hikes. Try your luck on trails at lower elevations, such as the challenging Kapa Kapa Trail from Gabagaba village on the island's southern coast.

Although not native to the Pacific islands, rainbow trees are arguably easier to see in the well-maintained botanical gardens of Hawai'i – there are some much-photographed rainbow gums on the 1-mile (1.6km) Ke'anae Arboretum Trail in the Ke'anae Arboretum on Maui, while the Keahua Arboretum on Kaua'i has the short Rainbow Eucalyptus trail, passing some colourful mature specimens.

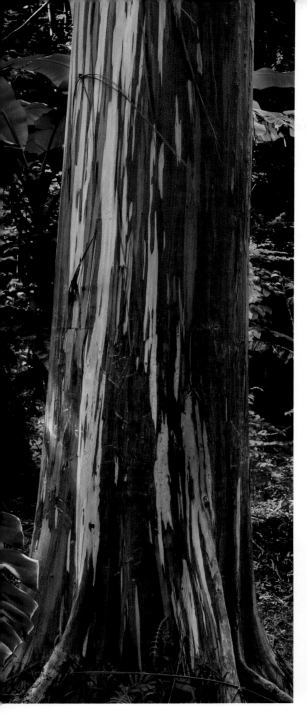

How to Identify

The trunk of the rainbow tree appears multicoloured, with shedding bark revealing irregular, vibrant patches of brown, purple, orange, green and yellow. The elongated green leaves typically measure 3in to 6in (8cm to 15cm), and are glossy to the touch. As a eucalypt, the foliage is aromatic when crushed. Buttress roots can often reach over 10ft high (3m), typical of the shallow-rooted trees that are found in the tropical regions.

WHEN
June to October is the driest time of year in Papua New Guinea, and the best time for rainforest hikes, before trails turn to quagmires during the rains. March to September brings good walking weather to Hawai'i.

ABOVE IN TROPICAL CONDITIONS, THE RAINBOW EUCALYPTUS CAN GROW TO A SUBSTANTIAL SIZE; RIGHT MANY RAINBOW EUCALYPTUS THRIVE OUTSIDE THEIR NATIVE RANGE, SUCH AS THIS ONE IN HAWAII, USA

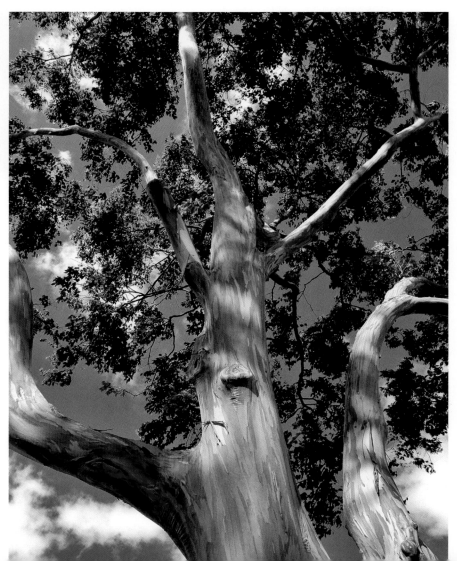

Moreton Bay Fig

Ficus macrophylla

Vitals

RANGE

Coastal Queensland, New South Wales and Victoria, Australia

STATUS

Unclassified

LIFESPAN

<200 years

AVERAGE HEIGHT

140ft-200ft (42m-61m)

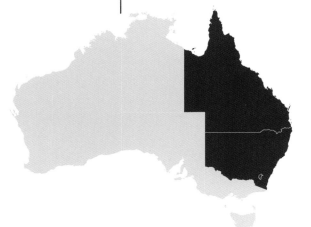

KNOWN AS THE 'KILLERS OF THE FOREST', THESE FIGS ARE BOTANICAL MARVELS WITH MURDEROUS INTENT

Named after the Queensland region in which it thrives, the Moreton Bay fig is native to the tangled forests lining the shorelines of eastern Australia. Despite challenging humidity and poor sandy soils, this coastal area offers a suitable habitat for these distinctive and unusual trees thanks to their great resilience and adaptability.

Also known as the strangler fig, *F macrophylla* has a life cycle unlike most other arboreal species. Originating as a hemiepiphyte – growing harmlessly on other plants or objects, deriving moisture from the air and rain – it begins its journey as a seed germinating high in the branches of a host tree, usually deposited there by animal digestion and excretion. As it grows, the fig's aerial roots cascade downwards, slowly enveloping the host tree whilst seeking out nutrients from the earth below. Over time, it produces a dense, lattice-like structure that encases and ultimately kills the once-healthy host tree. Survival in the natural world is a ruthless pursuit.

Despite such parasitic beginnings, the Moreton Bay fig goes on to play an important role in the forest ecosystem. The strangled host's decomposing trunk becomes a valuable habitat for insects, birds and small mammals, while the fig's intricate root system provides stability for the forest floor below, preventing erosion and creating microhabitats for a diverse array of plant and animal species. Large Moreton Bay fig trees can be found across eastern Australia, including in Melbourne's Carlton Gardens, where the large specimen has served as a meeting and rallying point for Aboriginal civil rights activists since the 1940s.

RIGHT THE VAST BUTTRESSED ROOTS OF A MORETON BAY FIG IN SYDNEY'S ROYAL BOTANIC GARDENS

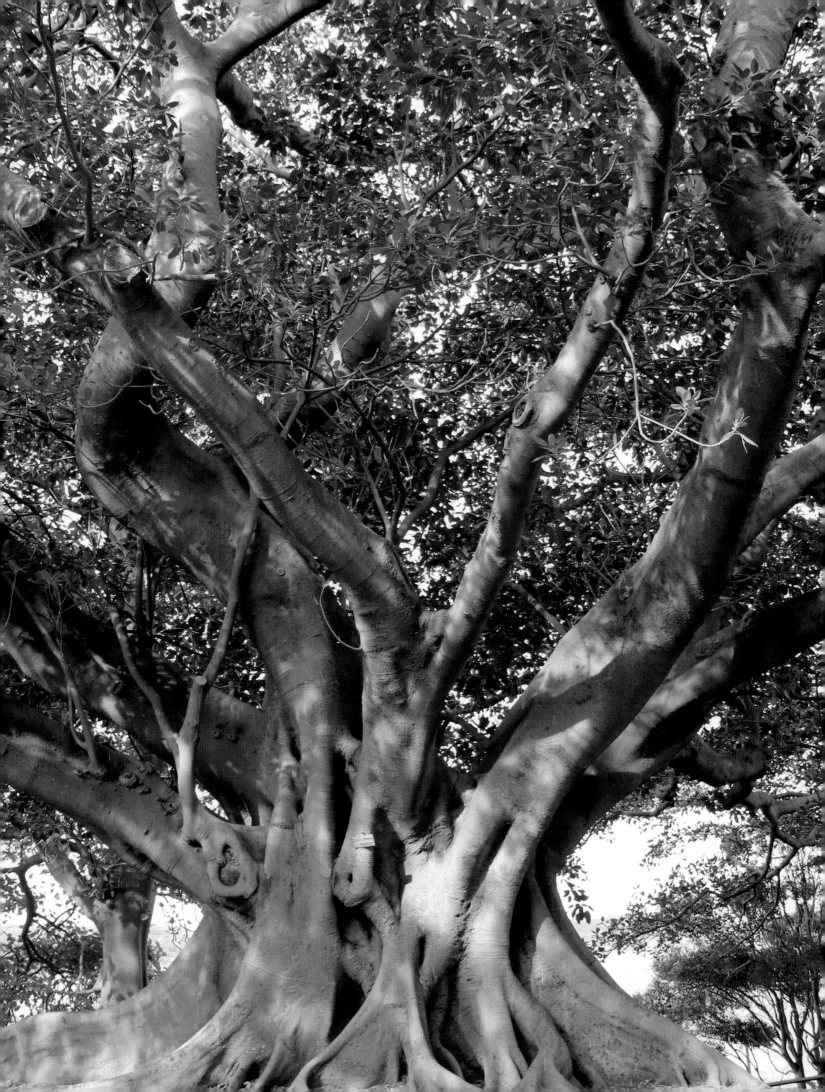

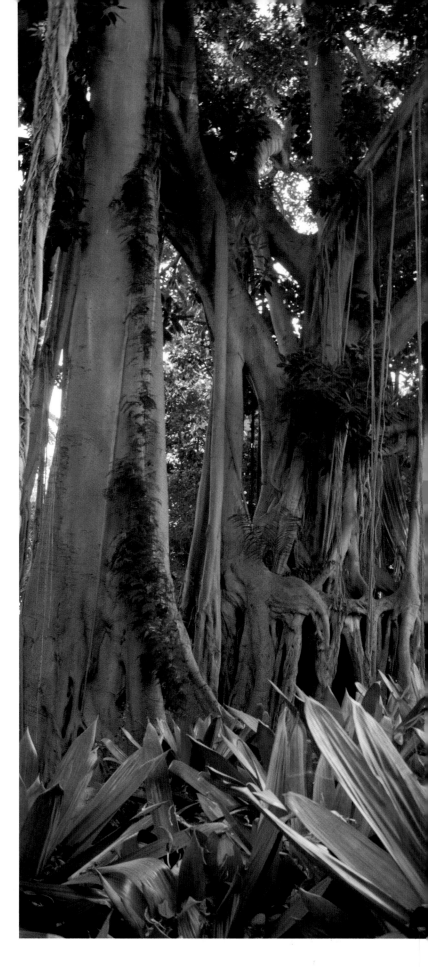

How to See

WHERE

Native to the tropical and subtropical forests of eastern Australia, these nefarious figs hitch a ride to the sunlight-filled upper canopy on other trees. They're easily spotted even in the heart of Sydney at the Royal Botanic Gardens, the Centennial Parklands and along the coastal path from Mosman Bay to Cremorne Point.

In Sydney's Centennial Parklands, an avenue of figs trees was planted in the 1860s by Charles Moore, Director of the Royal Botanic Garden. On Musgrave Avenue, one huge fig's buttresses are as tall as human. On Lang Rd, another giant fig is known as the 'Dragon Tree', due to its imagination-firing shape. Parklands' oldest and largest Moreton Bay figs grow in Queens Park.

Head offshore from Sydney to Lord Howe Island to find more impressive specimens, including on the island's golf course and on the rainforest treks up Mt Gower (or the ambitious ascent of Mt Lidgbird). As well as normal Moreton Bay figs, the island has its own subspecies, *F macrophylla f. columnaris*, characterised by dense, vertical roots.

WHEN

The best time to visit Sydney is September to November or February to May, avoiding the cooler winter and peak Christmas season crowds.

RIGHT MORETON BAY FIGS CAN START LIFE AS A SEED THAT GERMINATES IN THE BRANCHES OF ANOTHER TREE AND THEN SEND ROOTS DOWN TO THE GROUND; OPPOSITE TOP THEY THRIVE ALONG AUSTRALIA'S EAST COAST; LOWER RIGHT THE FRUIT OF A MORETON BAY FIG IS EDIBLE IF NOT VERY PALATABLE

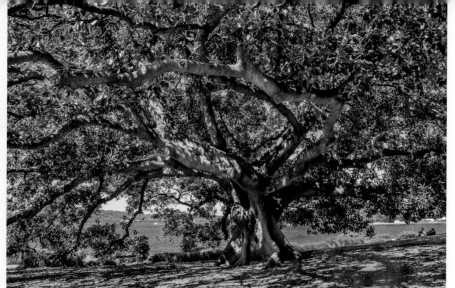

How to Identify

Distinguished by its descending aerial roots, *F macrophylla* often grows to grand proportions, sometimes with a trunk diameter of up to 10ft (3m) wide. The bark is smooth and light grey, ageing to a brown with visible fissures as it matures. As an evergreen, the large, glossy green leaves remain on the tree year-round, measuring 4in to 7in (10cm to 18cm) with a white vein running through the middle of the leaf. Fruits tend to grow from February, turning from green to purple.

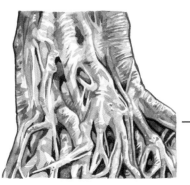

Index

A

acacia *see* Umbrella thorn acacia
Alentejo, Portugal 151–153
Alerce (*Fitzroya cupressoides*) 101–103
Almond (*Prunus dulcis, syn. P. amygdalus*) 193–198
Argentina 85–87, 101–103
Armenia 110–113
Aspen *see* Quaking aspen
Aspen, USA 72
Atlas cedar (*Cedrus atlantica*) 41–43
Atlas Mountains, Morocco 41–43
Australia 198–201, 203–205, 206–209, 214–217, 219–221, 232–235
autumn colour
 Common beech (*Fagus sylvatica*) 170–173
 English oak (*Quercus robur*) 180–183
 European larch (*Larix decidua*) 162–165
 Ginkgo (*Ginkgo biloba*) 118–121
 Horse chestnut (*Aesculus hippocastanum*) 188–191
 Quaking aspen (*Populus tremuloides*) 70–73
 Sugar maple (*Acer saccharum*) 59–61
Avenue of the Baobabs, Madagascar 50

B

Baja California, Mexico 93–95
Banyan *see* Indian banyan
baobab *see* Grandidier's baobab
Beech *see* Common beech
Beijing, China 138
Black Hills, USA 90
Black mulberry (*Morus nigra*) 110–113
blossom trees *see* spring-blossoming trees
Bolivia 85
Boojum (*Fouquieria columnaris*) 93–95
botanic gardens & arboretums
 Acharya Jagadish Chandra Bose Botanical Gardens, India 128–130
 Keahua Arboretum, Hawai'i 230
 Ke'anae Arboretum, Hawai'i 230
 Kew Gardens, England 118
 Mt Annan Botanic Gardens, Australia 204
 Mt Tomah Botanic Gardens, Australia 204
 Royal Botanic Gardens Sydney, Australia 204, 234
Bright, Australia 220
Bristlecone pine *see* Great Basin bristlecone pine
Buenos Aires, Argentina 85–87
Bulabog Beach, Philippines 134
Bulgaria 188–191
bushfires *see* wildfires

C

Calaveras Grove, USA 78
Canada 59–61, 70–73, 75–77, 96–99
Cape Reinga/Te Rerenga Wairua, New Zealand 224–226
Carob (*Ceratonia siliqua*) 18–21
Centennial Parklands, Australia 234
Charleston, USA 62–65
Cherry (*Prunus serrulata*) 123–125
Chile 67–69, 101–103
China 118–121, 136–139
Cirio *see* Boojum
climate change
 Atlas cedar (*Cedrus atlantica*) 41
 Giant sequoia (*Sequoiadendron giganteum*) 78
 Quiver tree (*Aloidendron dichotomum*) 22
 Red mangrove (*Rhizophora mangle*) 27
 Wollemi pine (*Wollemia nobilis*) 203
clonal trees
 Norway spruce (*Picea abies*) 185–187
 Quaking aspen (*Populus tremuloides*) 70–73
coastal trees
 Alerce (*Fitzroya cupressoides*) 101–103
 Coconut palm (*Cocos nucifera*) 133–135
 Date palm (*Phoenix dactylifera*) 30–33
 Maritime pine (*Pinus pinaster*) 154–157
 Moreton Bay fig (*Ficus macrophylla*) 232–235
 Norfolk Island pine (*Araucaria heterophylla*) 214–217
 Pacific madrone (*Arbutus menziesii*) 75–77
 Pōhutukawa (*Metrosideros excelsa*) 224–227
 Red mangrove (*Rhizophora mangle*) 27–29
Coast redwood (*Sequoia sempervirens*) 78
Coconut palm (*Cocos nucifera*) 133–135
Common beech (*Fagus sylvatica*) 170–173
conkers 188–191
Cork oak (*Quercus suber*) 151–153
Cornwall, England 67
Coromandel Peninsula, New Zealand 212
cultural connections
 Cherry (*Prunus serrulata*) 123–125
 Common beech (*Fagus sylvatica*) 170–173
 Dragon's blood tree (*Dracaena cinnabari*) 44–47
 English oak (*Quercus robur*) 180–183
 Flame of the forest (*Butea monosperma*) 141–143
 Ginkgo (*Ginkgo biloba*) 118–121
 Holly (*Ilex aquifolium*) 159–161
 Horse chestnut (*Aesculus hippocastanum*) 188–191
 Indian banyan (*Ficus benghalensis*) 128–131

Joshua tree (*Yucca brevifolia*) 104–107
Kauri (*Agathis australis*) 211–213
Mountain ash (*Eucalyptus regnans*) 198–201
Olive (*Olea europaea*) 177–179
Pōhutukawa (*Metrosideros excelsa*) 224–227
Ponderosa pine (*Pinus ponderosa*) 88–91
Quiver tree (*Aloidendron dichotomum*) 22–25
Silver birch (*Betula pendula*) 146–149
Tree rhododendron (*Rhododendron arboreum*) 115–117
Western redcedar (*Thuja plicata*) 96–99
Yew (*Taxus baccata*) 167–169
Yulan magnolia (*Magnolia denudata*) 136–139

D

Dajue Temple, China 138
Date palm (*Phoenix dactylifera*) 30–33
deciduous trees
 Almond (*Prunus dulcis, syn. P amygdalus*) 193–195
 Cherry (*Prunus serrulata*) 123–125
 Common beech (*Fagus sylvatica*) 170–173
 English oak (*Quercus robur*) 180–183
 European larch (*Larix decidua*) 162–165
 Flame of the forest (*Butea monosperma*) 141–144
 Ginkgo (*Ginkgo biloba*) 118–121
 Horse chestnut (*Aesculus hippocastanum*) 188–191
 Jacaranda (*Jacaranda mimosifolia*) 85–87
 Quaking aspen (*Populus tremuloides*) 70–73
 Silver birch (*Betula pendula*) 146–149
 Southern live oak (*Quercus virginiana*) 62–65
 Sugar maple (*Acer saccharum*) 59–61
 Yulan magnolia (*Magnolia denudata*) 136–139
deforestation & logging
 Atlas cedar (*Cedrus atlantica*) 41
 Giant sequoia (*Sequoiadendron giganteum*) 78
 Jacaranda (*Jacaranda mimosifolia*) 85
 Karri (*Eucalyptus diversicolor*) 206
 Kauri (*Agathis australis*) 211
 Monkey puzzle (*Araucaria araucana*) 67
 Norfolk Island pine (*Araucaria heterophylla*) 214
 Western redcedar (*Thuja plicata*) 96
desert trees
 Boojum (*Fouquieria columnaris*) 93–95
 Date palm (*Phoenix dactylifera*) 30–33
 Joshua tree (*Yucca brevifolia*) 104–107
 Quiver tree (*Aloidendron dichotomum*) 22–25
Dinglin Temple, China 120
Douglas, David 88
Dragon's blood tree (*Dracaena cinnabari*) 44–47
drought-deciduous trees
 Boojum (*Fouquieria columnaris*) 93–95
 Grandidier's baobab (*Adansonia grandidieri*) 49–51

E

edible fruits, nuts & seeds *see* fruit, nut & seed trees (edible)
Edisto Island, USA 64
Egypt 30
England 118, 159–161, 167–169, 180–183
English oak (*Quercus robur*) 180–183
European larch (*Larix decidua*) 162–165
evergreen trees
 Alerce (*Fitzroya cupressoides*) 101–103
 Atlas cedar (*Cedrus atlantica*) 41–43
 Carob (*Ceratonia siliqua*) 18
 Coconut palm (*Cocos nucifera*) 133–135
 Cork oak (*Quercus suber*) 151–153
 Date palm (*Phoenix dactylifera*) 30–33
 Dragon's blood tree (*Dracaena cinnabari*) 44–47
 Giant sequoia (*Sequoiadendron giganteum*) 78–81
 Great Basin bristlecone pine (Pinus longaeva) 54–57
 Holly (*Ilex aquifolium*) 159–161

Indian banyan (*Ficus benghalensis*) 128–131
Karri (*Eucalyptus diversicolor*) 206–209
Kauri (*Agathis australis*) 211–213
Maritime pine (*Pinus pinaster*) 154–157
Monkey puzzle (*Araucaria araucana*) 67–69
Moreton Bay fig (*Ficus macrophylla*) 232–235
Mountain ash (*Eucalyptus regnans*) 198–201
Norfolk Island pine (*Araucaria heterophylla*) 214–217
Norway spruce (*Picea abies*) 185–187
Olive (*Olea europaea*) 177–179
Pacific madrone (*Arbutus menziesii*) 75–77
Pōhutukawa (*Metrosideros excelsa*) 224–227
Ponderosa pine (*Pinus ponderosa*) 88–91
Rainbow eucalyptus (*Eucalyptus deglupta*) 229–231
Red mangrove (*Rhizophora mangle*) 27–29
Snow gum (*Eucalyptus pauciflora*) 219
Tree rhododendron (*Rhododendron arboreum*) 115–117
Umbrella thorn acacia (*Vachellia tortilis*) 34–37
Western redcedar (*Thuja plicata*) 96–99
Wollemi pine (*Wollemia nobilis*) 203–205
Yew (*Taxus baccata*) 167–169

F

Falaj Al Jeela, Oman 32
Falaj Muyasser, Oman 32
fall colour *see* autumn colour
Finland 148
fires *see* wildfires
Flame of the forest (*Butea monosperma*) 141–143
forests & woodlands
 Algonquin Provincial Park, Canada 60
 Dervisha Managed Nature Reserve, Bulgaria 190
 Green Triangle Forest, Australia 220
 Hamalachim-Shahariya Forest, Israel 20
 Hampstead Heath, England 160
 Hollies Nature Reserve, England 160
 Kaibab National Forest, USA 90
 Kingley Vale, England 167–169
 Landes Forest, France 156
 Queen's Wood, England 160
 Quiver Tree Forest, Namibia 22–25
 Sherwood Forest, England 180–183
 Waipoua Forest, New Zealand 212
France 156
fruit, nut & seed trees (edible)
 Almond (*Prunus dulcis, syn. P amygdalus*) 193–195
 Black mulberry (*Morus nigra*) 110–113
 Carob (*Ceratonia siliqua*) 18–21
 Coconut palm (*Cocos nucifera*) 133–135
 Date palm (*Phoenix dactylifera*) 30–33
 Grandidier's baobab (*Adansonia grandidieri*) 49–51
 Olive (*Olea europaea*) 177–179

G

Giant sequoia (*Sequoiadendron giganteum*) 78–81
Ginkgo (*Ginkgo biloba*) 118–121
Grafton, Australia 85
Grandidier's baobab (*Adansonia grandidieri*) 49–51
Great Basin bristlecone pine (*Pinus longaeva*) 54–57
Greece 178

H

hanami, Japan 123–125
Hawai'i, USA 230
Hawkes Bay, New Zealand 226
Himalaya, Nepal & India 115–117
Holly (*Ilex aquifolium*) 159–161
Horse chestnut (*Aesculus hippocastanum*) 188–191

I

India 115–117, 128–131, 141–143
Indian banyan (*Ficus benghalensis*) 128–131
Iraq 30
Israel 20

J

Jacaranda (*Jacaranda mimosifolia*) 85–87
Japan 123–125
Johns Island, USA 62–65
Joshua tree (*Yucca brevifolia*) 104–107

K

Kanchenjunga Base Camp, Nepal 116
Karahunj, Armenia 112
Karri (*Eucalyptus diversicolor*) 206–209
Kauri (*Agathis australis*) 211–213
Kolkata, India 128–131
Kyoto, Japan 124

L

Lake Fyresvatn, Norway 186
Lesvos, Greece 178
Live oak *see* Southern live oak
Locust bean *see* carob
long-lived trees
 Alerce (*Fitzroya cupressoides*) 101–103
 Dragon's blood tree (*Dracaena cinnabari*) 44–47
 English oak (*Quercus robur*) 180–183
 European larch (*Larix decidua*) 162–165
 Giant sequoia (*Sequoiadendron giganteum*) 78–81
 Ginkgo (*Ginkgo biloba*) 118–121
 Grandidier's baobab (*Adansonia grandidieri*) 49–51
 Great Basin bristlecone pine (*Pinus longaeva*) 54–57
 Indian banyan (*Ficus benghalensis*) 128–131
 Kauri (*Agathis australis*) 211–213
 Monkey puzzle (*Araucaria araucana*) 67–69
 Olive (*Olea europaea*) 177–179
 Pōhutukawa (*Metrosideros excelsa*) 224–227
 Ponderosa pine (*Pinus ponderosa*) 88–91
 Southern live oak (*Quercus virginiana*) 62–65
 Umbrella thorn acacia (*Vachellia tortilis*) 34–37
 Western redcedar (*Thuja plicata*) 96–99
 Wollemi pine (*Wollemia nobilis*) 203–205
 Yew (*Taxus baccata*) 167–169
logging *see* deforestation & logging
Lord Howe Island, Australia 234

M

Madagascar 49–51
Magnolia *see* Yulan magnolia
Maidenhair tree *see* Ginkgo
Mallorca, Spain 193–195
Mangrove *see* red mangrove
Maple *see* Sugar maple
Maritime pine (*Pinus pinaster*) 154–157
Mexico 93–95
Mojave Desert, USA 104
Monkey puzzle (*Araucaria araucana*) 67–69
Moreton Bay fig (*Ficus macrophylla*) 232–235
Morocco 41–43
Mountain ash (*Eucalyptus regnans*) 198–201
mountain trees
 Atlas cedar (*Cedrus atlantica*) 41–43
 European larch (*Larix decidua*) 162–165
 Giant sequoia (*Sequoiadendron giganteum*) 78–81
 Great Basin bristlecone pine (*Pinus longaeva*) 54–57
 Monkey puzzle (*Araucaria araucana*) 67–69
 Norway spruce (*Picea abies*) 185–187
 Ponderosa pine (*Pinus ponderosa*) 88–91

 Snow gum (*Eucalyptus pauciflora*) 219–221
 Tree rhododendron (*Rhododendron arboreum*) 115–117
Mt Bogong, Australia 220
Mt Feathertop, Australia 220
Mt Manganui, New Zealand 226
Mt Yoshino, Japan 124
Muir, John 78
Mulberry *see* Black mulberry

N

Namibia 22–25
Napier, New Zealand 226
national parks & reserves
 Blue Mountains National Park, Australia 204
 Botany Bay Heritage Preserve, USA 64
 Dandenong Ranges National Park, Australia 200
 Dervisha Managed Nature Reserve, Bulgaria 190
 Fulufjället National Park, Sweden 185
 Giant Sequoia National Monument, USA 80
 Gloucester National Park, Australia 208
 Grand Canyon National Park, USA 90
 Great Basin National Park, USA 56
 Great Otway National Park, Australia 200
 Greater Beedelup National Park, Australia 208
 Hawke National Park, Australia 208
 Ifrane National Park, Morocco 42
 Joshua Tree National Park, USA 104–107
 Kings Canyon National Park, USA 78–81
 Kosciuszko National Park, Australia 220
 Makalu-Barun National Park, Nepal 116
 Masai Mara National Reserve, Kenya 36
 Mt Buffalo National Park, Australia 220
 Norfolk Island National Park, Australia 216
 Nuuksio National Park, Finland 148
 Pacific Rim National Park Reserve, Canada 98
 Parque Nacional Alerce Costero, Chile 102
 Parque Nacional Nahuelbuta, Chile 68
 Parque Natural de Gorbeia, Spain 172
 Reserva Costera Valdiviana, Chile 102
 Sequoia National Park, USA 78–81
 Serengeti National Park, Tanzania 36
 Tazekka National Park, Morocco 42
 Warren National Park, Australia 208
 Wollemi National Park, Australia 203–205
 Yarra Ranges National Park, Australia 200
 Yosemite National Park, USA 78
Nepal 115–117
New Zealand 211–213, 224–227
Nigeria 28
Norfolk Island pine (*Araucaria heterophylla*) 214–217
Norway 186
Norway spruce (*Picea abies*) 185–187
notable trees
 Angel Oak (Live oak), USA 62
 Carlton Gardens Fig (Moreton Bay fig), Australia 232
 Centurion (Mountain ash), Australia 198
 Cheewhat Giant (Western redcedar), Canada 96–99
 Dave Evans Bicentennial Tree (Karri), Australia 208
 General Sherman (Giant sequoia), USA 80
 Gran Abuelo (Alerce), Chile 101–103
 Great Banyan (Indian banyan), India 128–131
 Lone Pine (Norfolk Island pine), Australia 214
 Major Oak (English oak), England 180–183
 Methuselah (Great Basin bristlecone pine), USA 54–57
 Old Tjikko (Norway spruce), Sweden 185
 Pando (quaking aspen), USA 70
 Tāne Mahuta (Kauri), New Zealand 211–212
 Thimmamma Marrimanu (Indian banyan), India 130
 Tyrant (Karri), Australia 208
nuts *see* fruit, nut & seed trees (edible)

O

Oil palm (*Elaeis guineensis*) 134
Olive (*Olea europaea*) 177–179
Oman 30–33
ornamental trees
 Black mulberry (*Morus nigra*) 110–113
 Cherry (*Prunus serrulata*) 123–125
 Horse chestnut (*Aesculus hippocastanum*) 188–191
 Jacaranda (*Jacaranda mimosifolia*) 85–87
 Pacific madrone (*Arbutus menziesii*) 75–77
 Sugar maple (*Acer saccharum*) 59–61
 Tree rhododendron (*Rhododendron arboreum*) 115–117
 Yulan magnolia (*Magnolia denudata*) 136–139

P

Pacific madrone (*Arbutus menziesii*) 75–77
Palm tree *see* Coconut palm & Date palm
Papua New Guinea 230
Paraguay 85
Pemba, Tanzania 28
Philippines 134
Pōhutukawa Coast, New Zealand 226
Pōhutukawa (*Metrosideros excelsa*) 224–227
Ponderosa pine (*Pinus ponderosa*) 88–91
Portugal 151–153
Preslav Mountains, Bulgaria 190

Q

Quaking aspen (*Populus tremuloides*) 70–73
Quiver tree (*Aloidendron dichotomum*) 22–25

R

Rainbow eucalyptus (*Eucalyptus deglupta*) 229–231
rare trees
 Dragon's blood tree (*Dracaena cinnabari*) 44–47
 Grandidier's baobab (*Adansonia grandidieri*) 49–51
 Quiver tree (*Aloidendron dichotomum*) 22–25
 Wollemi pine (*Wollemia nobilis*) 203–205
Red mangrove (*Rhizophora mangle*) 27–29
Red maple (*Acer rubrum*) 60–61
Redondo, Portugal 152
Rhododendron *see* Tree rhododendron

S

sakura, Japan 123–125
Santiniketan, India 142
Saudi Arabia 30
Sequoia *see* Giant sequoia
Serra d'Ossa, Portugal 152
Shengshui Temple, China 120
Siargao Island, Philippines 134
Silver birch (*Betula pendula*) 146–149
Snow gum (*Eucalyptus pauciflora*) 219–221
Socotra Archipelago, Yemen 44–47
South Africa 22–25
Southern live oak (*Quercus virginiana*) 62–65
Spain 172, 193–195
spring-blossoming trees
 Almond (*Prunus dulcis, syn. P amygdalus*) 193–195
 Cherry (*Prunus serrulata*) 123–125
 Flame of the forest (*Butea monosperma*) 141–143
 Jacaranda (*Jacaranda mimosifolia*) 85–87
 Tree rhododendron (*Rhododendron arboreum*) 115–117
 Yulan magnolia (*Magnolia denudata*) 136–139
St Moritz, Switzerland 164
Strangler fig *see* Moreton Bay fig
Sugar maple (*Acer saccharum*) 59–61
Sweden 185
Switzerland 164
Sydney, Australia 204, 234

T

tall trees
 Alerce (*Fitzroya cupressoides*) 101–103
 Giant sequoia (*Sequoiadendron giganteum*) 78–81
 Karri (*Eucalyptus diversicolor*) 206–209
 Kauri (*Agathis australis*) 211–213
 Mountain ash (*Eucalyptus regnans*) 198–201
 Norfolk Island pine (*Araucaria heterophylla*) 214–217
 Ponderosa pine (*Pinus ponderosa*) 88–91
 Rainbow eucalyptus (*Eucalyptus deglupta*) 229–231
 Western redcedar (*Thuja plicata*) 96–99
Tanzania 28, 36
Tasmania, Australia 198–201, 219–221
Tell Atlas, Algeria 42
Tokyo, Japan 124
Tree rhododendron (*Rhododendron arboreum*) 115–117

U

Umbrella thorn acacia (*Vachellia tortilis*) 34–37
USA 54–57, 62–65, 70–73, 75–77, 78–81, 88–91, 104–107

V

Valle de los Cirios, Mexico 94
Vancouver Island, Canada 76, 98

W

Wadmalaw Island, USA 64
Waiau Falls, New Zealand 212
Western redcedar (*Thuja plicata*) 96–99
Whakakaiwhara Peninsula, New Zealand 226
wildfires
 Giant sequoia (*Sequoiadendron giganteum*) 78
 Maritime pine (*Pinus pinaster*) 154
 Mountain ash (*Eucalyptus regnans*) 198
 Snow gum (*Eucalyptus pauciflora*) 219
Wollemi pine (*Wollemia nobilis*) 203–205
woodlands *see* forests & woodlands
Wufeng Mountain, China 120

Y

Yemen 44–47
Yew (*Taxus baccata*) 167–169
Yulan magnolia (*Magnolia denudata*) 136–139

Z

Zanzibar, Tanzania 28

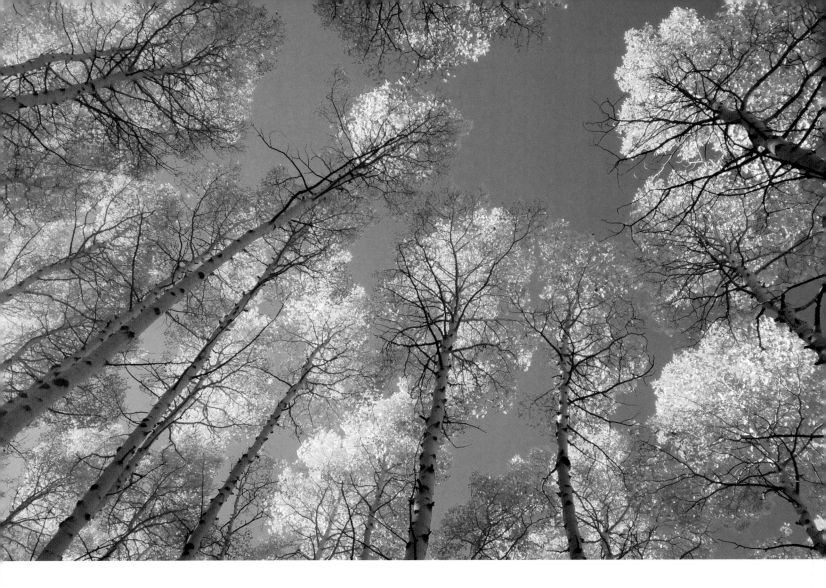

The Tree Atlas
October 2024
Published by Lonely Planet Global Limited
CRN 554153
www.lonelyplanet.com
10 9 8 7 6 5 4 3 2 1
Printed in Malaysia
ISBN 978 18375 8267 9
© Lonely Planet 2024
© photographers as indicated 2024

Publishing Director Piers Pickard
Gift & Illustrated Publisher Becca Hunt
Senior Editor Robin Barton
Written by Matthew Collins, Thomas Rutter
& Joe Bindloss
Editor Polly Thomas
Designer Emily Dubin
Typesetter Hillary Caudle
Illustrator Holly Exley
Print Production Nigel Longuet

Cover photograph
© Lukas Bischoff Photograph / Shutterstock
Back cover photographs
© Ronda Kimbrow, ESB Professional / Shutterstock

Lonely Planet Global Limited
Digital Depot, Roe Lane (off Thomas St),
Digital Hub, Dublin 8,
D08 TCV4
Ireland

STAY IN TOUCH lonelyplanet.com/contact